The Inbetweenness of Things

The Inbetweenness of Things

Materializing Mediation and Movement between Worlds

Edited by
PAUL BASU

Bloomsbury Academic
An imprint of Bloomsbury Publishing Plc

B L O O M S B U R Y
LONDON · OXFORD · NEW YORK · NEW DELHI · SYDNEY

Bloomsbury Academic

An imprint of Bloomsbury Publishing Plc

50 Bedford Square
London
WC1B 3DP
UK

1385 Broadway
New York
NY 10018
USA

www.bloomsbury.com

BLOOMSBURY and the Diana logo are trademarks of Bloomsbury Publishing Plc

First published 2017

British Library Cataloguing-in-Publication Data
A catalogue record for this book is available from the British Library.

ISBN: HB: 978-1-4742-6477-8
ePDF: 978-1-4742-6480-8
ePub: 978-1-4742-6478-5

Library of Congress Cataloging-in-Publication Data
A catalog record for this book is available from the Library of Congress.

Cover design by ClareTurner.co.uk
Cover image © The Trustees of the British Museum.
All rights reserved.

Typeset by Newgen Knowledge Works (P) Ltd., Chennai, India.
Printed and bound in Great Britain

Contents

Figures

List of contributors

Paul Basu is Professor of anthropology at the School of Oriental and African Studies, University of London. His research focuses on issues of cultural heritage, memory and material culture, particularly relating to West Africa. He has long-standing engagements with critical museology and exhibition practice, recently co-curating, with Julie Hudson, the exhibition *Sowei Mask: Spirit of Sierra Leone* at the British Museum. His earlier books include *Exhibition Experiments* (co-edited with Sharon Macdonald) and *Museums, Heritage and International Development* (co-edited with Wayne Modest).

Khadija von Zinnenburg Carroll is Professor of global art at the University of Birmingham. She is the author of the book *Art in the Time of Colony*, the curator of various international exhibitions and a co-editor of the journal *Third Text*. An expert in global contemporary art and colonialism, as well as the history of museums and collecting, she received her PhD from Harvard University and has held fellowships from the British Academy, Sackler-Caird and Humboldt Foundation.

Catherine Cummings is currently research fellow in cultural heritage at the University of Exeter. She is working on the EU-funded project RICHES (Renewal, Innovation and Change: Heritage in European Society). She has previously lectured in art and design history, cultural theory and museology. Her research interests include museum anthropology, colonialism and the formation of ethnographic collections, object biographies, the digitization of cultural heritage, and tangible and intangible cultural heritage.

Sandra H. Dudley is a social anthropologist whose research has focused on refugees, material culture, Burma, India, museums and cultural heritage. A thread running throughout her work is an exploration of what it means, for people and things alike, to be 'at home' (or not). Dudley has published widely; her books include *Materialising Exile* (2010) and *Museum Materialities* (2010). She is currently deputy head of the School of Museum Studies, University of Leicester.

Silvia Forni is curator of African arts and cultures at the Royal Ontario Museum. She is also associate professor of anthropology at the University of Toronto. She has published essays in several journals, including *African Arts*, *Critical Interventions* and *Museum Worlds*, and has contributed chapters to many edited volumes. In 2015 she co-edited, with Christopher B. Steiner, the volume *Africa in the Market*, and is currently co-writing with Doran Ross the volume *Art, Honor and Ridicule: Fante Asafo Flags from Southern Ghana*.

Stacey R. Jessiman (JD, LLM) is an international transactional and dispute resolution lawyer and an expert on cultural heritage trade issues. After practicing law in New York and Paris, Jessiman completed graduate research work at the University of British Columbia Faculty of Law. She has been a visiting student researcher at the Stanford Archaeology Center, a lecturer in law and visiting scholar at Stanford Law School, and a lecturer in Stanford's Art History and Native American Studies departments.

Madeline Rose Knickerbocker is a white settler scholar and PhD candidate in the Department of History at Simon Fraser University. She is currently completing her community-engaged dissertation, which examines connections between cultural heritage curation and sovereignty activism in Stó:lō communities during the twentieth century. She researches and teaches Indigenous and Canadian histories focusing on politics and activism; feminism, gender and sexuality; material culture, heritage and commemoration; and oral history and community-engaged research methods.

John Picton is Emeritus Professor of African art at the University of London. He worked for the Nigerian Government Department of Antiquities between 1961 and 1970, the British Museum Department of Ethnography between 1970 and 1979, and the School of Oriental and African Studies between 1979 and 2003. His research and publication interests include the sculpture of Yoruba, Edo (Benin City) and lower Niger region peoples, textile history and masquerade in West Africa, and developments in sub-Saharan visual culture since the late nineteenth century.

Lucy Razzall has a PhD in English literature from the University of Cambridge. She has held research and teaching positions at Emmanuel College, Cambridge and Queen Mary University of London. Her research interests lie at the intersections between literature and material culture, particularly in post-Reformation England. She is working on a book about the material and metaphorical possibilities of the box, one of the most ordinary and most evocative of all objects, in early modern English literature.

Will Rea is Senior Lecturer in the history of African art in the School of Fine Art, History of Art and Cultural Studies at the University of Leeds. He completed his PhD at the Sainsbury Research Unit at the University of East Anglia. He has conducted fieldwork in Nigeria since 1990 and has written on Nigerian art history and culture as well as curated exhibitions of Yoruba textiles.

Clare Rowan is an assistant professor in the Department of Classics and Ancient History at the University of Warwick. She works on ancient money and the roles it plays in the formation of identities, communities and ideology in the ancient world. Most recently she has become interested in the role of tokens in antiquity, and their role in constituting daily social life.

Mary Katherine Scott is the acting director for the International Programs Office at the University of Wyoming. She is also a visiting assistant professor of art history in the University of Wyoming's Department of Art and Art History. Scott received her PhD in world art studies from the University of East Anglia in 2013, specializing in Latin America. Scott's ongoing ethnographic research focuses on how Mexican tourist arts circulate and acquire value within local and international art markets.

Bill Sillar is a senior lecturer at the Institute of Archaeology, University College London. His research focuses on material culture and technology. His fieldwork in Peru and Bolivia has included ethnographic work on pottery production, trade and use, and archaeological research into the emergence of the Inca Empire, including a project based around the Inca site and modern village of Raqchi, Cuzco Department, Peru. More recently he has been studying changes in the organization of pottery production, stoneworking and monumental architecture in the Inca capital of Cuzco.

Nick Stanley is currently an honorary research fellow at the British Museum Department of Africa, Oceania and the Americas, and emeritus professor at Birmingham City University. His research interests are in museum presentations mainly in Melanesia and particularly in West Papua. He is editor of *The Future of Indigenous Museums*, and his most recent book is *'Some Friends Came to See Us': Lord Moyne's 1936 Expedition to the Asmat*.

Lisa Truong is a PhD candidate in Carleton University's Institute for Comparative Studies in Literature, Art and Culture. Working with the Cree Nation of Eeyou Istchee, her dissertation examines the development of the Aanischaaukamikw Cree Cultural Institute. Her research interests focus on the changing relations between museums and indigenous communities, indigenous museological practices, and Inuit and Native North American material culture and art. She is also an active and independent curator of Inuit art.

Acknowledgements

The majority of the chapters in this book were first aired at a two-day symposium, also titled *The Inbetweenness of Things*, which was hosted at the British Museum and University College London in March 2013. I should especially like to thank Julie Hudson, curator of African Collections in the Department of Africa, Oceania and the Americas at the British Museum, with whom I organized the symposium. Sincere thanks also go to those participants in the symposium whose contributions are not included in this book, but who nevertheless animated our discussions of inbetweenness: Zara Anishanslin, Nicholas Bell, Lissant Bolton, Patrick Bresnihan, Mads Daugbjerg, Christine Taitano DeLisle, Taisuke Edamura, Julia Farley, Mariana Françozo, Rodney Harrison, Marc Jacobs, John Mack, Mhairi Maxwell, Wayne Modest, Michael Rowlands, Fiona Sheales, Devani Singh, Bjørn Thomassen and Nadine Zacharias. I am grateful to Clara Herberg and Jennifer Schmidt at Bloomsbury for their patience and support.

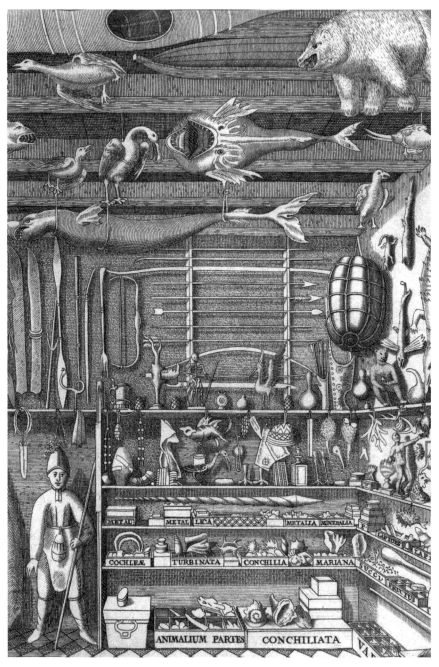

FIGURE 1.1 *Detail of frontispiece from* Museum Wormianum *(1655). Courtesy of the John Carter Brown Library at Brown University.*

1

The inbetweenness of things

Paul Basu

Between *things does not designate a localizable relation going from one thing to another and back again, but a perpendicular direction, a transversal movement that sweeps one* and *the other away, a stream without beginning or end that undermines its banks and picks up speed in the middle.*
DELEUZE AND GUATTARI, *A Thousand Plateaus*

A cabinet of curiosities

Imagine, if you will, that the thing now open before you is not a book, but a cabinet of curiosities. A collection of objects arranged not according to Linnaean principles of classification and taxonomy (the disciplined chronologies, typologies and geographical categorizations of the Enlightenment museum), but assembled according to a more idiosyncratic, speculative logic such as might have been devised before we imagined we were 'modern' (Latour 1991). Mounted on walls, placed on shelves, laid out in drawers, set on the floor, perhaps suspended from the ceiling, before you is an array of curious things: a feather-headdress (the crown of Montezuma, no less – or so it is claimed), a bonnet fashioned out of turtleshell, teacups woven from seagrass, a memorial pole of the Haisla First Nation (and its Swedish double), a carved wooden bee

taken from the throne of Thibaw Min, masks from West Africa, ancient coins from Macedonia, a stone vessel for making offerings to the Andean gods and more. However arbitrary the connections may seem, these apparently random things share a quality that defines this collection: the curious state of *inbetweenness*. Indeed, to the modest inventory contained within, one might add an infinity of things, since an argument of this book is that we might regard all things as being 'inbetween things', migratory, mediatory, transitive, 'always in the middle' (Deleuze and Guattari 1987: 25).

This book is, then, conceived as a kind of exhibition in which each of the contributing authors takes an object from the cabinet and holds it forth, as a curator might, for your consideration. The word 'exhibit' is, after all, derived from the Latin *exhibēre*, to hold forth, to present (Basu and Macdonald 2007: 2). As Sherry Turkle (2007) has noted, and as Claude Lévi-Strauss (1964: 89) long ago observed, whatever else they may afford, things are also 'good to think' with. Thus this collection of essays adopts an object-centred approach, and the things presented in each chapter provide starting points for each author to explore the notion of inbetweenness, grounding an otherwise abstract concept in the 'logic of the concrete' – in material culture. But things are not only material metaphors that evoke, express or represent ideas; as a number of the exhibits in this cabinet of curiosities demonstrate, things also have agency (Gell 1998; Latour 1999) – they act in the world, and here again their inbetweenness is key.

The 'inbetween' provides a way to escape the methodological essentialism that continues to dominate Western logic; the relentless search for the singular and true nature of things; the desire for certainty, for dividing the world into *this* or *that* (one fixed 'essence' separated from another). Yet, inbetweenness does not simply posit the opposite and argue that everything is social construction, contingency and flux. Inbetweenness is what Paul Gilroy (1993: 102) terms an 'anti-anti-essentialist' position. Inbetweenness is defined by its 'essential connectedness'; a double-consciousness born from 'histories of borrowing, displacement, transformation, and continual reinscription' (ibid.). This double-consciousness is not characterized by symmetry, however, but by 'syncretic complexity' (ibid.: 101). It is a diasporic consciousness, a consciousness that 'mediate[s], in a lived tension, the experiences of separation and entanglement, of living here and remembering/desiring another place' (Clifford 1997: 255). To consider the inbetweenness *of things* is thus to normalize an understanding of the material world as being constituted by movement and mediation (Basu and Coleman 2008). All objects are, in this sense, 'diasporic objects' (Basu 2011): entanglements of ongoing social, spatial, temporal and material trajectories and relationships, dislocations and relocations. This book seeks to explore how these lines of connectivity are manifest in different ways in the

form, function and perceived affordances of things; and how, in turn, these things help us to widen our understanding of the essential connectedness of the world.

A laboured distinction between 'objects' and 'things' is generally not made in what follows. Some of the things discussed are formally accessioned in institutional collections. Subjected to the *parerga* of museological framings (see Carroll, this volume), it may be argued that these are things that have been transformed into 'epistemic objects' – objects that are illustrative or representational of particular codifications of knowledge, or that embody such knowledge as exemplars or specimens (Alberti 2005). At the same time, as Sandra Dudley's and Stacey Jessiman's contributions make particularly explicit, even these accessioned objects are not constrained or determined by the museum's disciplined 'order of things'. They share, in other words, an indeterminacy that Bill Brown (2001) reserves for the world of things. While all objects are arguably things, one can accept that not all things are necessarily objects; yet Brown's object/thing dialectic nevertheless runs counter to the project of this book, which does not accord such absolute power to 'the grid of museal exhibition' (ibid.: 5), but rather asserts that, *as things*, the objects in this cabinet of curiosity also 'hover over the threshold between the nameable and unnameable, the figurable and unfigurable, the identifiable and unidentifiable' (ibid.; see also Dudley 2012). Whereas Michael Taussig (2004: 315; see Carroll, this volume) incites us to smash the museum's vitrines and free these 'captured objects' from their epistemological, and indeed ontological, bondage, one might question the capacity of the museum to *contain* these things in the first place.

The objects in this book/cabinet/collection have been contributed by scholars who, despite their particular disciplinary orientations – as anthropologists, art historians, archaeologists, classicists, museologists, lawyers and literary scholars – work in the 'undisciplined' interstitial space of material culture studies (Miller and Tilley 1996; cf. Basu 2013). Two of the enduring theoretical concerns of this field have been to question the apparent dichotomy between subjects and objects, and to challenge the common-sense assumption that things are merely the products of human labour and imagination, material expressions of immaterial ideas. The argument is, rather, that things create people as much as people create things. As Daniel Miller (2005: 8) states:

> We cannot comprehend anything, including ourselves, except as a form . . . We cannot know who we are, or become what we are, except by looking in a material mirror, which is the historical world created by those who lived before us. This world confronts us as material culture and continues to evolve through us.

Objects, then, make subjects; subjects make objects. Yet, as Miller and others also note, such a dialectical theory of objectification is *not* a theory of the mutual constitution of *prior* forms (such as subjects and objects):

> In objectification all we have is a process in time by which the very act of creating form creates consciousness or capacity such as skill and thereby transforms both form and the self-consciousness of that which has consciousness, or the capacity of that which now has skill (Miller 2005: 9).

While acknowledging, with Christopher Pinney (2005: 257), that 'the purification of the world into objects and subjects cannot be easily undone' and that focusing on objects seems merely to restate the straitjacket of binary logic, the aspiration of this book is precisely to think through things in their most obvious material manifestation – as objects – as a way of grasping the *process* of an inbetweenness that does not go 'from one thing to another and back again' (for example, a dialectical to-ing and fro-ing from subject to object to subject), but rather that flows in a 'perpendicular direction', sweeping away the dichotomous conceptual frameworks that still pervade dominant world views (Deleuze and Guattari 1987: 25).

Fetish

Let us take a step further into the cabinet. The symposium that gave rise to this collection was programmed to coincide with an exhibition that Julie Hudson and I curated as part of the British Museum's Asahi Shimbun 'Objects in Focus' series. The display, *Sowei Mask: Spirit of Sierra Leone*, featured a single wooden helmet mask of the Sande (or Bondo) society, a female initiation society common throughout Sierra Leone and in parts of Liberia and Guinea (see front cover image). The mask was placed at the centre of a small gallery, juxtaposed with text and image panels, and a video installation, offering various conceptual framings. This approach was an attempt to explore some of the many ways of understanding the mask while avoiding the dominance of any singular, reductive narrative. The sowei mask was thus refracted through multiple epistemological lenses: the ethnographic, the art historical, the performative, and in relation to the histories of colonial collecting and exchange, as well as postcolonial national iconography. One of our objectives was to unsettle canonical readings of the mask and draw attention to its resistance to straightforward categorization or interpretation according to familiar museological criteria such as period, place, style and ethnic or tribal association. The exhibition sought to give the mask voice, and it spoke not to the purity of type, but to 'impure' material histories of

entanglement, admixture and multidirectional exchange (Basu and Hudson 2012). Manifesting inbetweenness in its very form, the sowei mask provides a good point of departure for our consideration of the materialization of movement and mediation between worlds. Let it be the first object in this cabinet of curiosities to be held forth.

In the popular metropolitan imagination of the late nineteenth century, Africa was, of course, perceived as the 'Dark Continent', a land supposedly bereft of civilization and peopled with fetish-worshippers and cannibalistic cults. Nothing epitomized this combination of fear and fascination so much as 'secret societies' and their devilish appurtenances. The collecting of ritual paraphernalia and their display, together with the sensationalist accounts of travellers, served to reinforce this view. Such was the context in which this sowei mask travelled to Britain. It was collected, in 1886, by a trading agent (and subsequent colonial administrator) named Thomas Alldridge from Sherbro, then an outlying island of the British colony of Sierra Leone, and sent, together with examples of country cloths, basketwork and other locally made products, to London for display at the Colonial and Indian Exhibition of that year. It was one of two Sande/Bondo society masks displayed in a central case of the Sierra Leone section, described in lurid terms in the exhibition catalogue as 'specimens of some of the most prominent Fetishes worshipped in these parts . . . the heads of two "Bundoo" devils . . . worn in native "Bundoo" ceremonies by the chief dancer or priestess' (Colonial and Indian Exhibition 1886: 499).

As a 'fetish' displayed at the Colonial and Indian Exhibition, and subsequently acquired by the British Museum (Figure 1.2), the sowei mask stood in a synecdochic relationship to West Africa and was deployed in that 'spectacle of empire' through which the familiar tropes of Africa – as dark, heathen, savage and occult – took form and were perpetuated in the popular imagination (Coombes 1994). Yet, while the mask evoked in these contexts an exotic world of magic and superstition, both distant and radically different from European metropolitan culture, what is perhaps most striking about its form is that it is surmounted by a representation of a Western-style hat of a type that was fashionable in Britain at the time. The presence of the hat disrupts the binary reading of the mask, its anticipated embodiment of the (savage) other in contradistinction from the (civilized) self of the exhibition's metropolitan audience. The mask stands not, then, for the alterity of Africa but for a more complicated, ambiguous story of cultural interaction in the colonial era. The mask was made and collected at a time of unprecedented mobility of people and things, and just as the mask was transported to London as a representation of primitive religion, so the European hat travelled to West Africa and was incorporated into the regalia of both male and female elites as a symbol of power. The sowei mask is thus neither wholly African in its

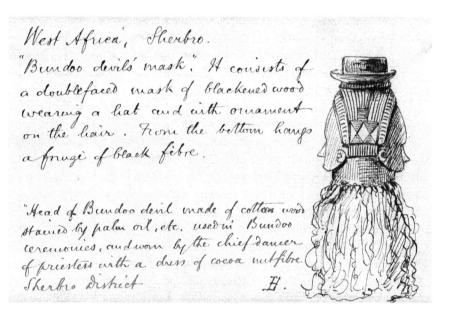

West Africa, Sherbro.
"Bundoo devils' mask." It consists of
a doublefaced mask of blackened wood
wearing a hat and with ornament
on the hair. From the bottom hangs
a fringe of black fibre.

"Head of Bundoo devil made of cotton wood
stained by palm oil, etc. used in Bundoo
ceremonies, and worn by the chief dancer
of priests with a dress of cocoa nut fibre
Sherbro District H.

FIGURE 1.2 *British Museum accession record for 'Bundoo devil's mask', 1886. Note the 'janus-faced' design of the mask and its European hat. (Af1886,1126.1.a-b) © Trustees of The British Museum. See also front cover image.*

iconography, nor, of course, wholly European – rather it hovers between these worlds; a travelling object, which materializes complex, multidirectional trajectories and entanglements in its hybridized form (Thomas 1991; Phillips and Steiner 1999).

But the mask hovers between other worlds too. Indeed, perhaps more than any other things, masks exemplify an ontological inbetweenness. In Sierra Leone, and in West Africa more generally, a mask is not a mask. Masks are not disguises, nor are they art objects that can be classified according to type or aesthetic characteristics associated with a particular region or ethnic group. Masks do not even *represent* something 'other-worldly'; rather they are *manifestations* of other-worldliness – manifestations, that is, of the spirit world. In the Sande society, the *ndoli jowei* – the 'dancing *sowei*' masquerade figure, of which the sowei mask is a part – is a manifestation of a particular spirit (*ngafa*), which has been coaxed or 'pulled' usually from beneath a river (Boone 1986; Phillips 1995). A visible, material manifestation of an invisible, immaterial presence, the *ndoli jowei* masquerade mediates between the worlds of human beings and spirits, and performs a central role in dangerous periods of human transition (from childhood to adulthood, for example, when young women are initiated into the Sande society, and from adulthood to 'ancestorhood', at the death of senior members of the society). As with the

Yoruba masquerade discussed by William Rea in his contribution to the book, it is not, of course, that people do not realize that the spirit manifestation is 'carried' by a human ritual specialist; rather the mask is an intermediary – human yet not human, spirit yet not spirit – occupying a space that transverses both domains (Jedrej 1980: 224).

The ambiguous inbetweenness of the *ndoli jowei* is expressed in another feature of this particular mask: it is 'janus-faced'. Thus one side faces the mundane, everyday world of humans, while the other faces the ordinarily hidden world of the spirits. Indeed, even when such masks do not literally carry two faces, or two sets of eyes, as in this instance, the faculty of having 'double vision' – or being 'twin-eyed', *ngama fele* – sets apart the ritual specialists who lead the Sande society, including the dancing *sowei*. As Sylvia Boone (1986: 177) remarks:

> When the carved eyes of the wooden mask are allied to the eyes of the dancer, a Sowo [the *ndoli jowei* masquerade] becomes a 'two-eyed' creature with all the attendant mystical powers; the mask-head forms a Janus with the head of the human being inside; she, with her human eyes, has added to her all the power of the mask's eyes to see inside the spirit world.

In the masquerade performance, human and spirit are both separate *and* indivisible, and the mask embodies a kind of double-consciousness that straddles ontological worlds. Through its donning of the Western hat, this mask also demonstrates that it was not only worldly chiefs who incorporated European headgear into their regalia, but also Sierra Leone's indigenous spirits who appropriated the colonizer's material culture into their other-worldly domain (it is a spirit, after all, who wears the hat) – even as the colonialists reappropriated such hybrid manifestations and transformed them into 'purified' objects of anthropological or art historical knowledge.

While colonial-era anthropologists, collectors and curators used the term 'fetish' indiscriminately to refer to objects such as the sowei mask, perceived to possess some kind of magical potency, the term has a more specific meaning. In his historical reappraisal, William Pietz (1985: 7) argues that the term originated from, and remains specific to, what he defines as 'the problematic of the social value of material objects as revealed in situations formed by the encounter of radically heterogenous social systems'. Thus the idea of the fetish – from the Portuguese *feitiço* – emerged in the sixteenth century on the west coast of Africa 'in a mercantile intercultural space created by the ongoing trade relations between cultures so radically different as to be mutually incomprehensible' (Pietz 1987: 24). Pietz describes the 'irreducible materiality' of the fetish objects that resulted from these cross-cultural encounters: the fetish is 'precisely *not* a material signifier referring beyond

itself', but something possessing an 'ordering power derived from its status as the fixation or inscription of a unique originating event that has brought together previously heterogenous elements into a novel identity' (1985: 7). 'Proper to neither West African nor Christian European culture' (Pietz 1987: 24), the fetish is in essence hybrid and inbetween. Hence, though the usage is more contemporaneous with the era of the cabinet of curiosity than of the colonial exposition, it could be argued that the description of the sowei mask as a fetish in the catalogue of the Colonial and Indian Exhibition is, ironically, apposite.

Following Pietz's rehabilitation of what was once an embarrassing archaism in the human sciences, the concept of the fetish has been used productively to explore the intercultural contact zones, border crossings and translations that characterize the contemporary world and, indeed, to critique the boundary-making practices and false essentialisms that continue to shape our understanding of the world, with often dire political consequences. As Patricia Spyer (1998: 3) remarks in the introduction to *Border Fetishisms*, the fetish 'is never positioned in a stable here-and-now and thereby confounds essentializing strategies that aim for neat resolutions and clear-cut boundaries among things and between persons and objects' (ibid.: 2). By honing in on the 'border zones that fetishisms trace out' and 'considering the effects of the crossings through which relations between subjects and objects may be reassessed, redrawn, and at times overturned', the contributors to that book seek a better understanding of how 'distinctions such as those of gender, class, race, ethnicity, and nationality might be negotiated, transgressed, and perhaps most of all, exposed' (ibid.: 3). This exploration of inbetweenness has similar ambitions: seeking, through its engagement with things, to reflect on the arbitrariness of seemingly self-evident categories; valuing ambiguity over false certainty.

Rhizome

Dictionaries define 'inbetweenness' as being between one thing and another; intermediate; neither *this* nor *that*. The semantic field of the inbetween is wide, embracing processes of mixture, mediation, transculturation, translation, entanglement, syncretization and creolization, and states of ambivalence, ambiguity, liminality, double-consciousness and hybridity. Inbetweenness is a middle ground, a contact zone, a borderland. It is a relational space, a space of networks and conjunctions; but it can also be a void, a limbo, a zone of suspended animation, of severed relationships. Inbetweenness troubles, begs questions, perplexes. It is paradoxical. It is, like the fetish, a *problematic*;

something unresolved (and unresolvable) that unsettles settled categories and destabilizes stable boundaries. Neither positive nor negative, it nevertheless generates a kind of productive unhomeliness. It is, to borrow from Homi Bhabha, 'an *interrogatory*, interstitial space' (1994: 3, emphasis added).

The inbetween is also the medium of metaphor: the space across which meaning is translated (in the sense of being 'carried over') from one context or domain to another, giving form to ideas and descriptions of the world otherwise inexpressible. Although usually associated with language and literature, as Christopher Tilley (1999: 271) has argued, 'the physical, tangible, *material* dimensions of material forms are essential in the creation of metaphoric meaning and significance', and it is often through this operation of metaphorical transference that things acquire their capacity to act on and affect us. Tilley draws on Roland Barthes's notion of *punctum* to describe the affective force with which the analogical references and associations of material metaphors may present themselves to the embodied mind of the observer. Significantly, this *punctum* – the 'prick' or 'puncture' that disturbs one's ordinary engagement with things, and which consequently animates them (Barthes 1982: 27) – operates at a prelinguistic level not subject to verbal discourse or linguistic mediation (Tilley 1999: 271; cf. Razzall this volume).

If the focus of this book is on the *artificialia* of our imagined cabinet of curiosities, this does not suggest that inbetweenness is not found in the world of *naturalia*. Although dividing the world into 'nature' and 'culture' is antithetical to the book's objectives (which accord with Descola's [2013] view of 'an ecology of relations'), one might nevertheless open a case of botanical hybrids, noting the complex semantic migrations of hybridity from plants to people, to technologies and to contemporary subjectivities (Bhabha 1994; Young 1995; Brah and Coombes 2000; Kuortti and Nyman 2007). One might point out a shelf loaded with jars of preserved specimens of hermaphroditic animals – species of snails, worms, echinoderms and fish – that challenges a view of the world as being neatly divided into two sexes and that constructs as aberrant intersexual bodies and identities (Dreger 1998; Harper 2007; Holmes 2008). However, from among the cabinet's displays of such *naturalia*, the object that begs to be held forth is a rhizome (Figure 1.3), that key metaphor of anti-essentialism. As Deleuze and Guattari (1987: 25) famously write:

> A rhizome has no beginning or end; it is always middle, between things, interbeing, *intermezzo*. The tree is filiation, but the rhizome is alliance, uniquely alliance. The tree imposes the verb 'to be', but the fabric of the rhizome is the conjunction, 'and . . . and . . . and . . . '

Whereas the image of the 'tree' or 'taproot' represents stasis, linearity, hierarchy and binary logic – epitomized in Linnaean taxonomy (a universe

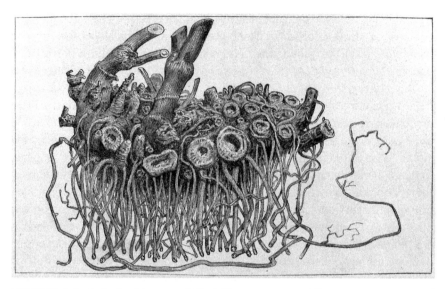

FIGURE 1.3 *A fresh rhizome of* Cimicifuga racemose, *Plate XXIII*, Drugs and Medicines of North America, *vol. 1, 1884–5. Wellcome Library.*

divided into kingdoms, classes, orders, families, genera and species) and in Chomsky's hierarchy of grammars – for Deleuze and Guattari the rhizome is emblematic of a new form of thought and politics. In contrast to the stratified totalities of the root-tree metaphor, the rhizome is non-hierarchical, horizontal and dynamic. It proceeds on the principles of connection and heterogeneity, of multiplicity and what Deleuze and Guattari refer to as 'asignifying rupture' (cutting a rhizome does not kill it, but contributes to its proliferation and reterritorialization). The rhizome is nomadic, it forges linkages and connections between multiple and seemingly incompatible elements; it is transversal, random and unregulated. It is unlike a structure, which Deleuze and Guattari (1987: 21) define as 'a set of points and positions, with binary relations between the points', but is rather made only of lines – 'lines of flight', or 'lines of becoming', with neither beginning nor end.

More recently, the anthropologist Tim Ingold has drawn inspiration from Deleuze and Guattari in his own 'linealogical' reflections (2007a, 2015) and particularly those relating to what he terms the 'meshwork' (2011: 63–94). Following Deleuze and Guattari, Ingold draws a distinction between meshworks and networks (particularly as conceptualized within Actor Network Theory), which has significant implications for how we might understand inbetweenness. Proponents of 'network thinking', he suggests, 'argue that it encourages us to focus, in the first instance, not on elements but on the connections between them, and thereby to adopt what is often called a

relational perspective' (2011: 70). This allows for the possibility that connected elements, by virtue of their relationships, may be mutually constitutive. However, Ingold contends that the network metaphor 'logically entails that the elements connected are distinguished from the lines of their connection' (ibid.):

> Thus there can be no mutuality without the prior separation of the elements whose constitution is at issue. That is to say, the establishment of relations *between* these elements – whether they be organisms, persons or things of any other kind – necessarily requires that each is turned upon itself prior to its integration into the network (ibid.).

This he regards as an 'operation of inversion'. It is to undo this inversion and repudiate the distinction between things and their relations that Ingold turns to the more organic metaphor of the meshwork and the primacy of movement: 'lines of growth' issuing from multiple sources and becoming comprehensively entangled with one another. It is within this 'tangle of interlaced trails, continually ravelling here and unravelling there, that beings grow or "issue forth" along the lines of their relationships' (ibid.: 71). Through this rhizomic logic, one can begin to understand how things *are* their relationships, that all things are inbetween. Ingold insists that we need to overcome the idea of things as entities, self-contained objects set over against other objects with which they can then be juxtaposed or conjoined. Rather than an assemblage of bits and pieces, Ingold proposes that the world is a tangle of threads and pathways (ibid.: 91–2).

Elsewhere Ingold has been critical of material culture scholars such as Daniel Miller, questioning their focus on consumption practices, on materiality and on what he characterizes as 'a world of objects . . . already crystallized out from the fluxes of materials and their transformations' (2007: 9). This is a curious attack insofar as much of the scholarship he criticizes has been concerned to do precisely what he proposes: 'to follow the multiple trails of growth and transformation' that converge in any given thing. One of the methodological boons brought to the study of material culture by Igor Kopytoff's (1986) contribution to Arjun Appadurai's seminal book, *The Social Life of Things*, has been the idea of the 'object biography', an approach that seeks to map the material and immaterial fluxes and transformations, the crystallizations and the disintegrations that Ingold alludes to (see John Picton's chapter in this book for a good example). One also might note Miller's own repudiation, already mentioned, of '*prior* forms' existing outside their co-constitution in a dialectical relationship, and his argument that 'in objectification all we have is *a process in time*' (2005: 9, emphasis added).

A rapprochement between Deleuzian/Ingoldian thought experiments and the broader body of material culture scholarship is particularly important in the context of this book, which unashamedly takes as its starting point 'a world of objects' (or, more accurately, a modest collection of curiosities), and seeks to discern in their supposedly crystallized forms the lines of the relationships through which they have come into being and, indeed, continue to 'issue forth' along new trajectories. The challenge here, then, is to apply models of becoming educed from ecological and organic metaphors (rhizomes, storms, spider's webs) to things like memorial poles, or feather headdresses, a carved gourd or a turtleshell bonnet. How can these objects – which are also things – be understood as 'tissues of interlaced threads'? While one might readily conceive of the *making* of these objects in such terms, for instance, as Ingold describes a basket as the embodiment of patterns of skilled activity (2000: 345), the objects discussed here are *encountered* as 'readymades' – just as the rhizome is encountered as a readymade entity that affords an understanding beyond itself. There is a need to take account of both the material trajectories of these things as they are made, unmade and remade, and their equally complex lines of becoming as social, political, economic, symbolic, epistemic, agentive or otherwise meaningful objects.

In a recent essay Ingold draws a distinction between *between* and *in-between*, which he regards as being of enormous ontological consequence (2015: 147). 'Between', he argues, articulates a divided world . . . It is a bridge, a hinge, a connection, an attraction of opposites, a link in a chain, a double-headed arrow that points at once to this and that'. 'In-between', on the other hand, is described as 'a movement of generation and dissolution in a world of becoming where things are not yet given' (ibid.). This is, in many respects, a restatement of the Deleuzian image with which this chapter begins. In the spirit of the miscellany, this collection adopts a more catholic approach to inbetweenness, encompassing both 'between' and 'in-between'. If the things that are presented in the book cut across seemingly pre-existing, fixed categories, it is by virtue of their intermediate, hybrid, liminal or otherwise 'between' status that they allow us to perceive the dynamism and ongoingness of their 'in-between' state. Pursuing Deleuze and Guattari's riverine metaphor, one might say that the best vantage point to perceive the perpendicular flow of the river (the '*midstream*' of in-betweenness, as Ingold terms it) is precisely from the centre of the bridge that transverses (or, better, articulates between) its banks. It is this point of intersection – between *between* and *in-between* (Ingold 2015: 147) – that constitutes the heuristic of this book, the optic through which these objects are viewed, and indeed the lens that each object provides on the worlds it mediates and travels between (Figure 1.4).

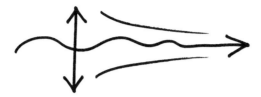

FIGURE 1.4 *The 'double-headed arrow' of* between *intersecting with the 'mid-stream' of* in-between. *Redrawn, with permission, from Figure 29.1, Tim Ingold,* The Life of Lines, *Routledge, 2015.*

Gift

Interest in the entangled relationships between people and things has been sustained by anthropologists and archaeologists since the emergence of these disciplines in the nineteenth century and has been renewed with each new theoretical turn (see Hicks 2010). These relationships have been conjugated in many different ways, each offering a different inflection of inbetweenness (Hodder 2012). Anthropology and archaeology began, of course, as museum-based disciplines in which objects acted as surrogates for different times, places and peoples. In the case of ethnographic museums, even as objects were extracted from their local contexts and recirculated via networks of collectors and collecting institutions, the relationships between these things and the people from whom they were sourced, though transformed, were also preserved, creating the possibility, perhaps a century or more later, for these relationships to be reanimated, for objects to be repatriated and for museums to become 'contact zones' in which competing claims (and ontologies) might be negotiated (e.g. Clifford 1997; Peers and Brown 2003; Bolton et al. 2013; Basu 2015). As Sandra Dudley (this volume) argues, while objects undeniably undergo a fundamental transition when they become part of museum collections, it is not an end to their social lives, but rather an entry into a liminal phase during which their capacity to become re-enlivened may at any time be activated. Museums remain profoundly inbetween spaces, places of 'transit' and 'contact work', as James Clifford has argued (1997: 213). Even their primary mode of communication relies on inbetweenness. Exhibition grammar is juxtapositional, and it is through *making connections* between things that visitors *make sense* of what is arranged before them (Bal 2007; Basu 2007). Museum exhibitions are like laboratories in which objects can be endlessly arranged and rearranged so as to explore and explicate the relationships between things (Basu and Macdonald 2007).

It is not only when objects are accessioned into museum collections that they are transformed. Nicholas Thomas (1991: 28) has, for example,

discussed the 'promiscuity of objects' in the context of colonial contact and exchange. Rather than possessing identities fixed in their structure and form, it is the 'mutability of things in recontextualization' that impresses (ibid.). While this is not unique to colonial interactions, it is at the crossings between the 'indigenous appropriation of European things' and the 'European appropriation of indigenous things' that new, mutable inbetween forms such as the Sierra Leonean *sowei* mask, or the Nlaka'pamux woven teacup discussed by Madeline Knickerbocker and Lisa Truong, or the Asmat Christ figure discussed by Nick Stanley, the 'traditional-yet-contemporary' carved gourd vessel discussed by Mary Katherine Scott, and other objects in this cabinet of curiosities have come into being. These are materializations of the 'midstream': expressions of processes in time and space, crystallized at a given moment, and in some senses suspended, even here, as they are held forth in this book, in a collection, in a church, an artist's workshop or a ritual. These are, however, temporary as well as temporal manifestations of movement and mediation, mutable in recontextualization as they continually become entangled in new relationships and disentangled from others.

Such processes of generation and dissolution are particularly highlighted in Stacey Jessiman's discussion of the G'psgolox memorial pole in this book. Thus, after protracted negotiations between representatives of the Haisla First Nation and Swedish national government, the Swedish Museum of Ethnography relinquished its proprietary preservationism and acquiesced to Haisla wishes for the pole to decay in its original setting and thence to 'return to nature'. In exchange, however, a new replica G'psgolox pole was gifted to the ethnographic museum – a memorial, one might say, to a memorial. And so the exchange of poles, which do their own mediatory work between time, space and spirit worlds, tied new 'postcolonial' relations in the present, while untying the 'colonial' relations of the past.

Indeed, the gift must surely be the next emblematic object in our cabinet of curiosities to contemplate. Look, here: *kula* shell valuables, or *vaygu'a*, from the Trobriand Islands. They might even have been collected by Bronisław Malinowski himself (Young 2000). *Soulava*, long necklaces of red spondylus shell discs, which, as every student of anthropology knows, travel in a clockwise direction between the island communities of the Massim archipelago off Papua New Guinea; *mwali* arm-ornaments of white conus shell, which travel in the opposite direction. 'Once in the Kula', Malinowski wrote, 'always in the Kula' (1922: 83), the journeys of these ever-moving objects described lines of connection between distant communities that Malinowski portrayed on his maps as the Kula Ring (ibid.: 82). While much of Malinowski's analysis has been revised by subsequent anthropologists, *vaygu'a* remain emblematic of the inbetweenness of things as intermediaries in the relationships between people, the 'chains along which social relationships run', as E. E.

Evans-Pritchard put it (1940: 89). They are, like all things in this collection, travelling objects, which give 'material expression' to the relationships they mediate (Mauss 2002: 34). Malinowski argued that *vaygu'a* had little intrinsic value, and yet these 'incessantly circulating and ever exchangeable valuables', which possessed names and carried the history of their circulations with them, were treasured above all else – a value and a status that accrued to the objects through their very circulation (1922: 511; Munn 1986).

All objects are, in a sense, travelling objects. Some, like the Roman/Macedonian coin discussed by Clare Rowan, mediate power by carrying intentionally ambiguous messages in their iconography or form; others extend the spatio-temporal reach or influence of the individuals or groups with whom they are inalienably associated – materialized 'sendings', like a 'detachable mask', projecting human potential beyond the everyday limits of space and time (Battaglia 1983: 302; Munn 1986). These objects are agentive in their interactions, actively shaping the relationships between those they 'go between'. In this respect one might question the distinction between 'intermediaries' and 'mediators' employed in Actor Network Theory. Whereas an *intermediary*, in Bruno Latour's vocabulary, 'transports meaning or force without transformation', *mediators* 'transform, translate, distort and modify the meaning or the elements they are supposed to carry' (2005: 39). A consideration of the inbetweenness of things brings into doubt whether anything transports without also transforming. All intermediaries mediate, although the transformations they effect are not always immediately apparent to our routine ways of seeing.

Prism

The objective of this introductory essay has not been to summarize or debate the chapters that follow. Rather the intention has been to introduce the idea of this book as a cabinet of curiosities, in which the contributing authors are invited to hold forth an object of their choice (an object they have donated to the collection, as it were) that provides a point of departure for their exploration of inbetweenness. A second objective has been to take down from the imagined cabinet's shelves a few objects that may be said to emblematize inbetweenness and invoke distinct theoretical literatures that engage with the inbetween: the *fetish*, a hybrid object of irreducible materiality, the power of which is animated in the 'fissured spaces' of intercultural encounter (Spyer 1998: 3); the *rhizome*, Deleuze and Guattari's key metaphor of anti-essentialism, defined by principles of connection, heterogeneity and multiplicity, 'always in the middle, between things', issuing forth along lines of becoming (1987: 25;

Ingold 2015); the *gift*, the paradigmatic 'travelling object', which accrues value through circulation and materializes the relationships it mediates; the object *as* relationship. They each provide an analytical lens – a *prism* – through which to reflect on the concrete, ethnographically informed case studies that follow. Indeed, although less canonically inbetween than these introductory object-metaphors, each of the things discussed in the subsequent chapters of this book provides a prism through which to view the others, and, ultimately, each throws light on the wider world of things that surrounds us.

Fittingly, then, the final emblematic object to be presented in this introduction is the prism itself. The prism is a material object, the inbetweenness of which enables us to understand the nature of reality differently. Famously, it was Isaac Newton, in his 1704 work, *Opticks: Or, A Treatise of the Reflexions, Refractions, Inflexions and Colours of Light*, who demonstrated through the use of prisms that white light, which was previously believed to be colourless, actually consisted of a spectrum of colours (Figure 1.5). The speed of light changes as it passes from one medium to another, for instance, from the air to the glass of the prism. This causes the light to be refracted in the new medium, and

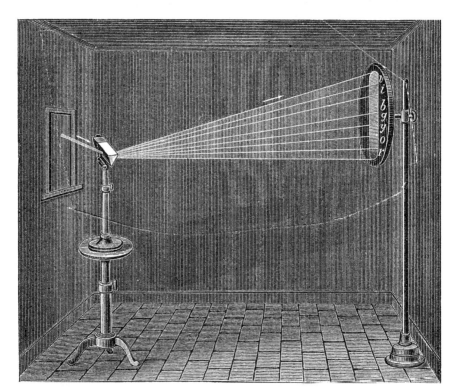

FIGURE 1.5 *Visible light spectrum experiment using a prism. Mehau Kulyk/Science Photo Library.*

since the refractive index of the glass varies with the wavelength of the incident light, light of different colours is refracted differently and thus exits the prism at different angles. The prism does not create these colours, as was thought prior to Newton's experiments, but separates the colours that are already present.

Like the fetish, the rhizome and the gift, the prism provides a material metaphor through which to 'think inbetweenness'. Just as the prism quite literally refracts waves of light as they pass through it, here, the intermediary – the object-as-prism, situated at the intersection of the between and inbetween – is shown to be a mediator that refracts the 'midstream' lines of growth and becoming. It is not passive, extraneous or inconsequential, but influences the processes in time and space through which subjects and objects constitute one another. At the same time, the object-as-prism possesses an 'heuristic inbetweenness'. It is a material medium that interrupts our routine assumptions about the world. Instead of singular, self-evident truths – a world divided into this or that, of one category separated from another – seeing through the prism of things allows us to perceive the complex heterogeneous flows, ambiguities and uncertainties that make up reality, causing us to pause, ask new questions and think again. Being mindful of the inbetweenness of things facilitates our entry into their interrogatory interstitial space and opens up a whole spectrum of possibilities.

And so, rather like Charles Willson Peale's painting *The Artist in His Museum* (1822), the crimson curtain is lifted, the doors of the cabinet are opened wide and you are invited to explore the curious things within.

References

Alberti, S. (2005) 'Objects and the Museum', *Isis* 96 (4): 559–71.

Bal, M. (2007) 'Exhibition as Film', in S. Macdonald and P. Basu (eds), *Exhibition Experiments*, 71–93, Oxford: Blackwell.

Barthes, R. (1982) *Camera Lucida*, trans. R. Howard, London: Jonathan Cape.

Basu, P. (2007) 'The Labyrinthine Aesthetic in Contemporary Museum Design', in S. Macdonald and P. Basu (eds), *Exhibition Experiments*, 47–70, Oxford: Blackwell.

Basu, P. (2011) 'Object Diasporas, Resourcing Communities: Sierra Leonean Collections in the Global Museumscape', *Museum Anthropology* 34 (1): 28–42.

Basu, P. (2013) 'Material Culture: Ancestries and Trajectories in Material Culture Studies', in J. Carrier and D. B. Gewertz (eds), *Handbook of Sociocultural Anthropology*, 370–90, London: Bloomsbury.

Basu, P. (2015) 'Reanimating Cultural Heritage: Digital Curatorship, Knowledge Networks and Social Transformation in Sierra Leone', in A. Coombes and R. Phillips (eds), *International Handbooks of Museum Studies, Volume IV: Museum Transformations*, 337–64, Oxford: Wiley-Blackwell.

Basu, P. and S. Coleman (2008) 'Introduction: Migrant Worlds, Material Cultures', *Mobilities* 3 (3): 313–30.

Basu, P. and J. Hudson (2012) 'Between Worlds', *The British Museum Magazine* 74: 29–30.

Basu, P. and S. Macdonald (2007) 'Introduction: Experiments in Exhibition, Ethnography, Art, and Science', in S. Macdonald and P. Basu (eds), *Exhibition Experiments*, 1–24, Oxford: Blackwell.

Battaglia, D. (1983) 'Projecting Personhood in Melanesia: The Dialectics of Artefact Symbolism on Sabarl Island', *Man* 18 (2): 289–304.

Bhabha, H. K. (1994) *The Location of Culture*, London: Routledge.

Bolton, L., N. Thomas, E. Bonshek, J. Adams and B. Burt (eds) (2013) *Melanesia: Art and Encounter*, London: British Museum Press.

Boone, A. A. (1986) *Radiance from the Waters: Ideals of Feminine Beauty in Mende Art*, New Haven, CT: Yale University Press.

Brah, A. and A. E. Coombes (eds) (2000) *Hybridity and Its Discontents: Politics, Science, Culture*, London: Routledge.

Brown, B. (2001) 'Thing Theory', *Critical Inquiry* 28 (1): 1–22.

Clifford, J. (1997) *Routes: Travel and Translation in the Late Twentieth Century*, Cambridge, MA: Harvard University Press.

Colonial and Indian Exhibition (1886) *Official Catalogue*, 2nd ed., London: William Clowes.

Coombes, A. E. (1994) *Reinventing Africa: Museums, Material Culture and Popular Imagination in Late Victorian and Edwardian England*, New Haven, CT: Yale University Press.

Deleuze, G. and F. Guattari (1987) *A Thousand Plateaus: Capitalism and Schizophrenia*, trans. B. Massumi, Minneapolis: University of Minnesota Press.

Descola, P. (2013) *Beyond Nature and Culture*, trans. J. Lloyd, Chicago, IL: University of Chicago Press.

Dreger, A. D. (1998) *Hermaphrodites and the Medical Invention of Sex*, Cambridge, MA: Harvard University Press.

Dudley, S. H. (2012) 'Encountering a Chinese Horse: Engaging with the Thingness of Things', in S. H. Dudley (ed.), *Museum Objects: Experiencing the Properties of Things*, 1–15, London: Routledge.

Evans-Pritchard, E. E. (1940) *The Nuer: A Description of the Modes of Livelihood and Political Institutions of a Nilotic People*, Oxford: Clarendon Press.

Gell, A. (1998) *Art and Agency: An Anthropological Theory*, Oxford: Clarendon Press.

Gilroy, P. (1993) *The Black Atlantic: Modernity and Double Consciousness*, Cambridge, MA: Harvard University Press.

Harper, C. (2007) *Intersex*, Oxford: Berg.

Hicks, D. (2010) 'The Material-Cultural Turn: Event and Effect', in D. Hicks and M. C. Beaudry (eds), *The Oxford Handbook of Material Culture Studies*, 25–99, Oxford: Oxford University Press.

Hodder, I. (2012) *Entangled: An Archaeology of the Relationships between Humans and Things*, Oxford: Wiley-Blackwell.

Holmes, M. (2008) *Intersex: A Perilous Difference*, Solinsgrove, PA: Susquehanna University Press.

Ingold, T. (2000) *The Perception of the Environment: Essays in Livelihood, Dwelling and Skill*, Abingdon: Routledge.

Ingold, T. (2007a) *Lines: A Brief History*, Abingdon: Routledge.

Ingold, T. (2007b) 'Materials against Materiality', *Archaeological Dialogues* 14 (1): 1–16.

Ingold, T. (2011) *Being Alive: Essays on Movement, Knowledge and Description*, Abingdon: Routledge.

Ingold, T. (2015) *The Life of Lines*, Abingdon: Routledge.

Jedrej, M. C. (1980) 'A Comparison of Some Masks from North America, Africa and Melanesia', *Journal of Anthropological Research* 36 (2): 220–30.

Kopytoff, I. (1986) 'The Cultural Biography of Things: Commoditization as Process', in A. Appadurai (ed.), *The Social Life of Things: Commodities in Cultural Perspective*, 64–91, Cambridge: Cambridge University Press.

Kuortti, J. and J. Nyman (eds) (2007) *Reconstructing Hybridity: Post-Colonial Studies in Transition*, Amsterdam: Rodopi.

Latour, B. (1991) *We Have Never Been Modern*, trans. C. Porter, Cambridge, MA: Harvard University Press.

Latour, B. (1999) *Pandora's Hope: Essays on the Reality of Science Studies*, Cambridge, MA: Harvard University Press.

Latour, B. (2005) *Reassembling the Social: An Introduction to Actor-Network-Theory*, Oxford: Oxford University Press.

Lévi-Strauss, C. (1964) *Totemism*, trans. R. Needham, London: Merlin Press.

Malinowski, B. (1922) *Argonauts of the Western Pacific*, London: Routledge.

Mauss, M. (2002) *The Gift*, trans. W. D. Halls, London: Routledge.

Miller, D. (2005) 'Materiality: An Introduction', in D. Miller (ed.), *Materiality*, 1–50, Durham, NC: Duke University Press.

Miller, D. and C. Y. Tilley (1996) 'Editorial', *Journal of Material Culture* 1 (1): 5–14.

Munn, N. D. (1986) *The Fame of Gawa: A Symbolic Study of Value Transformation in a Massim Society*, Durham, NC: Duke University Press.

Peers, L. and A. K. Brown (eds) (2003) *Museums and Source Communities: A Routledge Reader*, London: Routledge.

Phillips, R. B. (1995) *Representing Woman: Sande Masquerades of the Mende of Sierra Leone*, Los Angeles: UCLA Fowler Museum of Cultural History.

Phillips, R. B. and C. B. Steiner (eds) (1999) *Unpacking Culture: Art and Commodity in Colonial and Postcolonial Worlds*, Berkeley: University of California Press.

Pietz, W. (1985) 'The Problem of the Fetish, I', *RES: Anthropology and Aesthetics* 9: 5–17.

Pietz, W. (1987) 'The Problem of the Fetish, II', *RES: Anthropology and Aesthetics* 13: 23–45.

Pinney, C. (2005) 'Things Happen', in D. Miller (ed.), *Materiality*, 256–72, Durham, NC: Duke University Press.

Spyer, P. (1998) 'Introduction', in P. Spyer (ed.), *Border Fetishisms: Material Objects in Unstable Places*, 1–11, New York: Routledge.

Taussig, M. (2004) *My Cocaine Museum*, Chicago, IL: University of Chicago Press.

Thomas, N. (1991) *Entangled Objects: Exchange, Material Culture, and Colonialism in the Pacific*, Cambridge, MA: Harvard University Press.

Tilley, C. (1999) *Metaphor and Material Culture*, Oxford: Blackwell.

Turkle, S. (ed.) (2007) *Evocative Objects: Things We Think With*, Cambridge,
 MA: MIT Press.
Young, M. W. (2000) 'The Careless Collector: Malinowski and the Antiquarians',
 in M. O'Hanlon and R. L. Welsch (eds), *Hunting the Gatherers: Ethnographic
 Collectors, Agents and Agency in Melanesia, 1870s–1930s*, 181–202,
 Oxford: Berghahn.
Young, R. (1995) *Colonial Desire: Hybridity in Theory, Culture and Race*,
 London: Routledge.

Museums as sites of inbetweenness

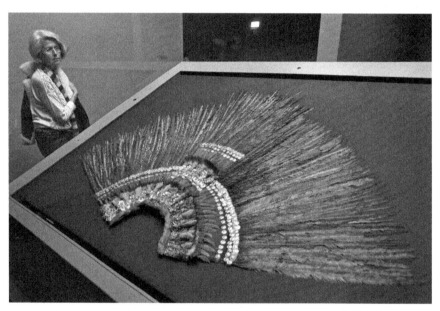

FIGURE 2.1 *Feather headdress in its vitrine as displayed at the* Penacho: Pract & Passion *exhibition, Museum für Völkerkunde, Vienna, 2012. APA-PictureDesk.*

2

The inbetweenness of the vitrine: Three *parerga* of a feather headdress

Khadija von Zinnenburg Carroll

The plume, the vitrine and the parergon

El Penacho, the fragile feather headdress that is the focus of this chapter (Figure 2.1), cannot be encountered except through the parergon of its vitrine, the architecture of thick glass that stands between it and us. As Jacques Derrida (1979) has argued, while parerga, such as the frames of paintings, are supplementary to works of art, they are not easily detached from them and instead form an ambiguous unity with the works, framing our perception and understanding of them. The vitrine, it might be said, holds the object it displays in a 'parergonic embrace' (Schachter 2014: 3).

Since the sixteenth century this headdress has passed through numerous vitreous parerga and, indeed, at the time of writing, it is awaiting installation in yet another, which has been especially designed for it in a new gallery of the Weltmuseum (World Museum), Vienna. This chapter traces the movements of the feather crown through three such cases. While the object appears to remain the same, it may also be said to change according to the interpretative context that each of these vitrines produces. The three vitrines represent three moments in the headdress's movement: the *Wunderkammer*, the soft politics of post-war international relations (including the power of museum

conservation in this context) and the potential of copies to break free of parergonic framings.

The vitrine is the 'inbetween' that distinguishes the museum from other spaces in which social and sacred practices engage material objects. The space of the museum vitrine thus constitutes an inbetweenness in all the objects it houses (Welchman 2013). It is justified by conservation demands, strengthened by technological advances, enforced by national law and institutionalized by design. It affects the ontology of the treasure, the art object, the collection on display; it demands particular attention, and asserts particular value. It may be more modern, more expensive, and more visually and physically present than the actual object it displays. The vitrine is in this sense a parergon: that which is 'against, beside, and above and beyond the ergon, the work accomplished, the accomplishment of the work' (Derrida 1979: 20). Other parerga include picture frames, plinths that hold the sculpture high above the viewing body and drapery that keeps the sculpted nude partly covered. These architectural elements are the cues to reading the contents they frame as desirable, aesthetic, elevated objects.

In its inbetweenness, the vitrine exits the flow of time. Like the watery glass that flows slowly downwards, always, with gravity, the vitrine materializes only the potential of suspension in between states. It blurs the image with age, with the historical specificity of its design (the *Wunderkammer* is dated: pre-Enlightenment) and the failure to replace a vitrine can make a museum look self-conscious, a museum of a museum (like the Victorian Pitt Rivers).

Materializing historical classificatory practices, the vitrine is constitutive of suspended transits for material objects. A glass case was never the origin of ethnographic display things from the world. The glass between the artefact and the viewer is the epistemic membrane crystallized around an object. In the vitrinized relationship between us (modern, civilized, cosmopolitan) and them (ancient, primitive, immobile), there is an alienation of cognition from identification and embodiment. Glass walls are the most insidious kind of alienation: transparent but impenetrable. In the Weltmuseum, the vitrine is a parergon of another world, the frame that frames the gap between colonized object and the completeness of context.

El Penacho – the plume – is the oldest-known feather headdress. Traditionally – though doubtfully – claimed to be the crown of the Aztec king Montezuma, it is like the bird from whose feathers it is made: shimmering to attract attention. Since the age of the *Wunderkammer*, however, this feather headdress has hovered in a succession of glass cases designed to resist movement and still the forces that might cause it to disintegrate into thousands of small feather particles. Encased in glass, this prize of colonial conquest is caught in suspended animation between Austria and Mexico.

Fragile and balding, the headdress spans 3x4 metres from its gold crown to the tips of its quetzal bird feathers. Spreading out in a luminescent green arc, it was made to be worn by humans who were closest to the realm of gods. The resplendent feathers are associated with the wind god Quetzalcoatl. Coatl is a snake, and the green feathers of Montezuma's crown would have snaked in the wind – they still would if not for the stillness of the air within the glass chamber. The quetzal's red breast feathers are said to have been dyed with the blood of the Aztecs killed during colonization.

In its original context, the movement of the crown's plumes activated connections with invisible spirits and they were worn with the understanding that ancestors born by the wind were articulated in the movement of feathers. The glass of the vitrine intervenes in this relationship between spirits in the wind and feathers worn as the spirits' avatars. For conservation science there is only the destructive force of wind that moves through the matter it buffets. The violence in the movement of the feathers experienced during el Penacho's journey to Europe is registered in the fragile state of the material. The same wind that the Spanish boat caught between Central America and Europe, and the swing of the sea as it sailed from Veracruz, must have caused damage to the fragile cargo on board, buckling el Penacho's feathers into shapes of resistance.

El Penacho's movement between Mexico and Austria is a lingering unknown that continues to tax historians and curators. While its attribution to Montezuma drifts in a lack of historical evidence, time lapses and anachronisms of interpretation (see Nuttall 1888; Nowotny 1960; Anders and Kann 1996; Feest 2012: 5–28), to Mexicans, el Penacho outlines the space of the absent and deceased body of the heroic emperor and represents the end of the Aztec Empire itself. It is one of the very few feather artefacts that has survived from the time of the Conquest, and is typical of the regalia that Montezuma and his priests wore. The crown's life therefore begins in a period of violent change for the Aztecs, corresponding with the overthrow of their empire in 1521. At this time the Aztec world was fundamentally transformed, and material things such as el Penacho are stubborn reminders, as contemporary Maya assert, that '*Weyanone*', '*Aqui estamos*', 'we are still here'.

The passage of el Penacho from the new to the old world did not leave a paper trail. Historians are yet to find a line in a ship's records that includes a feather headdress in its inventory of possessions amassed in Mexico and bound for Europe (Russo 2011). Nor has the hand that took the crown left a line for us to identify him by. It is unclear exactly what date and what route el Penacho took from Central America. While it does not appear in the list of things Hernán Cortés acquired in Mexico, in 1577 it is described for the first time in the inventory of the Swabian Count Ulrich von Montfort zu

Tettnang's collection among 'all sorts of Moorish armory and featherwork' (*Allerlei mörsche Rüstung und Federwerk*). It was subsequently acquired by the Habsburg archduke Ferdinand II when he purchased part of Montfort's collection. In the 1596 inventory of Ferdinand's still extant cabinet of curiosities in Ambras Castle, Innsbruck, the feather headdress is recorded under the similar classification of 'Moorish hat'. Thus the life of el Penacho went from being the material avatar of Aztec spirits, inspired by the spectacle of the quetzal, to becoming a vitrinized signifier of global power.

Vitrine 1: Schloss Ambras, Innsbruck, 1595

In Schloss Ambras, in the Tyrolian Alps, may be found the *Wunderkammer* of Archduke Ferdinand, one of the few Renaissance collections still intact and in situ. As the son of the emperor at the height of the Habsburg Empire, Ferdinand was able to collect widely and install his *Wunderkammer* in the castle he gifted to his wife, Philippine Welser. The work of a cultured romantic rather than a man of military prowess, this *Wunderkammer* in the classic sense displays art together with science, non-European together with European. Among these wonders of the world was el Penacho, the feather headdress from Mexico.

In the sixteenth century, there does not seem to have been a hierarchy in the way the objects in these *Wunderkammer* were organized (Bredekamp 2000). In one case after another, material was classified according to type – gold, silver, feathers – but also lumped together were incommensurables: Turkish costumes, china, crocodiles. The displays of these cabinets of curiosity fell somewhere between ignorance and order. At Schloss Ambras, the vitrines of the *Wunderkammer* are the kind of beautiful custom carpentry that is now fetishized as antique – floor to ceiling glass cases in rooms fitted especially for the purpose of display. The spectatorial pleasures in this court moved easily between play-fights and aesthetic treasures of a world discovered and conquered (Bůžek 2009). The wealth of the New World colonies was distilled into containers, while the craftsmanship of European artists provided the parerga. The levelling effect of these vitrine parerga are given in defence of the Eurocentrism of the *Wunderkammer*. Here, European scientific instruments lay beside the ritual artefacts of animists, unfettered by later evolutionary arguments.

Walking through this *Wunderkammer* gives an impression of great delicacy, wonderful artistry and the excitement of 'extremophilia'. Freakishly complicated forms of nature and culture are the signature style, if anything, of the *Wunderkammer*. Paintings of *Haarmenschen* – people who are blackened

by the amount of hair growing over their bodies and faces – and of unicorns were hung with pride in the Ambras collection (Zapperi 2004). Behind glass in a vitrine of their own and sometimes behind a curtain – a red velvet parergon – a natural marvel could be encountered as *imponderabilia*. *Mirabilia* – things that inspire wonder, including people living with physical deformities and freakish bodies – set off the other perverse wonders of nature.

On occasion, Ferdinand, Philippine and their guests would take things out of the vitrines and wear them. Blackface masks, for example, were worn in play-battles with the 'Moors' that were staged in the courtyard outside the *Wunderkammer*. The Siege of Algiers in 1541, at which Cortéz was present, was one inspiration for theatrical battles (Russo 2011: 237). The collections from the Americas and Africa were often called 'Moorish' in the age of the *Wunderkammer*, as a general term meaning 'foreign' (Bujok 2009: 19). In 'Cabinet 9' of the Ambras Castle collection was what seemed to be a Moorish skirt, or perhaps a hat; it was not certain, hence Cabinet 9 was dedicated to the category *Varia*, variety. The *Varia* were exhibited between cabinets displaying precious metals and stones that had been shaped by European craftsmen into a contortion between *Naturalia* and *Artificialia*. The aesthetic frisson of these things was in the play between naturally occurring objects and human-made artefacts. Montezuma's crown was encased in Cabinet 9 alongside bundles of bird of paradise feathers, examples of *Naturalia*. New World peoples and their *Artificialia* were ambiguously placed close by on this continuum.

Vitrines painted with bright coloured backgrounds, dramatically lit, made this *Wunderkammer* not only spectacular, but also frightening. Visual titillation was part of the larger experience in the court at Ambras. Display of wealth and power and all the attendant other-worldliness grew in the sheltered fortress on the mountain above Innsbruck. Some privileged artists of the time like Albrecht Dürer also enjoyed cabinets of curiosities as they filled them with wonders 'from the new land of gold [Mexico]' (Goris and Mariler 1971: 64). After visiting a display of gifts given to Cortés by Montezuma in Brussels in 1520, Dürer recorded in his diary: 'I have seen nothing that rejoiced my heart so much as these things, for I saw amongst them wonderful works of art, and I marvelled at the subtle *Ingenia* of people in foreign lands' (ibid.). Though he concludes that 'I cannot express all I thought there', the Northern Renaissance master's acknowledgement of the Mexican objects as having great artistry was enough. The *Wunderkammer* does not have the same snobbishness about items of ethnographic or merely cultural interest versus high art. It did not yet matter who made the marvel, or where it was made. The objects seemed to stand on the merit of their extraordinariness, and then, as if to turn this on its head, they were all subjected to the parergon of the vitrine. This was the moment of their birth into museal being. Shed of the

power with which they might have been imbued in another context, in the *Wunderkammer* they became pure display. The audience, historical viewers through to those of the present day, have the power to make of the objects behind glass what they will. The objects hover, spectacular and ready, but, for the most part, not going anywhere.

Vitrine 2: Museum für Völkerkunde, Vienna, 2012

In the early nineteenth century the imperial collection from Ambras Castle was transferred to the Baroque palace of Lower Belvedere in Vienna. The headdress was subsequently accessioned into the collections of the K. K. Naturhistorisches Museum (the Imperial Museum of Natural History) and was restored in 1878, though identified at the time as a mantle rather than a crown. El Penacho was again transferred with the founding of the Museum für Völkerkunde in part of the Hofburg Palace complex in 1928. After surviving the Second World War in storage, the headdress featured in an exhibition of treasures from Austria (*Meisterwerke aus Österreich*) sent as part of a cultural diplomatic mission to Zurich. It was returned in a damaged state in 1947, and after further restoration work was placed back on display in a new vitrine at the Museum für Völkerkunde, never to travel again. Despite intensifying demands to repatriate the headdress from the 1980s, el Penacho has remained a centrepiece in the modern museum, immobilized in a succession of increasingly sophisticated cases.

When I encountered el Penacho in 2012, after a major refurbishment project at the Museum für Völkerkunde and soon before the museum was renamed the Weltmuseum, the headdress was poised at an angle of 45 degrees in another new custom-built vitrine at the centre of a special exhibition titled *Penacho: Pracht & Passion* (Penacho: Glory & Passion). The exhibition, which granted free access to Mexican citizens and was accompanied by a Spanish version of the catalogue, focused on the art of museum conservation and studiously avoided any reference to the by-now vociferous repatriation lobby.

Pressed up against the vitrine in which el Penacho was displayed, I was more aware of the glass placed between the headdress and me than of anything else. I stood back and looked at others looking. Some visitors ambled by aimlessly, most were arrested for a time. They fascinate me, these people who come to the museum. I talked to young Mexicans, evidently surprised and awed in the presence of this object. They have grown up learning about the Aztec Empire, and objects like this crown stand most powerfully for their identity. Many think that it was because of Maximilian, the Habsburg emperor

of Mexico between 1864 and 1868, that the headdress came to Vienna. In fact, Maximilian came to Mexico some three hundred years after the crown had departed, but the association speaks volumes of the lingering feeling of material and emotional suspense between Mexico and Austria since colonization (Elderfield 2006; Gallo 2010; Ibsen 2010). The fact that the crown in its vitrine is framed by the stately interior of the Hofburg Palace, the seat of the Habsburgs at the heart of the Austro-Hungarian Empire, is not lost on me.

The vitrine's inbetweenness accentuated this sense of suspense within the museum's royally coloured marble rooms. The Russian doll-like architecture that surrounded the crown included a black box that created a theatre around the vitrine. There were no seats but after a while one leant against the back wall of the blackened space to watch the spotlighted centre. The dimensions of this vitrine theatre were such that only a small group of visitors was able to wander through at a time. The air was poor and the glass was smeared from fingers pressed against it in a careless attempt to see the crown better. When I visited, dust had already gathered on the glass ceiling of the vitrine, which was backlit by the synthetic ochre sun installed as faux skylight coming from the ceiling.

This redisplay of the headdress in 2012 was advertised as 'demystifying' (*Wiener Zeitung* 2012). Focusing on the scientific process of restoration, the *Pracht & Passion* exhibition said nothing of the demands for its restoration to Mexico. Echoing this word is intentional, for it is ironic that the same term is used to justify opposite ends. Thus the same word can be used to describe the process of repairing a work of art so as to restore it to its original condition and the action of returning the object to a former owner or place. The Museum für Völkerkunde performed one restoration to avoid doing the other. Thus the new glass case and support added the parergon of scientific conservation to the previous powers of public display from princely accumulation. This high-tech case was purpose designed for the crown to counter any vibrations that could adversely affect it in its fragile state. Indeed the vitrine signified el Penacho's extreme fragility and the impossibility of its movement, including its return to Mexico.

The vibration-proof design of the case and mount resulted from the discovery that the headdress was losing many of the individual barbs that make up its feathers. They were found, to the horror of the conservators, lying on the sheet on which the headdress was previously supported. As well as defining the specifications of its new vitrine, the conservation scientists who analysed the headdress also reported that the levels of vibration encountered in transporting it – by air, for example, to Mexico – could destroy its fine and brittle feathers. When the Museo Nacional de Arte in Mexico requested a loan of the headdress for its temporary featherwork exhibition *El vuelo de las imagines: Arte plumario en México y Europa* (Russo, Wolf and Fane 2011), they were presented with a specialist engineering report, which stated that a special vibration-proof case

would have to be built to transport it to avoid damage. The cost of manufacturing such a case was, of course, prohibitively expensive for the Mexican museum. Indeed, due to the cost of the required expertise, the Museo Nacional de Arte was only able to commission a separate independent engineering report with the assistance of the Mexican president's office.

There was an air of conspiracy when I interviewed the key actors on this matter in Vienna in 2014. The head scientist advising the conservation team had been both eager to participate in my research and vague about his availability. It was not until the end of our interview that he explained he had to seek the museum's approval before speaking to me. He was one of the few who had met in a closed room of the Hofburg Palace to discuss the repatriation at the highest level of government. I wondered why the head scientist had to be briefed before he spoke about this topic. The former director Christian Feest was quick to say that it was the Mexican museum that commissioned the conservation report from the counter-vibration expert directly.

Ironically this second report was prepared by the same Austrian engineering company that had prepared the first one for the Museum für Völkerkunde. It is based on tests of the vibration in the gallery under different conditions, from a crowd of visitors and a glass cleaning in the anyway always-heaving Hofburg architecture, to the effect of an airplane. All this can be mathematically predicted, and the more the vibration, the larger the container necessary to counter that vibration, according to the laws of physics. The resulting document looks like an engineering report but reads like a science fiction joke. On the last page there is a drawing of the 300-metre-long and 50-metre-high airplane that would be necessary, in the mathematic model, to buffer the velocity of take-off and landing to meet the conservation requirements set by Vienna (Wassermann 2012). Since such an aircraft does not exist, it was deemed unreasonable and unaffordable for the Mexicans, hence the headdress could not be loaned and, supported by scientific rationale, must remain a captive in its vitrine in Vienna. The case around the crown again asserted its inextricability from the object.

As I write, the Museum für Völkerkunde – now Weltmuseum – is again closed for refurbishment. When it reopens, el Penacho will be transferred into yet another new state-of-the-art, vibration-proof vitrine sited in its own room in the Hofburg Palace: a new high-tech *Wunderkammer*.

Vitrine 3: Museo Nacional de Antropología, Mexico City, 1940

There is a copy of el Penacho in a vitrine in Mexico City, which is less about impenetrable protection and more about simulating the parergon of the original

in Vienna. In a memo written before the copy of the crown was installed, the museum notes that while the crown has not arrived they have already built the vitrine (Guzman and Vera 2012: 108). It stands again as a frame, symbolic of the power it will contain. In photographs taken at the press conference in 1940 the new Penacho is flanked by Daniel Cosío Villegas, author of *Modern History of Mexico*, and the pre-Columbian archaeologist Alfonso Caso. The vitrine adds to the monumental height of the crown that is already as tall as many of those who stand beside it. Portable, it is presented by the throng of dignitaries and reflects them as if in a huge mirror, before being hung in the gallery.

The portraiture and self-reflection in this copy vitrine continues with full force in the age of the 'museum selfie'. Hundreds of thousands of photographs must have been taken in front of the Penacho copy in the Museo Nacional de Antropología in Mexico City by now. In the central space of the Mexican museum the copy el Penacho is displayed vertically at a height that invites visitors to photograph themselves as if wearing the crown (Figure 2.2). The significance of such a gesture has a broad spectrum, from the playful to the esoteric. Prior to the *Penacho: Pracht & Passion* reinstallation, the headdress was displayed in a similar manner at the Museum für Völkerkunde in Vienna. In the *Pracht & Passion* vitrine I saw in 2012, it was laid at a 45-degree angle in a case with vertical glass sides that reach high and wide around the headdress (Figure 2.1). The design is justified on the basis of conservation standards, but this makes it impossible for visitors to identify with el Penacho by framing themselves with the crown in the selfie photograph.

The ways the vitrines enable – or disable – audiences to interact with the crowns in Vienna and Mexico City speak of the very different political positions of the state to the constituencies represented by the 'national treasure'. The Museo Nacional de Antropología in Mexico City classifies the Aztec as a pinnacle of civilization, with Teotihuacan's material culture, including el Penacho, as primary evidence (Paz 1968). The copy crown is symbolic of pre-contact power, but the Weltmuseum sees it as its duty to safeguard and maintain the original as a part of the 'World Heritage' that it came to possess 'in good faith'. As the current legal owners of el Penacho, the Republic of Austria is the custodian of this cultural heritage, a heritage that is itself suspended between the histories of two empires and two nation-states.

In Mexico, the Museo Nacional de Antropología invites identification with the display of the commissioned copy – and an array of other copies have now followed. *Concheros* dancers campaigning for the repatriation of the original outside the museum in Vienna have performed in replica feather crowns in a display that embodies the entrapment of the crown within the vitrine (Figure 2.3). The power of performative acts is a tool for political self-identification (the 'selfie' has been theorized by Shipley [2015] in such terms). But what of those who perform their opposition to the vitrine, not

FIGURE 2.2 *The vertical display of the el Penacho copy in its case in the Museo Nacional de Antropología, Mexico City, invites visitors to photograph themselves as if wearing the crown. Photograph by Alberto Yanez.*

with the visual tricks of photography, but with their own copies of the crown? These *Concheros*, who have been termed by Galinier as 'Neo-Indian' (2013), religiously make feather crowns for their 'dances of conquest' in Mexico City (Rostas 2009). How should we understand the process of making, wearing and dancing a feather headdress like el Penacho? What inspires the *Concheros* to make these crowns? When they are worn, what happens to their dance? The crown *does* things. It has effects. But how does this work? The references for these copy crowns are old and new. Their makers do not struggle for authenticity. Indeed, some of the makers in Mexico City are oblivious to the 'ur-crown' in Vienna, but their statements about the significance of their feather headdresses echo what is said of the precolonial priests' rituals. The feather crowns guide and constitute their wearers, as many objects do.

If objects also stand in for absent people then the problem of authenticity and moral right can be approached differently. In this way the Mexican repatriation claims can be understood as being about Montezuma, rather than being about the crown itself. This is why it has also proven unsatisfactory to protestors campaigning for its repatriation to have historians debunk the claim that links the provenance of the headdress with Montezuma, the last indigenous emperor of Mexico. While the authenticity, name and status of the original headdress are in question, the Viennese enjoy the cruel irony that the copy of the crown is more correctly Montezuma's than Vienna's own since it happened to be made by a traditional craftsman named Francisco Montezuma (van Bussel 2012).

FIGURE 2.3 *Protestors campaigning for the return of the feather headdress in Vienna, 2007. Photograph by Douglas Sprott.*

Indeed, over the years, in repeated processes of restoration, the original crown in Vienna has been flattened, new feathers have been added, pure gold has been replaced with gold plate, and other substitutions have been made (Trenkler 2012). After so many changes to the original, a question is raised in the Mexican literature whether Mexico even wants it back in such an altered state. What of the 'original' crown actually survives? How much is it artefact and how much is it artifice? Despite this, there are still ongoing requests for a return of el Penacho from Vienna.

When repatriation is negotiated at the highest diplomatic level, the object and its authenticity itself disappear behind political or corporate interests. Instead, it is a history of relationships, gifts, favours and opportunities that are being weighed up. At the other extreme of this abstract bargaining between politicians, diplomats and museum directors of representative national collections, however, is the physical presence of the object.

Conclusion – smashing the vitrines?

The stasis of inbetweenness always has a shadow of transportation. The journeys that an object has completed are engrained in its very materiality. Where it stops, for the time being, and where it started being separate, the

transport in between becomes an important part of the story. The inability to now move el Penacho due to its fragility has become the basis of the denial of the demand for repatriation that Mexico has been making since the 1980s. Movement is absorbed into immobility, life is stilled to a promise of eternity. In the narcissistic reflection of the glass the European visitor can see themselves and the world, and thus the illusion of universalism and cosmopolitanism. Made invisible, through an invisible glass shield, it is a *Vitrinendenken*, a 'thinking through vitrines' (Carroll 2013), which guides the audience through enlightenment museums. Herein lies the difference between the *Concheros*'s view of the feather crown and the Weltmuseum's. In the performance of identification with Montezuma, the meaning of the crown changes. No longer is the suspended inbetweenness that the Weltmuseum conserves with science the only authority.

Anticipating the latest redisplay of the feather headdress at the Weltmuseum, the three vitrines I discuss in this chapter raise a more provocative question in relation to museum display. What would a museum without vitrines look like and how might the kinds of community engagement we have witnessed around el Penacho help us to imagine this break? In the afterword to his book *My Cocaine Museum*, the anthropologist Michael Taussig conjures the image of the gods imprisoned in museum cabinets awakening and escaping their bondage:

> I can only hope that the gods asleep in the museum – all 38,500 of them – will awaken and come to life with the tinkling of glass as the vitrines give way. This is my magic and this is why I write strange apotropaic texts like *My Cocaine Museum* made of spells, intended to break the catastrophic spell of things, starting with the smashing of the vitrines whose sole purpose is to uphold the view that you are you and over there is there and here you are – looking at captured objects, from the outside. But now, no more! Together with the previously invisible ghosts of slavery, the awakened gods will awaken remote pasts and remote places (Taussig 2004: 315).

El Penacho, too, has been visited by priests and shamans who would break the spell of things and free the spirits of the headdress from the vitrine that encases them.

The replica crown in the Museo Nacional de Antropología in Mexico is no substitute for el Penacho, but perhaps copies provide a 'third way' out of the seemingly irreconcilable conflict between how a living community wants to use a ceremonial object and how a museum must scientifically protect it. For the priests, who are able to speak to the spirits through the object, power

does not reside only in the original. In a contemporary ceremony, and with the agreement of the spirits, it is possible to transfer the ritual efficacy from the original to a copy.[1] Such re-enactment is cast by historians who resist these claims (Feest 2012) as a self-conscious version of historical ritual, an invention of tradition that creates a distance between the participant and some perceived authenticity of the ritual from the past. Yet the possessions of the past can also possess those who wear them. The parergon is one kind of spell that protects and captures the object, the spoken spell another.

Note

1 Interview with Kajuyali Tsamani, March 2016.

References

Anders, F. and P. Kann (1996) *Die Schätze des Montezuma Utopie und Wirklichkeit*, Wien: Museum für Völkerkunde.

Bredekamp, H. (2000) *Antikensehnsucht und Maschinenglauben*, Berlin: Wagenbach.

Bujok, E. (2009) 'Ethnographica in Early Modern Kunstkammern and Their Perception', *Journal of the History of Collections* 1: 17–32.

Bůžek, V. (2009) *Ferdinand von Tirol: Zwischen Prag und Innsbruck*, Wien: Böhlau.

Carroll, K. von Zinnenburg (2013) 'Vitrinendenken: Vectors between Subject and Object', in G. Ulrich Großmann and P. Krutisch (eds), *The Challenge of the Object*, 54–56, Nuremberg: Germanisches National Museum.

Derrida, J. (1979) 'The Parergon', *October* 9: 3–41.

Elderfield, J. (2006) *Manet and the Execution of Maximilian*, New York: Museum of Modern Art.

Feest, C. (2012) 'Der Altmexikanische Federkopfschmuck in Europa', in S. Haag, A. de Maria y Campos, L. Rivero Weber and C. Feest (eds), *Der altmexikanische Ferderkopfschmuck*, 5–28, Altenstadt: Zkf.

Galinier, J. and A. Molinié (2013) *The Neo-Indians: A Religion for the Third Millenium*, Denver: University Press of Colorado.

Gallo, R. (2010) *Freud's Mexico: Into the Wilds of Psychoanalysis*, Cambridge, MA: MIT Press.

Goris, J.-A. and G. Marlier (eds) (1971) *Albrecht Dürer: Diary of His Journey to the Netherlands, 1520–1521*. London: Lund Humphries.

Guzman, M. O. M. and B. Olmedo Vera (2012) 'Die Nachbildung des Altmexikanischen Federkopfschmucks', in S. Haag, A. de Maria y Campos, L. Rivero Weber and C. Feest (eds), *Der altmexikanische Ferderkopfschmuck*, 107–14, Altenstadt: Zkf.

Ibsen, K. (2010) *Maximilian, Mexico, and the Invention of Empire*, Nashville, TN: Vanderbilt.

Künstlerhaus Wien (1959) *Präkolumbische Kunst aus Mexiko und Mittelamerika und Kunst der Mexikaner aus späterer Zeit*, Wien: Österreichischen Kulturvereinigung und Museum für Völkerkunde.

Nowotny, K. (1960) *Mexikanische Kostbarkeiten aus Kunstkammern der Renaissance*, Wien: Museum für Völkerkunde.

Nuttall, Z. (1888) *Standard or Head-Dress? An Historical Essay on a Relic of Ancient Mexico*, Cambridge, MA: Peabody Museum of American Archaeology and Ethnology.

Paz, O. (1968) *The Other Mexico: Critique of the Pyramid*, trans. Lysander Kemp, New York: Grove Press.

Rostas, S. (2009) *Carrying the World: Conceros Dance in Mexico City*, Boulder: Colorado University Press.

Russo, A. (2011) 'Cortés Objects and the Idea of New Spain: Inventories as Spatial Narratives', *Journal of the History of Collections* 23 (2): 229–52.

Russo, A., G. Wolf and D. Fane (eds) (2011) *El vuelo de las imágenes: Arte plumario en México y Europa, 1300–1700*, México: Museo Nacional de Arte.

Schacter, R. (2014) *Ornament and Order: Graffiti, Street Art and the Parergon*, Farnham: Ashgate.

Shipley, J. W. (2015) 'Selfie Love: Public Lives in an Era of Celebrity, Pleasure, Violence, and Social Media', *American Anthropologist* 117 (2): 403–13.

Taussig, M. (2004) *My Cocaine Museum*, Chicago, IL: University of Chicago Press.

Trenkler, T. (2012) 'Federgelagerte Vitrine für die flachgedrückte Federkrone', *Der Standard*, 15 November, available online: http://derstandard.at/1350261515780/Federgelagerte-Vitrine-fuer-die-flachgedrueckte-Federkrone (accessed 16 September 2016).

van Bussel, G. W. (2012) 'Der altmexikanische Federkopfschmuck. Aspekte einer Reszeptionsgeschichte', in S. Haag, A. de Maria y Campos, L. Rivero Weber and C. Feest (eds), *Der altmexikanische Ferderkopfschmuck*, 115–33, Altenstadt: Zkf.

Wassermann, J. (2012) 'Options for Vibration Reduction of a Plate during Transport by Aircraft', Unpublished report, Institute of Mechanics and Mechatronics, Vienna.

Welchman, J. C. (ed.) (2013) *Sculpture and the Vitrine*, Farnham: Ashgate.

Wiener Zeitung (2012) 'Entmystifizierte Schmuckpracht: Voelkerkundemuseum zeigt restaurierte und "entmythologierierte" Federkrone', 15 November, 28.

Zapperi, R. (2004) *Der wilde Mann von Teneriffa: Die wundersame Geschichte des Pedro Gonzalez und seiner Kinder*, München: C. H. Beck.

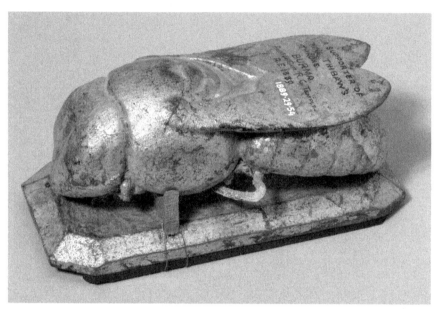

FIGURE 3.1 *Gilded wooden bee, on display in the Pitt Rivers Museum, length 180 mm. Donated to the museum in 1889, by Richard Carnac Temple. 1889.29.54. © Pitt Rivers Museum, University of Oxford.*

3

The buzz of displacement: Liminality among Burmese court objects in Oxford, London and Yangon

Sandra H. Dudley

On display in the University of Oxford's Pitt Rivers Museum (PRM) is a gilded, wooden bee, about 18 cm long (Figure 3.1).[1] Together with another in the museum's stores and three in the collections of the Victoria & Albert Museum (VAM), it is one of only five of the original thirty-six bees that embellished the now lost Bee Throne (*Bhamara Thana*) of the Mandalay Court in pre-British Burma, known today. The Bee Throne was one of nine thrones, each located at different points in the palace of Burma's last king, Thibaw Min, each carved from a specific wood, each themed with distinct natural motifs and each serving particular ceremonial functions. All were made at one auspicious time, in the waning moon month of Kason, BE 1220 (May 1858 CE), determined by astrology and enhanced by accompanying rituals (Ma Thanegi 2003).

The five bees are all now displaced, in the sense of no longer being in the place for which they were originally designed and where they first belonged. But does that necessarily mean they are *out* of place, out of context, lost? In what senses are they *in between* places and times? Might being inbetween, be different from being out of place? Might the answers to these questions be different depending on one's vantage point? This chapter examines such

questions, and in doing so offers a particular vision of displacement that can be usefully applied not only to the Burmese bees but also to museum objects more generally. This is a model of displacement in which the *object's* experience of the process is foregrounded and Victor Turner's anthropological theory of ritual (e.g. 1969) provides a clear parallel for the stages undergone by the displaced artefact.

Orientations

The English term 'displacement' clearly conveys a changed association to place, but important too is the movement emphasized by its Middle French ancestor *desplacer*, with its connotations of travelling between one place and another and even of connecting the two. This articulates the fluidity of displacement as it is experienced not only by forced migrants but also by their possessions; by objects now in museums, however obtained; by things long since lost at the back of the wrong drawer; by items sold at a car boot sale . . . by anything, in other words, that has moved from its original location. Moreover, the movement may still be in process, need not have been forced or externally imposed, and, as I shall return to later, is as much temporal as spatial. Displacement inevitably creates breaches between places, moments, objects and people; yet as we shall see, its mutability also means that ruptures can be transgressed and connections reforged.

Displacement also appears to advance in discernible stages. After an initial phase of leaving home, which necessitates crossing at least one boundary or threshold, there is a second period of being in transition and inbetween, before a final step in which the displaced person or thing becomes settled in their new abode. There is a marked similarity between these stages and those of separation, liminality and incorporation, identified in ritual process by Turner, building on Arnold van Gennep's theory of ritual (1909). Through this process, the ritual participant is removed from their previously usual place in the social group, before undertaking a journey (physical, symbolic, or both) and remaining 'betwixt and between' for a period, until being finally absorbed back into the community in their new status. Thus, for example, Turner describes the rituals of the Ndembu, with whom he worked in what is now Zambia, as essentially consisting of (i) the separation phase, *Ilembi* or *Kulemba*, which involves dance and other activities that effectively remove the initiand from the everyday and render them sacred; (ii) the marginal phase in which the participant undergoes a period of seclusion; and (iii) the *Ku-tumbuka*, in which dance and other practices reincorporate the new initiates back into their everyday life (Turner 1967: 13–14).

Because of their structural similarity, I utilize Turner's ritual theory in thinking through the process of displacement. In the context of this book on inbetweenness, I focus particularly on the liminal phase. For Turner, liminality is not a state in itself, but rather a period of transition between one state and another. It is a time of becoming, in which the initiand is 'betwixt and between' categories and problematic and polluting to those who have not also been through the same ritual (1967: 97–8). The initiand in this phase is unable to fully participate in everyday life, unable to be themselves in the sense of fulfilling normal social roles or exhibiting their personhoods – either as they were pre-ritual (perhaps as an uninitiated, adolescent male) or as they will be afterwards (as a newly initiated, adult man).

In the case of museum objects, we need to understand why they are liminal at certain times and in certain places, and between which states they are in transition. But a fuller picture of displacement, and of inbetweenness and transition in particular, also necessitates grasping something of the *objects'* experiences. If liminality in displacement means, as it does in ritual, being outside one's normal social position(s) and unable, for a while, to be or assert one's full self, how does that manifest for an object like the bee? What would be its point of view? How might it feel about it? What would being 'incorporated', settling into a new role and place, no longer liminal, comprise from the bee's perspective? To attempt such a switch of outlook, if only as a thought experiment, rather than constituting a fetishistic or excessively anthropomorphized approach, shifts us away from an anthropocentric perspective, enabling insight not only into how the PRM bee, for example, may impact the viewer from behind the glass, but also into how the viewer might impact on it. This may help move us towards a more subtle understanding of the relationships between the bee and those who come and go around it.

This method draws in part on the object-oriented ontology of Levi Bryant, who writes of a 'democracy of objects' in which all objects, including people, are equally objects – although this does not mean they are equal to each other in value, power, kind or characteristics. This idea implies that 'we cannot treat one kind of being [e.g. humans] as the ground of all other beings' (Bryant 2011: 73). Not all things frame the world as we do and one cannot know what it is like to be the bee or how we might appear from its perspective; moreover, even if one could know, one would be unable to present it in the language of the object and would instead have to translate it into familiar terms. Such challenges are familiar in anthropology, albeit to a less extreme degree, and difficulties in knowing and translating need not stop a dedicated ethnographer trying. Even to use the phrase 'the object's point of view' is a rhetorical device: we do not think that objects have viewpoints like we do. However, as historiographers of the subaltern

have found, an interpreter has to write the voices of a silenced group in the dominant idiom if it is to be understood beyond its own margins. For objects, using human vocabulary like 'point of view' seeks, apparently contradictorily, to *decentre* the person and to look instead at the material world and its web of relationships from the starting point of the object. It is methodological *prosopopoeia*, the ascription of an essentially human voice to an inanimate object, animal or dead body. It is also a process in which the representer holds the balance of power. An analogy is that the colonizer was able to dominate the articulation and comprehension of knowledge such that the colonized's forms of understanding and representation were ineffectual by comparison (cf. Spivak 1988). In colonies, refugee camps, ritual processes, museums and books, it is those in charge who define, describe, confine, control and appear to have the agency. In all these settings, though, those who appear to be powerless nonetheless have the ability to impact on others who encounter them. The perspectives on this developed in this chapter are shaped by my long-term research with encamped Karenni refugees from Myanmar (Burma) in northwest Thailand (e.g. Dudley 2010).

Separation

As outlined, in the displacement theory proposed here separation is, in spatial terms, departing from 'home', leaving behind what one knows. This involves crossing a threshold of some kind and journeying away from the place and role in the structured machinations of daily life for which the displaced was made. I do not dwell here on the threshold, the boundary that marks off the familiar world from what lies beyond (cf. Dudley 2017). In the case of the bees, the invasion of their familiar world by British soldiers (Figure 3.2) had already violated and made it strange before they ever crossed the physical threshold to leave it. Separation broadly defined can apply to any moving thing – it need not concern only the *forcibly* displaced – but for the PRM and VAM bees alike, it began with their physical removal from the Bee Throne when the Mandalay Palace was looted by British forces following the fall of Thibaw Min. They then journeyed to Britain, with the personal effects of British veterans of the Third Anglo-Burmese War or in a large collection consignment sent direct to an institution.[2] Thereafter those not delivered straight to a museum probably languished for a while in quiet corners of the Shires, before ultimately ending up where they now reside. Some of these journeys, from palace to museum, were complex and stretched over considerable time as well as space, fractured into a series of smaller displacements, together making up manifold composites of separation, liminality and reincorporation.

Two of the VAM's bees, for example, are accessioned together on one record as museum item IS.78A-1977. They were donated to the museum together with a figure of a mythological creature – a *camari* – also from one of the royal thrones, by Sir Geoffrey Ramsden in 1976. All three throne ornaments were collected by Ramsden's father, Colonel H. S. F. Ramsden, in 1885, at the end of the Third Anglo-Burmese War in which Ramsden senior had served as a junior officer.[3] The third VAM bee does not have an accession record at all. The record for the bees donated by Ramsden does mention, however, that in the museum's Battersea store is to be found a similar (though not identical) bee, which appears never to have been accessioned and is accompanied by a piece of paper that, in a nineteenth-century hand, notes:

> This gilded beetle [sic] is from the throne of Theebaw [sic], last King of Burmah, & was brought from Mandalay by the late Major General Elphinstone Waters Begbie C.B., D.S.O, in 1989 [sic – clearly 1889 is meant].[4]

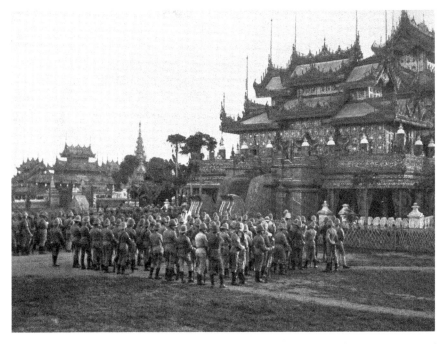

FIGURE 3.2 *Christmas Day, 1885. Less than a month after taking possession of Mandalay on 28 November, British soldiers from the Hampshire Regiment hold an outdoor church service. Photograph by Willoughby Wallace Hooper. © The British Library Board, Photo 312(31).*

Major General Elphinstone Waters Begbie had a distinguished service record in a number of campaigns, including the Third Anglo-Burmese War that ended with the arrest of King Thibaw and the annexation of Mandalay and Upper Burma to the British Empire. Begbie (and presumably his bee) eventually retired to West Sussex, where he died in 1919.[5]

The PRM bees were donated directly to the institution in 1889 by their initial acquirer, Richard Carnac Temple. Temple was at that time a captain in the Indian Army, and he, too, fought in the Third Anglo-Burmese War. After the annexation of Upper Burma, Temple stayed on there for some years, serving as an administrator and a magistrate. His bees came to the PRM together with around 250 other objects sent directly from Burma, with his address given as The Palace, Mandalay – by that time a British military and administrative base. This was not Temple's first donation to the PRM, and would not be his last; neither was the PRM the only museum in Britain to which he gave objects. Not all of his museum donations originated in Burma, though the majority did. In his 1889 donation, we find not only the bees (which are not, incidentally, exactly the same: one is larger than the other), but also 'one very large and 4 smaller carved wood figures of mythological lion [and a] carved wood, nude and gilt figure of a boy', all of which are described in the Museum Notebook entry list, with inadvertent and poignant irony, as 'supporters of Thibaw's throne'.[6]

In comparison to Temple's bees, and probably Begbie's too, it is clear that Ramsden's bees followed a more convoluted trajectory to the museum where they now lie. Indeed, they may have undergone a series of displacements. Precisely what is not clear, but we can speculate that their first journey may have been to India, with the elder Ramsden's personal effects. Later, they went onwards, accompanying Ramsden back to Britain and then eking out his retirement with him, maybe as cherished mementos on display, or perhaps forgotten things growing dusty in an attic. Eventually, Ramsden senior died, and the bees passed into the hands of his son. In the process another displacement cycle began: separation from the now familiar home, a renewed liminality in which the stories of the past now accrue added layers encompassing not only Burma but also family histories. It is only with the younger Ramsden's donation of the bees to the VAM that the final separation occurs, and the bees enter yet another liminal phase – an institutional one that may, as we shall see, last indefinitely.

Liminality

Once across the threshold that bounds its place of origin, the material object is loosed from the physical, social and cultural structures that previously determined its position and its functions. But this is only the beginning. For

Turner, it is the transformative potential of the liminal phase that is especially important. In ritual this constitutes a dynamic transition from one state to another, during which initiands acquiesce to teaching and even physical transmogrification carried out by ritual experts (Turner 1967). For Karenni and other refugees fleeing across borders and entering camps, their exodus is – as for the bees – just the start; on arrival at the refugee camp they experience, at the hands of camp administrators, the descriptive and containing processes of registration, allocation of space, and restriction to the area within the boundaries of the camp. The bees likewise undergo institutional disciplining processes enacted by museum staff in order to turn them into museum objects: accessioning, physical numbering and cataloguing.

From an external perspective, we could conclude that becoming a museum object completes the liminal phase: the transformation is complete and the artefact is now reincorporated, in Turner's terms, into the social world, albeit unlike the ritual initiand the object now finds itself in a new world, the museum. But from the object's point of view, the liminal phase not only concerns the moment in which artefacts *become* museum objects, but is also defined and, significantly, perpetuated, by their subsequent and ongoing use as *representational* objects – in other words, the very fact of *being* a museum object means the artefact, seen from its own perspective, is liminal, in between social worlds. As we shall see, however, as well as removing the object from proper involvement in the everyday, this liminality also confers on it an active transitionality through which it can act as a connector that sustains, embodies and changes relationships with the past (and possibly also the future).

Once institutionalized, after they have entered the museums and been numbered, documented, stored or displayed, the bees are unable to participate in Burmese Court life as they once did, and are functionally and socially disempowered. They are materially and aesthetically disempowered too, no longer able to be experienced in their familiar cultural domain, no longer able to be seen and touched in the setting for which they were intended. In Turner's terms, their complete involvement in the everyday life of their new world, the museum, just like ritual participants' reincorporation into their social world, will happen only when they are once again able to function and assert themselves in a fully social sense, influencing people and other things (I return below to what this means for the bees and other artefacts). In the museum, however, the object's materiality is no longer mutually interdependent with a particular time, place and social exigency in the ways in which it once was. The bees no longer cluster around the grand seat of the Bee Throne in its intimate setting in the *Hman Nan* (central Glass Palace), ever ready to play their part as bringers of wisdom during private family occasions such as ear-piercing ceremonies for royal daughters (Ma Thanegi 2003; see Figure 3.3).

FIGURE 3.3 *The Glass Palace in the middle of the Nandaw (Royal Palace) at Mandalay, 1903–1907. Destroyed in 1945, the Royal Palace has now been partially reconstructed.* © *The British Library Board, Archaeological Survey of India Collections, Photo 1004/1(26).*

Nonetheless, the bees are not without a role, for now they become the centre of the stories told by others. They become souvenirs, keepsakes of a military campaign, family mementoes of forebears who served in an eastern land; they turn into vestiges of a lost kingdom and, in time, a lost empire; still and flightless while tales are told and forgotten. Quite what they come to stand for depends on who uses them and how, who responds to them and why. They may be positioned as an example of the animal form in art, or as representations of the royal court of Burma illustrating narratives through which we might learn that the bees and the Bee Throne itself were all made of cassia wood (*Cinnamomum tomata*; Burmese: *karawé*) and less elaborate than some of the others in the palace; or they could be displayed as examples of nineteenth-century British imperial plunder. Whatever the representational approach, these displaced objects are not only remnants *of* the past, but also metaphors *for* it. Indeed, metaphor itself is a displacement, its ancient Greek root implying 'transport', and its very action 'producing new figurations' (Robertson et al. 1994: 2). The bees become potentially powerful

metaphors not only for animals in art, royal thrones, Burma, wisdom, the initiation of princesses and the British annexation of upper Burma, but also for wider issues of imperialism, theft of cultural property, loss and a precolonial past.

For whom does this happen, however? For whom, in the museum, are the bees representational objects? It is not for themselves or those they left behind. It is for those who choose to utilize them as a means to tell a story (curators, exhibition designers) and those who come to view them. The tales woven around them are not their own; if they tell at all of the violent breakage from the throne and travel to Britain, it is not from the bees' points of view. From their own perspective, the bees are rendered passive, no longer able to participate in social life in the way in which they were made to do, in the fullest sense for wooden creatures on a throne; like the ritual initiand, they have left behind what they were and had before. As individual material forms the bees still exist as they did before, but the coexistent material forms that were part of the throne, and the associated social forms they once comprised together, are, like the former social being of Turner's initiand, lost. As stories and representation come to the fore, the objects and direct social action recede.

From the bees' perspectives, then, they were first separated from their original social world, taken into the hands of their collectors, constrained by museum accessioning and subsequently moved into the institutional vitrine or store, wherein they are embedded by others into processes of description and representation that continue to keep them in a temporally and socially liminal zone. This does not mean that the museum world as a whole is not one full of life – we know both that it is and that, for the people involved in that world, museum objects are an important part of it. Nor does it imply that museum objects, removed from their societies of origin, are frozen in suspended animation, sad or lifeless (cf. Boon 1991; Crimp 1993; Bouttiaux 2012). The museum is a world of dynamic social relationships. But *from the viewpoint of the objects* their inability to function in a fully participative manner in social life is one of two principal influences perpetuating the liminal phase they entered when they first became displaced. Further propagative of that liminality is museum representation, itself – especially through metaphor – a form of displacement that transports and translates the object into something beyond itself. That process may ultimately bring exciting, creative change, as ritual process does for the initiand who eventually emerges as a new initiate, ready to reabsorbed back into the community, and as successful resettlement may ultimately produce for the refugee (or her children). But for initiand, refugee and displaced object alike, it also brings loss; as Peter Burke puts it, 'translation necessarily involves both decontextualizing and recontextualizing. Something is always "lost in translation"' (2007: 38). To others the museum

object stands for sensory experience, event, social action as they are recorded or imagined to have happened in the place of origin; but from its own perspective it is, like the encamped refugee and the ritual initiand, in between holistic social domains and precluded from full integration, function and assertion within them.

Like Turner's liminal phase, however, representational processes do not just act to marginalize objects and place them between social worlds; they also turn objects into bridges that connect different realms in efficacious ways: liminality is both a gap and a connection. In trying to bring the past alive, or, at least, in seeking to describe aspects of it through physical objects, we attempt both to render it comprehensible in our terms and to create for our audience some temporal continuity between that past and the present. This sense of continuity is materialized in the sustained identity of the artefact itself, which reassuringly seems to be the same object now (albeit perhaps a little more battered and worn) as it was in the past. Moreover, for some audiences and in some places there may be particularly acute sensitivities about that past and about apparent ruptures between then and now; hence representation also plays an important role in creating a sense of historical continuity between past and present socio-cultural identities and in smoothing over past fissures, even if the continuities are often at least partially imagined. Thus the Throne Room in the National Museum of Myanmar in Yangon today, for example, sets out to convey the detail, majesty and complexity of all the thrones, and thereby of the former royal dynasty and precolonial era, by grouping a series of ornate gold models around the surviving Lion Throne. Yet this representational process does not, of course, seamlessly or simply connect past and present. The same objects and stories that are mementoes of and connectors with court life in the Mandalay Palace are simultaneously tokens of traumatic upheaval, disjuncture, loss, reappropriation and absence. The very fact that in Yangon all but one of the thrones is represented by a model replica rather than the real thing, or even a real piece of the original, is deeply poignant.

Again, however, one must ask for whom is this so? For many museum visitors, including those whose own histories do not lie in Myanmar, in Yangon – and in London and Oxford, albeit in different ways – the presence of original, now displaced, royal Burmese objects may represent that country's past and losses to colonialism. These artefacts may even stimulate in such visitors a new level of historical awareness, what Frank Ankersmit describes as 'a Gestalt-switch [that] gives us the discovery of the past as a reality that has somehow "broken off" from a timeless present' (Ankersmit 2005: 9). What, though, is the effect for the bees, from their own perspective, of standing for, and in some way connecting the present to, the past? For refugees, certain objects and practices come to stand for the pre-displacement past (Dudley 2010).

Such things may include items of dress, food, the performance of particular rituals or other activities (such as weaving) and the artefacts involved in such practice. Indeed, they come to include the displaced, embodied, dressed, actor herself. The exiled person's habitual wearing of certain clothes, eating of particular foods and enacting of specific endeavours, and the simultaneous sensory and emotional familiarity and difference that come with doing so in a new environment, are fundamental to how far a refugee feels connected to where she came from (ibid.). Moreover, as Ankersmit (2005) reminds us, attempts to recover or reconnect with the past are often simultaneously painful and pleasurable; there is 'both alienation and an act of recovery' (Curtis and Pajaczkowska 1994: 200). In displacement, because of both what has brought about the sense of loss, and the spatial as well as temporal distance from it, this may be particularly difficult and complex. For Karenni refugees, for example, remembering and perpetuating a sense of connection with the pre-exile past is important; but it is also distressing, a reminder of what – and who – has been lost, of the irrevocability of the break with the past in question, and of the impossibility of returning to it. Might we then imagine that for the Burmese bees, their own senses of connection with their pre-displacement past may be enhanced by others' positioning of them as standing for that past and by their own physical form? In other words, we could fancy that they were being continually reminded of their original location and purpose by both the stories told about them and their bee-ness and gilded decoration. And for the bees as for the refugees, is this sense of connection with the past painful as well as reassuring?

Objects, practices and the physical person herself are also important in refugee camps in trying to make the displaced present more tolerable and homelike (Dudley 2010). Home is not simply somewhere 'one feels most safe and at ease' (Malkki 1995: 509), but a place that people feel is an intrinsic part of themselves, of who and what they perceive themselves to be. For refugees home lies in the past and somewhere else, yet a crucial part of how refugees cope with displacement is precisely by also seeking to make home in the present, in the camp (Dudley 2010: 9). For refugees, cultural aesthetics – 'a feeling of rightness about the world, enjoining correct styles of action and response' (Gosden 1999: 203) – play a vital part in these processes. Refugees' embodied, sensorial experiences of the refugee camp environment, clothing, food, climate, and their remembered and imagined experiences of equivalent things prior to displacement are fundamental to how far they feel at home in displacement. Moreover, in the camp there is always an ambivalence because the displaced setting is forever *becoming* home but never quite *being* it. The pre-exile home (even for those born in the camps) thus remains an object of nostalgia in the vanished, faraway past (Serematakis 1994). How might this apply to objects such as the bees?

Physically, they are not 'at home' insofar as they are not in the place for which they were made and used; moreover, as I have explained, they are unable, once they have become museum objects, to be or assert themselves. In terms of cultural aesthetics, that inability is equivalent to not feeling at ease or right with the world, not being able to perform or react as is customary or proper for who or what one is. Of course the bee on display in the PRM does not 'feel' in the way that we do and understand; but from its perspective it can no longer take part in cultural life as it formerly did, and there is now a sense of a greater distance between it and the world immediately around it. To extend the thought experiment, we might picture it wanting to feel at home where it now is, but not wanting to let go of the past for which it yearns. Karenni refugees experience this dual longing – characteristic, perhaps, of the liminal phase as what Victor Turner calls society's 'subjunctive mood, where suppositions, desires, hypotheses, possibilities, and so forth, all become legitimate' (1969: vii). Might, then, we also imagine the displaced bees having such yearnings?

There is another characteristic of Turner's liminal phase of significance to the bees too: *communitas*. This is the sense of mutuality that is cultivated between ritual participants, which transcends the usual disparities among them (Turner 1967: 100). In the museum, one would identify *communitas* partly in the solidarity and camaraderie that is shared by all the things within it. Through various forms of mostly forced migration, like diverse refugees now in one camp, the objects in the museum are now all there. Apparently (though not necessarily actually) rendered silent and still, the things on display cannot avoid the gaze of museum visitors but at least share the experience, staying put while people come and go, massed with each other in the museal space. *Communitas* also lies, I suggest, for museum objects as for refugees, in what John Davis has called a 'bond of suffering' (1992), a notion of pain that when applied to the displaced explains the current situation in which they find themselves. But having undergone experiences of loss and hardship does not only explicate the reality of displacement, it also reinforces the feelings of being displaced and the limitations this places on individuals' senses of the possibilities open to them. Proust viewed suffering as 'part of an experiential continuum . . . the ache that remains after the initial disappointment, the anguish that endures after the illusion has vanished . . . [and] affective proof of the continuity of ourselves' (Rivers 1987: 125). *Communitas* means that the anguish is shared with others who have also experienced loss and exile. Might it be imagined that this is the case for the Burmese bees as much as it is for Karenni refugees? And can we fancy such a bond helping to mitigate the impact of museum objects being prevented from participating fully in social life, as it does, in different ways, for both ritual initiands and encamped forced migrants?

Reincorporations

If museums and their visitors expect objects to stand for people, communities and stories, and if taking such a representational role perpetuates the liminality of displaced things, how can this be overcome? How can objects become once more fully incorporated and active within social life? How, from their own viewpoints, can they come to be 'at home' in their museum world? My contention is that this occurs in rare, unpredictable and fleeting, intensely affective engagements between the object and a museum visitor: moments when something catches someone's eye and surprises, delights, perplexes or appals, drawing them to stop and stare. These engagements are quite different from the brief glances objects receive as visitors glide through galleries. They are interactions reaching far beyond the cognitive, unconcerned with the descriptive and the representational and bringing new, compelling and sometimes conflicting possibilities. For the object these moments may be transitory, followed by slippage back into liminality of unforeseeable duration. However evanescent, it is these encounters that properly incorporate the artefact into a new social realm, the object once again able to act as a material and sensory thing in its own right rather than as simply a figure in someone else's storytelling.

The bee displayed at the PRM, for example, moved a visiting wood-whittler sufficiently for him to later create his own bee based on it. He subsequently posted an image of his bee online, writing about his making of it 'after seeing a really nice gilded carving of a bee from the throne of Thibaw Min in the Pitt Rivers museum in Oxford'.[7] Indeed, he was sufficiently intrigued to source and include on the blog an image of Thibaw himself. He then pointed to both the shape of the bee and the material from which it is made, adding a note about the products of the honeybee and their benefits for wood. There was something about the combination of the bee's figure (and its associations), and the substance and process from which it was constructed, that attracted this particular PRM visitor to the artefact. Before knowing its story, his eye was caught by its partly dull, partly shining, solid, clearly apian, clearly ligneous form and surface detail. The bee moved him enough to create its contours anew; moreover, he was also inspired to learn and tell about King Thibaw. This is not only an impactful encounter but also one that neither whittler nor museum might have foreseen before it occurred. The woodworker's inspiration by the bee and his ability to reproduce it also demonstrates how far, even when handling is not permitted and sight is the only directly utilisable sense, the visitor may intuit surface and three-dimensional form, cultivating a sense of what the object *feels* as well as looks like. From the object's perspective, it is in such moments, when it affects someone significantly, that it is fully participating and asserting itself in its new social world.

Museum objects can capture the attention or catch the visitor off guard in two key ways. In the first, like the bee for the whittler, their form, materials and surface details together make up a composition that in some way attracts the attention – though whose attention, and when and why it is caught, is unpredictable, as is whether or not the viewer will (as the whittler was) be subsequently inspired to find out more about the object's history and other details. In the second, the object is arresting because of its very embodiment of, and the knowledge of it having lived through, particular historical moments. Thus, for example, to see the Lion Throne in Yangon and know that it was once in the Mandalay Palace, and sat upon by the last king of Burma, lends it an especially potent quality. There is a similarity between these two modes of object power and what Stephen Greenblatt refers to as 'wonder' and 'resonance' (1991). Moreover, these two ways in which objects arrest the attention of visitors frequently coexist. Most important, however, is the fact that both come from something within the material object itself. It is this that makes these encounters – and the second mode in particular – different from the more usual museum experience of viewing still liminal objects used to represent or illustrate a wider story. Instead, in those encounters, objects become enlivened, active historical witnesses, and the details of their shape, ornamentation, texture, signs of wear and so on may all be excited voices that clamour to be heard and to make an impression, even if it is only, in the end, to 'tickle' the viewing subject (Bryant 2011; see also Žižek 2006).

Concluding remarks

The model of the displacement of things I have outlined, drawing on ritual theory, has emphasized less the shift from one topographical place and social position to another and more the ceasing of full material, sensual involvement in social life that happens when an object crosses the threshold and leaves its familiar domain. This does not mean the object becomes inactive, but its transition to focal point in representational practice nonetheless fundamentally changes its relationships with other objects and persons such that this phase is both liminal and has the potential to continue indefinitely. However, just as the museum does not constitute a prolonged freeze frame in the lives of objects, neither does liminality comprise prolonged inactivity. Metaphor and the other processes of representation bring transformation, activity and connection, as well as stillness and loss. And even when an object leaves this liminal phase and is reincorporated into social life in a new way through brief, potent engagements with museum visitors, there is the likelihood that the object will slip back into liminality thereafter.

None of this means that the inbetween, the liminal, is a bad thing. Liminality has its own value and meanings. Indeed, as I intimated at the outset of this chapter, we need not think of the displaced, liminal object as *out* of place; displacement and being out of place are not, despite first appearances, necessarily synonymous. Of course, an artefact like the PRM bee is no longer in the place whence it originally came; we may even say it is not fully at home where it now finds itself. To be *out* of place, however, implies something different: it has connotations of rupture that has caused not only loss of connection to one's past place, but has also left one *without* place in the present. As attempting to imagine – and connect to the refugee experience – the perspective of the PRM bee demonstrates, however, this is not the case. Physical rupture from the past there may have been, but connections – material and otherwise – with it persist; moreover, in the now of the museum the object might be imagined to work to make this new environment as much its 'own place' as possible, just as refugees do in camps.

Kenneth Olwig suggests that a 'liminal temporal pause in space *creates* place' (2005: 265, emphasis added); that is, while encamped refugees and accessioned museum objects are alike displaced and inbetween, rather than out of place in the zones they end up in, they are active and agentive in creating both their own emplacement and in making these zones the distinctive places they are. The massed, solid presence of objects within institutional walls defines most museums; the same is true of refugees and bounded camps; and in both cases there is a kind of *communitas* in the experience shared by the displaced within the perimeters. As we have seen, both museum and camp are controlled by others and limit the extent to which their displaced occupants can fully assert themselves or participate is social life; but they are not non-places. Writing on the movement of the Israelites in and out of the desert, Lichtenberg-Ettinger and Rancière frame the desert 'as a space of indeterminacy where there is no "here" or "there"' (Robertson et al. 1994: 2). I would argue, however, that such spaces – including refugee camps and museums – are better understood as both 'here' and 'there' at once. For Israelites and Karenni refugees, this is because of their ongoing, active efforts to create and sustain continuity with the pre-exilic past and to aspire to an ideal future. For museum objects, it is a result of the connections with the past materially inherent within them and the ever-present possibility of reincorporation into full social life through an extraordinary encounter with a museum visitor. Different objects have different powers. Some attract the eye of many visitors, while others wait quietly in the shadows until someone happens to be intrigued by them.

So how might we conceptualize 'liminality' more broadly, and what potential value could this have for reflecting on museum practice? This chapter emphasizes the fluidity (and potential longevity) of the liminal phase, as, in different ways, do other writers (e.g. Dawson and Johnson

2001: 330). Dawson and Johnson also suggest that rather than seeing liminality as what lies in between, it may be better to perceive it as '*the awareness or realization* of the betwixt and between' (ibid., emphasis original). How might this apply to museum objects? Within the institutional walls, their changed status is made materially evident, as they are bagged, frozen, numbered, labelled, and stored or displayed, and no more handled or used in the ways to which they were previously accustomed. In our imaginations at least, from the object's perspective there may be a grasp of being inbetween. Certainly for refugees, arriving in a camp and undergoing registration, interviews, house allocation and so on, such cognizance is immediate; it is not necessarily wholly negative, however, but can also be transformative and productive, providing 'detachment, even vision and creativity – the poetics of exile' (Graham and Khosravi 1997: 115). This returns us to Turner's description of liminality as a subjunctive mood, an irrealis modality where reflections, desires and longings can come to the fore. The yearnings of those going through the liminal phase are likely to concern the reincorporated future as much as the pre-separation past. For museum objects, there is always the possibility – the hope – of reincorporation into social and material life, even if only transitorily, through powerful encounters with visitors. The liminality of these exiled things is characterized by this ever-present chance of coming to be 'at home'. This, and coexistence with other objects in a shared *communitas* of the displaced, are two key implications from this chapter for understanding the potential of museum objects and display. When things in museums remain, as so often, as representational objects alone they are marked off from the present (cf. McCarthy 2007: 6). Attempting in museum practice a thought experiment to understand the object's point of view enables productive reflections on object qualities and potencies – material and otherwise – and their possible impacts on visitors; returning to Bryant's notion of the democracy of objects, it also permits innovative insights into different ways of seeing and knowing. And ultimately, if the fluidity and richness of the liminal phase, and the moving and powerful collectivity of objects, can be understood and allowed to speak, then we may see new and exciting forms of democracy in the museum.

Notes

1 Accession number PRM 1889.29.54.
2 After removal from the throne, the bees were most likely sold by auction under the auspices of the Prize Committee set up by the British colonial authorities after the annexation of Mandalay. Led by Lieutenant Colonel W. T.

Budgeon, the committee operated for two years, and was required to oversee and account for the disposal of objects acquired in Mandalay in 1885 and immediately thereafter. However, as Daw Kyan points out, 'It is not unlikely that many "Prizes" were never mentioned in the official records and many others were not handed over to the Committee' (1979: 127).

3 http://collections.vam.ac.uk/item/O54089/camari-samari/, accessed 10 July 2014.

4 http://collections.vam.ac.uk/item/O54205/two-figures-of/, accessed 10 July 2014.

5 http://familytreemaker.genealogy.com/users/t/o/d/Guy-B-Tod/WEBSITE-0001/UHP-1372.html, accessed 18 November 2013.

6 http://web.prm.ox.ac.uk/sma/index.php/articles/article-index/394-1888-1889-ethnographic-acquisitions.html, accessed 18 November 2013.

7 http://bleedingthumb.blogspot.co.uk/2010/07/bee.html, accessed 20 March 2013.

References

Ankersmit, F. R. (2005) *Sublime Historical Experience*, Stanford, CA: Stanford University Press.

Boon, J. A. (1991) 'Why Museums Make Me Sad', in I. Karp and S. D. Lavine (eds), *Exhibiting Cultures: The Poetics and Politics of Museum Display*, 255–78, Washington, DC: Smithsonian Institution Press.

Bouttiaux, A.-M. (2012) 'Challenging the Dead Hand of the Museum Display: The Case of Contemporary Guro (Côte d'Ivoire) Masquerades', *Museum Anthropology* 35 (1): 35–48.

Bryant, L. R. (2011) *The Democracy of Objects*, Ann Arbor, MI: Open Humanities Press.

Burke, P. (2007) 'Cultures of Translation in Early Modern Europe', in P. Burke and R. Po-Chia Hsia (eds), *Cultural Translation in Early Modern Europe*, 7–38, Cambridge: Cambridge University Press.

Crimp, D. (1993) *On the Museum's Ruins*, Cambridge, MA: MIT Press.

Curtis, B. and C. Pajaczkowska (1994) 'Getting There: Travel and Time Narrative', in G. Robertson, M. Marsh, L. Tickner, J. Bird, B. Curtis and T. Putnam (eds), *Traveller's Tales: Narratives of Home & Displacement*, 197–214, London: Routledge.

Davis, J. (1992) 'The Anthropology of Suffering', *Journal of Refugee Studies* 5 (2): 149–61.

Daw Kyan (1979) 'Prizes of War, 1885', *Research in Burma History* 3: 127–43.

Dawson, A. and M. Johnson (2001) 'Migration, Exile and Landscapes of the Imagination', in B. Bender and M. Winer (eds), *Contested Landscapes: Movement, Exile and Place*, 319–32, Oxford: Berg.

Dudley, S. H. (2010) *Materialising Exile: Material Culture and Embodied Experience among Karenni Refugees in Thailand*, Oxford and New York: Berghahn.

Dudley, S. H. (2017) *Displaced Things: Loss, Transformation and Forgetting amongst Objects in Burma and Beyond*, London: Routledge.

Gosden, C. (1999) *Anthropology and Archaeology: A Changing Relationship*, London: Routledge.

Graham, M. and S. Khosravi (1997) 'Home Is Where You Make It: Repatriation and Diaspora Culture among Iranians in Sweden', *Journal of Refugee Studies* 10 (2): 115–33.

Greenblatt, S. (1991) 'Resonance and Wonder', in I. Karp and S. Lavine (eds), *Exhibiting Cultures: The Poetics and Politics of Museum Display*, 42–56, Washington, DC: Smithsonian Institution Press.

Malkki, L. H. (1995) *Purity and Exile: Violence, Memory, and National Cosmology among Hutu Refugees in Tanzania*, Chicago, IL: University of Chicago Press.

Ma Thanegi (2003) 'The Thrones of the Myanmar Kings', available online: http://www.myanmar-image.com/enchantingmyanmar/enchantingmyanmar2-2/thrones.htm (accessed 14 March 2013).

McCarthy, C. (2007) *Exhibiting Māori: A History of Colonial Cultures of Display*, Oxford and New York: Berg.

Olwig, K. R. (2005) 'Liminality, Seasonality and Landscape', *Landscape Research* 30 (2): 259–71.

Parkin, D. (1999) 'Mementoes as Transitional Objects in Human Displacement', *Journal of Material Culture* 4 (3): 303–20.

Rivers, J. E. (1987) 'Proust and the Aesthetic of Suffering', in B. J. Bucknall (ed.), *Critical Essays on Marcel Proust*, 119–33, Boston, MA: G. K. Hall.

Robertson, G., M. Marsh, L. Tickner, J. Bird, B. Curtis and T. Putnam (eds) (1994) 'As the World Turns: Introduction', *Travellers' Tales: Narratives of Home and Displacement*, 1–7, London: Routledge.

Seremetakis, C. N. (1994) *The Senses Still: Perception and Material Culture in Modernity*, Chicago, IL: University of Chicago Press.

Spivak, G. C. (1988) 'Can the Subaltern Speak?', in C. Nelson and L. Grossberg (eds), *Marxism and the Interpretation of Culture*, 271–315, Urbana: University of Illinois Press.

Turner, V. W. (1967) *The Forest of Symbols: Aspects of Ndembu Ritual*, New York, NY: Cornell University Press.

Turner, V. W. (1969) *The Ritual Process: Structure and Anti-Structure*, New York, NY: Cornell University Press.

van Gennep, A. (1909) *Les Rites de Passage*, Paris: Emile Nourry.

Žižek, S. (2006) *The Parallax View*, Cambridge, MA: MIT Press.

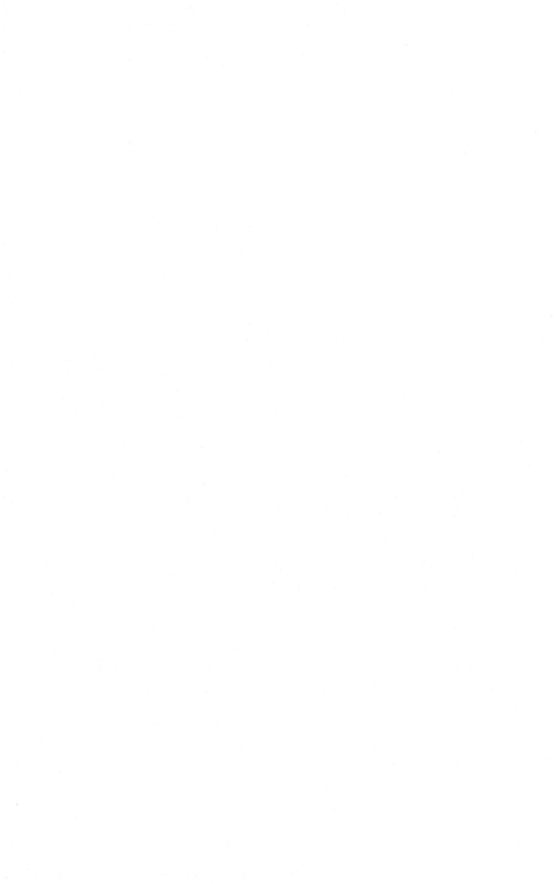

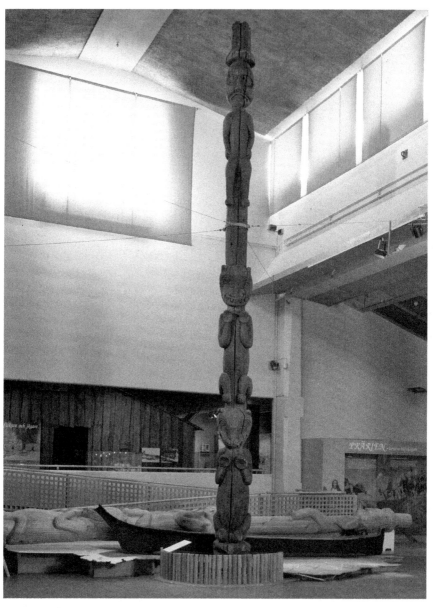

FIGURE 4.1 *The original and replica G'psgolox poles at the Swedish Museum of Ethnography, Stockholm, 2000. Photograph by Tony Sandin. Courtesy of Världskulturmuseerna, Sweden.*

4

Object and spirit agency: The G'psgolox poles as mediators within and between colonized and colonizer cultures

Stacey R. Jessiman

Introduction

The G'psgolox pole, a memorial pole removed in 1929 from traditional Haisla First Nation territory in British Columbia to the Swedish Museum of Ethnography in Stockholm, suffered a fate similar to that of many cultural objects removed from Canadian Indigenous peoples in the nineteenth and early twentieth centuries. Once sold or gifted to museums, such objects often were either kept hidden in storage or put on display as 'salvaged' remnants of dead or dying cultures (Ames 1992; McLoughlin 1999; Phillips 2011). By the later part of the twentieth century, however, representatives of indigenous communities that had survived government and church assimilation efforts began arriving at museums, demanding the objects' return. In the years of struggle that followed, the objects remained uncomfortably situated in between colonized cultures seeking means of righting colonial wrongs and reinvigorating cultural practices, and colonizer cultures that were in turn forced to examine their preconceptions, historic acts and museological practices.

Though difficult and painful, many of these object-human entanglements have also been transformative. Such is the case of the G'psgolox pole. On its rediscovery at the Swedish Museum of Ethnography by descendants of Chief G'psgolox sixty years after it was cut down by the Swedish Consul to British Columbia, the pole became an involuntary mediator in and between those colonized and colonizer cultures, bringing them together in complex, cross-cultural physical and psychological 'contact zones' (Pratt 1992; Clifford 1997) as they negotiated the pole's repatriation. Although that fifteen-year negotiation leading to the pole's repatriation to Haisla Nation territory in 2006, and its ultimate return to nature in 2013, caused conflict in and between the two cultures, the original pole and the replica pole that the Haisla people offered to the museum also spurred collaborative, enlightening, reinvigorating and healing entanglements (Figure 4.1).

This chapter analyses the position and power of the original and replica G'psgolox poles in and between the colonized and colonizer cultures, and the conflicts and transformations arising from those relationships. It also argues for consideration of the beliefs of many Haisla relating to the agency of the spirits associated with the original pole and its replica, which, according to those beliefs, not only affected those who came in contact with them, but were also affected themselves by those entanglements.

In order to provide context for my discussion of the agency of the G'psgolox poles and their spirits in affecting transformations in and between colonizer and colonized cultures, I first discuss the story of the original pole's removal and repatriation, a story that necessarily includes certain grim aspects of the encounters between those cultures on the Northwest Coast of Canada and of their entanglements with the pole.

The journey of the G'psgolox poles in and between cultures

The traditional territory of the Henaksiala or 'Kitlope' people, who in 1947 joined the Haisla or 'Kitimaat' people to form the Haisla Nation (to whom I refer collectively as the 'Haisla'), is the remarkable Kitlope Valley. Located 600 kilometres northwest of Vancouver, it contains the world's largest continuous tract of coastal temperate rainforest. Relying on natural resources for their subsistence fostered in the Kitlope people a deep-seated belief in their connectedness with the earth and its living beings and with the spirit world. Across Haisla Nation territory, spirit encounters are commemorated in various forms of cultural expression, including rock pictographs, dances, carved masks, house posts and totem poles.

The legend of this particular pole involves a hereditary Kitlope chief named G'psgolox wandering into the forest in a state of deep mourning following the death of his children and other members of his clan. There he encountered the spirit Tsooda, who, on learning of the chief's loss, advised him to bite into a piece of transparent crystal. When he did so, G'psgolox was reunited with his family and clan members as they descended alive from the trees where they had been interred, accompanied by Tsooda (Barbeau 1950: 476–7; Hume 2000; Bell et al. 2008: 380).

In 1872, Chief G'psgolox erected a pole to commemorate this event. The carvers he commissioned placed Tsooda, wearing a hat that revolves on his head, in the place of honour at the top of the pole, and below him Asoalget, another personified spirit with the paws of a bear. Below Asoalget was a mythical grizzly bear that lived under water, an important symbol of spiritual power in Haisla culture. Considered a semi-divinity, the grizzly bear forms a link between humans and the spirit world (Kramer 1995: 63; Greenfield 2007: 317). At the bottom was a frog. The pole was erected in Misk'usa, one of the four traditional villages of the Kitlope people, where for 57 years it 'acted as a portal to the world of water, air and earth, and stood as a gateway to the village' (Greenfield 2007: 317; Figure 4.2).

The pole's historical context involves devastating colonial human-human, human-object and human-spirit entanglements that deeply marked the Haisla. By the mid-nineteenth century, contact between Northwest Coast Aboriginal peoples and European and American traders had resulted in the rapid spread of diseases such as smallpox and influenza, against which local indigenous populations had no immunity (Fisher 1992: 115). A smallpox epidemic in the 1860s, for example, decimated the population of four Haisla villages, which plummeted from around 3,500 to just fifty-seven people (Bell et al. 2008: 380). At the same time, Christian missionaries were urging potential converts to give up their traditional ways, including their production of totem poles. Ceremonial regalia and other cultural objects, including totem poles, were often taken by missionaries for their private collections, sold to collectors or simply destroyed in bonfires, some totem poles being cut up as firewood (Stewart 1993: 20). According to the anthropologist John Pritchard, the Kitimaat people were subjected by missionary George Raley (1893–1907) to one of the 'sterner, more uncompromising missions, which may have accelerated abandonment of elements of their traditional culture' (Pritchard 1977: 2).

The Canadian government dealt a number of further blows to Haisla culture through legislation aimed at solving Canada's 'Indian question'. One such blow was its 1884 ban on holding or participating in a potlatch – the gift-giving ceremony central to west coast Aboriginal culture and society, during which rights are acknowledged, traditional knowledge is passed

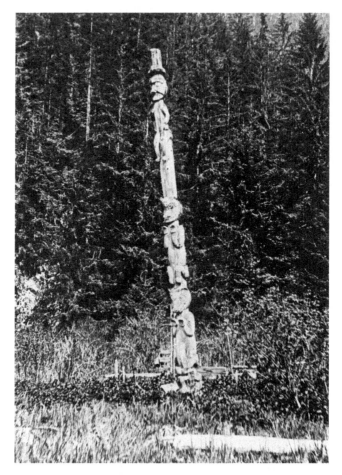

FIGURE 4.2 *The original pole at Misk'usa photographed by Olof Hanson in 1928. Courtesy of Världskulturmuseerna, Sweden.*

on to younger generations and significant events such as marriages, births and raising a totem pole are celebrated. Seeing the potlatch as an impediment to their attempts to 'civilize' Aboriginal peoples, missionaries on the Northwest Coast urged the government to outlaw the ceremony. Colonial government officials supported the idea, as they recognized the impossibility of converting to a Euro-capitalist way of life a people whose primary motive for collecting wealth was to give it away during a potlatch in order to garner esteem and perpetuate reciprocity as a societal precept. While some Haisla continued to potlatch despite the ban, Raley worked hard to realize the demise of the ceremony among the Kitimaat, including by helping to draft an 1893 edict stipulating that anyone who participated

in a potlatch would be fined $140, the equivalent of a season's salary at a cannery (ibid.: 200).

In 1894, the federal government augmented its assimilation efforts by passing legislation aimed at 'killing the Indian in the child' by enabling government officials to forcibly remove Aboriginal children from their families to Christian residential schools. For the next century, at church-run schools across the nation, Aboriginal children were prohibited from speaking their native languages and engaging in forms of Aboriginal cultural and artistic expression. Approximately 150,000 Aboriginal children attended the schools before the last one closed in 1996. Many were abused psychologically, physically and sexually and subjected to forced sterilization and medical experiments (Mosby 2013), while countless died from tuberculosis and unsanitary conditions (Bryce 1922).

At the residential school constructed on the Haisla Nation reserve, children were allowed to stay with their parents who lived in close proximity only on weekends and holidays. At approximately the age of 10–12, they were sent to Coqualeetza residential school near Vancouver, 500 kilometres from their homes, or to the equally distant residential school in Port Alberni on Vancouver Island. Renowned Haisla carver Henry Robertson recounts that when he was caught carving poles secretly at residential school '[the principal] got mad at me and slapped me around and told me I am not going to the school to learn to carve totem poles, the Indian ways, I am going to the school to learn the white man's ways' (*Totem* 2003).[1] Raley rationalized the residential school system as follows: 'If we want the future of the people to be Christian, the children must be removed from such demoralizing surroundings, into homes where they are under the constant influence of Christian teaching' (in Pritchard 1977: 205).

Thus, as a result of disease, missionary work and federal assimilation laws aimed at destroying Aboriginal cultures and identities, the people of the Haisla Nation and other coastal First Nations struggled to maintain their connections to their past and their future. Many carvers died without passing on their skills and knowledge to the next generation. Children, often kept apart from their families for extended periods, grew up afraid or unable to speak their native language, which was the main medium for passing on traditional knowledge in these oral-based knowledge systems. As James Clifford (1997: 125) recognizes, 'The punishments and loss of regalia dealt a severe blow to the traditional community: large-scale exchanges disappeared, and ceremonial life and social ties were maintained with difficulty in the face of socioeconomic change and hostility from government, missions and residential schools'.

Meanwhile, private collectors, anthropologists, archaeologists and other representatives of museums in Europe and North America were scouring British Columbia for cultural material, including masks, headdresses, rattles,

baskets, coppers and totem poles, as Aboriginal communities struggled to survive. As Hilary Stewart (1993: 21) notes, 'Between the 1870s and 1920s hundreds of poles were purchased or simply removed without permission or payment from villages that were seasonally vacant or thought to be abandoned'.

It was during the 1920s that Olof Hanson, the Swedish consul in British Columbia, was looking to acquire a totem pole for Sweden (Barbeau 1950: 477). At the time, many European museums had totem poles in their collections. In 1928, after several failed attempts by Hanson to secure a pole, the federal government granted his request for the G'psgolox pole on the basis that 'the Indian reserve is uninhabited and very isolated . . . and provided that the Indian owners are willing to dispose of it'.[2] The pole was then severed at its base and sent by Hanson as a gift to the Museum of Ethnography in Stockholm.

According to Louisa Smith, great-great-granddaughter of the chief who commissioned the pole, her ancestors discovered the totem pole's disappearance when they arrived in Misk'usa after a fishing trip. Smith, who helped negotiate the pole's repatriation, insisted that the pole 'was taken against the will of the family of G'psgolox' (Totem 2003). The museum claimed that Hanson negotiated the sale of the pole with the Kitlope people, although Hanson admitted after the pole was removed that at least one older member of the tribe had resisted the sale (Lindblom 1936: 138). The museum also admits that no documentary evidence of the date or terms of the sale exists (The Local Sweden 2005). Thus began the pole's journey as an involuntary mediator between colonized and colonizer cultures.

After the pole arrived in Sweden in 1929, it was erected in the open air for six months before being placed horizontally in an unheated storeroom for forty-five years when the museum moved to new premises. In 1975, the pole underwent conservation work to deal with the effects of dry rot, and in 1980 was re-erected in a climate-controlled hall built especially to house it at the new Museum of Ethnography. During the subsequent two decades, according to Karin Westberg, an education officer at the museum, the pole became one of its most cherished treasures (Totem 2003) – an awkward role for a pole whose removal and absence had remained a source of grief for the Haisla.

Indeed, during its absence, Louisa Smith says Elder Cecil Paul Sr 'kept hearing our grandmother's voice to keep your ears open for the whereabouts of the old pole' (Blouinartinfo.com 2006). In the early 1980s, just after the pole was moved into public view at the new Museum of Ethnography, Cecil Paul Sr. began a search for its whereabouts. Eventually, using photographs of the pole taken in situ at Misk'usa by the early twentieth-century photographer Frank Swannell, he was able to confirm the pole's location.

In 1991, a delegation that included Louisa Smith, Haisla Chief Councilor Gerald Amos and anthropologist John Pritchard travelled to Stockholm to discuss the Haisla's repatriation claim with the museum. The three Haisla representatives, wearing their ceremonial button blankets, were taken to see the pole. On seeing the pole, held erect by a system of metal wires attached to a yoke, they wept openly. Vowing to free the pole from shackles that served as a painful reminder of the Haisla's history of colonial oppression, Mr Amos remembers realizing that 'this is one of the symbols that could heal the people, and Lord knows there is a lot of healing to do' (*Totem* 2003).

Despite disagreement between the parties regarding who had valid title to the pole, Per Kaks, director of the Museum of Ethnography between 1991 and 2002, says he soon realized that repatriating the pole 'wasn't a legal discussion, it was an ethical discussion, [namely,] who has the better use of it, and for whom does this pole mean something' (*Totem* 2003). The pole and its meanings prompted Kaks to visit the Haisla in Kitimaat Village in 1992, a trip that provided an important opportunity for the Haisla to air their feelings that the pole had been stolen, and for Kaks to get to know the Haisla in their own context. According to Kaks, 'they were very good hosts. They took me in a helicopter up the Valley and landed on the spot where the pole had been. I saw a lot of fantastic things on that trip and became very good friends with them'. Kaks also came to understand part of the Haisla's motivation in seeking the pole's return, namely, that 'they wanted to have an object around which they could gather the youngsters'.[3] Back in Sweden, the old pole then offered further teaching opportunities about Haisla history and culture. For example, when a museum staff member asked Chief Councillor Amos why the Haisla did not just carve a new pole, instead of taking back the old, weathered pole, Mr. Amos replied, 'We are struggling to bring back some of our history so that our people understand where we came from.'[4]

The pole also prompted the Haisla to make a number of constructive, empathetic gestures that resulted in the museum recommending to the Swedish government that the pole be returned. First, they acknowledged that the museum had been designed around the pole and that the Swedish people had an attachment to it. As Karin Westberg explained, 'People have spent years and years looking after it and preserving it. So this is a very complex project, it has a long, long history and it contains a lot of opinions and emotions. And it's very, very difficult and complex' (*Totem* 2003). The Haisla also emphasized that they believed that the museum (as opposed to Olof Hanson) received the pole in good faith, and then offered to make a replica pole in exchange for the original. The museum was enthusiastic about the idea and, in 1994, the Swedish government granted permission for the

totem pole to be presented as a gift to the Haisla Nation Council, at the same time directing the museum to ensure that the Haisla would preserve the pole in a climate-controlled facility on its return.

The offer of a 'gift' did not sit well with the Haisla, however, as they viewed the pole as stolen treasure. In addition, the preservation condition posed serious financial and cultural challenges for the Haisla, while prompting articulation of some key differences in the cultural values of the museum and the Haisla that were difficult to reconcile. The museum worked to explain to the Haisla its desire that the pole be preserved and seen by future generations, saying, 'This is our profession, to keep things alive' (Per Kaks, *Totem* 2003). That cultural value helps explain the museum's vision of the pole as belonging not *only* to the Haisla. As Per Kaks stated, 'I wanted to give it back. The only condition we had, having kept the pole for so many years and tried to make it survive . . . was that together we could look upon the pole as the property of mankind. I would be unhappy if they put it back according to their traditions because it wouldn't survive' (ibid.).

According to Haisla tradition, however, totem poles are meant to fall naturally to the ground and decompose. Carved from red cedar trees, typically they will stand for between just sixty and eighty years. Then, as hereditary Chief G'psgolox Dan Paul Sr. has explained, 'If it falls you don't lift it, you let it go back to Mother Earth' (*Totem* 2003). Thus, *re-erecting* the pole in a museum was out of the question for the Haisla. The issue then became whether they could accept to display it in a purpose-built facility lying down. Henry Robertson, the grandson of one of the original pole's carvers, said, 'My father told me, when the pole comes back from Sweden, take the old pole up to Misk'usa and leave it there, lay it on the ground and let it go back to Mother Nature where it came from' (*Totem* 2003). Haisla Elder Louise Barbetti acknowledged that it was painful to think of placing it in a museum (*Totem* 2003). Gerald Amos believed, however, that building a new facility was important to the community for several reasons, particularly righting colonial wrongs:

> There are very few First Nations' artifacts left in British Columbia – they are in museums all over North America and our kids can't see them . . . We think if we build the center we can begin the process of healing between our community and the Canadian government and public (Ecotrust Canada 2004).

Louisa Smith similarly recognized that displaying the pole could be helpful for informing Haisla children about their ancestors: 'I really wanted the old pole to be a teaching tool . . . It holds the invisible umbilical cord to our ancestors. And if we were to take the old pole and put it in a museum our children

could see and observe it first hand, and understand the history of our people' (*Totem* 2003).

Ultimately, a decision was taken to place the pole horizontally indoors and use it as a means of cultural education and revival. But that decision caused grief to certain Haisla. Elder Cecil Paul Sr. explained:

> Our culture is that when it falls let it go, Mother Earth will cover it. When that thing is no longer there, then a new one will come. So in my journey . . . I have a heaviness. I have broken that. I have now agreed we will put it in a museum, the white man way of thinking (*Totem* 2003).

Despite painful conflict within their community, the Haisla decided to act in accordance with their traditional law (*nuyem*) that privileges relationship building and sharing, and maintained their offer of a carved replica. For the Haisla, the offer was more than a negotiating tactic. As Gerald Amos said to the Haisla, 'If we rip that totem pole out of there and we don't leave anything behind, we will be doing the same thing [they did]. And I think if we do this properly, and engage in a real relationship building exercise, who knows what the possibilities are in the future.'[5] Beginning in May 2000, renowned Haisla carver Henry Robertson, his nephews Derek and Barry Wilson, and granddaughter Tricia Wilson, began to carve two replica poles, one to be sent as a gift to Sweden and the other to be erected at Misk'usa. Thus, while spurring divergences, controversies and frustration within and between cultures, the original pole had also helped the Haisla and Swedish peoples slowly deepen their relationship with each other as they worked through their conflicts. Then, later in 2000, the original and replica poles entered a new, highly dynamic and productive phase as mediators.

In August 2000, one of the replica poles brought together 200 guests of the Haisla Nation, including Olof Hanson's daughter, for a formal ceremony to celebrate the pole's erection at Misk'usa. In September 2000, the other replica pole brought the Haisla carvers to Sweden so that they could continue their carving work near the original. They spent the next two months finishing the replica pole in front of visitors to the museum, sharing with them their beliefs, their repatriation story and their pride in their culture. One visitor told the carvers, 'I want to say I feel that it is very generous of you to make such a thing for us, and give us a hint of your history and of your beliefs' (*Totem* 2003).

Per Kaks has commented on how this was a critical phase in the Swedish peoples' deepening relationship with and comprehension of the Haisla people and their culture: 'It's very important to be able to tell this story, especially to the children, because they have this vulgar idea that totem poles were something where you tied up the enemies and threw axes at them' (*Totem* 2003). Kaks also acknowledged that 'one of the goals of giving the pole back

was to build up a live contact with the Kitimat group . . . on a human basis. It's not just that we give back something, but we have a lot of things coming back to us – their experience, their knowledge, their thoughts and their friendships' (*Totem* 2003).

Carver Derek Wilson echoed that sentiment when he told a crowd of visitors gathered to witness the carving of the replica:

> We believe in sharing . . . Share with you our happiness and at the same time, share with you our pain and suffering . . . Sadness in effect that what has happened to our people is represented by what you see up there. And happiness at the same time, to see that our people are finally being recognized as human beings, finally recognized as people, not objects of archaeology or objects of anthropology. New history, that [replica] pole is creating (*Totem* 2003).

Unfortunately, the Haisla carvers had to return to Canada without the original pole, as they still lacked the funds needed to build a facility to house it and cover other repatriation costs, including shipping it home. Louise Barbetti, a member of the Pole Repatriation Committee, expressed her frustration, saying, 'I really feel that the Swedes need to do more to help us bring the pole home. We didn't give the pole away. The pole was taken from where it was originally. And for the Swedes to be waiting for us to finance this, that's very wrong' (*Totem* 2003).

Disappointed but resourceful, the Haisla raised funds from private foundations and individuals to assist with repatriation costs (*Native News North* 2004; Bell et al. 2008: 381). The release in 2004 of Gil Cardinal's documentary film, *Totem*, recounting the pole's unfinished repatriation story provoked a flurry of international interest. A Swedish/Norwegian transport company then offered to ship the pole to the west coast of Canada. Finally, in 2006, a fifteen-member Haisla delegation travelled to Sweden to participate in traditional ceremonies accompanying the raising of the replica pole outside the museum. Three hundred Swedes then joined the Haisla to see the original pole, packed in a special padded case built and paid for by the museum, leave on its journey home via the Panama Canal. The poles prompted not only significant media attention but also a constant stream of museum visitors wanting to see the replica pole and learn about Haisla culture and the repatriation story.

Six weeks later, Anders Björklund, Per Kaks's successor as director of the Museum of Ethnography, flew to Vancouver to witness the original pole's arrival. Gerald Amos told the crowd gathered at the University of British Columbia Museum of Anthropology (MOA) to witness the historic event, 'We are here today to recognize the friendship that has evolved between the Haisla and the

Museum. I've always maintained that our mission must be to create better stories together. Stories that we can be proud of together. Stories we can tell our children' (*Totem* 2007). For the next two months, the pole remained at MOA, encouraging discussions of the importance of repatriation to Aboriginal peoples and other ways to achieve reconciliation between Aboriginal and non-Aboriginal peoples in Canada (*Totem* 2007).

In July 2006, neighbouring First Nations came to help the Haisla celebrate the pole's homecoming to Haisla territory. Subsequently, the pole was moved to the Kitimat City Center Mall, where local Aboriginal and non-Aboriginal populations meet on a daily basis. Prominent Haisla author Eden Robinson explains how the decision to house the pole at the mall was made:

> Some from our community had wanted the pole to be temporarily housed [at MOA] until we can raise enough funds to build a cultural centre on our reserve (sometime in the next three to five years, we hope). But other members, especially those on the influential Totem Pole Committee . . . had insisted that G'psgolox come home after 77 years of exile and rest as near as possible to its traditional territory. The mall was an uneasy compromise (Robinson 2007).

In this new cross-cultural contact zone, the pole again acted as mediator within and between cultures, recounting to all the story of its creation, its journey to a distant land and the persistence of those who worked to bring it home, while providing a means for Haisla Elders to pass on their traditional knowledge to Haisla children eager to learn about their culture and history.

In 2012, however, the pole again became a fulcrum of debate among the people of the Haisla Nation. As the health of hereditary Chief G'psgolox Dan Paul Sr. declined, he and others who were concerned that the spirits of the old pole were unhappy with the decision not to respect tradition lobbied to return the pole to Mother Earth. Other Haisla, however, including renowned Haisla artist Lyle Wilson, the nephew of Dan Paul Sr., argued in favour of continuing to preserve the pole:

> I've spent almost 30 years tracking down and studying old Haisla artifacts – I know how rare they are. Words, photographs, even three-dimensional computer scans cannot take the place of real objects. These old objects are like roots that reach out from the past to help anchor us in today's complex world. They transcend time and form our collective history and identity . . . If that pole is allowed to disintegrate at Kitlope my generation will lose another part of our historical identity (Wilson 2012).

One problem, however, was that the community had not yet been able to construct a cultural centre to house the pole, and, ultimately, the old pole was transported back to traditional Kitlope territory several hours from Kitimaat Village, where it now rests, exposed to the elements. While the decision caused distress to certain Haisla, according to Louisa Smith, it was made in order 'to do what is right in the eyes of our customs, our culture, that the pole belongs to G'psgolox. Today, the circle is complete' (McFarlane 2012).

The story of the journeys of the G'psgolox pole and its replicas is thus a hybrid of painful, frictional, educational, transformative and healing elements. To facilitate analysis of these complex elements, and of the pole's position and power in their story, I briefly consider how various scholars have discussed objects and their power. I then propose a framework for understanding the beliefs of certain Haisla in the agency of the spirits associated with the poles.

The power of objects

Writings by scholars regarding the impact of objects on humans interacting with them – causing them to behave in certain ways and construct social relationships around them – provide a framework for understanding how the original and replica G'psgolox poles have affected the Haisla and Swedish peoples, and have been affected themselves, as they have journeyed between and within cultures.

For example, Bruno Latour's description of Actor Network Theory (2005) helps us understand how the poles-as-mediators constructed and affected social relationships *between* the colonized and colonizer cultures, while forging relationships themselves *with* those parties. Indeed, while the poles caused the Swedish Museum of Ethnography to serve as a 'contact zone' (Pratt 1992; Clifford 1997), where colonized and colonizer cultures could 'come into contact with each other and establish ongoing relations' (Clifford 1997: 192), the original and replica poles also functioned as contact zones themselves, as 'sources of knowledge and as catalysts for new relationships' (Peers and Brown 2003: 5).

Further, Alfred Gell's theory (1998) that cultural objects can prompt viewers to react as if the objects were living beings and develop emotional relationships with them can help explain the Swedish people's feeling of attachment to the original pole. In addition, as explored below in my discussion of spirit agency, the emotional reactions of certain Haisla to the poles and their journeys reflect their belief that the spirits associated with the pole *are* literally alive.

Indeed, understanding the G'psgolox poles' inbetweenness, and the various human-human, human-object, object-spirit and spirit-human entanglements

that the poles prompted, also requires considering the ontologies of certain Haisla involved in the entanglements, particularly their beliefs regarding what I term 'spirit agency'. According to them, the spirits associated with the poles had an impact on and were affected by the various inter- and intra-cultural relationships in the poles' repatriation story. I detail below relevant explanations of the beliefs of carvers and certain other Haisla community members involved in the repatriation effort.

Spirit agency

The ontologies of many cultures embrace an understanding that spirits associated with cultural objects have agency – in other words, that while humans (or nature) may have had a role in creating an object in which spirits become embedded or associated, and while such spirits may alter or be altered by human interaction during their sojourn, those spirits also have an existence independent of human interaction, and may precede and succeed the objects themselves (Brown 2001: 62). This is not the same as Martin Holbraad's concept of things 'speaking for themselves' while being circumscribed by human-oriented agendas (2011: 21). Rather, certain peoples believe that things-within-things (i.e. spirits) speak for or act/react by themselves and in doing so affect peoples' behaviour. Haidy Geismar (2011: 215) argues that objects can transcend their context. Some peoples believe spirits can do the same thing.

Haida lawyer gii-dahl-guud-sliiaay (Terri-Lynn Williams) explains that many Canadian First Nations 'recognize that cultural objects possess their own spirits and the creator of these objects is only a medium through which our ancestors speak . . . Upon their creation, (and conceivably prior to their physical creation) ceremonial cultural objects such as Northwest Coast masks, rattles, dance blankets and regalia possess an independent "life"' (1995: 185–6). Eduardo Viveiros de Castro's (1998) description of 'perspectivism' in some Amerindian cultures provides a useful point of comparison with Northwest Coast beliefs concerning what I term 'spirit agency'. According to Viveiros de Castro, those Amerindian cultures' understanding of human and non-human existence involves acceptance that humans, animals and spirit beings each apprehend reality and each other from their own perspective, that is, in their own distinct and sometimes even similar ways. Thus, a spirit may perceive itself as an anthropomorphic being with an organized social system resembling that of humans (ibid.: 470).

Similarly, certain Haisla believe that spirits have an existence independent of any object with which they may be affiliated, and can interact with humans,

sometimes inflicting suffering if not treated properly. Anthropologist Jay Powell, in his study of Haisla beliefs, co-authored with numerous Haisla peoples, describes how 'the folk history of Kemano traditional territory maintains a tradition of close contacts between the everyday world and the spirit world, as the people perceive it' (2011: 173). Crosby Smith confirms that 'we Kemano people feel that we are somehow in touch with each other through the spirit world' (ibid.: 174). Powell (2011: 198) goes on to explain how in traditional Haisla belief 'there is a causative spiritual relationship between individuals doing the right thing (protecting, avoiding waste and being grateful) and having good outcomes'. Thus spirits, if offended, 'can cause the animals and fish to withhold themselves and cause even the lucky and talented hunter, fisher or trapper to get skunked', and moreover, 'if offended by a single individual, family, clan or non-Haisla business group, could exact retribution against the entire Haisla tribe' (ibid.: 27). This belief in spirit agency had a profound effect on many Haisla peoples' search for the old pole, their efforts to repatriate it and the importance they placed on its ultimate return to nature.

The G'psgolox poles and their spirits

Although the old G'psgolox pole and its spirits ultimately brought about numerous transformations as mediators within and between cultures, it should be remembered that the old pole and its spirits did not adopt those roles voluntarily. Indeed, throughout the repatriation negotiations, many Haisla, including Gerald Amos, Louisa Smith and carvers Henry Robertson and Derek Wilson, made clear that they believed that the spirits in the old pole were unhappy in their forced exile in Sweden and were waiting to return home. Many Haisla pointed out that the old pole was never intended for travel – it was meant to stay in situ and eventually fall to the ground and decay – and that because it memorializes ancestors, its return home was especially important to them. As hereditary Chief G'psgolox Dan Paul Sr. pointed out, 'The pole is not decoration; it was on top of a grave' (*Totem* 2003). Louisa Smith added, 'In order for our ancestors to rest peacefully everything must be in place' (ibid.).

Instead, the pole had been severed at its base and transported to a foreign country, where it endured a long period of confinement, estrangement and misinterpretation. Indeed, in 1929, when the G'psgolox pole arrived in Sweden, totem poles were viewed as symbols of a 'dead' culture that had been overcome by a superior, civilizing force. They were tangible evidence of the 'us/them', 'present/past', 'modern/primitive' dichotomies that dominated colonial (and anthropological) thinking at the time. During the subsequent forty-five years, the pole was treated with corresponding disregard, kept

locked in storage away from the view of visitors. Eventually, however, the old pole experienced – and itself prompted – rediscovery and rebirth. Sixty years after its removal, 'colonizer' and 'colonized' came face to face again in a new contact zone, and the old pole forced them to make an important cross-cultural journey in which they came to better understand each other's histories, cultural practices and traditions.

The spirits associated with the old pole were seen as having agency in that process. While working on the replica at the museum in 2000, carver Derek Wilson explained to the Swedish museum visitors that 'when the old pole comes back to our territory, it will bring back the spirit of our ancestors'. In 2006, Gerald Amos reminded those who had assembled to watch the old pole depart from Sweden that 'the spirits of our ancestors are waiting and will be very pleased when this totem pole comes home to where it belongs' (*Totem* 2007). On its return home, he stated, 'I believe it was the guidance and wishes of our ancestors that have helped us finally achieve what most thought was impossible' (Na na Kila Institute 2006).

The journey of the original G'psgolox pole back home spurred further complex moments, however. The fact that the old pole lay on its back in a local mall for six years after its repatriation caused distress to certain descendants of Chief G'psgolox who had commissioned the pole, since its placement violated the tradition of letting totem poles fall to the ground to complete their natural cycle. At the same time, however, the pole acted as a connectivity tool, teaching younger generations about the spirit world and their traditions, while reinforcing to them the strength of their culture and identity. Ultimately, however, mediating the gap between generations caused by colonialism proved to be an untenable position, and the pole was returned to nature – an event that reminded the Haisla of the complexities of carrying on traditions while dealing with the ongoing effects of colonial oppression on their community.

Certain Haisla believe the pole is now where it should be, and that the spirits are pleased. One could certainly argue that, although it is no longer viewable by all Haisla, by returning to nature the old pole continues to act as a teaching tool, reinforcing to all Haisla the age-old ways of understanding spiritual and cultural renewal. As Cecil Paul Sr. has said, 'As old poles fall, then new ones spring up in their place' (*Totem* 2003). Those replica poles, one in Misk'usa and one outside the Museum of Ethnography in Stockholm (Figure 4.3), carry on the work of the old pole, mediating within and between cultures.

On the other hand, the current locations of the original and replica poles are somewhat inaccessible to many Kitlope and Kitimaat people, who have been living together as the Haisla Nation in Kitimaat Village since population decline forced movement and amalgamation of the tribes. Misk'usa, where

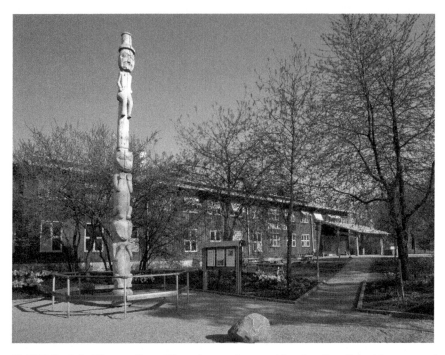

FIGURE 4.3 *The replica G'psgolox pole outside the Swedish Museum of Ethnography, Stockholm, 2011. Photograph by Tony Sandin. Courtesy of Världskulturmuseerna, Sweden.*

one replica pole now stands, is a four-hour boat journey from Kitimaat Village, while the flight to Stockholm, where the other replica is located, is long and expensive. Moreover, the replica pole in Sweden seems awkwardly placed between worlds. Erected outside the Museum of Ethnography, it seems somehow lost in its paved, urban setting. Like Hinemihi, the Maori *whare nui* that was relocated to Clandon Park in England, 'the ground on which she stands is alien ground in a foreign country' (Hooper-Greenhill 1998: 136). Still, the replica pole does stand in the open air outside the museum, exposed to the elements while it speaks its truths about loss and survival, as the original G'psgolox pole did for fifty years in Misk'usa, and as the second replica pole now standing in Misk'usa continues to do in its place.

One wonders whether the reality of colonial disruption of Haisla Nation peoples' cultural practices means that they should consider, at least in the short term, interim solutions for preserving ancient cultural objects in order to help ensure cultural reinvigoration. That this is a subject of discussion, however, is a painful reminder that colonialism is still causing harm on the Northwest Coast of Canada.

Still, it remains true that the original and replica G'psgolox poles and the spirits associated with them have successfully acted as multifaceted mediators within and between colonized and colonizer cultures, helping those cultures acknowledge and work through the difficult aspects of their entanglements, including ontological divergences about the role of cultural objects. By forcing the cultures to confront and discuss these issues, the poles and spirits helped colonizer and colonized to transform their views of themselves and each other and forge an enduring cross-cultural relationship. Indeed, one important product of this process was an equalization of power, including a correction of the misperception that Haisla culture was dead and that museums are best placed to preserve it. As James Clifford reminds us:

> It has become widely apparent in the dominant culture that many Native American populations whose cultures were officially declared moribund, who were 'converted' to Christianity, whose cultural traditions were 'salvaged' in textual collections such as that of Boas and Hunt, whose 'authentic' artifacts were massively collected a century ago, have not disappeared (1997: 145).

The story of the G'psgolox poles confirms Clifford's analysis as well as his prediction that 'master narratives of cultural disappearance and salvage could be replaced by stories of revival, remembrance, and struggle' (1997: 108–9). In their roles as mediators between cultures across distance and time, and between humans and the spirit world, the poles and the spirits associated with them took part in the Haisla peoples' resistance efforts by not only fostering the survival of Haisla culture and identity, but also forcing the Swedish people to re-examine their presumptions about the Haisla peoples and indigenous cultures.

Ultimately, then, the story of the G'psgolox poles teaches us that fully understanding the agency of those objects and the spirits associated with them, as well as the conflicts and transformations they experienced and brought about as mediators within and between colonized and colonizer cultures, requires careful consideration of the distinct histories, beliefs, values and perspectives, and sometimes difficult modern realities, of the peoples and cultures with which they interact.

Notes

1 I acknowledge the significant value to my research of Gil Cardinal's two films on the G'psgolox poles, *Totem: The Return of the G'psgolox Pole* (2003) and *Totem: Return and Renewal* (2007). I am also grateful to Gerald Amos,

Lyle Wilson, Anders Björklund and Per Kaks for sharing their knowledge and perspectives.
2 Letter from the Deputy Superintendent General to Iver Fougner, 11 January 1928. Library and Archives Canada, Public Archives, RG10, Vol. 4087, File 507,787-2B.
3 Interview with Per Kaks, 21 April 2011.
4 Interview with Gerald Amos, 6 April 2011.
5 Ibid.

References

Ames, M. (1992) *Cannibal Tours and Glass Boxes*, Vancouver: University of British Columbia Press.
Barbeau, M. (1950) *Totem Poles: According to Location*, vol. 2, Ottawa: National Museum of Canada.
Bell, C., G. Statt, M. Solowan, A. Jeffs and E. Snyder (2008) 'First Nations Cultural Heritage: A Selected Survey of Issues and Initiatives', in C. Bell and V. Napoleon (eds), *First Nations Cultural Heritage and Law: Case Studies, Voices and Perspectives*, 367–414, Vancouver: University of British Columbia Press.
Blouinartinfo.com (2006) 'Canadians Rejoice over Return of Totem Pole from Sweden after 77 Years', available online: www.artinfo.com/news/story/15287/canadians-rejoice-over-return-of-totem-pole-from-sweden-after-77-years/?page=1 (accessed 3 November 2013).
Brown, J. E. (2001) *Teaching Spirits: Understanding Native American Religious Traditions*, Oxford: Oxford University Press.
Bryce, P. (1922) *The Story of a National Crime: Being an Appeal for Justice to the Indians of Canada*, Ottawa: James Hope.
Clifford, J. (1997) *Routes: Travel and Translation in the Late Twentieth Century*, Cambridge, MA: Harvard University Press.
Ecotrust Canada (2004) 'Canadian Indians Want Totem Pole Back from Sweden', available online: www.ecotrustcan.org/canadian-indians-want-totem-pole-back-sweden (accessed 3 November 2013).
Fisher, R. (1992) *Contact and Conflict: Indian-European Relations in British Columbia, 1774–1890*, 2nd ed., Vancouver: University of British Colombia Press.
Geismar, H. (2011) '"Material Culture Studies" and Other Ways to Theorize Objects: A Primer to a Regional Debate', *Comparative Studies in Society and History* 53 (1): 210–18.
Gell, A. (1998) *Art and Agency: An Anthropological Theory*, Oxford: Oxford University Press.
gii-dahl-guud-sliiaay (Terri-Lynn Williams) (1995) 'Cultural Perpetuation: Repatriation of the First Nations Cultural Heritage', *UBC Law Review*, special edition, 183–201.
Greenfield, J. (2007) *The Return of Cultural Treasures*, 3rd ed., Cambridge: Cambridge University Press.

Holbraad, M. (2011) 'Can the Thing Speak?' (Working Papers Series #7), *Open Anthropology Cooperative Press*, available online: http://openanthcoop.net/ press/2011/01/12/can-the-thing-speak/ (accessed 13 June 2016).

Hooper Greenhill, E. (1998) 'Perspectives on Hinemihi: A Maori Meeting House', in T. Barringer and T. Flynn (eds), *Colonialism and the Object: Empire, Material Culture and the Museum*, 129–43, London: Routledge.

Hume, S. (2000) 'Return of the Spirit Pole', *The Vancouver Sun*, available online: http://indian.malmborg.info/stammar/haisla/000605.htm (accessed 17 November 2014).

Kramer, P. (1995) *Totem Poles*, Canmore: Altitude Publishing Canada.

Latour, B. (2005) *Reassembling the Social: An Introduction to Actor-Network-Theory*, Oxford: Oxford University Press.

Lindblom, G. (1936) 'A Kwakiutl Totem Pole in Sweden', *Ethnos* 1 (6): 137–41.

McFarlane, W. (2012) 'A Monument Returned: An Earth Shaking Event', *Kitimat Daily*, available online: www.kitimatdaily.ca/go6544a/A_MONUMENT_ RETURNED_AN_EARTH_SHAKING_EVENT (accessed 3 November 2013).

McLoughlin, M. (1999) *Museums and the Representation of Native Canadians*, New York: Garland.

Mosby, I. (2013) 'Administering Colonial Science: Nutrition Research and Human Biomedical Experimentation in Aboriginal Communities and Residential Schools, 1942–1952', *Histoire Sociale/Social History* 46 (1): 145–72.

Na na Kila Institute (2006) 'The Haisla Prepare to Welcome Their Totem Pole Back Home', available online: www.turtleisland.org/culture/culture-haisla.htm (accessed 30 October 2014).

Native News North (2004) 'Urgent Request for Haisla First Nation', available online: https://groups.yahoo.com/neo/groups/NatNews-north/conversations/ topics/6268 (accessed 30 October 2014).

Peers, L. and A. Brown (eds) 2003. *Museums and Source Communities: A Routledge Reader*, London: Routledge.

Phillips, R. B. (2011) *Museum Pieces: Toward the Indigenization of Canadian Museums*, Montreal: McGill-Queen's University Press.

Powell, J. (2011) 'Stewards of the Land', available online: www.ceaa-acee.gc.ca/ 050/documents/p21799/80479E.pdf (accessed 5 September 2014).

Pratt, M. L. (1992) *Imperial Eyes: Travel Writing and Transculturation*, London: Routledge.

Pritchard, J. (1977) 'Economic Development and the Disintegration of Traditional Culture among the Haisla', PhD dissertation, University of British Columbia, Vancouver.

Robinson, E. (2007) 'G'psgolox at the Mall', available online: http:// mediacentre.canada.travel/content/feature/gpsgolox (accessed 3 November 2013).

Stewart, H. (1993) *Looking at Totem Poles*, Vancouver: Douglas & McIntyre.

The Local Sweden (2005) 'Swedish Museum Returns Totem Pole to Canadian Tribe', available online: www.thelocal.se/20051118/2527 (accessed 30 October 2014).

Totem: The Return of the G'psgolox Pole (2003) [Film], Dir. G. Cardinal, Canada: National Film Board.

Totem: Return and Renewal (2007) [Film], Dir. G. Cardinal, Canada: National
 Film Board.
Viveiros de Castro, E. (1998) 'Cosmological Deixis and Amerindian
 Perspectivism', *Journal of the Royal Anthropological Institute* 4 (3): 469–88.
Wilson, L. (2012) 'The G'psgolox Pole', unpublished article.

Masquerades and mediation

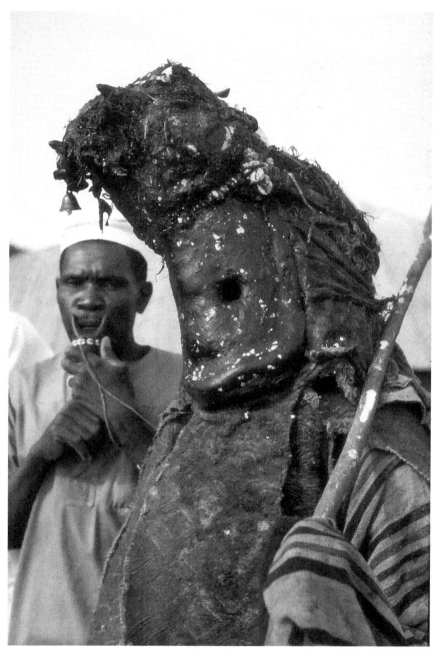

FIGURE 5.1 *Onogidi and one of his flute players, June 1966. Photograph by John Picton.*

5

At the centre of everything? A Nigerian mask and its histories

John Picton

This chapter is about a masquerade of the Ebira-speaking people in the village of Kuroko in the south-western region of Kogi State, Nigeria (see also Picton 2011a, 2011b). There are some things that are entirely unique to this particular masked performance (Figure 5.1), such as its name, Onogidi, and the histories entailed therein. The literal meaning of *on'ogidi* is 'inhabitant of' or 'person from' Ogidi, a village in the Ijumu-Yoruba region about twenty miles north-west of Kuroko. Other things about Onogidi are generic to a particular class of Ebira masquerade, and some things again generic to masquerade as a dominant element of Ebira social practice; and in filling in the details what we shall find is a seemingly paradoxical context wherein an artefact so inextricably male gender-based proved to be at the centre of so many interdependent networks of 'ideas-and-practices'. Perhaps this was because Onogidi was, in itself, an inbetween thing, neither one thing nor another. In its proven ability to entertain, to heal and sometimes to frighten the life out of the unwary, Onogidi put before the people of Kuroko a practical demonstration of their inheritance of lineage values, traditions of practice and ritual presuppositions, such that this inbetween thing at the centre of everything was also emblematic of those values, traditions and presuppositions.

In describing Onogidi as both 'emblematic' and as 'inbetween', and in assessing these terms, I do not see their difference as an either/or matter. The whole point of this account of Onogidi is to show how Onogidi can be understood as a form of synecdoche – that is, Onogidi as a sign of the whole, that 'whole' being the complex context of ideas-and-practices summarized in the ethnographic account that I present. At the same time, Onogidi as 'inbetween' is about the manner in which the parts within that complex of ideas-and-practices were ordered and articulated. Onogidi stood between people (supplicants, diviners, owners, performers; the overt authority of men, the covert power of [some] women; the people who made this, the people who made that; this lineage, that lineage; 'ourselves', those with whom we feud and/or trade) and between differing conditions of being and time (afflicted, healed; past, future; knowledge, forgetfulness), while also being emblematic of these events and their histories. Of course, for those who take no interest in masked performance and, for whatever reason, have no connection to it, these propositions might seem preposterous; but to have no interest, whether direct or indirect, in masquerade was not how Ebira people were!

Meeting Onogidi

I first encountered Onogidi in December 1965. I had been taken to meet Anako, an irascible old man, one of the Elders of the Anuhwami lineage that dominated Kuroko. We sat in his *abara*: the room where he slept, ate, sacrificed, castrated his dog, met people who came to see him and so forth. A brass bell hung over the doorway to the room. (I would later be told that just as nothing can stop a bell from ringing, so nothing could ever put an end to the household; for this reason, bells of various shapes and sizes were often among the accoutrements of masquerade performers.) Within Anako's room there was a mud shelf in one corner with a stool on it. I later learned that the stool had belonged to Anako's grandfather, Inono, who figures in the inception of Onogidi. The base of the stool was immersed in white chicken feathers, and placed on it was a large round basket with no cover, inside which was another round basket with a cover. Onogidi was inside this. Arrows, later identified as sacrifical offerings, were stuck into this basket around the rim of the outer basket. The two baskets were tied together with rope. Above all this, on a shelf, was an *irapa*, a cylindrical box made of bark, the usual container for masks and their costumes. This contained an *ekuoba*, the masked form that permitted ancestral re-embodiment (see below), and part of the cloth costume for Onogidi. In the bottom of the

outer basket rubbish had accumulated – feathers and decayed cloth. The mask itself was wooden but almost featureless except for the eyes (one of which was slightly lower than the other) and a ridge around the edge of the face. Its surface was blackened with palm-kernel oil and completely covered with the blood of sacrifices – ram, male goat, cock (so I was told) – and broken eggshell, while the top of the mask was obscured by the piled up assemblage of medicines, tokens of sacrifice – horns, cowries, yet more dried blood – and a small bell. I estimated the overall height at 18 inches. On that occasion a photograph was not possible: I did not use flash, there was only one small window in the room and the mask could not be carried outside.

Anako described Onogidi as 'the property of *ohiku*' (literally the lords of *eku*, the domain of the dead, i.e. the ancestors); it had been captured during the time of his grandfather in a feud with Ogidi. I later discovered that the mask was a replacement, not the original, and that in any case what had been stolen was not a mask but the magical medicine at the core of the accumulated material on top. Onogidi came out to perform during *Ec'ane*, literally 'the feast of women', which I was able to follow over three years – 1966, 1968 and 1969 – in each of the districts of central Ebira. Anako described Onogidi as a strong and 'bad' *eku*, beating anyone and everyone – even Europeans! Even its owner!! – and sometimes throwing hoe blades into the assembled onlookers. Within a month of arriving in Ebira I had learned that masquerade was a dangerous business.

The last time I encountered Onogidi was in July 1982. It was 'sitting in *abara*', located in a man's bedroom, but no longer Anako's: he was dead and it was now in Ohubi's house, whose grandfather, Ariko, had first stolen whatever it was that was the essential component of Onogidi. By the time of my visit, public display of the mask over the nine days of the festival of *Ec'ane* in Kuroko was done and it was no longer seen moving about the village causing laughter and havoc; but it had not yet been put away in its basket. It remained exposed in a room within Ohubi's house to be consulted by supplicants regarding matters of concern to them, especially young women unable to conceive. Consultation entailed human intermediaries and a process of divination. The last time I visited Kuroko was in 1990; it was not the masquerading season, almost all the men I had known, and on whom my research had depended, were deceased, and masquerade had been proscribed (see Picton 2011b). This is why I write using the past tense, avoiding the 'ethnographic present'. Since then, such was the Ebira interest in masquerade and after a ban of some twenty years, it has been revived, but how the revival compares with my data is research someone else will have to do.

The mask and its attachments

The surface of the mask was as it was because of sacrifices offered to it as determined by divination, whether before and after performances, or in response to supplicants coming to Onogidi at other times. The assemblage on the top of the mask included sacrificial tokens as evidence of its efficacy, and magical medicines promoting that efficacy and protecting those involved in its performance from their enemies. Sacrifice and magical medicine worked together in mutual support. Attached to the mask were lengths of *ubanito*, the heavily brocaded cloth woven in Bunu villages (also Yoruba-speaking), twenty-five miles to the north of Ebira, which made use of red woollen yarn, unravelled from hospital blankets (Renne 1995: 111). These draped down over the tunic and trousers worn by the performer made from *itokueta*, a hand-spun cotton textile with a distinctive pattern of indigo and white stripes, indicating that it was for the shrouds of dead men (Picton 2009). Woven by Ebira women, it was always easily available in local markets. Several layers, and footwear, of hand-spun cotton shroud cloth were worn, together with huge wreaths of fresh palm fronds. Nothing of the performer's body was exposed to view. The weight and practical inconvenience of the mask and its costume were such that movement demanded great physical strength and the forceful support of magical medicines, as well as sacrifices offered by the performer independently of those done by Anako. Onogidi would carry a long thick stick with which to chase and beat people, and his entourage always included a flute player, advertising his presence by means of his praises (the melodic line following the speech-tone patterns of these poetic formulae), as well as a gang of young men carrying sticks partly as a show of force, but also so that a replacement was readily at hand as and when Onogidi, in performance, broke the one he was carrying. The manner in which Onogidi could walk, turn, double back, run, chase and beat those whom he chose was the basis of its entertainment; and in its display of physical strength and healing power, Onogidi's reputation was legendary throughout Ebira.

Overt male authority and covert female power

The reasons for masked performance were common knowledge. Time and again I was told, 'God made everything in two: *eku* for men, and *opoci* for women' (Picton 1988, 1989). The word *eku* translates as 'masquerade' or as 'world of the dead', according to context, a usage that presupposed a continuity between masked performance and the deceased that authorized male access to powers that maintained social order while also giving

protection and healing. *Eku* as 'world of the dead' was contrasted with *ehe*, 'life', the 'world of the living'; and *eku* as 'masquerade' was contrasted with *opoci*, 'witch' or 'witchcraft' – that is, the ability, located in Ebira in some women, to cause another person's affliction within the household or lineage, anything from mere bad luck to lingering disease and even death (a witch could only afflict someone with whom she was related, through either lineage or marriage). These powers resided in (some) women for no other reason than that they were women. *Opoci* were a law unto themselves even as they were guardians of the moral consensus: to offend lineage and other social values was to invite their attention. Men might seek to contain these powers through divination, sacrifice, magical medicine and masked performance, but they could not control them. Indeed, a man's success in life was contingent on the support of his mother and other senior women of his lineage, and his sisters and daughters. The loyalty of a wife was somewhat more ambiguous. A man was not frightened of women, but he did have to watch his step and ensure they had a good share in the wealth of his household. However, in contrast to divination, sacrifice and masquerade, most people, men and women, had some knowledge of medicine, whether magical or therapeutic (Picton 1989, 2012), and there were also both male and female specialists. It should also be added that by the 1960s most people in Ebira were Muslim, with varying degrees of devotion; yet there remained a hankering after these proven local methods of explaining and dealing with disease and misfortune, an inheritance that still held out the promise of a future in which one's problems could be resolved.

From *ekuecici* to *ekuobanyi*

Onogidi was one example of a very large number of masked figures across Ebira, all characterized by a costume that preserved a recognizably human form, with a clear definition of head, arms, legs and so forth, and with a face of some sort, even if only the eyes were clearly formed: the mask might be no more than a cloth hood. That the use of a schematically carved wooden face together with the indigo and white shroud cloth was recognized throughout Ebira as the authentic tradition did not stop individual performers experimenting with whatever materials were at hand, provided the entire body was fully covered. Indeed, performance at *Ec'ane* encouraged individual differentiation and it was always possible to tell one performer from another. Reputations were built up over many years of performance, some developing their vigorous display, chasing and beating, while others developed an ability to speak as an oracle of the world of the dead in effecting healing; and the

relative ages of masked figures – and here I mean the mask-in-performance, not the age of the performer – were well known. Onogidi was one of the few that excelled in both display and healing, and in Kuroko it was the elder among masquerades of this kind.

Each masked figure had a specific reason for its existence. They were collectively known as *ekuecici*, the '*eku* of rubbish', that is, the leaves, sticks and stones, and broken earthenware and so forth that inevitably littered the ground. Anako used to refer jokingly to Onogidi as his *ecici in'abara*, 'the rubbish in the bedroom'. However, given the Ebira-wide fame of Onogidi, the generic status of the *ekuecici* was no longer regarded as appropriate. Onogidi was now classed as *ekuobanyi*, 'grand *eku*' ('grand' in the sense of both aged in the company of masks and well-known). Yet the fact that Onogidi had originated within the category of '*eku* of rubbish' raises the question: why rubbish? To answer this we must continue the discussion of witchcraft. I personally do not believe that (some) women fly around at night, gathering together to eat people, though Anako firmly admonished me for my absurd view: 'You are just ignorant! It's because you Europeans stopped us killing witches that there's so much of it about these days.' Lingering illness and premature death were the consequences, and a man or woman so afflicted would be buried in an unmarked grave outside the back of the compound wall with minimal ritual observance; whereas the death of a man or woman of great age, a grandparent, dying in correct birth order, was an event of great celebration. The details need not concern us here; what matters is that at some interval – it might be several years – after a man's burial, divination might reveal that he wanted to be re-embodied in masquerade to return to his household, greet his family and make himself available for consultation as an oracle from the world of the dead to heal any problems that individual household members might bring to him.

The masked form proper to the process of re-embodiment was the *ekuoba*, 'the *eku* that stretches up', a reference to its movement as an essentially featureless tube of cloth, made from *ubanito* and *itokueta*, and sometimes other materials (see Picton 2011a, 2011b); and because the performer must walk on the costume trailing on the ground behind him, his progress was inevitably hazardous: on the rough and stony terrain of an Ebira village he might easily trip and fall over some perhaps quite minor obstacle not seen through the weave of his costume – there were no eyeholes. When a new *ekuoba* was made, an *ekuecici* was made to accompany him, clearing his path of rubbish and keeping people from pressing too close and treading on the costume. However, whereas the *ekuoba* was identified as the re-embodiment of a deceased elder, well-known to his community (an identity secured by sewing the eyelashes of the deceased into the costume), the *ekuecici* was named after some event in the history

of the lineage to which the elder belonged. *Ekuecici* were not 'spirits', and, lacking the re-embodiment of the *ekuoba*, nor were they ancestors. They were what they were, entirely sui generis, even within the larger category of *eku*, and the status of *ekuecici*, even when they had graduated to *ekuobanyi*, remained as messengers of the deceased. Of course, the appearance of anything dressed in a shroud would suggest some kind of relationship with the dead, and here were figures running around the village as if the dead had re-emerged from their graves, a temporary invasion, as it were, of one domain by the other, an invasion with continuing therapeutic and other social value, but carefully put away after the allotted times and seasons. Yet the individual masked figures were neither living nor dead, but in some inexplicable manner inbetween the two. Moreover, once an *ekuecici* had been invented it performed as an agent of its household, no longer tied in performance to the *ekuoba* that occasioned its invention; and whereas *ekuoba* appeared only rarely (Picton 1992), *ekuecici* appeared in great numbers at the annual mid-year feast of *Ec'ane*.

Onogidi's genealogy

The particular story of Onogidi is this: when the sons of Ijebere, Anako's great-grandfather, raided an Ogidi farm, the youngest brother, Ariko, stole a protective medicine placed in the fields to protect the land and its crops. As they ran off with it, the Ogidi farmers shouted after them that they should never put red pepper on the medicine otherwise it would become aggressive, killing those who possessed it, but that if that did happen they could cool it down using the urine of a virgin girl. In due course, Ijebere died, and, some time later, when his sons were preparing his *ekuoba*, the eldest brother, Inono, determined that they should use the medicine stolen from Ogidi as the basis of the *ekuecici* that would appear with their father's re-embodiment; hence the name, *on'ogidi*, 'that which is from Ogidi'. Inono was thus the first owner, or caretaker, of Onogidi (it was on Inono's stool, carved in Ebira, that Onogidi in its basket now resided). After Inono, Onogidi passed to the eldest among Ijebere's male descendants. This was the normal pattern of inheritance in Ebira, although given the expenditure demanded by an elder's funerary and post-burial rites, and given that such clothes as he possessed would have been buried with him, land rights and masks were about the only things left to be inherited. Anako was the ninth person to inherit Onogidi, and after his death it went to Ohubi, Ariko's grandson. I do not know if it is still being performed, whether the basket and its contents still exist, and who would now be looking after them.

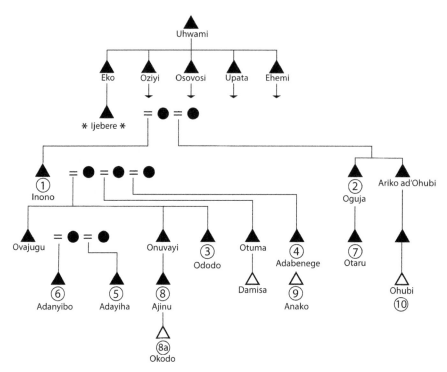

FIGURE 5.2 *Onogidi's genealogy showing the inheritance pattern through four generations, as noted in conversation with Damisa, 18 November 1966. Ijebere was the elder for whose post-burial rites Onogidi was made by Inono (1) and his brothers, and the numbers 2–10 indicate the succession through Ijebere's descendants. Graphics by Doig Simmonds.*

In the genealogy (Figure 5.2) the inheritance pattern through four generations begins with Inono (1), and the numbers 2–10 indicate the succession through Ijebere's descendants thereafter. Regarding Adanyibo (6) and Adayiha (5), though the former was the elder he did not live in Kuroko so he delegated the role of caretaker to his junior half-brother, who, in any case, would have been the next in line, and it was only when the latter predeceased the elder of the two that Adanyibo took Onogidi to his own house. Then, regarding Ajinu (8) and Okodo (8a), Ajinu had delegated the care of Onogidi to Anako (9) in whose house it was kept until Ajinu's death in 1963. Then his son, Okodo was allowed to keep it at his house in memory of his father until *Ec'ane* in June–July 1965, when it finally moved to Anako's house. By 1982 Anako was dead and it was now with Ohubi (10). As already noted, the mask in Figure 5.1 was not the original, which was damaged during the time of Oguja (2). There were two explanations for this: some said it had been damaged in a house fire; others said that it was broken during a

fight between rival performers and their attendant gangs. Either explanation was feasible; and by the time Ododo (3) took over, the present mask was in place.

The very existence and success of Onogidi had established an ongoing relationship in which mask and genealogy were necessary to each other. Onogidi was both emblematic of a genealogy that celebrated a raid on Ogidi one day in the previous century, and the means whereby the remembrance thereof mattered, thereby standing between knowledge and forgetfulness in relation to a history that confirmed Ebira lineage values and the emphasis on seniority within a group of descendents, as well as participating in the rivalry between lineages played out in masked performance and in the ad hoc meetings of elders that constituted the government of Kuroko. And that participation presupposed another kind of inbetweenness in the balance between rivalry and collaboration that was essential to village government and, as we shall see, masked performance.

Ownership and performance

Another key player in this genealogy was Damisa Enevene. He was one of the most remarkable men I have ever met. I would describe him as poet, philosopher, astronomer, judge, doctor, mind reader, diviner and tax collector, all (except for tax collecting when he had a clerk to assist him) within Ebira non-literate social practice. This is not the place to elaborate on these qualities (see Picton 2014); we must first unravel the multiple roles necessary for the maintenance of a masked performance with an Ebira-wide reputation. We know about the flute player, the young men with spare sticks and Onogidi's genealogy; the mask (and the flute) had been carved, the cloth locally woven or traded in from elsewhere, the diviner consulted and the animals made ready for sacrifice; the flute player, in his childhood, had learned how to move from speech tone to melodic pattern in the context of proverbs and praises. Now, we need to contrast ownership and performance, which were governed by different criteria. The mask with its costume was the property of the lineage descending from Ijebere, the role of caretaker being taken by the oldest man in this group, but elders were expected to stay at home. They might occasionally go to the market or to the farm, and attend the ad hoc meetings that governed a village like Kuroko. Otherwise they were the focus of stability in the household; and an elder's role included that of dispensing patronage, whereas to perform in masquerade was to be in receipt of patronage. In other words, one of the duties of the elder with responsibility for a mask like Onogidi was to ensure that someone suitable performed it; and throughout the late 1960s, this was in

the hands of two men. Public performance, wearing mask and costume, was the responsibility of Sule Ocu, a farmer from another Kuroko lineage called Aneeku. However, responsibility for the preliminary sacrifice Onogidi made at the rock where Sule would dress the next day, and for the post-performance divination clinic, when anyone could turn up for a consultation, fell on Damisa Enevene. Damisa had the better voice for speaking as Onogidi, and his skills as a diviner were essential to the post-performance element. Both Sule and Damisa had been chosen for these roles by Ijamboro, also of the Aneeku lineage, a local authority policeman who was, by common consent, the most famous performer of the most famous masquerade in Ebira. One could hardly speak of Onogidi throughout Ebira without someone bringing the name of Ijamboro into the conversation. Ijamboro had been responsible for all aspects of Onogidi's performance, but, some years earlier, in the process of handing on these responsibilities before his own death, he had recognized that there was no one then in Kuroko who could take on both aspects of performance, while Sule was already an established, tough, masked performer whose father had been Onogidi before Ijamboro, and Damisa was known for his divination, ritual expertise and devotion to Onogidi. By 1982, when I last met Onogidi, Anako, Sule and Damisa were all dead, and Ijamboro's son, having been trained in these matters by his illustrious father, had taken back both aspects of performance.

Ec'ane, the 'feast of women': The ritual cycle and the marking of time

The Ebira ritual environment was structured around (i) ad hoc events such as funerary observances, divination and sacrifice as individual circumstances required, the rites of infancy, and the preparation of magical medicines; (ii) an annual cycle of festivities; and (iii) the *ireba*, a place of considerable ritual importance, which, in Kuroko, was situated down a hillside to the west of the village. Kuroko was still in its nineteenth-century hilltop location and had expanded along the top of the hill as well as down into the valley below. Traces of its defensive 'wall' of cactus planted around the village were still visible, and beyond this, the Kuroko *ireba* was formed of a small carefully built heap of stones at the foot of a shallow rock shelter. Once a year the officials concerned with regulating masking affairs – the *ohi'reba*, 'the master of the *ireba*', and the *oz'oku ete*, 'the elder of the land' (offices we shall return to) – carefully opened the heap of stones, together with the village *ekuoba* performer, and kneeling over whatever lay beneath, listened for the voice of the dead in the ground, carefully spreading their gowns over them so that no

one could see anything of what they might be doing. Just what was beneath those stones, and what they heard, I have no idea; all I was told was that 'it is only when we hear the *eku* in the earth shout that the *eku* on the earth can shout'. The role of the *ekuoba* performer on this occasion was to answer the voice of the dead coming from the ground, and this was all that any of us could hear. Throughout Ebira, the location of an *ireba* was always outside the village but not yet on farmland, as if marking a spatial contrast between 'home' (the village community, pre-eminently the domain of women) and 'farm' (the hamlet with its surrounding fields where men camped out for much of their working lives – unless they were caught up in teaching or the office work of local modernity). It also marked a temporal contrast between living and dead; the rite of listening re-established the relationship between the two as the essential preliminary to the inception of the annual cycle of feasts. All masked performance was thereby understood to be authorized by the *ireba* as mediated by its master, whose permission was needed before any new masked figure – such as Onogidi had once been – could perform. Everyone, men and women, knew where the *ireba* was, but because of its ritual connotations it was a place of uncertain potential. Everyone knew not to go anywhere near it unless you were among the group of men who, from time to time, had reasons for doing so. (Outsiders to Kuroko were not permitted anywhere near it: Andrew Ogembe, my field assistant, and I were allowed access only because of our friendship with the *ohi'reba*, and then only when he chose to take us there.)

There were two parts to the annual cycle. The primary set of celebrations marked a period when it was said that 'two years meet', a time when the old year overlapped with the new, an inbetween time that structured the regular passage of time. It began just before the new moon of late September–early October in a staggered sequence of events, district by district, ending with the new moon of late November–early December: a communal divination, known as the 'oracle of the year', a listening for the voice of the dead at the *ireba*, the appearance of a single *ekuoba* coming out from each *ireba* to inaugurate this inbetween season, and the night-time feast of *Ekueci*, a celebration from which women were excluded, during which all the male dead visited their living descendants to mark the beginning of the new year (see Picton 1989, 1990b, 1992, 2011a and b). *Ekueci* was the night when all masked performers could come out to entertain the (male) community, an entertainment dominated by singers who, supposedly, were sons who had predeceased their mothers. However, as women were shut away for the night, and all men were in on the supposed secret (i.e. that masked emanations from the world of the dead were performed by their brothers, sons and fathers), the faces of performers were not masked; and sometimes no costume at all was worn. I remember Sule Ocu during an *Ekueci* in Kuroko, in ordinary dress, an indigo-dyed gown,

a wicked smile on his face, a long thick stick in his hands, the slightest twitch of man and/or stick causing onlookers to scatter – and laugh. He had intended wearing Onogidi's trousers but because of an argument Anako had refused to let him have them; Sule performed as Onogidi anyway.

The lesser celebration was the daytime *Ec'ane*, the 'feast of women', and women were allowed to see (most of) what was going on. It lasted three days in one district, five days elsewhere and nine days in Kuroko, in a staggered sequence district by district between late April and early June, but it was not marked by a complex sequence of rites and events. *Ec'ane* was principally a time of eating and drinking, and rest (for men) from farm labour: *ec'ane* is a compound of *ece*, the generic term for palm wine or guinea-corn beer, and *ane*, women; and from mid-afternoon masked performers of the *ekuecici* variety, and those now judged to be *ekuobanyi*, would appear. Some were simply the property of a group of young men who had clubbed together and obtained permission from the *ohi'reba*, and they were not the subject of any particular ritual observance; whereas the appearance of masked figures approaching the status of Onogidi would be preceded by divination and sacrifice in the days leading up to the festival; and there were many such across Ebira, all lineage property and all subject to the kind of inheritance as described earlier.

Both festivals, 'the meeting of the years' and 'the feast of women', defined the passage of time. Beforehand it was last year and afterwards it was this year. This did not mean that the Ebira year was only six months long, but that the passage of time was marked at two different points in the annual cycle. One could argue, therefore, that the public appearance of Onogidi at *Ekueci* and especially *Ec'ane* was emblematic of those feasts; and that by its participation in marking the point at which one year turned into another, Onogidi stood between past and present in terms of the cyclical passage of time. Moreover, both the *ireba*, and Onogidi as authorized by the *ireba*, stood between 'home' and 'farm', and living and dead; we have already seen Onogidi as emblematic of its lineage, standing between past and present in regard to the lineage; and, as we shall see below, Onogidi was emblematic of the possibilities of healing, standing, as it were, between affliction and health.

Ec'ane, Onogidi, performance and inter-lineage collaboration

During the night before his public appearance, Onogidi came out to make a sacrifice at the rocky outcrop in front of Damisa's house. A tree was growing out of the middle of the rock, and it was where Onogidi would dress the

following day. It was known as Onogidi's *ireba*, although it had none of the community-wide significance of the village *ireba* described above: no heap of stones and no listening for anything. It was in June 1966 at the end of the first day of *Ec'ane*, and around 10 p.m. the flute player made his own sacrifice of alligator pepper at the foot of the tree in the rock. Then he began to play with long drawn-out notes turning into the melodic patterns that replicated the praises of Onogidi. Meanwhile Damisa arrived, poured a libation of palm wine on the rock and began to shout in the voice of Onogidi, invoking God, Earth, the rock on which we were standing and the lineage ancestors of Kuroko, all the while holding a kola and one of the arrows from Onogidi's basket. In doing this, Damisa was Onogidi, with the flute player warning everyone within earshot of its presence.

There were more sacrifices at Anako's house the following morning before the basket containing the costume was carried through Kuroko to the rocky outcrop of the previous night. This was the point at which financial negotiation between Sule and Anako would begin, each man at home with messengers running between the two houses, for Sule would refuse to turn up until the money offered by Anako was judged by him to be sufficient. Once that was settled, Sule would arrive and in full view of everyone he would strip off completely and put on the costume and, finally, its mask. The manner of his doing so was all part of the performance: as each garment was put on Sule might, well without warning, grab a stick and chase away anyone standing close by. The unpredictability of when the *eku* might burst into action was part of the entertainment, and onlookers' cheers and hooting would accompany any sudden movement. Everything was accompanied by the flute player, with a warning to keep clear, especially for women who might, by accident, 'see *eku* naked' – that is, see the performer before he was fully masked.

Onogidi (Figure 5.3) was now ready to begin a procession to the houses of prominent members of the Anuhwami lineage who owned them, and the Aneeku lineage that provided the men, such as Ijamboro and Sule, and their fathers, who performed Onogidi; and between one house and another there was the opportunity for the masked performer to run and chase anyone who caught his eye. The flute player, in addition to singing the praises of Onogidi, was expected in his playing to draw his attention to personal and lineage enemies.

The inter-lineage collaboration between Anuhwami and Aneeku was typical of Kuroko. The village had been founded by the Anuhwami lineage whose elders had authority over most of the land, whereas masquerade had been initiated by the Aneeku lineage, whose members had followed Anuhwami in moving to Kuroko. One could thus argue that Onogidi stood between the two lineages, emblematic of lineage values with particular regard to the value of

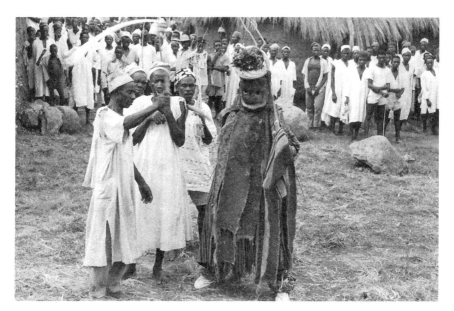

FIGURE 5.3 *Onogidi fully dressed and ready to turn on his followers, June 1966. Photograph by John Picton.*

collaboration. The *ohi'reba* during my research in Ebira was Belo Attaa: it was his grandfather within Aneeku who had prepared the *ireba*, the place where, as already noted, contact with the world of the dead was re-established annually; and it was the elder within Belo's grandfather's descendants who filled the role of 'master of the *ireba*', responsible for organizing the 'oracle of the year' and subsequent activities, supervising the appearance of masked performers and settling the disputes that arose as a result of inter-masking/inter-lineage rivalry in performance. But the land on which the *ireba* had been prepared belonged to Anuhwami, and the *ohireba* always worked in collaboration with the representative delegated by the Anuhwami elders and designated thereby as *ozoku ete*, the 'elder of the earth'. Neither the *ohireba* nor the *ozoku ete* acted without first consulting the other; they listened together for the voice of *eku* in the ground, and together they administered masked performances with the help of a messenger delegated by the elder of the third lineage to settle in Kuroko.

At each house visited by Onogidi, the household elder provided food and drink (locally distilled gin, palm wine or guinea-corn beer) for the performer and his entourage to enjoy, preferably within a room in the house secluded from the gaze of women, so that the mask could be removed and the refreshments consumed. Then, by late afternoon in Kuroko or one of its satellite villages, drummers would set themselves up at one side of the

orere, an open space used for markets and public meetings. Men would dance first, older men whipping younger men with thin sticks, and while doing so all masked performers would assemble, with Onogidi arriving last to sit opposite the drummers, as if presiding. Each mask would dance in ascending order of seniority, kneeling to greet Onogidi. Finally Onogidi would dance across the *orere* accompanied by lineage elders, the flute player and the *ohi'reba* towards the drummers, placing his hands across the drums to silence them. This was done three times, by which time night was almost fallen and everyone dispersed, Onogidi returning to the house where it was kept.

Once the nine days of *Ec'ane* were done, Onogidi remained available for consultation. The mask was not put away, but placed in a corner of a room; in the 1960s this was in Anako's house, and it was when Damisa Enevene took over as the voice of Onogidi, accompanied by the flute player and many of the senior men of the two lineages responsible for Onogidi (Sule Ocu played no role in this part of the proceedings). The *ohireba*'s messenger sat at the doorway to mediate between those outside and inside the room. Figure 5.4

FIGURE 5.4 *Outside Ohubi's house, July 1982. Onogidi sits* in'abara *for consultation. The messenger of the* ohi'reba *sits at the doorway to interpret, while crouched in front is a young woman supplicant with her husband. To the right are more supplicants, and mothers with children born through Onogidi's intervention. Photograph by John Picton.*

illustrates the scene as it was in 1982, when Onogidi was at Ohubi's house, and Damisa's place was taken by Ijamboro's son.

Those outside included both men and women, mostly women it must be said; but whereas a man could approach Onogidi on his own behalf, a woman would always be accompanied by either her husband or a senior woman relative: a sister, her mother or a co-wife of her husband. The supplicant, kneeling outside the door (a man might be invited into the room) would state his or her problem and make an offering of kola. Within the room, and not visible to the supplicant, the 'voice' of Onogidi (Damisa in the 1960s, Ijamboro's son by 1982) would first touch the headpiece with the kola and then break it to cast an oracle, thereby receiving the guidance needed for understanding and healing the supplicant's affliction. The supplicant would be told what had to be done (usually a sacrifice) by the 'voice' speaking in a gruff manner, covering his mouth with his hands, and the messenger at the doorway would repeat what was being said. The supplicant would then say what gifts she or he would bring once healing was effected: an animal for sacrifice, new cloth for the costume, money, drink, kola or any combination of these. Moreover, if a woman had previously been healed of her barrenness she would bring the child to be presented to Onogidi, and it was passed into the room by the messenger and shown the mask. These procedures would continue for as many days as there were supplicants, and it was evident from the numbers of women bringing their children to meet Onogidi that these procedures were often effective enough to be convincing. The women and their children were all the evidence anyone needed as proof of Onogidi's successful intervention.

Emblematic or inbetween?

The very existence of Onogidi presupposed almost the entire gamut of Ebira material culture. The mask itself had once been carved; woven textiles, whether in Ebira or imported from Bunu, were necessary for its costuming; and Bunu textiles entailed a network of trade through which they were obtained for Ebira use (Renne 1995). Onogidi was always accompanied by his flute player; boys were taught through particular games how to recognize words by translating from a melodic line to speech-tone patterns; and this was true also for the drummers who performed at the village meeting place each afternoon during *Ec'ane*. Songs had to be learned; animal husbandry was necessary for sacrifices to be done; medicines were needed by performers for their own protection from enemies, whether rival performers or witches; and there were the arrow makers, and the smiths who made the arrowheads and hoe blades, as well as the ankle rattles that were part of the costume. Onogidi had been founded on the basis of a magical medicine stolen during

a feud with Ogidi, a village some twenty miles away; and feuding and trading happened side by side in the precolonial era. Onogidi's very existence was emblematic of and inbetween all these relationships. Finally, in addition to all else in these networks of patronage, performance, trade and feuding, by the 1950s performance was recorded by local photographers and in schoolboy drawings. Onogidi was among the means whereby Ebira ideas-and-practices existed, and whereby they mattered to the people involved. Onogidi held all these things in being precisely because it was at the centre of them all. Onogidi was emblematic of all those inbetween capacities.

Onogidi stood between life and death within a tradition of masquerade that was intended, overtly, to deny human agency while at the same time, within the company of men, covertly celebrating that very agency; and yet Onogidi, as a thing running around Kuroko at the expected times and seasons, and as a thing in a basket that remained a source of energy, was an entirely sui generis entity. It emerged in grave clothes, thereby constituting a thing out of place. It was a thing from the world of the dead, but now running about in the world of the living where, after all, the dead were not supposed to be – but it was not a dead person. I have discussed Ebira metaphysics elsewhere (Picton 1992), and it must suffice here to say that Onogidi was not the materialization of some component of anyone deceased. Even those masked figures, the *ekuoba*, that did permit re-embodiment remained a mystery in that sense: a deceased man returned to his household and village, an identity secured through the relics preserved from his body, and yet the performer, when performing, both was and was not the deceased even as he spoke with the authority of the deceased. Yet Onogidi did not even have that kind of connection. Its very existence referred back to an episode in lineage history celebrated initially in an elder's post-burial rites, thereafter embodying as well as memorializing that history and in so doing celebrating lineage values, but not by representing a particular person or element thereof. Its source of energy was contingent on the magical thing originally stolen from Ogidi, the nature of which was a complete mystery, and yet it was an energy that could be maintained, boosted indeed, via sacrifice. Onogidi had come to mediate a healing power authorized via the post-burial rites of a deceased elder and the authority of the *ohi'reba* within a tradition that allowed masked performers thereby to speak with the authority of the deceased in general, a continuing power authorized by divination and sacrifice, and by the continuing line of elders. Onogidi stood for those elders, and yet also stood between living and dead in its perplexing identity, and, in its authority to perform and heal, between affliction and the possibilities of healing.

None of the information presented here was difficult to come by; much of it was gathered in a few months. While not everyone had a close eye for detail across all aspects of life, what I have written here was largely common knowledge readily available to anyone who moved with the appropriate men.

It is partly, then, for this reason that I can say that Onogidi was emblematic, in Kuroko, and indeed, to an extent, throughout Ebira, of a ritual environment with a proven track record of delivering healing, and of lineage values as represented variously in land rights, inheritance patterns, the authority of elders, masked performance and a history extending well back into the nineteenth century. As such, Onogidi stood between being Ebira and being something else altogether; between knowing and not knowing, affliction and health, order and chaos, life as we know it and an unknown hereafter. It was, in itself, an inbetween thing: in the village, but not a living being; from the world of the dead, but not a deceased person; and the dress that enabled masked performance in the daytime presence of women was located between the overt work of masked performance and the hidden reality of the energies manifested thereby, even though that reality was both a mystery and a deceit subsisting in the very denial of a human agency covered up by the mask and its accoutrements.

If it is objected that all this is all about men, all I can say is that it should be obvious that it was not quite that simple. It was not just that women were the principal supplicants, for the continuity of social life in Ebira tradition rested on that subtle balance between overt male authority and covert female power, coupled with the dependence of the former on the latter. Of course, this is taking what Ebira people told me at face value – but that is what this chapter is about, in the work of examining the inbetweenness of a thing. If it is objected that the process of being inbetween seems to be ever shifting from one social domain to another, I would suggest that the inbetween is not obliged, either by definition or some other necessity, to be a fixed point in the ordering of a social world. And if it is then objected that different people will have different senses of Onogidi's inbetweenness, I would say: of course. The accumulated experience of an Anako or a Damisa could not possibly be the same as that of an older woman of their households watching them year after year playing their games, or a young woman healed through Onogidi's intervention, or a young man free from farm labour letting off steam in a masked performer's gang, or a little boy scared out of his wits in his first encounter with masquerade. Onogidi had its origins and authority from one side of male/female difference, as understood in Ebira, but the practical work of being Onogidi was both useful and entertaining. Its very success in performance and in healing imparted a mediating role, standing inbetween yet drawing together so many of the diverse elements of Ebira social practice.

References

Picton, J. (1988) 'Some Ebira Reflexions on the Energies of Women', *African Languages and Cultures* 1 (1): 61–76.

Picton, J. (1989) 'On Placing Masks in Ebira', *African Languages and Cultures* 2 (1): 73–92.

Picton, J. (1990a) 'Transformations of the Artifact: John Wayne, Plastic Bags and the Eye-That-Surpasses-All-Other-Eyes', in C. Deliss (ed.), *Lotte or the Transformation of the Object*, 36–65, Graz: Kunstverein.

Picton, J. (1990b) 'What's in a Mask?', *African Languages and Cultures* 3 (2): 181–202.

Picton, J. (1991) 'On Artifact and Identity at the Niger-Benue Confluence', *African Arts* 24 (3): 34–49.

Picton, J. (1992) 'Masks and Identities in Ebira', in J. Maw and J. Picton (eds), *Concepts of the Body/Self in Africa*, 67–86, Vienna: Afro-Pub.

Picton, J. (1997) 'On (Men?) Placing Women in Ebira', in F. E. S. Kaplan (ed.), *Queens, Queen Mothers, Priestesses and Power: Case Studies in African Gender*, 337–69, New York: New York Academy of Sciences.

Picton, J. (2009a) 'Cloth and the Corpse', *Textile: The Journal of Cloth and Culture* 7 (3): 296–313.

Picton, J. (2009b) 'Bottom Tells the Story of Cloth', in B. Gardi (ed.), *Woven Beauty: The Art of West African Textiles*, 16–21, Basel: Museum der Kulturen.

Picton, J. (2011a) 'Ebira Masquerade and Its Histories', in M. Berns, R. Fardon and S. Kasfir (eds), *Central Nigeria Unmasked: Arts of the Benue River Valley*, 115–23, Los Angeles, CA: Fowler Museum of Cultural History.

Picton, J. (2011b) 'Ebira and the Niger-Benue Confluence: Material Culture and Masquerade; Artifact and Identity Revisited', in M. Berns, R. Fardon and S. Kasfir (eds), *Central Nigeria Unmasked: Arts of the Benue River Valley*, 140–63, Los Angeles, CA: Fowler Museum of Cultural History.

Picton, J. (2012) '"Treasures of Heaven": Relics and Their Consequences, an Africanist's View', *Journal of Material Religion* 8 (2): 249–52.

Picton J. (2014) 'Fetishising Modernity: Bricolage Revisited', in G. Genge and A. Sterken (eds), *Art History and Fetishism Abroad: Global Shiftings in Media and Methods*, 205–34, Bielefeld: Transcript Verlag.

Renne, E. P. (1995) *Cloth That Does Not Die: The Meaning of Cloth in Bunu Social Life*, Seattle: University of Washington Press.

FIGURE 6.1 Amòdu *cloth worn by Chief Odoba, Ìkòlé Ekìtì, 2006. Photograph by Will Rea.*

6

Amòdu and the material manifestation of Eégún

Will Rea

The aim is to stop giving prime attention to the meaning of signs, to their representational contents, and to focus instead on their practical effects; to give up trying to decode the significance hidden behind symbols and instead ask what forces they draw upon or shore up (Gil 1999: xii).

This chapter is concerned with a material thing. It is a thing that, as a material (a textile, a fabric), sits precisely between another thing and a body. Importantly, for the present analysis, the wearing of this material allows for the emergence, the manifestation, of another thing. My concern is with a type of cloth from the Yoruba-speaking region of Nigeria known as Ekìtì and the place that this cloth has in allowing the presence of masquerade. Masquerade is conventionally described as the covering of a human identity by a mask or other such material thing, but in the north-eastern Ekìtì Yoruba town of Ìkòlé, where my fieldwork was conducted, it is also the manifestation of a presence. In Ekìtì (and Yoruba more generally), this is known as Eégún, a term often translated as 'ancestral masquerade' and therefore relating to a physical representation, conventionally regarded as a singular visible thing, but that, in my experience, could more accurately be described as belonging to a cluster of terms denoting the presence of ancestral legitimacy and/or authority made manifest.

The cloth closest to the masquerade
is called *Jépè*

The cloth with which I begin is generally known as *Jépè*, but as P. S. O. Aremu (2005) points out it is also known as *Amòdu*. In Ìkòlé the cloth is known as *Amòdu* (Figure 6.1). It is an essential element in the costume of a group of masquerades that exist in the town. The masquerades in the Ekìtì region of south-western Nigeria are known as *Egígún* (Rea 2008), but not all *Egígún* wear this particular cloth.

A focus on the masquerades of Ìkòlé establishes a number of common features with the masquerade that is the focus of John Picton's contribution to this book. Ìkòlé lies approximately seventy-five miles to the west of Okene, and while the people of Ekìtì nowadays identify with the majority Yoruba-speaking people of Nigeria there is a history of connection between this region of Ekìtì and the peoples of the Niger-Benue confluence, including Ebira-speaking communities. As a number of authors have pointed out (e.g. Obayemi 1976), this is a region of diverse 'shatter groups' of people and although the intervention of colonial 'tribal' normalization now presents state-sanctioned homogeneity and boundedness, the historical (and ongoing) relationships between these groups remain open to excavation and a number of obvious continuities exist between the cultural and social practice of masquerade in Ebira and Ekìtì.

Thus while the Ekìtì region nowadays identifies absolutely with Ile Ife as the fount of its cultural foundation, there are a number of idioms that, while at first sight might seem orthodox Yoruba, actually display marked differences. One point of difference is the forms of masquerade found in the region. This is an acknowledged difference and the standard Yoruba name for masquerade, *Egúngún*, is not used in Ìkòlé. More generally known as *Egígún*, these masquerades appear at various times, most strikingly during the biennial masquerade festival (*orò Eégún*), but also during the *Ògun* festival and on occasion at funerals. One difference is in the use of palm leaves in masquerade costumes in Ekìtì in contrast to the cloth used in Oyo Yoruba costumes. Nonetheless a number of Ekìtì masquerades do use cloth coverings in a very particular way and cloth figures centrally within at least one of the origin stories that were recounted to me:

> In origin the mother of masquerades is from Upele. She came to Ijan and there she died, there they made her burial. When they made her funeral ceremony, after that time the children of masquerade are suffering. The people of Ijan town then told the children to go and put a garment, *Amòdu*, on their mother's grave. They put the *Amòdu* on top of their mother's grave.

The grave divided into two parts and the masquerade came out (David Fabimi pers. comm. 1991).

The *Amòdu* cloth that figures so centrally in the mythological narratives is a tunic made from cloth of a type that is known as *Kíjìpá*, a rough locally woven cloth. Worn underneath the main, visible garment of the masquerade, it is particularly characteristic of the senior masquerades in Ìkòlé, known as *Egígún Ekú* (Figure 6.2). In the case of these masquerades, the visible outer garment is a tunic *(agbádá)* made of blue cloth with a speckled design or pin-stripes of white threads, which is itself either overlain with palm leaves or white cloth. The *Amòdu* tunic is an essential aspect of a senior practitioner's costume, without which he would not perform, and as might be expected from a cloth that sits beneath the visible outer garment, it is subject to a great deal of secrecy and is rarely seen. Although reportedly washed in black soap, a form of magical medicine, the cloth gains primary significance not by any grand symbolic statement or iconographical device, but simply because of what it

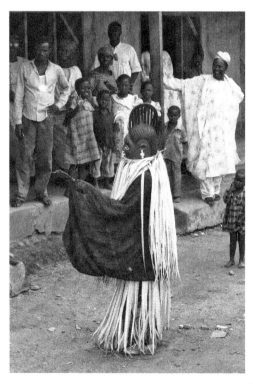

FIGURE 6.2 *The senior* Aborogi *masquerade of Chief Odoba, Ìkòlé Ekìtì, 1991. Photograph by Will Rea.*

is and where it is carried: between the skin of the performer and the outer visible robes of the masquerade.

Textiles occupy a central place in Yoruba religious life. Elisha Renee and Babatunde Agbaje-Williams (2005: 4–6) list some of the characteristics of cloth, which make textiles so appropriately suited to religious belief and practice. These include flexibility, texture, absorbency and opacity, as well as the sometimes high cost and extensive labour involved in production. The flexibility of textile, its ability to sit close to the skin, invokes the suggestion that cloth acts as a second skin, a principle enhanced by the fact that textiles often literally absorb skin as well as fluids such as blood, sweat and semen that are produced and shed by the body. Cloth is also 'Janus-faced', with an interior and an exterior; at once facing outward, revealing design, metaphor and identity, but also wrapping and concealing, keeping hidden the knowledge of what is on the inside in a visually striking fashion. Renee and Agbaje-Williams point to the term 'chasuble', derived from the Latin *casula* ('little house') and suggest that cloth acts as a house-like sanctuary – for bodies (whether living or dead) as well as other materials such as trees or other items identified (as often as not literally by being cloth wrapped) as repositories of spiritual power. More particularly in relation to *Amòdu*, they cite the Yoruba aphorism '*Aso to sún mó egúngún ni a upé ni Jépè*' ('The cloth closest to the masquerade is called Jépè'), arguing that it associates the closeness of the *Jépè* cloth with 'inside knowledge' (Renee and Agbaje-Williams 2005: 9).

The aphorism seemingly states a simple fact – that the cloth that sits close to the masquerade is known as *Jépè*. And yet this is a strange construction. Masquerades throughout south-western Nigeria are often primarily assembled from cloth, yet the phrase does not refer to those outer cloths. Nor does the phrase state that the cloth nearest the *body* of the performer is called *Jépè*. This is not, then, a cloth that lies between an outer layer and an inner body, between a costume and a performer. Understanding the implications of this phrase might allow for a closer understanding of the status of masquerade in more general terms. It may allow us to move from the common understanding of masquerade as the essential 'inbetween' liminal figure – perhaps the primary metaphor of inbetweenness in West Africa, which is played out through a cunning trickery of disguise – towards an ontology of productive centrality. This is to suggest that the masquerade is not simply an object standing in relation to a concept (such as 'ancestor'), but rather something that acts with a productive capacity.

As such the attempt here is to move from an analytical model that reproduces the gaze of the Western museum, which places a fixed unified object of contemplation before an audience (which in turn proposes a model of Western knowledge based on a particular type of perspectival looking), towards a more indeterminate principle that might more closely correspond

with Andrew Apter's (1992) argument that the 'deeper' one goes into 'deep Yoruba' the closer one comes to a potential rather than a fixed core proposition (see also Guyer 2006). If the 'closeness of the *Jépè* cloth' is juxtaposed with 'inside knowledge', this suggests that the meaningful potential of masquerade is not simply metaphorical presentation but also the activation of effect.

Here, of course, sits a collocation with Victor Turner's binary: that between ordinary life, which he describes as the 'indicative mode' (with the invariant operation of cause and effect, rationality and common sense), and that of the 'liminal', which he describes as 'being dominantly in the subjunctive, the mood of maybe, might be, as if, hypothesis and fantasy' or again as 'fructile chaos, a storehouse of possibilities' (Turner 1986: 42). Clearly, if we follow a reading of Yoruba 'deep knowledge' as a storehouse of potential, as Apter suggests, then Turner's reading of the liminal and the place of the 'inbetween' in Yoruba ritual knowledge would seem to have resonance. Yet it is precisely because Turner is keen to make a distinction between the everyday and the moment of ritual that give us cause to pause. Yoruba knowledge, however deep, is not only symbolic, despite this being the mode in which its critical and political philosophy appears to work, but also always practical and effective. The difficulty in Turner's delimiting of separated, bounded operative spheres (apart from, or especially in, reproducing the old division between sacred and profane) is that it limits the definite and pervasive play of indeterminacy in the lives of people. As Jane Guyer (2006) has argued, in distinction to the model Turner draws from Arnold van Gennep, restitution of generalized order is not possible: just time-place-person–specific intervention. Guyer draws her wider argument from Hirokazu Miyazaki's (2004) discussion on the temporal understanding of ritual, which is approached from an actor's sense of living through it, rather than the analyst's sense of observing. Thus Miyazaki argues that the model 'separation-liminality-reintegration' might be reframed as 'action-abeyance-resolution'. Following from this, Guyer argues that abeyance – a period of suspension – is not necessarily experienced as transitional or liminal; rather in a state of abeyance actors express

> their anticipation that there is beneficent agency in the world that lies beyond and between the parties to the ritual and which inhabits their moments of interaction. Any specific resolution is left to that agency to create and the participants to recognize (Guyer 2006: 4).

This move from static resolution to potentials and anticipation also has the effect of disrupting the notion of the singular symbolic object. Turner's work, even if this were not the intent, has been used in the construction of a 'charter' utilized in African art history for the discovery of meaning. As Whitney Davis (1989) notes of African art history in general, all too often studies (of

masquerade and related forms) fall into a 'cryptological semiology', at the heart of which are relationships between binaries that are somehow meant to explain meaning (cf. Sperber 1975). To an extent the issue is one that Turner initiates. His 'betwixt and between', whatever its structural properties, is

> characterized by monstrous images, sacred symbols . . . the emergence of symbolic types represented by maskers and clowns, gender reversals and many other phenomena which I have elsewhere described as liminal (Turner 1986: 11).

Is it any wonder then that the masquerade, as object, is regarded as a singular totality, a thing that can be viewed against a background context? Things in this instance become epiphenomenal, static symbolic markers of a presumably deeper underlying social structure. In this way, things are foregrounded as totality but only to the extent that they refer to some other more important social unity. Seen thus, and as described by Davis, all that is necessary for African art history to work is the discovery of the fixed poles between which the signifier floats and from which the conceptual symbolic universe can be understood. The museological gaze demands singular object and background context.

One practitioner, irritated with my ignorance, responded to my questions about the 'meanings' of the 'symbolism' contained within his masquerade with the answer, '*o jé mi isé, ti o jé gbogbo*' ('It is my work – that is all'; David Fabimi pers. comm.). The claim that masquerade was 'work' initially disrupted my sense of what masquerade should be; that in some way it had a productive capacity rather than iconologic meaning or symbolic relevance appeared too instrumental, too functional in the light of my need for the masquerades to *represent* something or to take part in a full set of symbolic relationships that I, the art historian, would then be able to deconstruct. Masquerade *as work* struck me as a rather mundane and technical explanation that provided little in the way of exegesis or interpretation.

Categories and divisions

One corollary of this form of museological gaze is an insistence on categorization. The prior or first principles of African art history are often models borrowed from anthropology. Thus the principles of classification that underlie African art historical paradigms follow those already established by the ethnographic imagining of Africa. It is a mapping of African art history that conforms to, and writes large, Barrie Sharpe's (1986) analysis of the

mental maps that ethnography created for northern Nigeria: discrete tribal groups placed within geographical boundaries and manifesting a lack of historical process (or historical awareness among anthropologists). One of the major paradigms in African art history is the relationship of ethnicity (usually couched as tribe) and style. As Zoë Strother (1998) notes, following Sidney Kasfir (1984), in African art history's mapping of style, geography has preceded chronology.

Perhaps nowhere is this more true than in the study of Yoruba masquerade. The most comprehensive comparative study of *Egúngún* remains the 1978 issue of *African Arts* (vol. 11, no. 3) dedicated to the subject. Almost all the authors in this volume point to the central problem of classification. Marc Shiltz makes the case succinctly:

> Yorùbá classifications of Egungun . . . are *ad hoc* classifications based on very specific criteria. The result is that one Egungun corresponds to two or more folk types, or the same type may have very diverse manifestations from one place to another (1978: 48).

Or again:

> The extent to which the choice of an Egungun name is definitely related to the style of its mask or to some other attribute like status or office is not always easy to establish (1978: 55).

Each of the authors in the issue produce separate categorizations of the *Egúngún* that they see, according to the position of the masks in the local arena. There is a clear sense in many of the articles that classification *ought* to be possible, and there is a concomitant drive to produce something that looks recognizably systematic. What emerges is both a frustration and a celebration that local situations refuse either systemization or assimilation to easy classification.

These principles of systematic classification were certainly a preoccupation of mine during and after my fieldwork in Ìkòlé. The major festivals of *Eégún* (*orò Eégún*) and for *Ogun*, the deity of iron, were characterized by the appearance of a plethora of masked figures, and as few of these had been documented in the Ekìtì region before, documentation and classification appeared logical. For me this categorizing exercise was the art historical precursor to understanding the hidden and (usually) non-exegetical 'meaning' that lay behind the performance of masquerade in Ìkòlé (another form of category-making). Documentation of stylistic variety would allow access to those 'fixed poles' of contextual meaning. That those categorical binaries can be found if looked for should not be a surprise. The performance and structure of masquerade

in Ìkòlé would, at first glance, appear to bear out the usual universe of binary categories that have become synonymous with masquerade in West Africa. During the *oro Egun* festival there is little initial difficulty in locating the many variants of Turnerian, or even Levi-Straussian, structuralist binaries.

Many of the masquerade costumes incorporate icons of the wild within their costume, either as direct representations, such as *Agbo* (the ram) and *Efòn* (the bush buffalo), or as markers and signs attached to their costumes. The masquerades appear from the *Igbò Eégún*, literally the bush shrine of *Eégún*, which is a space located outside the town, surrounded by *atorin* (*Glyphaea lateriflora*) trees, in the centre of which is a pot buried in the ground containing the material things that make masquerade possible and that, I was told, marks the boundaries both between the earth and the sky, but more importantly between the world as it is known (*Aiyé*) and the world of *Òrun* (the world other than this world, i.e. the world of ancestral presence). The binaries proliferate in performance: during the major part of the masquerade festival (the night festival), women (and visiting strangers) stay behind locked doors and shutters as the masquerades parade around the town. As with the Ebira *ekuecici* masquerade that Picton (this book) describes, so it is with the masquerade in Ìkòlé: the masquerade figures centrally in the conceptual order of Ìkòlé sociality, yet it is conceptually positioned in between boundaries. That these boundaries are neither fixed nor necessarily an actuality should not be a surprise. As Richard Fardon (1990), Carol MacCormack (1980) and numerous others have demonstrated, the division of social life into binary categories such as these is as much a product of the analysts' imagination and Euro-American intellectual practice as it is a product of West African social life.

Yet confusion abounds even at the most formal level. A whole series of distinct forms are performed and categorical distinctions are readily described by audiences and practitioners alike. When asking about masks, however, my usual question, '*kí Nìyìî?*' ('What is this, what is this one?'), would most often be met with the response '*Egígún ni*' ('It is *Egígún*'). Fixated on categorical exactitude it has taken me a very long time to understand the importance of the response. Initially the answer seemed frustrating: not all *Egígún* look, perform or behave in the same way. A number of different masquerades are performed in Ìkòlé and they have different modes of performance, different ways of doing what they do, and yet routinely all of them would be referred to as *Egígún ni*. For me then it was clear that the local exegesis of stylistic types was either unimportant (certainly not true) or that knowledge of the distinctive forms was not widely shared (again not true) or I was both asking the wrong question and looking for the wrong answer.

In fact, what was at fault was both my translation of the term *Egígún ni* and my conceptualization of what materiality and form were (are) in Yoruba thought. The importance of understanding the term *Egígún ni* only became

apparent after reading Helen Verran's (2001) outstanding work on Yoruba numbers. While acknowledging his simplification of this complex book, Apter provides a succint summary of the work:

> In English and 'Western' epistemology more generally, things, objects and numbers in the world are conceived of as spatiotemporal particulars, individual entities that form collections of specific kinds and types – in more formal terms as members of an abstract set. In Yoruba language and culture, Verran shows, objects and numbers in the world are conceived as 'sortal particulars', qualitative sorts of 'thinghood' that infuse the universe and which manifest themselves in different modes at particular times and places (2013: 363).

In her understanding of Yoruba logics of counting, Verran explores the way in which differences in the form of designation in Yoruba and English language point to differences in the qualitative form of things. The linguistic fulcrum on which these differences in designation stand is found in the answer to the question 'what is this?' ('*kí Nìyìí?*'). According to Verran, Western epistemology relies on an answer that tends to include three terms: the predicting term (is), the designating term (it) and the predicate expression that contains the characteristics of the thing described (in Verran's examples 'Hoe' or 'water'). The thing is given a spatio-temporal particularity – either characterized with a boundary (a thing) or as continuous (a flow), for example, water or sand.

The Yoruba answer to the question '*kí Nìyìí?*' introduces a more complex relationship between thing and designation. In Verran's version the answer to this question always includes an emphasizing function – the word *ni*. In the example she uses, asking the question '*kí Nìyìí?*' while pointing to a hoe would elicit the answer '*Okó ni ó jé*'. Here the word *ni* acts to 'introduce an element that emphasizes'; in other words it emphasizes the words *ó jé* – which has been conventionally translated (as I did) as 'it is' (and in many cases is simply left out of the sentence). Verran, however, argues that a more correct translation of the term *jé* implies 'exists or manifests with its inherent characteristics'. Thus, she argues, the term '*ni ó jé*' emphasizes the intrinsically characteristic way in which the manifestation is occurring. Thus things are not individual, bounded and self-referential, but rather things are the manifestation of qualitative sorts of matter. Verran (2001: 184) demonstrates that rather than translating the term '*Okó ni ó jé*' as 'it is a hoe', a more correct translation would be: 'Hoematter manifests' (or 'matter with the characteristics of Hoe manifests'). In a further elaboration she talks of number as a degree of dividedness – an orange seller selling five oranges (*Oson maruun*) would be selling 'orangematter in the mode collected in the mode five', that is, orangeness divided into a plurality of five. As Apter (2013: 364) elaborates, 'Set membership is not additive, rather

it is differentiating or decompositional.' Clearly the responses to my questions about what type of masquerade was being performed make sense in the frame that Verran elucidates. When asked '*kí Nìyìí?*' the appropriate answer can only be '*Egígún ni*' – that is, 'matter with the mode of *Egígún* (masquerade) manifesting'. To this extent all masquerades, whatever their formal qualities, are a particulate of a mode of masquerade.

The implications of Verran's work point to a concern with the framing of knowledge. The sortal particular relies on a very distinct notion of the thing divided. Initially, in thinking of this in relation to *Egígún* masquerade, I relied on the notion that underlying the idea of a 'mode manifested' was a concept – a type of knowledge – and in this instance that concept was *Eégún*. In my initial iteration *Eégún* was more concept in a metaphysical relationship with the world than an actual materialized presence. What is apparent, however, is that this is not the case. *Eégún* is given form and presence through its ability to manifest as a thing. As such, this is knowledge and thing materialized.

At one level it is the pot buried in the ground in the *Igbo Eégún*; at another it is the substances that are in the pot in the ground that presumably hold, mark or otherwise access the potent powers of *Eégún*. At yet another level the pot is simply a sign of the boundaries that exist at this point – those between *Aiyé* and *Òrun*, the worlds of the living and the dead. What is clear, and the specific history of Ìkòlé's masquerades make this absolutely so, is that the performance of *Egígún* cannot take place, and has no sanctioned authority, without the presence of this object. Buried in the pot are a number of things that were brought to Ìkòlé as an essential prerequisite for the introduction of the *Egígún*. No *Eégún* – no masks.

Clearly, however, there is more to *Eégún* than a concatenation of material metaphors. Sacrifice is performed at the exact spot where the pot is buried in the ground. It is the place where *Egígún* not only come from, but also go to die – to return to the earth and thence *Òrun*. A reminder of this is also performed in the festival when masquerades throw themselves to the ground even as their supporters implore them to stand up. At the same time *Eégún* is the ancestral presence and, as such, it is that presence made manifest by the material things known as *Egígún*.

Gesture

The implication here is that *Egígún* are not simply (not only) dramaturgical devices. The notion of masquerade as a metaphorical disguise, often invoked in the West, is on one hand true to the point of banality and on the other reliant

on a very clear notion of individual separability from the mask. Those readings of masquerade that argue that, while offering substitutions of identity, masquerade is in fact only a disguise (of self, emotion, identity, gender and so on), can only suggest that the transformations involved are essentially dramaturgical. And while disguise might offer the performer freedom to challenge boundaries and play with identities, the essential point is that this is a 'mask' that can be removed. The masquerade is always placed in contrast with some other sense of defined identity – one that is core or essential and ultimately unsubstitutable. In these terms masquerade becomes a 'playing' around with identity, and performance relies on the willing suspension of audience disbelief. Clearly this dramaturgical view is not one that is sustained in Ìkòlé. Grasping that this is the case lies within the action of gesture.

The movement of the senior masquerades is interstitial (Rea 2008). Rather than asserting a presence at the centre of the town, these masks walk through the town in a stately and regal manner. Their movement is oblique, passing in between and through alleyways and compounds, pausing when greeted and stopping at the graves of the deceased. As they move through the town, women petition them, calling the *oríkì* (the praise name) of the mask, praising the performance, their ancestry and occasionally the lineage to which they belong (see Figure 6.2). Some women also petition the mask for blessings. The form of this petition is gestural and two forms of gesture are made. The most common, especially made by a young woman, is to kneel before the mask, who then wraps the excess cloth of its costume around her, embracing and covering her head and upper body in the folds of the *età agbádá*. As it does so the masquerade sings into her head. In the second gesture of greeting – more rarely used and then more often by an older woman – the woman turns her back to the masquerade and kneels facing away from the mask, her head towards the floor as the mask stands behind her, arms raised and chanting.[1] These gestural forms outline particular relationships between women and *Egígún*, which begins to allow an understanding of the way in which the work of *Egígún* operates.

In her seminal article, 'How Man Makes God in West Africa', Karin Barber (1981) points to what at first sight seems to be an implicit (Yoruba) scepticism about the idea of hidden presences, one that initially looks like a similar mode of thinking to the Western notion that allows for the suspension of disbelief, of masquerade as a hidden performer. That this mode of thought exists should be obvious. At one point, interested to know what women thought about the *Aborogi* masquerade that was performing in the marketplace, I declared to the assembled (female) stallholders that of course they could not know what was in the mask. My presumption caused much merriment, especially when one of the stallholders declared, 'If we

do not know what is there then why is it wearing Elutan's shoes!' (Elutan's shoes were distinctive and a general source of amusement, being an old pair of football boots.) To an extent the case is a simple one: 'Don't be taken in by the cunning trickery of the mask!' This is a commonplace scepticism often repeated by women when their 'belief' is questioned. And yet, it is women who will kneel before a senior masquerade, be encompassed by it and petition for (their) children. In other words, while there may clearly be knowledge of 'what's in a mask' among women, that knowledge exists alongside belief in the very real practical action of the masquerade.

Barber (1981) points to the fact that Yoruba religious practice depends exactly on making the transcendent immanent and relatable. The relationship between humans and what is generally glossed as a metaphysical world is intensely personal. It is relational in ways that differ, Barber argues, from other West African religious systems. She explains that the relationship between deity and devotee in Yoruba religious thought must be regarded as reciprocal. While the main thrust of Barber's paper is to provide a comparison of the links that exist between religious form and structural (political) hierarchy, it achieves conviction through noting the personal relationships that pertain in devotee practice and metaphysical effect. Devotee and deity stand in a self-sustaining mutual regard to each other.

Egígún offer a keen visual expression of this relationship. The manifestation of masquerade is literally that they are there to be seen, to be looked at. This is a regard that is enhancing. In the terms set out by Barber, *Egígún* need praise as much as humans need their sanctioned blessing. Barber's discussion of Yoruba religious practice helps us to understand the position of the masquerade as standing in close relationships not only with the audience (devotee), but also with performers. Here I would go a step further. What happens if we take seriously the professed belief that masquerade does not simply represent another identity, the representation of an invisible 'concept' from *Òrun*, but actually is, as is often stated, the invisible made present and immanent? This suggests that we take seriously the notion that what is invisible is made manifestly visible by the performance – the enactment – of *Egígún*. What then is made manifest? The simplest explanation is that it is the presence of the ancestors, the world of the dead returned from *Òrun*. However, as I have argued above, this is a presence that, at least in Ekìtì, is not that of the individual, but a general category of ancestral presence. Yet as the number of different forms of masquerade on display demonstrates, this does not mean that this presence is represented by a single form. Rather this multiplicity of forms needs to be understood as fragments, different modes of manifestation of the primary thing, a plurality that is in a mode of dividedness in relation to a primordial whole.

Manifestation and the productive inbetween

Verran's (2001) work on Yoruba logic suggests a crucial shift in the way in which representation has to be imagined. In brief, the shift is between the European notion of an object recognized as a spatio-temporal particular (matter with a particular set of characteristics in the here and now) and the Yoruba logic by which matter is conceptualized as infinitely spread across the here and now, but which manifests in particular modes. Thought of this way, a Yoruba 'theory' of number has radical implications for not only (types of) scientific representation, but also representation more generally. In the context of this chapter, these implications relate to the analysis of those things that are generally thought of (by Western commentators) as 'art' – in this case, masquerade. This should not necessarily be a surprise, because ultimately, while based on a radical difference, the underlying logic of the argument aligns with those scholars who argue that changing logics of enumeration sit at the heart of changing notions in Western visual perception (e.g. Baxandall 1972; Edgerton 1976; Goldstein 1988). This changing perception not only led to new conceptions of space and developed the form of the perspectival, but also, as Foucault most famously notes, is concomitant with the development of Western subjectivity and the separation between subject and object – a separation that, as Eduardo Viveiros de Castro (1998) has argued, sits at the root of an elaborate epistemology that disguises an essentially simple ontology.

Here, then, is another inbetween. It is one that resides at the heart of the methodological apparatus of art history. In his famous essay, 'Perspective as Symbolic Form', Erwin Panofsky ([1924] 1991: 67) draws on Albrecht Dürer to argue that 'perspective creates distance between human beings and things ("the first is the eye that sees, the second is the object seen, the third is the distance between them")'. It is this inbetweenness that, as Michael Ann Holly (1984: 150–1) goes on to state, 'set[s] a distance between "subject" and "object" much as in artistic practice perspective placed a distance between the eye and the world of things – a distance which at the same time objectifies the "object" and personalises the "subject"'. To this we might add that, crucially, perspective objectifies the object within time and space, allowing it a position within an infinity of other, singular, objects.

The Yoruba designation of the object – as sortal particular – suggests a very different sense of representation. Rather than representation of a specific unitary thing, located in a visual system designed to precisely objectify objects from a subject position (itself positioned by viewpoint), the Yoruba case suggests that it is the way in which the unitary concept manifests that is of more importance than the singular object. It is not that there is a world

out there 'to be seen'; rather what is seen is what is made manifest – what is revealed. As such persons exist in a world without separation; things are always already present (even if unseen). Here, however, is another difference – one that crucially operates around the field of the inbetween. Panofsky's view of perspective (drawn from Cassirer) demands a gap, and it is in this gap that Panofsky sees the work of the symbolic. It is in the inbetween that the work of Western representation is given meaningful (symbolic) form. The issue here, then, is what happens to the idea of the symbolic if that gap between object and subject is closed.

In 1990, John Picton published what remains perhaps the definitive work on the differing forms and types of masquerade found in western Nigeria. He offered a continuum of masquerade forms, but the type of *Egígún* described here would seemingly fit with his type II

> masks that effect dramatic distance and at the same time deny human agency. For the masker the separation between everyday self and performed identity is extreme. He is at the very least, metaphysically re-identified, and in the most extreme cases that mask, in effect, effaces his very existence. The mask, with its costume and accoutrements is the acceptable face, so to speak, of something, a power, an energy, a metaphysical presence, otherwise too dangerous to see. Secrecy will be an essential in a way in which it is not in other cases, for the human agent in performance is no mere animator of a mask . . . the masker in some sense becomes whatever it is that the mask hides, sometimes in a state of possession by that metaphysical presence, sometimes not, though invariably with the authority to speak as its oracle (Picton 1990: 192).

Here the denial of human agency, the separation of everyday self and performed identity is extreme. However, I would argue that this is not the same as the position set out by writers on masquerade such as Herbert Cole (1985), who appeal to a European tradition that begins with the 'primitive mind' and then draw on the notion of a 'psychological ecstasy' in offering African masquerade as a definitive replacement of identity (Strother 2013: 19). There is little doubt that the separation that Picton describes is also present: the identity of the masker is subsumed to that of *Eégún*, and any identification of the person in the masquerade by an audience member is inherently dangerous. But this subsumation of the performer's identity is neither one of dramatic effect nor some sort of psychological transference of the performer's identity into the 'real' thing. Rather the performer is 'carrying' *Eégún*, the presence of which demands the absence of the (visible) carrier. The performer is not 'changed' in character – rather their identity is subsumed

by the manifestation of *Eégún* as presence and that is carried into the town and thereby becomes an effective presence in social relations.

The practical efficacy of magical technique compared to the psychological is addressed by Levi-Strauss (in the context of shamanic curing; 1958: 205–26). He explains this in terms of the alteration of patients' representations of their own bodies. Michael Rowlands and Jean-Pierre Warnier's (1993) critique in relation to iron smelting in Cameroon is interesting in this respect. They argue that interpreting the magical elements involved in technical working in terms of purely symbolic and representational meaning is inadequate. Rather they point out that the ethnocentric separation between persons and things has produced a failure to understand African religious cosmology where the transformation of person into thing is of the utmost importance within the productive process (whether of iron or of humans). They go on to argue that in theory a productive process should be continuous and uninterrupted, but that it is precisely in the gaps in the process, where nothing could be seen to account for what was happening, that there is the most need for (magical) intervention, since it is within these gaps between productive flow that malevolent intention could gain its purchase. For Rowlands and Warnier, humans are facilitators within a natural process, protecting against sources of danger. The important difference that Rowlands and Warnier point to is the way in which representational form is thought about. Manifestation is not representation in the conventional sense as understood in Western visual culture. At its most simple, there is no necessary symbolic gap of representation, no distance between subject and concept within which the work of representation (or we might suggest metaphor or symbol or allegory) can gain traction. What is made manifest is there, manifested in a particular mode, as the real thing.

Here we might draw an analogy with the idea of the fetish as described by Peter Pels (1998). He argues that as a material object the fetish is always on the verge of overwhelming or overpowering its subject, its materiality standing out as uncontrollable. Pels (ibid.: 101) argues that the fetish points to an aesthetic sensibility 'in which we cannot only think animistically, of anthropomorphized objects, of a spirit *in* matter, but also fetishistically, of human beings objectified by the spirit *of* the matters that they encounter'. For Pels, the fetish tells us to 'move in, rather than escape, the sensuous border zone between ourselves and the things around us' (ibid.: 102).

In its most basic, material, form *Eégún* is a fixed point and one that is hidden from general view – in Apter's terms, a 'deep' knowledge, in this instance, hidden from view in the *Igbo Eégún*. And yet, one of the defining elements of masquerade is that they are motile: they move around and they are seen. In order to achieve its effect, *Eégún* – the energizing and protective embrace of ancestral presence that is held within that boundary between

Aiyé and *Òrun* and physically represented by the buried pot and its associated substances – needs to be brought into the town. The mechanism by which this transcendent form made imminent is distributed is in the forms and figures of *Egígún*.

Here, then, is the explanation of masquerade 'as work' as given by David Fabimi (above). If so, what type of work is it that the motile and imminent presence of masquerade achieves? At its most simple and basic, the explanation is that masquerade allows the production of children. This is another transformation, both from fluid substance to moral human being, but also, the giving of breath (*emi*) to the inanimate body, in essence the active life force or spirit derived from *Òrun* and to which it will return. This transformation is subject to interruption, particularly through the intervention of malevolent forces, predominantly through the action of witchcraft. It is in the gaps between action and result that masquerade works to have its effect. In essence masquerade works to facilitate a natural process of transformation from inanimate substance to living child, intervening in the process of production where necessary, whether in the form of (magical) intervention for particular women, or more generally in the prevention of the action of witchcraft – the intervention of which occurs precisely while the child is in the womb; that is, at the point where the productive process is unknowable. It is here, in its work to prevent malevolent intervention during the unknown, that we might return to Guyer's analysis of abeyance. Rather than seeing masquerade as a symbolic marker of the liminal, the emphasis should rather be on the anticipatory. It is within this moment of the abeyant inbetweenness, that masquerade, in facilitating and controlling this inbetween, gains its productive power.

Central to this productive process is the presence of the *Amòdu* tunic. This seemingly innocuous cloth garment is the essential technical apparatus that makes masquerade possible. Not only does it lie between the body of the performer and the outer visible garment of the masquerade, but it also encloses those powers of *Eégún* as it is bought from *Òrun* into the world. This enclosure is an essential element, allowing for the transcendent to be made material, and at the same time protecting the human person within the masquerade. Here there is a contrast between the inner cloth and the outer visible cloths of the masquerade. The outer cloths, alongside their aesthetic and metaphorical purpose, also protect the performer, in this instance, from the dangerous gaze of the witch. *Amòdu* tunics, by contrast, protect a more essential inner identity: that of the performer's self. To enter a space wherein the very forces of *Orún* are carried into the world is inherently dangerous. Placing oneself (in essence) next to ancestral presence would run the risk of becoming, in a very literal sense, an ancestor oneself: having one's own identity subsumed to that of the dead. To carry masquerade is known to be

dangerous, not only inviting the action of witches, but also more acutely doing work that places the performer in close proximity to a metaphysical other. (The number of shrines to performers who have 'entered the earth to heaven' – that is, died – is testament to this danger.) Without this mediating cloth, the presence of the ancestral cannot be contained and controlled. It is the *Amòdu* that allows the material manifestation of *Eégún* to have full play.

Note

1 This gesture, with hips raised into the air and head on the ground, is also often described in relation to the 'release' of witchcraft – for instance, it is how witches are rumored to sleep.

References

Apter, A. (1992) *Black Critics and Kings: The Hermeneutics of Power in Yoruba Society*, Chicago, IL: University of Chicago Press.

Apter, A. (2013) 'Yoruba Ethnogenesis from Within', *Comparative Studies in Society and History* 55 (2): 356–87.

Aremu, P. S. O. (2005) 'Socio-religious Realities of Yoruba Egungun Costumes', in E. P. Renee and B. Agbaje-Williams (eds), *Yoruba Religious Textiles: Essays in Honour of Cornelius Oyeleke Adepegba*, 89–129, Ibadan: BookBuilders.

Barber, K. (1981) 'How Man Makes God in West Africa: Yoruba Attitudes towards the Orisa', *Africa* 51 (3): 724–45.

Barber, K. (1990) *I Could Speak Until Tomorrow: Oriki, Women and the Past in a Yoruba Town*, Edinburgh: Edinburgh University Press.

Baxandall, M. (1972) *Painting and Experience in Fifteenth Century Italy*, Oxford: Oxford University Press.

Cole, H. (1985) *I Am Not Myself*, Los Angeles: UCLA Museum of Cultural History.

Davis, W. (1989) Review of *Objects and Intellect*, ed. H. J. Drewal, *African Arts* 22 (4): 24–32, 85.

Drewal, H. (ed.) (1978) 'The Arts of Egungun among Yoruba Peoples', *African Arts* 11 (3): 18–19, 97–98.

Edgerton, S. Y. (1976) *The Renaissance Rediscovery of Linear Perspective*, New York: Harper & Row.

Fardon, R. (1990) *Between God, the Dead and the Wild: Chamba Interpretations of Ritual and Religion*, Edinburgh: Edinburgh University Press.

Gil, J. (1998) *Metamorphosis of the Body*, Minneapolis: University of Minnesota Press.

Goldstein, L. (1988) *The Social and Cultural Roots of Linear Perspective*, Minneapolis: Marxist Educational Press.

Guyer, J. (2006) 'When and How Does Hope Spring Eternal in Personal and
 Popular Economics? Thoughts from West Africa to America', Unpublished
 paper delivered at Hope in the Economy Conference, Cornell University.
Holly, M. A. (1984) *Panofsky and the Foundations of Art History*, Cornell: Cornell
 University Press.
Kasfir, S. (1984) 'One Tribe, One Style? Paradigms in the Historiography of African
 Art', *History in Africa* 11: 163–93.
Levi-Strauss, C. (1958) *Anthropologie Structurale*, Paris: Plon.
MacCormack, C. P. (1980) 'Nature, Culture and Gender: A Critique', in C.
 P. MacCormack and M. Strathern (eds), *Nature, Culture, Gender*, 1–24,
 Cambridge: Cambridge University Press.
Miyazaki, H. (2004) *The Method of Hope: Anthropology, Philosophy, and Fijian
 Knowledge*, Stanford, CA: Stanford University Press.
Obayemi, A. (1976) 'The Yoruba and Edo-Speaking Peoples and Their Neighbours
 before 1600', in J. F. A. Ajayi and M. Crowder (eds), *History of West Africa*, vol.
 1, 196–263, London: Longman.
Panofsky, E. ([1924] 1991) *Perspective as Symbolic Form*, trans. C. S. Wood,
 New York: Zone Books.
Pels, P. (1998) 'The Spirit of Matter: On Fetish, Rarity, Fact and Fancy', in P.
 Spyer (ed.), *Border Fetishisms: Material Objects in Unstable Places*, 91–121,
 London: Routledge.
Picton J. (1990) 'What's in a Mask?', *African Languages and Cultures* 3
 (2): 181–202.
Rea, W. (1995) *'No Event, No History: Masquerade in Ìkòlé Ekìtì'*, PhD
 dissertation, Sainsbury Research Unit, University of East Anglia.
Rea, W. (2008) 'Making History: The Modernity of Masquerade in Ìkòlé Ekìtì',
 African Arts 41 (4): 14–29.
Renee, E. P. and B. Agbaje-Williams (eds) (2005) 'Introduction', *Yoruba
 Religious Textiles: Essays in Honour of Cornelius Oyeleke Adepegba*, 1–23,
 Ibadan: BookBuilders.
Rowlands, M. and J.-P. Warnier (1993) 'The Magical Production of Iron in
 the Cameroon Grassfields', in T. Shaw, P. Sinclair, B. Andah and A. Okpolo
 (eds), *The Archaeology of Africa: Food, Metals and Towns*, 512–50,
 London: Routledge.
Sharpe, B. (1986) 'Ethnography and a Regional System: Mental Maps and the
 Myth of States and Tribes in Northern Nigeria', *Critique of Anthropology* 6
 (3): 33–65.
Shiltz, M. (1978) 'Egungun Masquerades in Iganna', *African Arts* 11 (3): 48–55.
Sperber, D. (1975) *Rethinking Symbolism*, Cambridge: Cambridge
 University Press.
Strother, Z. (1998) *Inventing Masks: Agency and History in the Art of the Central
 Pende*, Chicago, IL: University of Chicago Press.
Strother, Z. (2013) 'Looking for Africa in Carl Einstein's Negerplastik', *African Arts*
 46 (4): 8–21.
Turner, V. (1986) 'Dewey, Dilthey, and Drama: An Essay in the Anthropology of
 Experience', in V. Turner and E. Bruner (eds), *The Anthropology of Experience*,
 33–44, Urbana: University of Illinois Press.
Turner, V. (1990) 'Are There Universals of Performance in Myth, Ritual
 and Drama?', in R. Schechner and W. Apel W (eds), *By Means of*

Performance: Intercultural Studies in Theatre and Ritual, 8–18, Cambridge: Cambridge University Press.

Verran, H. (2001) *Science and an African Logic*, Chicago, IL: University of Chicago Press.

Viveiros de Castro, E. (1998) 'Cosmological Deixis and Amerindian Perspectivism', *Journal of the Royal Anthropological Institute* 4 (3): 469–88.

Syncretism, intercession and iconoclash

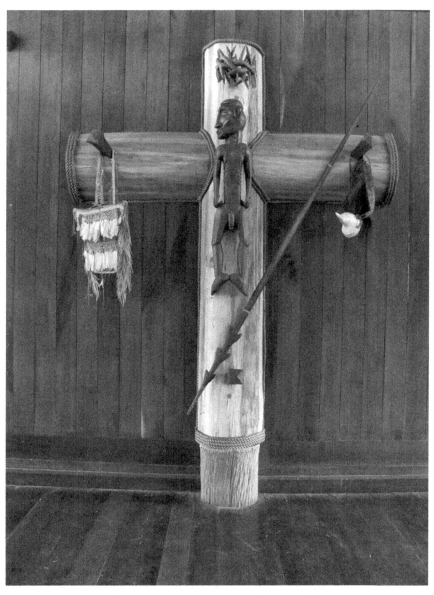

FIGURE 7.1 *Anaklitus Yiwirjak's crucifix figure, Church of Kristus Amor, Sawa, Asmat, West Papua, 2010. Photograph by Roy Villevoye.*

7

Desire, imitation and ambiguity in Asmat sculpture

Nick Stanley

The anthropologist Simon Harrison notes with approval René Girard's proposition that 'desires are not innate or naturally given, but acquired by imitation. They are contagious; we catch our desires like illnesses from other people' (Harrison 2002: 213). He goes on to state, 'Hence, desire is not a relation between a desiring subject and an object, as is naively supposed. It is an inherently *triangular* relationship between a desiring subject, an object and what Girard calls a model or 'mediator' – a real or imagined other from whom the desire was copied' (ibid.). I would like to take this proposition and employ it in a particular case that might initially appear unexpected: a crucifix figure carved by the Asmat artist Anaklitus Yiwirjak (Figure 7.1).

I first saw this crucifix carving in 2005 in the newly constructed church of Kristus Amor in the village of Sawa in the Asmat region of West Papua. It is one of a pair of crosses facing each other down the length of the church. The companion piece is a direct replica of the first in its construction. Both are composed of massive beams that are flat, smooth and precision-finished with joints concealed by ropework. This braided rope forms a kind of decorative border both at the intersection of the beams and at each extremity, so emphasizing the tautness of the form and its crisp outline. The second cross does not have a figure on its surface, but instead has a tassel of fabric pieces suspended in the place where the figure would be, hanging from a red circular loop. This second crucifix is flanked by two wall hangings that depict on one side aspects of daily life in the village while the other shows everything alive

and powerful associated with the resurrection. So, on one hand it is visually more plain, lacking a figure, yet it is, nevertheless, situated between two narrative tapestries. Nevertheless, the second cross acts principally as a foil for the dominant original. It provides a reflection and response to its mirror image opposite, and reinforces its significance. It is to the first crucifix that our attention is immediately drawn.

But why have I introduced the concept of desire in such a context and in this book concerned with the inbetweenness of things? Who would think of approaching this figure as an object of desire? Certainly it is arresting, composed in an expressive form, angular and tortured, placed on its smooth and featureless background. While the figure might be described as a troublesome object that perhaps evokes our compassion or pity, it does not immediately invoke *desire*. To understand why I proffer this reading requires us to look initially at the Christian symbolic system in which this figure appears to be caught: the figure on a cross accompanied by the traditional features of a crown of thorns, a lance and, of course, the nails. But another quite different register, and indeed a new stylistic vocabulary, is also simultaneously actively at work. The figure already hints at this second way of reading in its singular disposition with the arms not extended towards the nails on the cross-beam, but instead tucked alongside the body. Traditional Asmat carvings, either in the form of house posts or the monumental *bisj* poles that grace the Pacific Hall in the Metropolitan Museum in New York and the permanent display at the Musée du Quai Branly in Paris, always show the figure naked in a schematic and abstract style. The gaunt ribs, the face in profile, the man's bag hanging from the nail and the woven belt with conch shell, all point to another set of purely Asmat referents: the ancestors (those who are memorialized in the majestic *bisj* poles). And the unmissable *cemen* (phallus), the central feature of the *bisj* pole, emphasizes fertility so central to Asmat cosmology. Perhaps, most emphatically non-Christian is the way in which, with his crown of thorns set above him as though a halo, the figure lies on the cross, not attached to the nails. And nails, here expanded into chisels, remind us of how vital they became for carvers as soon as they appeared on the shoreline in driftwood in the early twentieth century. These tools revolutionized the process of carving.

This is where the concept of desire enters the equation: *bisj* pole figures are carved to commemorate specific ancestors who, in turn, incite their living followers to remember them and to fulfil their urgent desire for their death to be avenged. Thus, the carved figure unites the desires of both dead and living in a common purpose, restoring harmony in a disordered world. So strong is the identification with the Christ figure carved by Yiwirjak that it has evoked 'contagious' imitation.

Another Asmat artist, Herman Omordó, carved this second figure (Figure 7.2) photographed in repose on a pandanus mat, as though on a bier. The features are recognizably in the same genre. While there are differences – the figure faces in the opposite direction, the ribs are more schematic, the arms less tightly folded into the body, the face is less gaunt – the figure is clearly an imitation of the original. But it has one property that the original lacks, it is portable and, as a third image (Figure 7.3) shows, it exercises its personality through involvement with the living in the celebration of religious ceremonies during Holy Week. This is an ancestor come to participate in communal action, to be the object of intense desire and to offer homage to the original from which it is derived.

There is a fourth image in this series (not reproduced here), which shows a recently deceased young man from Sawa lying on a pandanus mat in the same church and placed in the same manner as in Figures 7.2 and 7.3. The relatives of the deceased asked for this photograph to be taken to commemorate his death. So the figure that first appears on the cross becomes normalized, the carving becomes an actor in the working out of ritual enactment. The figure becomes a person or rather the body of a man who has died in the village and has been laid out in symbolic style.

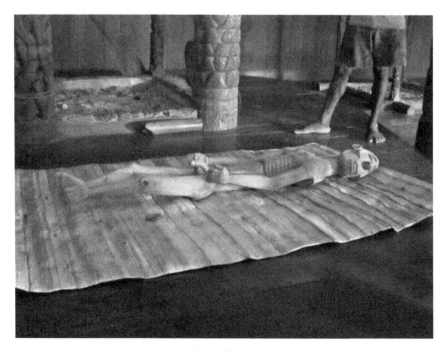

FIGURE 7.2 *Herman Omordó, Christ figure on mat, Church of Kristus Amor, Sawa, Asmat, West Papua, 2010. Photograph by Roy Villevoye.*

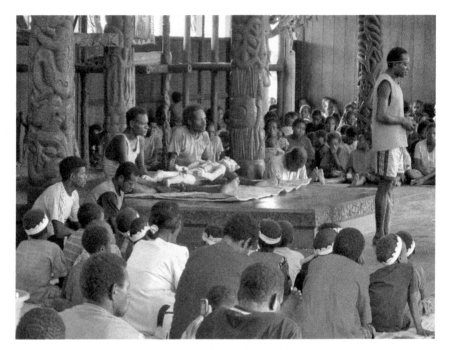

FIGURE 7.3 *Holy Week liturgy, Church of Kristus Amor, Sawa, Asmat, West Papua, 2010.* Photograph by Roy Villevoye.

Tim Ingold, in his book *Lines* argues that, when discussing style, 'the repertoire of marks forms a closed set, and since they can be combined in any number of ways to describe different schemes it seems perfectly reasonable to suppose that they add up to a notation. But it is also clear that the meanings assigned to each element, though context dependent, are far from arbitrary' (2007: 125). This is a very satisfying definition of stylistic identity. Iconic resemblances build up to a notational system that is visually encoded. In the case of the Sawa Crucifix it seems initially persuasive to place the Christ figure within the design vocabulary of Asmat sculpture. Clearly it belongs here. But the problem is that the figure refuses to be confined by such a definition, it also has to be seen as a response to the Christian iconography that has existed in its gestural form since the time of St Francis's incarnationalism, with Christ depicted in his full humanity. A well-rehearsed argument that we can use to resolve the dilemma of competing stylistic registers is by treating the central figure or motif as syncretic, containing aspects of each tradition and fusing them into something new. Indeed, *Encyclopaedia Britannica* explicitly offers a similar example of a 'syncretistic cross in Acolmán, Mexico (*c.* 1560s), with the face of Jesus Christ shown at the centre and the crossbar showing foliage representing the world tree

connecting the underworld to the heavens' ('Cross: Syncretistic Cross'). But for several reasons I argue that this is not a satisfying answer. First, Roman Catholic theology has moved on from exploring syncretic forms of belief and practice to the introduction of an anthropologically informed perspective, especially since the promulgation of 'Gaudiem et Spes' emanating from the Second Vatican Council (1962–1965). This document set the new tone by its questioning: 'What must be done to prevent the increased exchanges between cultures, which ought to lead to a true and fruitful dialogue between groups and nations, from disturbing the life of communities, destroying ancestral wisdom or jeopardizing the uniqueness of each people?' (Abbott 1966: 261). Western designed statues of saints in local garb will no longer satisfy the demands for indigenized churches. There has to be a cultural shift that embraces local belief systems and practices.

An example from Western renaissance history may offer some clue as to how we may simultaneously embrace two different perspectives. In this case what is in question is how to negotiate perceptual uncertainty; who is the viewer and who is the subject in the painting in Diego Velázquez's *Las Meninas* (1656), famously the subject of Michel Foucault's preface to his *The Order of Things*? Foucault asks us to consider the painter staring out from the canvas at us and observes, 'We are looking at a picture in which the painter is in turn looking out at us. A mere confrontation, eyes catching one another's gaze, direct looks superimposing themselves upon one another as they cross. And yet this slender line of reciprocal visibility embraces a whole complex network of uncertainties, exchanges and feints' (Foucault 1970: 4). What I like about Foucault's analysis is that no resolution is offered. We are destined to swap glances into an indefinite future.

I suggest that the insinuation of stylistic analysis of the spectators' and painter's reciprocal gaze in *Las Meninas* subjects us to a constant buffeting. On one hand we are the object of the painter's gaze as he pauses, paintbrush in hand before his canvas, and yet, when we look into the scene depicted we see ourselves already in the persons of the king and queen of Spain reflected in shadowy form in the mirror directly opposite us. So, we have to see ourselves simultaneously within two 'closed sets' with their own characteristic form of 'notation' as both present and yet absent from the picture. This induces a kind of constant oscillation on behalf of the viewer from one canon to the other (Stanley 2012: 198). This is not a comfortable experience because neither system cedes preference to its competitor: each commands our attention and respect. But perhaps that tells us something particular about the status of syncretic objects. When Asmat churchgoers contemplate the Christ figure in Sawa church, they are faced with two simultaneous perceptual demands: that of the redeemer and of the ancestor to be avenged. The cross suggests the Christian form; the disposition of the figure emphasizes its affinity with

the *bisj*. There is no way of prioritizing a specific reading; both have agency and power.

Does the object that I have offered you satisfy the conditions that Peter Weibel and Bruno Latour prescribe for 'iconoclash' – the suspension of the iconoclastic gesture in order to interrogate it and render it an interesting and problematic topic' (Weibel and Latour 2007: 95–6)? Initially it is difficult to consider the creation of the Asmat Christ figure as an attack on the original from which it derives its character (ibid.: 97). And yet it is clear that the figure does raise all three questions about representation that the authors consider fundamental: how to represent the people, how to represent objects and how to represent their collective gathering (ibid.: 98). But, at the end of the day, in my case example, while the Asmat engaged in their own enactment of the crucifixion, employing the symbolic object and giving it agency, it does not really raise the prospect of iconoclasm. It is not that one system deals with and vanquishes its opponent. There is no suspension at any time of one genre in favour of its rival. Both remain fully active. As I hope I have indicated, the figure on the cross remains a problematic item precisely because it refers as much to Asmat cosmology as to Christian doctrine; it brings a close ancestor into the ceremonial world of the church and it offends our concept of redemption by insisting on vengeance as a primary value.

As Girard concludes, the original is not only emulated but also locked in 'a rivalry generated by their similarity – a rivalry generating further reciprocal imitation and escalating the rivalry' (Harrison 2002: 213). This is a profoundly problematic position for those seeking a satisfactory resolution to uncertainty. This is why this development has not been replicated widely elsewhere in Asmat: the Christ figure in Sawa is something of a disappearing rarity. Elsewhere, as, for example, in the church at Pirimapun, local Indonesian Catholic clergy have made such Asmat carvings modest by covering the genital area with a skirt. It is difficult to avoid seeing this as in symbolic alignment with the Indonesian state programme *Operasi Koteka*, initiated in 1972, which sought to clothe West Papuans. The Indonesian state may have tried to put the people of Papua in shorts and T-shirts since then, but Asmat artists today still continue to carve their figures unclothed. Whether local clergy in West Papua, or indeed in any location where rival symbolic worlds coexist, can cope with operating in an ambiguous symbolic world remains an open question.

The crucifix in Kristus Amor retains a constant ambiguity. The plainness of the cross contrasts with tension in the Christ figure. This figure acts as a model or mediator between two symbol systems, the Christian and the Asmat world of the ancestors, locked in a rivalry generated by their similarity. The gaunt face twisted to the left avoids our gaze, refusing mutual regard or

engagement with our desire, whether it be for salvation or vengeance. We are caught between two worlds, unable to decide which model to imitate.

Acknowledgement

With special thanks to Roy Villevoye for permission to reproduce all the photographic images.

References

Abbott, W. M. (ed.) (1966) 'Decree on the Missionary Activity of the Church' and 'Pastoral Constitution of the Church in the Modern World', (*Gaudium et Spes*), *Documents of Vatican II with Notes and Comments by Catholic, Protestant and Orthodox Authorities*, New York: Guild Press.

'Cross: Syncretistic Cross' (n.d.) *Encyclopedia Britanica Online*, available online: http://www.britannica.com/topic/religious-syncretism/images-videos/Syncretistic-cross-in-Acolman-Mexico-with-the-face-of-Jesus/88450 (accessed 20 October 2013).

Foucault, M. (1970) *The Order of Things: An Archaeology of the Human Sciences*, London: Tavistock.

Harrison, S. (2002) 'The Politics of Resemblance: Ethnicity, Trademarks, Headhunting', *Journal of the Royal Anthropological Society* 8 (2): 211–32.

Ingold, T. (2007) *Lines: A Brief History*, Abingdon: Routledge.

Stanley, N. (2012) *The Making of Asmat Art: Indigenous Art in a World Perspective*, Canon Pyon: Sean Kingston.

Weibel, P. and B. Latour (2007) 'Experimenting with Representation: *Iconoclash* and *Making Things Public*', in S. Macdonald and P. Basu (eds), *Exhibition Experiments*, 94–108, Oxford: Blackwell.

FIGURE 8.1 Conopa. *Emilo Montez collections, Field Museum of Natural History, Chicago. Cat. No. 3463. Photograph by Bill Sillar. Courtesy of the Field Museum.*

8

Animating relationships: Inca *conopa* and modern *illa* as mediating objects

Bill Sillar

In the inventory of the Field Museum of Natural History, Chicago, accession number 3463 is described as a zoomorphic cup, made of stone, originating from Cuzco, Peru, and it is identified as a *conopa* (Figure 8.1). The animal depicted is almost certainly an alpaca as the four lines on the neck indicate folds of fleece, with a fringe, ears and teeth. It is 12 cm long, and weighs 324 g. There is a 2.8-cm wide, 3-cm deep vertical-sided hollow in the animal's back, giving rise to the description that it is a 'cup'. Accession 3463 is one small item in a collection of approximately 1,200 artefacts including archaeological and colonial-era ceramics, metal, cloth and stone artefacts, which were acquired by Emilio Montez in the vicinity of Cuzco. Montez, a Peruvian citizen, brought the collection to the World's Fair: Columbian Exposition held in Chicago in 1893 to celebrate the four hundredth anniversary of Columbus's arrival in the Americas. The Field Museum purchased the collection from Montez on 9 September 1893. This was two months before the end of the exposition, but a letter from Montez shows that he was eager to find a buyer as he had to return to Peru urgently (Bauer and Stanish 1990: 2–3).

Conopa were not simply stone figurines or whimsies. In the Andean highlands a *conopa* was considered to be an animate entity that was an active participant in the preparation of offerings. The objects themselves

were thought to be alive, forming part of people's communicative relationship with the sacred geography of the Andes. Spanish colonial priests considered these 'cult objects' to be a dangerous focus of idolatrous practice that they were trying to eradicate. *Conopa* and objects like them, which are now more commonly referred to as *illa*, continue to play an active role in ritual offerings and are an emotive expression of Andean ideals and aspirations. In this chapter I wish to explore a range of mediating and transforming roles that were and are played by these objects. Inca *conopa* and modern *illa* are an active link between distinct entities and ideas: between people and deities, intimacy and inaccessibility, consumption and production, household and state, animism and Catholicism, tradition and modernity, preservation and destruction, ethnography and archaeology. But this analysis raises questions about how we should use the concept of 'inbetweenness'. If we are to avoid a return to overly simplistic structuralist pairings, we need to ask what relationships particular objects mediate. By emphasizing the social role that *conopa* play in facilitating communication, and how this has changed in different historical contexts, I hope to show that they are not only a link between oppositional pairs, but also active participants and transformative agents within social networks.

Social relations between people and things: Mediating objects

People do not just have relationships with people: objects are always 'inbetween'. Human beings surround themselves with objects, and any social relationship is facilitated and expressed by the artefacts people use. Our clothes, homes and work tools are active agents in human communication. But, not all artefact–people interactions are the same, and artefacts can play multiple roles in communication (Schiffer 1999). Like people, objects can take on identities and mediate relationships. Objects can engage our emotions and evoke memories, ideas and meanings, so that things can have a 'social life' (Appadurai 1986; Merleau-Ponty [1948] 2004). Some objects acquire part of their identity from their makers or previous owners, who become 'inalienably' linked to the memory and meaning of the object (Weiner 1992). Artefacts may also have a 'secondary agency' (Gell 1998) that has an effect on other people, which may be quite independent of the original maker's intentions (Latour 1993; Gosden 2005).

Within the Andean highlands of Peru and Bolivia animistic beliefs attribute active social identities to places and things. Although Edward B. Tylor (1871) defined animism as the belief that an entity has a soul or animating spirit,

R. R. Marett (1914) critiqued the focus on a 'spirit' or 'soul' and adopted the Melanesian word *mana* to describe this vitalizing force. Equivalent Andean expressions are *camay or ánimo*, which refer to an animating force that resides in and activates living things including material objects (Bray 2009; Sillar 2009). Recent discussions of animism (e.g. Ingold 2006) have emphasized how animism may be an experienced aspect of the physical world and that the material world can be understood to be sentient, something that can be communicated with in a direct and social way. Nurit Bird-David (1999) adopts the term 'relational epistemology' to describe how animism locates people as participants in the materiality of the world who take responsibility for their relationship with animals, plants, places and things, as well as other people.

As Catherine Allen (1988: 62) has argued, 'For Andeans, all matter is in some sense alive, and conversely, all life has a material base.' Places and things are considered to be sentient with social identities, and people have a duty to care for these through their labour, moral behaviour and ritual obligations (Isbell 1978). Andean animism is most clearly expressed in relation to prominent mountains, agricultural fields, the house and the recently dead, as well as miraculous Catholic saints who have been incorporated as important players in the Andean pantheon (Bastien 1978; Allen 1988; Gose 1994). These entities have a power, or sphere of influence, that extends beyond their physical location: the ancestors and *pachamama* (the animate earth) influence the growth of crops; the *Apu* (sacred mountains) care for and maintain animal herds and some mining activities; and the saints may teach people how to weave, provide security during travel or promote good health (Sallnow 1987; Allen 1988; Gose 1994). The mountains and saints can offer benevolent productivity to those who engage in appropriate reciprocity, but they can also become malevolent and potentially violent to those who do not participate appropriately in reciprocal exchange. The mountains and miraculous saints are, however, somewhat distant bodies (Sallnow 1987; Allen 1988), so it is largely through 'lower-order' intermediaries, such as village crosses and specific offering locations, that people seek to communicate with the *Apu* and direct their offerings to more distant animate powers. Small stone *illa* and *conopa* facilitate a personal relationship between the human actors and the animate world, acting as vital intermediaries when making offerings.

Illa: The sympathetic communicative power of objects

In the Andean village of Raqchi, in the Department of Cuzco, an offering is made by most households on the night of San Luis (24/25 August) when family

members chew coca, and make libations. Watching over the preparation of this offering are the *illa*, which are carved figures, found objects and natural pebbles, some of which evoke animals, houses or crop plants (Figure 8.2). The offering itself involves preparing a sequence of small bundles of three leaves of the coca plant (referred to as a *k'intu*) that are held in the hand while blowing across the leaves to dedicate them to a named recipient. The naming of these recipients starts with the house, hearth and stores, as well as fields worked by the family, pasturelands or paths used by their animals, and the clay mines, roads and marketplaces that the household members commonly visit. After each *k'intu* of three coca leaves has been prepared and directed to the named recipient, it is placed onto a cloth or paper alongside a maize kernel and a small piece of llama fat (*vira*, a vitalizing force). One bundle of the coca leaves, fat and maize may be taken into the household patio to be burnt and another is taken to one of the household's fields where it is burnt with libations of alcohol. After arranging these burnt offerings the family members move back to the house and chew coca while the fire consumes the offering. Only later do people return to observe the ash and see if the complete burning of the offering shows it has been fully

FIGURE 8.2 *A ritual bundle with the* illa *positioned to watch over the preparation of the offering. Most of the contents of this bundle were inherited by the father of the house, when he inherited the house itself. Raqchi, Cuzco Department, Peru. Photograph by Bill Sillar.*

accepted. The household's *illa* are then stored away carefully until the next offering needs to be prepared.

As noted above, *illa* can be oddly shaped pebbles, ancient artefacts and other objects found by the household, or they may be small carved stone figures representing animals, maize cobs or houses, for example, which can be bought at annual pilgrimage sites. *Illa* are considered to be living entities that are powerful sources of animal and crop fertility. *Illa*, like people and animals, have '*ánimo*', the vitalizing energy that animates life (see Allen 1982; 1988: 60–2; Gose 1994: 115–6; Stobart 2006: 27–8; Sillar 2009). During rituals they are said to drink the *chicha* and chew the coca given in the offerings (Allen 1988: 54, 150). Although some of them are clearly carved stones of the type sold in markets, very few householders offer this as the explanation as to how their *illa* were acquired; most say that they either inherited them from their parents or found them in the fields or pasturelands. *Illa* are under the care of the household, but they are not considered to be 'owned' commodities. Rather, *illa* choose to reside with the family – and if they are lost (or stolen) it is because they have chosen to leave. In his study of contemporary Andean pastoralists, Jorge Flores-Ochoa (1976: 249) states that some herders are still using pre-Columbian carved stone animals that have an indentation in their back, which is filled with animal fat during rituals. Some *illa*, particularly the stone figures, are described as children of the mountain deities (*Apu*) (Isbell 1978; Sillar 1996). According to Flores-Ochoa's (1979: 84) informants, *illa* come from *Ukhu Pacha* (the inner world associated with the mountain deities and the dead), and emerge through caves or springs (origin places called *paqarina*), which are the source of life through which the creator god Viracocha sent the original inhabitants of the world. Because *illa* are children of the mountain *Apu* they are constantly communicating with the *Apu* (Skar 1994: 65). Thus the performance of these rituals and participation of the *illa* creates a liminal time when past and future are interacted with: the *illa* themselves evoking a mythical time of creation. During the ritual, participants remember their inheritance, dead family members and where they have been in the landscape; and the offering itself expresses both thanks for previous health and fecundity and aspirations for the future well-being of the household.

The ritual brings together a hierarchy of different entities: the recipient of the offering (e.g. *Apu* or a saint), the constituents of the offering (e.g. coca, maize or fat), material intermediaries used to help transmit the offering (e.g. *illa*), the target of concern (e.g. fields/crops, animals and households/stores) and the human actors who prepare and direct the offering. The importance of 'sympathetic magic' can be seen not just in the connection of the small stone *illa* to the mountain *Apu*, but also in how the composition of the offering brings together a wide range of important locations either by naming them during the ritual or through the orchestration of material elements used in

preparing the offering. J. G. Frazer (1915) identified two principle components of sympathetic magic. First, homeopathic magic in which like produces like, or an effect resembles its cause (which he called the law of similarity). Second, 'contagious magic' where things that have once been in contact with each other continue to influence and affect each other at a distance. This could be described as an 'inalienable character of things'. Whereas Annette Weiner's (1992) analysis of inalienable possessions focused on how objects remain connected to previous human owners, even if physically separated, Andean animism stresses how objects can communicate because of the source of their raw materials, visual representation or prior connection to a person, place or thing. Although I do not favour the term 'magic' in this context, the descriptor 'sympathetic' is a highly appropriate way of expressing the connectedness (the 'concern' or 'attachment') that is thought to exist between physically separated things. These sympathetic relationships are a primary principle of Andean ritual practice, where the components of an offering are brought together from a wide range of environments and contexts in order to influence the animate forces of the material world (Bolin 1998: 40–1; cf. Zedeño 2008). Just as people remain connected to their family through kinship obligations, so too the 'inalienable character of things' means objects continue to exert an influence on their origin or referent. Places and things are considered to have a social relatedness similar to those surrounding human kinship. For this reason the little *illa* are interlocutors that can communicate with the mountains as well as with the animal herds, crops and houses, just as the icons from pilgrimage sites are thought to communicate with 'their' origin saint. *Illa* consume the coca, alcohol, fat and maize themselves and direct these offerings to the mountain deities; they can also bring the vitalizing *ánimo* from the mountains so that herds procreate, crops are productive and humans are healthy. For this reason *illa* must be guarded and passed down the generations, usually staying with the child who inherits the family house.

Illa are not for public display, they play no overt role in any aggrandizing behaviour by the household, they are curated for private household use. Nonetheless, they play an important role in maintaining the value systems and commitments of family members. It is not primarily the physical materials or appearance of the *illa* that is important; what is important is its relationships with the animate landscape and host household. The construction of the offerings, which the *illa* bears witness to, is an emotive performance that involves the choreography of meaningful materials as well as the evocation of people, places and things that are the concern of the family (the landholdings, animals and buildings that came through the maternal and paternal lines, as well as the craft and trading activities that members of the household are engaged in). Offerings are 'sent' to named recipients through the preparation of selected ingredients with life-giving qualities that are directed to specific

locations, through the choice of materials and verbal evocation of the recipient (Allen 1982; Sillar 2009). Through the skilful process of bringing words and things together the members of the household activate sympathetic magic, and the *illa* play an essential role as intermediaries or conduits to send the offering to the recipients. One common name for these Andean offering is a *despacho* (from the Spanish word for a dispatch or shipment), as the offering is sent to the deities.

Conopa: The Inca state's insertion within household rituals

The term *illa* was in use at the time of the Spanish conquest (1533). Diego González Holguín ([1608] 1989: 366) defines *illa* in his Quechua dictionary as a notable stone that may be bright and shiny or found in the stomach of an animal, and which will be kept for riches and luck; the alternative spelling *ylla* is defined as all that is old and guarded for many years, while *yllayoc runa* is a rich person who has and guards 'tesora' (treasure). But in the period following the Spanish colonization of South America, another Quechua term, '*conopa*', was more commonly used to describe these objects. Today archaeologists, museum curators and collectors tend to restrict their use of the term *conopa* to refer to carved stone in the form of camelids with a hollow in their back. But colonial sources discuss *conopa* in very similar terms to the *illa* from Raqhi described above. According to seventeenth-century documentary sources, Spanish priests reported many individuals whom they found guarding *conopa* (Mills 1997). *Conopa* of various materials, such as wood and found stones, are described as being selected for their unusual natural colour or shape, as well as stones that were carved in the form of llamas, maize, potatoes and so forth (Arriaga [1621] 1999: 36). In some cases these *conopa* were used specifically in relation to the care of the crops and herds, whereas others were used more generally for the well-being, wealth and protection of the household (Mills 1997). The Catholic priest Pablo José de Arriaga records that *conopa* were family heirlooms, passed on from father to son, and that they were fiercely protected and regarded 'as the most precious thing that their parents had left them' ([1621] 1999: 35). 'Rare are those who do not have them, for they are the principal inheritance of the family, and sometimes they have two, three, or four of them' (ibid.: 80). *Conopa* were the focus of intimate household rituals that were held in private at particular times of the year, such as before going on a journey or beginning to sow crops (ibid.: 36). Arriaga ([1621] 1999: 50) also describes the use of coca, maize, animal fat and *chicha* (maize beer) within the offerings, the blowing of the essence and burning of

these offerings to dedicate them. Here again the *conopa*, like modern *illa*, were not part of the offerings, but witnessed and mediated the composition and directing of the offerings, and were guarded by the household for use whenever the offerings were being prepared.

Religious practices during the Inca period (1400–1533) ranged from massive public rituals in the architectural complex and ceremonial spaces of Cuzco to small-scale community and household rituals. A major focus was the devotion to *huaca*, which included large rock shrines and other sacred locales in the landscape (Cobo [1653] 1990; Dean 2010). Most *huaca* were locations for small-scale community devotional practices, although some *huaca* were visited on long-distance pilgrimages and were endowed with new buildings and priests by the Inca state. Arriaga describes many instances where *conopa* are found next to *huaca*, and he quotes Licentiate Rodrigo Hernández who discovered a stone *huaca* in the form of a falcon surrounded by many *conopa*, which represented the children or servants (*criados*) of the *huaca* (Arriaga [1621] 1999: 99), much like modern *illa* are considered to be the children of the mountain *Apu*. Similarly another Catholic priest Rodrigo Hernández Príncipe ([1621] 1923: 27) describes how herders kept their *conopa* above their old village, next to a cult place for lightning. Irene Silverblatt (1987: 199) discusses how a priest, Father Avendaño, removed a stone idol in the form of a man with five *conopa* around it that had been placed at the base of a *molle* tree near the village of Otuco. This may suggest not only that *conopa* were more openly displayed prior to the Spanish Conquest, but also that *conopa* were being placed next to *huaca* in order to benefit from the contagious effect of each other's identities. Cristobal Albornoz ([1584] 1989: 171) describes how the power of a *huaca* could be reproduced, for instance, a cloth that had been laid on the original *huaca* could be placed on a distant stone, thus transferring the *camay* (animating force) to the new *huaca*, which took on the name of the original. It seems likely therefore that the placing of a *conopa* near a *huaca* was also intended to facilitate their connectedness or communication.

I have reviewed collections of carved stone *conopa* held in various museums, including Museo Inka, Cuzco; Museo de Antropologia y Arqueologia, Lima; the Field Museum, Chicago; the British Museum, London; the Pitt Rivers Museum, Oxford; and the Museum of Archaeology and Anthropology, Cambridge. Many examples in these collections are in the shape of llamas or alpacas, ranging in length from 5 to 15 cm, and carved from a wide range of stone types, some of which have distinctive coloration and banding. A small number of the llama and alpaca *conopa* in the Museo Inka have come from secure Inca contexts in the Cuzco region, particularly from excavations in the area of Sacsayhuman, so we know that some of these objects were being produced by the Inca. The choice of stone, the size and shape of the animal, and the quality of carving is variable, suggesting that

many are 'one-offs' carved out of 'charming' stones found by non-specialists. But there are also recognizable groups made in similar forms using consistent raw materials. For instance, some highly polished fine black and dark green serpentine stone, alpacas with stylized folds representing the wool around their neck and a hollow in their back, are particularly distinctive, with examples of these in each of the above collections (Figure 8.3). A preliminary look at the elemental composition of some of these, as measured by portable X-ray fluorescence, suggests there are two distinct compositional groups representing two sources for a large number of the carved stone *conopa*. This points to fairly large-scale production, which is quite different from the rather individual relationship to 'found objects' described by most colonial sources. In the absence of a market trade within the central part of the Inca Empire, the large-scale production and distribution of these *conopa* suggests institutional involvement in their production and circulation. The large-scale production of these black *conopa* in the non-market Inca economy, and the large number of these found in and around the Inca capital of Cuzco, indicates that the state is likely to have been involved in distributing them. An association with state rituals and prestigious *huaca* would have added to the power of these *conopa*,

FIGURE 8.3 *A number of highly polished black stone Inca* conopa, *five of which are alpacas with stylized folds of fleece carved around their necks. Museo Inka, Universidad de San Antonio Abad del Cuzco. Photograph by Bill Sillar.*

and their use as gifts to trusted devotes and state workers could have been a powerful tool of apparent state largess that brought the state into the core of household identity, with the *conopa* taking Inca state institutions into the intimacy of family/household concerns.

Seek and destroy: *La Extirpación de la Idolotría en el Perú*

Andean rituals and the use of cult objects were a major concern for Spanish colonial authorities who sought to locate and eradicate indigenous religious practice. This included public *autos de fe* during which idolatrous objects were gathered together and burned or destroyed, often in the village plaza. Arriaga's ([1621] 1999) book, *La Extirpación de la Idolotría en el Perú*, is written as an instruction manual to advise other Spanish priests how to locate and root out idolatrous practice. Arriaga ([1621] 1999), Albornoz ([1584] 1989) and Hernández Príncipe ([1621] 1923) glorify in the success of the church rooting out 'diabolical idolatrous practices'. For instance, Arriaga ([1621] 1999: 23) reports that between February 1617 and July 1618 Hernando de Avendaño heard 5,694 confessions of idolatry, discovered and punished 669 'ministers of idolatry', and destroyed 603 *huaca* and 3,418 *conopa*. The Catholic church also considers some objects, such as images of saints and relics, to be an animate conduit for communication with the supernatural, and Spanish priests in Peru were aware of Protestant iconoclasm in Europe, so they would have understood the feeling of horror when the sacred objects of Andean people were destroyed. But, as *conopa* and other objects of Andean veneration were not communicating with the Christian god, many priests believed they were communicating with the devil and felt compelled to eradicate them. Although the aim of the extirpations was to root out the idolatrous beliefs of Andean people the enumeration of how many *conopa* and other objects were seized suggests that the rapacious desire of these priests to seek and destroy native cult objects became an expression of their Christian devotion. Ironically, however, in recording their 'achievements' the priests unwittingly preserved some of the most detailed accounts of native beliefs and religious practices. Neither was the physical destruction of these animate objects that easy. Not only were there many attempts to hide cult objects, including Christian converts who re-engaged in native ritual practices, but 'sympathetic magic' also made the destruction of *huaca* and *conopa* very difficult. In many incidents objects that priests had burnt or broken were rescued or their place of destruction and burial became the focus of renewed Andean offerings (ibid.: 31, 93).

During the Spanish colonial period (1533–1821), it was perilous for households to possess *conopa* and it is unlikely that these small objects would have been on open display. The ritual focus of Andean animism moved away from named *huaca* and ancestor cults. While the ceremonies of the Catholic churches and saints' cults were rapidly absorbed into native cosmologies, animistic concerns focused on the indestructible features of the landscape so that local *huaca* were replaced by a focus on the more distant mountain *Apu* (Gose 2006). Despite Spanish attempts to extinguish household ritual practices, four centuries later *illa* continue to provide a strong focus for domestic rituals. The *illa* and *conopa* provided a vehicle for the continuity of some aspects of native Andean cosmologies and cultural values, although the fact that these rites are today held in private within the security of the household may well be a consequence of the historical fear and dread of extirpation. The continuity of these practices was an act of defiance and faith in the face of physical aggression from colonial authorities, and these familial acts became a focus for cultural continuity.

At the same time, native ritual practice began to incorporate the materials, ideals and iconography brought by Spanish colonial authorities. An extirpation trial from 1656 describes how a native, Hernando Caruachin, was given a black stone *conopa* in the form of a man's face and an indentation on the back that he filled with llama fat and a small colonial coin to supplicate for good fortune (Mills 1997: 96–7). And one of the *conopa* within the Montez collection of the Field Museum is unusual in having a human face carved in a European/colonial style. Today the cloth on which *illa* are displayed is referred to as a *messa*, and when devotees raise each *k'intu* of three coca leaves and name its recipient it is reminiscent of a Catholic priest raising the bread at communion. *Conopa* continued to be made in the colonial period and the example in the Field Museum's collection with which I started this chapter (Figure 8.1) has the hollow in the alpaca's back drilled out as a vertical cylinder (unlike the Inca period hollows that are chiselled out and have concave sides); European carving techniques have been used to produce an indigenous cult object.

It might also be noted that some *huaca* were transformed into shrines for Catholic saints (Sallnow 1987). For example, the two cult sites of el Señor de Huanca and el Señor Qoyllur Riti near Cuzco attract many thousands of pilgrims to see miraculous images of Christ painted onto the rock, and here devotees buy the stone and pottery objects that become their *illa*, as well as portable copies of the miraculous images of Christ, and ingredients used for their *despachos*. The iconoclastic efforts of Spanish priests to excise indigenous 'idolatry' did not fully succeed, but rather resulted in the development of syncretic forms of ritual practice. Although most Andean communities adopted Catholicism (until more recent incursions of evangelical Protestants), many continue to

communicate with the animate landscape through making offerings. The intimate repetition of family members communing with their *conopa* and *illa* must have been an important element in achieving this integration of animism and Catholicism. A 'syncretistic' combination of native Andean concepts and European Catholicism is expressed in today's ritual practices, including those involving *illa*, which have brokered the culture clash of European colonization and now draw together the beliefs, materials and techniques of distinct cultures within the intimacy of household rituals.

Display objects: *Conopa* and *illa* as museum accessions

The display of Emilio Montez's collection of artefacts from the Cuzco area at the World's Fair and their acquisition by the Field Museum in the 1890s took place at a time when many thousands of artefacts were being looted from archaeological sites in Peru. Most of this material was coming from coastal cultures such as Moche, Chimu, Chancay, Nazca and Paracas, with much of it shipped out of Peru to be sold in auction houses and acquired by museums around the world (McEwan and Sillar 2013). Although the Peruvian highlands were not experiencing the same level of economic development and were less integrated in world trade systems, they also suffered from some looting (Gänger 2015). In the late nineteenth and early twentieth centuries many private collectors and museums sought to acquire Inca material and most collections included some *conopa*. Inca *conopa* became desirable acquisitions for tourists and collectors and, despite Peruvian and international legislation against the antiquities trade, they, alongside more recent *illa*, and modern fakes/replicas, are sold in the streets, markets, boutiques and antique shops of Cuzco and Lima, as well as via the Internet and international antiquities market. For this international audience they have the aura of exotic found objects and curiosities to be displayed in the living rooms of tourists and art lovers. Colonial documents explain that *conopa* can be almost any small natural or manufactured item (as is true of *illa* today), and the Montez collection is unusual for including a number of stones with crude faces and some lacking any ornamentation. But, today archaeologists, museum curators and collectors have restricted their use of the term *conopa* to refer particularly to the carved camelids with a hollow in their back. Part of what makes these desirable to museums and private collectors is that, unlike most Inca material culture, they have a clear representational form that appeals to 'Western' tastes, as expressed in Cara

Becker's comments on the recent National Gallery of Australia's exhibition *Gold and the Incas: Lost worlds of Peru*: 'My favourite item is a basalt Incan *conopa* . . . Subtly carved, the sculpture is sturdy, smooth and pleasing . . . it is a lovely link to an ancient culture and sparks a human conversation that spans 500 years' (Becker 2014).

Very few *conopa* in the collections of museums in Peru or elsewhere have any archaeological context recorded. This could be considered a counterpart to Andean householders who no longer recall having bought their *illa* – for collectors any knowledge of the looting of these objects from archaeological sites would be 'an inconvenient truth'. But it may also be because many have been acquired more directly from Andean households, some of which are now abandoning the ritual performance and beginning to see their *conopa* and *illa* as having a commodity value. Others are of recent manufacture, with some being made directly for the tourist and 'antiquities' market. *Conopa* are now being used for display in elite households and museums rather than being guarded under wraps for the privacy of an occasional Andean ritual.

It could be claimed that museum *conopa* have been made 'inanimate' by their removal from their original social and ritual context. They have become mere accessions in museum collections. However, even in this setting they can enchant and enthral visitors and researchers. Perhaps by recontextualizing these seemingly passive objects, as I have attempted to do here, by drawing on historical records and analogous practices in the present, these museum objects can remain animate, as are the millions of *illa* and other objects used in Andean household rituals.

Objects are always inbetween

Human agency is 'a *process* or *relationship* of engagement with a social and material world' (Gardner 2007: 103). But the material world does not just provide a medium for human agency; objects evoke memories, ideas and meanings, which gives them a 'social life' of their own (Merleau-Ponty [1948] 2004; Appadurai 1986; Jones 2007). John Robb (2004) has discussed the idea of the 'extended artefact', highlighting the complex web of interdependent relationships that things embed us in, and Alfred Gell (1998) refers to the 'secondary agency' of artefacts that can provoke reactions from people. For all these reasons objects are located 'between' or 'within' layers of social relationships, and some objects can become touchstones for contested identities and ideas. Robb (2004) argues that the degree to which an object

has a 'secondary' or 'effective' agency depends on how people perceive and engage with that object: within Andean animism *illa* and *conopa* have powerful roles as 'extended artefacts', which actively mediate many relationships.

At the start of this chapter I suggested that *conopa* were a vital link between distinct people, entities and ideas. The *conopa* mediate these relationships. Mediation is not passive; rather, objects can be active intermediaries that draw distinct entities together and help to transform the relationship between them. *Illa* are thought to originate from the mountain deities and make the sacred mountains accessible for familial communication with the greater powers of their animate world. The Inca state appears to have sponsored the production and distribution of *conopa* and subsequently the Catholic priests of the Spanish viceroyalty sought to destroy them. While *conopa* were a focus for the extirpation of idolatry and imposition of Catholicism, the continuing use of *conopa* and *illa* today combines Catholicism and animism in a syncretic process whereby households now prepare offerings that are directed towards saints and mountain deities. *Illa* and *conopa* are living entities that link and protect places, things and people that are of concern to the household. This is why *conopa* were guarded as the most precious part of a household's inheritance. The destruction of these objects threatened the network of relationships that linked households to the sources of their prosperity. Andean *conopa* and *illa* are not inert rocks, or even beautiful carvings; they are animate objects that mediate relationships between people and the living landscape.

This may seem an exotic belief to someone within an objective or scientific approach to the world. But human social relations are never just between people. We all invest our hopes and fears in objects. This includes the aspiration that a new acquisition (a computer, bicycle or house) will help to transform our lives, as well as the sentiments we attach to mementos and keepsakes. Objects are inherently inbetween both because the world is an active place where things are in constant interaction, and because humans conceive of and interpret the world in terms of relationships. All objects make connections – and all human relationships are mediated through objects.

But our perception of the world is learnt within a social and historical context. When the Inca commissioned and distributed *conopa* they were probably proudly displayed; this was very different to the defiant practice of secret household rituals conducted during the extirpation of idolatry, or the commercial value that *conopa* gained in the late nineteenth and twentieth centuries. Yet, each of these changes in significance, and the role that *conopa* played was predicated on some knowledge of their earlier connections. Indeed the *conopa* were one of the foci around which changing values and beliefs were negotiated. Exploring precisely what relationships are mediated

by particular objects, and how these relationships and the object's significance are changed in relation to their historical context, is a productive approach for future research.

Acknowledgements

I owe a continuing debt of gratitude to residents of Raqchi for allowing me to participate in and discuss their family *k'intuqwi*. I would like to thank the the Field Museum of Natural History, Chicago, and Museo Inka, Universidad de San Antonio Abad del Cuzco, for help and support as well as their kind permission to analyse a selection of their *conopa*. I thank Paul Basu for his helpful comments on an earlier version of this essay.

References

Albornoz, C. de ([1584] 1989) 'Instrucción para Descubrir Todas las Guacas del Pirú y sus Camayos y Haziendas', in H. Urbano and P. Duviols (eds), *Fábulas y Mitos de los Incas*, 16, Madrid: Historia.

Allen, C. J. (1982) 'Body and Soul in Quechua Thought', *Journal of Latin American Lore* 8 (2): 179–96.

Allen, C. J. (1988) *The Hold Life Has: Coca and Cultural Identity in an Andean Community*, Washington, DC: Smithsonian Institution Press.

Appadurai, A. (ed.) (1986) *The Social Life of Things: Commodities in Cultural Perpective*, Cambridge: Cambridge University Press.

Arriaga, P. J. de ([1621] 1999) *La Extirpación de la Idolotría en el Pirú*, ed. H. Urbano, Cuzco: Bartolomé de las Casas.

Bastien, J. W. (1978) *Mountain of the Condor: Metaphor and Ritual in an Andean Ayllu*, St. Paul, MI: West Publishing.

Bauer, B. and C. Stanish (1990) 'Killkie and Killkie Related Pottery from Cuzco, Peru, in the Field Museum of Natural History, Chicago', *Fieldiania Anthropology* (N.S.) 15.

Becker, C. (2014) 'Humble Conopa Enthrals', *Canberra Times*, 8 March.

Bird-David, N. (1999) 'Animism Revisited: Personhood, Environment, and Relational Epistemology', *Current Anthropology* 40: 67–91.

Bolin, I. (1998) *Rituals of Respect: The Secret of Survival in the High Peruvian Andes*, Austin: University of Texas Press.

Bray, T. L. (2009) 'An Archaeological Perspective on the Andean Concept of Camaquen: Thinking through Late Pre-Colombian Ofrendas and Huacas', *Cambridge Archaeological Journal* 19 (3): 357–66.

Cobo, B. ([1653] 1990) *Inca Religion and Customs*, trans. R. Hamilton, Austin: University of Texas Press.

Dean, C. (2010) *A Culture of Stone: Inka Perspectives on Rock*, Durham, NC: Duke University Press.

Flores-Ochoa, J. A. (1976) 'Enqa, enqaychu, illay y khuya rumi: Aspectos mágico-religiosos entre pastores', *Journal of Latin American Lore* 2 (1): 115–34.

Flores-Ochoa, J. A. (1979) *Pastoralists of the Andes*, trans. R. Bolton, Philadelphia, PA: Institute for the Study of Human Issues.

Frazer, J. G. (1915) *The Golden Bough: A Study in Magic and Religion*, 3rd ed., London: Macmillan.

Gänger, S. (2015) 'Collecting Inca Antiquities: Antiquarianism and the Inca Past in 19th-Century Cusco', in M. Barnes, I. de Castro, J. Flores, D. Kurella and K. Noack (eds), *TRIBUS (Special Edition): Perspectives on the Inca*, 38–48, Stuttgart: Linden-Museum.

Gardner, A. (2007) 'Agency', in R. A. Bentley, H. D. G. Maschner and C. Chippindale (eds), *Handbook of Archaeological Theories*, 95–108, Lanham, MD: Altamira.

Gell, A. (1998) *Art and Agency: An Anthropological Theory*, Oxford: Clarendon Press.

Gosden, C. (2005) 'What Do Objects Want?', *Journal of Archaeological Method and Theory* 12 (3): 193–211.

Gose, P. (1994) *Deathly Waters and Hungry Mountains: Agrarian Ritual and Class Formation in an Andean Town*, Toronto: University of Toronto Press.

Gose, P. (2006) 'Mountains Historicized: Ancestors and Landscape in the Colonial Andes', in P. Dransart (ed.), *Kay Pacha: Cultivating Earth and Water in the Andes*, 29–38, Oxford: Archaeopress.

Hernández Príncipe, R. ([1621] 1923) 'Mitología Andina', ed. C. A. Romero, *Inca* 1: 25–68.

Holguin, D. G. ([1608] 1989) *Vocabulario de la lengua general de todo el Peru llamad Lengua Quichua o del Inca*, Lima: Universidad Nacional Mayor de San Marcos.

Ingold, T. (2006) 'Rethinking the Animate, Re-animating Thought', *Ethnos* 71 (1): 9–20.

Isbell, B. J. (1978) *To Defend Ourselves: Ecology and Ritual in an Andean Village*, Austin: University of Texas Press.

Jones, A. (2007) *Memory and Material Culture*, Cambridge: Cambridge University Press.

Latour, B. (1993) *We Have Never Been Modern*, Cambridge, MA: Harvard University Press.

Marett, R. (1914) *The Threshold of Religion*, London: Methuen.

McEwan, C. and B. Sillar (2013) 'La Arqueología Británica en el Perú en los Siglox XIX y XX', in H. Tantaleán and C. Astuhuamán (eds), *Historia de la Arqueología en el Perú del Siglo XX*, 409–42, Lima: Instituto Francés de Estudios Andinos.

Merleau-Ponty, M. ([1948] 2004) *The World of Perception*, trans. O. Davis, London: Routledge.

Mills, K. R. (1997) *Idolatry and Its Enemies: Colonial Andean Religion and Extirpation, 1640–1750*, Princeton, NJ: Princeton University Press.

Robb, J. E. (2004) 'The Extended Artefact and the Monumental Economy', in E. DeMarrais, C. Gosden and C. Renfrew (eds), *Rethinking Materiality: The Engagement of Mind with the Material World*, 131–9, Cambridge: McDonald Institute of Archaeological Research.

Sallnow, M. J. (1987) *Pilgrims of the Andes: Regional Cults in Cusco*, Washington, DC: Smithsonian Institution Press.

Schiffer, M. B. (1999) *The Material Life of Human Beings: Artifacts, Behavior, and Communication*, New York: Routledge.

Sillar, B. (1996) 'Playing with God: Cultural Perception of Children, Play and Miniatures in the Andes', *Archaeological Review from Cambridge* 13 (2): 47–63.

Sillar, B. (2009) 'The Social Agency of Things? Animism and Materiality in the Andes', *Cambridge Archaeological Journal* 19 (3): 367–77.

Silverblatt, I. (1987) *Moon, Sun and Witches: Gender Ideologies and Class in Inca and Colonial Peru*, Princeton, NJ: Princeton University Press.

Skar, S. L. (1994) *Lives Together – Worlds Apart: Quechua Colonization in Jungle and City*, Oslo: Scandinavian University Press.

Stobart, H. (2006) *Music and the Poetics of Production in the Bolivian Andes*, Aldershot: Ashgate.

Tylor, E. B. (1871) *Primitive Culture: Researches into the Development of Mythology, Philosophy, Religion, Language, Art and Custom*, London: Murray.

Weiner, A. (1992) *Inalienable Possessions: The Paradox of Keeping while Giving*, Berkeley: University of California Press.

Zedeño, M. N. (2008) 'Bundled Worlds: The Role and Interactions of Complex Objects from the North American Plains', *Journal of Archaeological Method and Theory* 15: 362–78.

FIGURE 9.1 *Mangbetu-style pot in Idrissou Koutou's workshop. Foumban, Cameroon, July 2012. Photograph by Silvia Forni.*

9

Visual diplomacy: Art circulation and iconoclashes in the Kingdom of Bamum

Silvia Forni

This story begins with a pot: a clay vessel terminating with two elongated female heads (Figure 9.1).

Anyone familiar with African art would immediately recognize it as a typical example of a Mangbetu-style vessel. Mangbetu ceramics are iconic objets d'art found in important African art collections in Europe and North America. Yet despite their undeniable status as prized and canonical examples of African ceramics, these jugs are the result of the history of intercultural dialogue, diplomacy and market demand, which characterized the Belgian Congo at the turn of the twentieth century.

As demonstrated by Enid Schildkrout and Curtis Keim (1990), anthropomorphic art, including stylized representations of the figures and heads of Mangbetu people, was produced in the north-eastern territories of today's Democratic Republic of the Congo (DRC) at the beginning of the 1900s. These artworks were mainly a form of diplomatic currency, used by local elites as markers of prestige and commissioned by chiefs as gifts for European colonial officers. Anthropomorphic pots were probably produced by male Mangbetu or Zande potters working in Niangara, a town populated by artists from the different ethnic groups of the region and by European colonial administrators and travellers (Schildkrout, Hellman and Keim 1989: 41). Looking at early twentieth-century collections of Mangbetu art in Belgium, the

United Kingdom and, in particular, at the well-documented anthropomorphic pieces that Herbert Lang collected for the American Museum of Natural History between 1909 and 1915, Schildkrout and Keim (1990: 257) suggest that this type of art flourished for a couple of decades and then dwindled due to the decline of the use of artworks as a form of political currency in this region. However, the style continued to be reproduced for the tourist market by artists living in the more accessible southern areas of the country (ibid.: 254). Even at the peak of their popularity, these objects were just a small part of the overall regional artistic production, which was mostly composed of non-figurative artworks for local use and consumption. Nevertheless, it is precisely this rather marginal diplomatic art, deeply informed by the colonial encounter, that has been selected by art collectors and the market as the 'classic' representation of Mangbetu artistic excellence. Rather than expressions of essentialized Mangbetu aesthetics, then, this anthropomorphic pottery is a paradigmatic example of art as a form of mediation between the different aesthetic, political and intellectual agendas characterizing the colonial encounter in north-eastern Congo.

What complicates my story further, however, is the fact that this particular 'Mangbetu' pot was not found in the DRC, or in a European or American museum collection originating from the 'scramble for art' of the turn of the twentieth century. Rather, I found this pot drying in the living room of Idrissou Koutou, a Cameroonian potter whom I have visited often over the last few years. Idrissou is a master potter in Foumban, a medium-size town in western Cameroon, known since early colonial times as one of the richest art-producing centres of the region. Given the striking temporal and geographical distance separating the original examples from my field 'discovery', in this chapter I wish to investigate the different mediations and movements that have inspired a twenty-first-century ceramic artist to revisit a hybrid-yet-canonical art style from a different region and a different era.

To address these issues, I believe we need to look at global markets and trends as well as the history of Foumban as an art-producing centre in the Cameroonian Grassfields. While this history is clearly specific to this location and region, it may be read as a typical example of the complex interactions, feedbacks and market forces that have shaped, and continue to shape, 'traditional' African art production in many villages, towns and cities across the continent.

International relations and material exchanges

Located 70 km east of the regional administrative centre, Bafoussam, Foumban is known as the capital of the Bamum kingdom, the largest and arguably

the best-known kingdom of the Cameroonian Grassfields. A narrative of the kingdom's history written under King Njoya's supervision at the beginning of the twentieth century shows that the political success and visibility of this kingdom – at regional, national and international levels – was achieved progressively since the nineteenth century, through not only strategic warfare and assimilation, but also the careful control of the production, preservation, exchange and display of art objects.[1] Indeed, the history of the Bamum kingdom is rich in stories of art creation and invention.

As often happens with centralized, hierarchical societies in Africa and elsewhere, the Bamum kings, who by the mid-nineteenth century led the expansion of the kingdom to its largest extent, were eager to secure the services of the best artists in the region for the court. Through his skill and prowess in warfare, King Mbuombuo (r. 1825–1840 c.) established the kingdom's boundaries to their current extent, repelling the attacks of Fulbe warriors from Banyo, and establishing an elaborate court hierarchy and an easily recognizable aesthetic of power, which clearly identified status and privileges. After a period of turmoil, with a troubled and rapid succession of kings and usurpers, Mbuombuo's grandson, Nsangu, was enthroned around 1870.[2] Under King Nsangu, the arts celebrating the court, the royal family and other notables developed and thrived. Many beautiful pieces from this era are found in European and American collections, as well as in the Palace Museum in Foumban. However, there is little doubt that the key figure responsible for the exceptional flourishing of Bamum art was King Njoya, who succeeded to the throne as a very young monarch around 1886 and reigned through a period of great social and political transformation, including the expansion of European interests in the region (Geary 2011: 20). During Njoya's reign, which lasted until 1931, Bamum artistic production and markets developed on an unprecedented scale. This period also saw the consolidation of European control over Cameroon, which dramatically transformed the diplomatic arena in which the various kingdoms of the Grassfields could establish their relative supremacy and importance. A young man when the first German colonial administrators and missionaries reached Foumban, Njoya was eager to engage directly in a relationship with foreign powers to strengthen the political standing of his kingdom and glean innovations that could be absorbed into local practices to improve the organization of the kingdom and its regional, national and international status. The production and circulation of art was one arena of innovation in which Njoya directed his creative impulse (Tardits 1980; Geary 1983). On one hand, he made strategic use of his privileged access to materials, forms and symbols to foster the production of high-quality royal artworks, displaying the iconography reserved for the palace. On the other, he promoted the creation of products that evolved into new forms of commercial art, such as brass figurines, drawings and carved narrative boards displaying an iconography and style different to that of traditional palace arts, which

have become trademarks of twentieth-century Bamum art (Geary and Xatart 2007: 140–8).

In the Grassfields, art had been an object of diplomatic exchange and commerce well before the arrival of the Europeans. In his seminal work *Open Frontiers* (1973), Rene Bravmann regards this region as a typical example of stylistic permeability beyond ethnic or linguistic boundaries. According to Ian Fowler (1997: 66) the consistency in the material culture found throughout the region was the result of centuries of warfare, alliances, market relations and diplomatic exchange among polities of different cultural and linguistic origins. The architectonic, material and aesthetic similarities between different groups in the Grassfields region, which struck the Germans at the time of their arrival in the late nineteenth century, suggested that, despite their fierce independence, the kingdoms of the Grassfields shared a number of visible cultural traits that clearly distinguished them from their southern and northern neighbours. Carved architectural elements, cloth, beads, masks, bags, pots and musical instruments were prized goods to be acquired and displayed. Art objects and skills were used to negotiate status both within a kingdom's hierarchy and between kingdoms. Fowler (ibid.: 67) argues that 'no one is innately Grassfields; rather one becomes more or less Grassfields relative to one's position in the regional structure of exchanges and the opportunity that this presents'.

As the monarch of the largest kingdom in the region, Njoya had a wealth of materials and skills at his disposal to employ in his negotiations with the Germans administrators, explorers, collectors and missionaries in Foumban at the beginning of the 1900s. Njoya strategically leveraged his control of the most prestigious workshops and materials to promote the creation of very high-quality beaded stools, pipes, headdresses, bags and a variety of other artworks (Geary 2011: 49–59). The iconography and materials of the objects produced in the workshops associated with the palace expressed the locally defined visual language of hierarchical privileges, which determined rather strictly the type of objects, material and symbols that could be used exclusively by the king and other palace authorities. Because the king himself commissioned them, these objects, which conformed to local sumptuary laws, could be used as gifts and tokens of alliance. For Njoya these elite creations were a way to initiate or reinforce diplomatic relationships with the foreign authorities and institutions that had established control over western Cameroon. At the same time by fostering the production of new prestige items for diplomatic exchange, he was able to protect important sacred objects from being collected and shipped abroad and to maintain control over the kingdom's treasures and the symbolic hierarchy connected to royal personal and ceremonial objects. While Njoya's shrewd use of innovation and creativity garnered him the favours of the German colonial administrators and

missionaries, his relationship with the French administrators, who took over after 1916, was not as positive (Geary 1983, 2011; Loumpet-Galitzine 2006). It is interesting to note that art also played an important role in determining the fate of the king's authority. The palace treasures and material privileges became a locus of political struggle between Njoya and his Christian rival, Mosé Yéyab, who worked as a translator for the French colonial administration (Figure 9.2).

Competitive displays and commercial entrepreneurship

With the establishment of French rule over Bamum territory, the king and the court started to face more direct challenges to their authority than they had under German rule. Colonial opposition and a more radical adoption of Islam after 1916 altered public displays and celebrations that had previously affirmed the spiritual and ritual power of the monarch and the elite. Important annual celebrations such as *nja* and *ngwon* were transformed or banned, and the progressive political isolation of the court undermined traditional patronage

FIGURE 9.2 *Mosé Yéyab with some of his collection in front of his museum. Photograph courtesy of Christraud Geary.*

and sumptuary laws.[3] In a rather pragmatic move, Njoya assumed leadership over change and proclaimed new legislation that relaxed control over the sale of and access to prestige goods, allowing artists to work for not only the kings and foreigners, but also a broader segment of the local society (Njoya 1952: 129ff.).

As a way of contrasting the political supremacy of the palace and asserting a new kind of authority based on his privileged connection to colonial functionaries, Yéyab, who belonged to a lineage of notables, accumulated a collection of objects that he kept on display in his household. Many of the pieces in Yéyab's collection reflected the new commercial focus of Bamum art. However, he also acquired several beaded stools, pipes, bags and other regalia that had previously been exclusively reserved for members of the royal family or palace authorities. Yéyab's defying and competitive use of regalia display culminated in the creation of the Musée des Arts et Tradition Bamum that he founded in Njissé, an area close to the Protestant mission where many former palace artists had opened their workshops and stores (Geary 1983: 294). Njoya was able to counter this desacralizing act by actively transforming part of his own collection – the kingdom's treasure that contained several magnificent objects by then somewhat disempowered by colonial intervention – into a palace museum. By putting on display objects that were once an exclusive and highly regulated privilege, Njoya was not able to reaffirm the sacredness of his role, but he did re-establish the material supremacy of the court vis-à-vis any external collection and affirmed the central role of the palace as a gateway to the appreciation of the highest examples of Bamum art. The iconoclastic efforts of Yéyab and the colonial administration were, however, not yet over. In 1929, Yéyab orchestrated a further attack on the symbolic control that the king and traditional elite still held over the rich material culture of the Bamum kingdom. At that time, he was directly involved in the public display of the sacred instruments belonging to the king and to the regulatory societies associated with the palace, access to which was hitherto a matter of not only status, but also spiritual initiation. These were objects whose power resided in the mystical rights that regulated their possession and in the ritualized context of their appearance. Their public exposure was intended as the final desacralization and disempowerment of the king and the palace hierarchy, and an act that prefigured Njoya's decline. In 1931 Njoya was exiled to Yaoundé, where he died in 1933. Yet his legacy is still strongly held in Foumban, where, despite the great political and social transformations that reconfigured the role of local rulers throughout the Republic of Cameroon, the king and his palace continue to be a centre of influence in local and regional politics.

The first three decades of the twentieth century are also a key period for understanding how Foumban became such an important centre for the

market of African art. If, on one hand, local politics and power struggles had a very obvious and explicit material component, with collections and museums becoming the visible markers of deep social transformation, on the other hand, this period also saw the active engagement of Bamum traders in the commodification of these same artworks for the international market.

Christraud Geary (2011) writes about several German collectors and researchers who acquired astounding numbers of objects during their sojourns in Foumban at this time. Particularly telling are the words of Bernhard Ankermann who, in 1908, reported:

> Bamum has by far surpassed my expectation; as a town it is extraordinarily rich in really splendid pieces fit for collecting. Naturally they are more expensive than anywhere else and many of them one can only get for cash. But one can get almost anything for cash (quoted in Geary 2011: 55).

At the time when Ankermann was collecting and writing, sales to foreigners were still regulated by the king and the palace authorities, who had a strong economic and symbolic hold over what could be sold. A few years later, by the mid-1920s, the lifting of sumptuary laws opened up production to a much larger group of artists and the art market to any willing buyer. Furthermore the long-lasting relationships with foreign missionaries, dealers, curators and functionaries meant that local merchants and workshops were already aware of the increasing commercial interest in African artworks and the formation of an African art canon in the West. In a letter to the director of the Peabody Museum written on 5 January 1930, missionary George Schwab who was collecting in Foumban for the museum gives a detailed report of his purchases and the fundamental mediatory role played by Mosé Yéyab. In the missive he also relates Yéyab's request for ' "a book with plenty pictures in English, French, or German" – all of which he reads and talks, on African art, "with plenty, plenty, pictures" '.[4] One can only speculate on Yéyab's use of the many images that were successively sent to him by the museum.[5] What is clear, however, is that already in the early years of the creation of Foumban's artist colony in the Rue des Artisans in the 1920s, brokers and artists were aware of the broader semantic and conceptual field of African art that was being constructed and defined in Western markets and institutions. If the market conditions at the turn of the twentieth century had put Foumban on the map as a good destination for art collectors, today Bamum traders control the vast majority of the art market throughout the Republic of Cameroon. Yet this market expansion is not just related to an increase in scale, but also grounded in important reconfigurations of the meaning and role of art in Foumban and elsewhere in Africa.

Ambiguous objects and iconoclashes

Several historians of Bamum have discussed different aspects of the material competition between Yéyab and Njoya. In this chapter, I consider this 'war of symbols' (Nelson 2007: 27), which reveals the highly political and communicative role of objects and collections, as a key historical precedent for the understanding of contemporary art production and marketing in Foumban. A useful theoretical framework to analyse this trajectory is provided by Bruno Latour's introduction to the 2002 exhibition *Iconoclash*.[6]

Latour's concept of iconoclash can be employed to describe historical and more recent evolutions in the production and circulation of Grassfields art. For Latour (2002: 22) iconoclash does not simply define a conflict over the nature and function of images, but evokes ambiguous situations in which it is difficult to interpret univocally the act of image-making or image-breaking. Njoya's innovative attitudes towards technical and aesthetic inventions and the power struggle with Mosé Yéyab, epitomized by the establishment and display of competing collections of regalia and the flourishing of artistic workshops around the palace and along the Rue des Artisans, are historical tensions that have set the tone for more recent developments. As we have seen, the first decades of the twentieth century were both a moment of great creative impulse and a period of active dismantling of icons and symbols in Foumban. From this perspective, I see an interesting relationship between the image-related conflicts and reconfigurations that have unfolded over the last hundred years and the extraordinary inventiveness and 'market savvy' of contemporary producers and traders.

The iconoclashes at the time of Njoya's reign determined increases in production, the diplomatic role, public display and commodification of Bamum art. This process laid the foundation for a radical change in the forms and meanings of the artworks themselves. As mentioned, during the nineteenth and early twentieth centuries, the assimilation of artists from conquered groups and the circulation of artworks through regional networks had promoted the development of a very particular Grassfield 'style', whereby a shared iconographic and symbolic pool was employed for the creation of a broad range of works over a vast area, crossing political and linguistic borders. Regional prestige of art-producing centres determined the circulation of objects and the adoption of a consistent regional aesthetic that could be interpreted and modified locally, creating a web of semantic variations on common themes.

The historical context described so far is essential for the understanding of artistic production in Foumban today. Notwithstanding significant historical continuities, though, the contemporary scenario presents further radical shifts,

insofar as the iconographic and symbolic pool inspiring the work of Bamum and other Grassfields artists derives from a commercial and symbolic network of exchange that goes far beyond regional and national boundaries. Despite the enthusiasm of early ethnographers and colonial officers, who secured large collections for a number of German, Swiss and, later, French museums, Cameroonian art was never particularly popular with Western collectors. The bold forms and volumes that clearly identify traditional Grassfields art have historically been less attractive to Western tastes than other central or western African styles. While there are exceptions, Grassfields artworks fetch lower prices in auctions and gallery sales than, for example, Luba, Baule, Fang or Mangbetu pieces.[7] The lesser appeal of Grassfields art is not just a phenomenon detectable in high-end auctions and galleries, but also very much felt by Bamum traders and artists, who often declare that Cameroonian art 'is really hard to sell'.[8] In addition, the significant increase in scholarly research and art catalogues over the last four decades has resulted in a much keener awareness, on the part of Foumban artists and traders, of the iconic, canonical African art styles that appeal to Western collectors. It is not surprising, then, that the successors of those artists who invented new regalia to embody the innovative vision of King Njoya or new commercial art forms to satisfy the needs of Western educated urban elites were ready to embrace the stylistic and formal challenges proposed by the richly illustrated catalogues of African masterpieces celebrated in the West. Bamum artists today pride themselves in being exceptionally skilled and versatile.[9] A walk through the galleries and workshops that occupy a vast area around the palace or the Rue des Artisans almost feels like an introductory course in African art: Igbo masks, Kongo *nkisi*, Benin plaques and leopards, Fang *bieri*, Yoruba *ere-ibeji*, Kota reliquaries, Djenne figures and Mangbetu pots are just some of the many artworks that fill the shelves of local outlets, all proudly and, in most cases, un-deceptively made in Foumban (Figure 9.3). And here one can detect another form of iconoclash.

According to Latour (2002: 19) we can talk about iconoclash 'when there is uncertainty about the exact role of the hand at work in the production of a mediator (image)'. In this context the omnivorous stylistic appropriation enacted in Bamum workshops creates a certain level of uncomfortable iconographic ambiguity for anyone familiar with historical stylistic traditions. Clearly Mangbetu pots produced in a Foumban workshop for South African, American or European customers have only a superficial resemblance to their historical referents. These pots do not epitomize the cultural superiority of Mangbetu leaders at a time of tense colonial negotiations. In a similar way, a Bamum-produced Fang *byeri* is functionally very different from the ancestral figures of the Fang, and cannot be interpreted as an access point to the complex realm of Fang metaphysical and religious world views. However,

FIGURE 9.3 *Selection of artworks for sale in one of the galleries of the Artisanat du Centre, Foumban, Cameroon, July 2013. Photograph by Silvia Forni.*

these objects' function as symbolic mediators is not lost. The mediation here is not between conflicting political powers or metaphysical realms, yet they quite aptly create the material link between the abstract concept of African art developed in the West and the reality of art production in a contemporary Cameroonian town. The blatant incongruity between the 'hand at work' and the iconic reference of the image produced unveils the economic and political conceptual underpinnings of Western canonical definitions. In more than one way, the images produced in this new context are iconic in their own right. If we accept, as Latour suggests, that an image is a sign that acts as a mediation to access something else, then it is quite easy to see that the pan-African creations of Foumban artists are a concrete and self-conscious actualization of the canon of African art informed by the selective filter of Western tastes and preferences.

V. Y. Mudimbe succinctly pointed out over three decades ago that 'African art' is a concept the invention of which needs to be traced within the historicizing and aestheticizing perspective of Western art history of the last two centuries (1986: 4). Notwithstanding, this concept is today all but an imaginary construct. De facto, since the beginning of the twentieth century, prestige, religious and domestic objects produced by artists of mostly western

and central Africa have been subsumed into the Western 'art-culture system' (Clifford 1988: 189–214) in which they have been canonized and absorbed into an elite art market that values uniqueness, antiquity and authenticity. Christopher Steiner (1996: 213) compares the canon of African art to the Indian caste structure, a closed system where inclusion and exclusion are based on strictly determined parameters, with high prestige accorded to a small group of artworks while pieces that do not conform are relegated to the rank of 'untouchables' (see also Forni 2011).

Despite decades of scholarship that have provided us with a deeper and more sophisticated emic understanding of African artworks and their diverse contexts of production and circulation, admission into the canon of African art is still predicated on a definition of authenticity that excludes any self-conscious market intentionality on the part of the maker. Within this realm of aesthetic objects not made for sale yet introduced in a regime of – at times, remarkable – market value after their acquisition on the part of Western collectors, certain stylistic traditions are in higher demand and therefore more valuable. In his recent analysis of African art sales based on a decade of Sotheby's auction results, Eric Nemeth (2011: 132) reports a noticeable increase of average sale price and a marked market preference for objects from the Democratic Republic of Congo, Ivory Coast, Nigeria, Mali and Gabon. While Nemeth – a financial and security analyst – sees in these trends an indication of increased risk of looting in the source nations, I see in the first place a striking consistency with the production trends of Foumban's art workshops. As clearly explained to me by Nji Tapche, a successful art dealer with a large international network, the high-end auctions set the parameters for market trends and it is very important to have in stock pieces that recall the works sold at Sotheby's, if one wants be sure to sell well.[10]

Yet clearly the canonically informed artworks made in Foumban would never be considered part of the canon that they reflect. While their status is for the most part unambiguous when investigated in the workshops and in many of the galleries in Foumban, their existence as 'spurious' objects produced by the 'wrong' hands, in the 'wrong' context and for the 'wrong' reasons cannot be considered anything but a threat by the sustainers of the essential 'otherness' and fundamental 'purity' of African art. Little does it matter that this purity is more a projection of Western longing than an historically proven reality of the original contexts of production of many pieces in Western collections. Indeed, the bold adaptability demonstrated by many contemporary artists and workshops working in traditional styles is in many circles considered proof of the ultimate degeneration of African aesthetics and cultural values. This is a complaint that I have heard expressed with different nuances by dealers and collectors of 'classic' African art, many of whom have never had a direct experience of the cultures and peoples whose art they collect and admire.

What my interlocutors find upsetting in these contemporary pan-African works is not just their status as commodities, but also the fact that they are created in quantity, for purely decorative purposes rather than for religious or ceremonial use. They are thus void of the canonical 'mysterious' and 'mystical' aura still so apparent in the fascination that many Western collectors have towards African art. It does not matter that these objects are often reflective of artistic skill and that they are in the great majority of cases individual and personal interpretations rather than copies of known masterpieces. The creative and artistic impulse driving the artists is less a criterion of evaluation than the perceived presence or absence of commercial motivation in the production of the artwork. These images are unsettling precisely because they point to an economic culture of strategic creativity and market savvy that contrasts with the still enduring stereotypes about 'authentic' African cultural patterns. The invented tradition (Hobsbawn and Ranger 1983) of African art, which sustains the multimillion-dollar high-end market of Western cultural capitals, such as Paris, London and New York, is, in fact, predicated on a perceived absence of market awareness at the producing end and on the conviction that anything produced as a commercial piece is a sign of erosion and degeneration of local culture and traditions. It matters little that today many scholars have demonstrated the adaptability, openness and commercial relevance of many 'traditional' pieces. Much of the attraction that African art exerts still resides in its perceived radical otherness, while the restrictive parameters of authenticity also have a much more mundane but rarely discussed effect of protecting the market value of the 'original' pieces whose value increases exponentially as they become more difficult to acquire on the market since they are by now almost exclusively in the hands of important Western collectors and institutions.

What emerges once more is the oft-quoted paradox for which the only true African artists are those who never intended to produce African art, while contemporary Bamum artists, who work and invent within the parameters suggested by the canon, can at best be defined as iconoclasts. For Latour (2002: 26), iconoclasts are not just those individuals who intentionally attack and destroy images, but also those who fight images that are frozen or isolated from the flow of life and meaning. This refusal to focus on the frozen image, to isolate it and remove it from the flow of life is a drive for many Bamum artists who appropriate the styles celebrated by the canon and imbue new life and creative potential in the otherwise rigid container of traditional African art. As stated by Salifou, a ceramic artist working behind the Rue des Artisans, 'I make Djenne, Yoruba, Mangbetu, Mambila. I can make any style. My favorite though is Mangbetu. I like to think of the container, and of the people who inhabit it. I shape my ideas in that style. I create my own stories.'[11]

From this perspective, contemporary artists in Foumban are somewhat iconoclastic creators of non-canonical art that mirrors and transforms popular canonical African art styles. For the purist collectors of 'authentic masterpieces', this is a meaningless aberration that has nothing to do with the 'true' meaning and function of African art. Yet, their work seems remarkably fitting of the historical trajectory outlined at the beginning of this chapter. If we recall Geary's analysis of the role and strategic use of artworks in the events that marked the rise and demise of King Njoya's political authority, it is not difficult to see that the seeds of today's vibrant art market were already all there.

Semantic brokerage and canonical inventions

Some of the seminal work on commercial and tourist art of the 1970s and 1980s had taken a semiotic approach to understanding the cultural values of these productions. Objects made for external markets were compared to simplified forms of communication between image producers and image consumers (Jules-Rosette 1984) or vehicular languages such as pidgin (Ben-Amos 1977). The work produced today in Foumban goes beyond the localized meanings still predicated in these early linguistic models of tourist art. The artists in Foumban are not making a simplified version of local pieces for an international clientele, they are appropriating the essentialist aesthetic and formal language that has been recognized as the marker of canonical African art and reinterpreting it through their personal inspiration and skill. This process of feedback clearly could not be possible without the cultural brokerage of the hundreds of art dealers that commission and acquire enormous quantities of artworks to sell both locally and internationally.

As convincingly demonstrated by Steiner (1994), traders are crucial players in determining trends and possible outlets for the creative efforts of artistic workshops. In this the situation appears quite different from that encountered by early collectors in the Grassfields. At the turn of the twentieth century the king of Bamum and the palace authorities were the privileged cultural brokers in control of relationships, communication and material exchanges with foreigners. Today this role is open to any entrepreneurial individual, although, in Foumban, there are usually very strong and direct family connections between artists and dealers. Both along the Rue des Artisans and around the palace, many of those who sell artworks are related to the makers or users of the objects they sell. Although there are no formal kinship restrictions regulating the access to a workshop, both art-making and trading are forms of knowledge that tend to be transmitted along family lines. Nji Salifou Njikomo, for example,

is one of the most important art dealers in town (Gebauer 1979: 121; Geary and Xatart 2007: 141). His three-story house in Njinka, just beside the palace, is filled with artworks that range from contemporary commercial pieces to antiquities similar to those he has sold to important international collectors. Njikomo is the descendant of generations of brass casters historically connected to the palace and today engaged in the production of an eclectic range of works, from elaborate monumental pieces for state authorities, local elites and Western collectors, to miniature objects easily sold as souvenirs throughout the country and beyond. For over forty years Njikomo has been a successful maker and cultural broker of the contemporary art scene. Although, in his old age, he is no longer producing artworks, his children and younger relatives have taken up his trade, and continue to practice lost wax casting and trading according to the family tradition. Even if the brass used in today's casting is obtained from scrapped machine parts and not from the manillas and ingots that were once a staple in the long-distance trade, the production process remains remarkably consistent.

What is more remarkable is that, apart from bracelets and a few modern commercial adaptations of traditional iconography, such as spider or double-headed snake key rings, the majority of the workshops in Njinka and along the Rue des Artisans are now making artworks in Benin style. As explained to me by Seidou, the head caster in one of the largest Njinka workshops, this is currently the style that is most sought after by both local elites and international clients. While leopards come in different sizes and are sold in great numbers through local outlets, where they are usually introduced to customers as symbols of success in hunting granted by a vaguely identified king to exceptional warriors and hunters, the large, almost monumental Oba statues and plaques are produced for local hotels and establishments, European and American customers, and, increasingly, Nigerian traders. Here, the narrative accompanying the pieces, which is considered an integral part of the attractiveness of the artwork, is usually framed in terms of celebration of traditional royal power and awareness of contemporary design needs. Mahomed, a young caster and trader son of Njikomo, showed me a very large (c. 2x2 m) version of a Benin plaque that he was in the process of finishing for a Belgian customer and that was lying in the courtyard of his compound in Njinka. This work, which had been occupying him and his brothers for several months, was clearly inspired by classic Benin plaques, but had by then taken on a new life and material identity as a contemporary African art piece. Mahomed was aware that the original plaques from Nigeria were small. He explained, however, that they were a way of highlighting the extraordinary powers of the Nigerian kings who commissioned them. The large plaque will be a door in the house of a wealthy man: 'This too is a sign of power', Mahomed elaborated, 'the casters in Nigeria worked for the king because he

was powerful and wealthy . . . We do the same, only the market is bigger now and we can work for whomever pays us . . . To acquire this piece you must be an important person, because it is very expensive.'[12]

One further element recurring in many of my conversations with artists and dealers was the desire to provide a narrative that made sense of an object in its context of use, whether it be a vaguely defined traditional past or an imagined use and function of the work in its future context of acquisition. Contemporary Bamum casters producing Benin pieces have, for the most part, a very superficial knowledge of the courtly structure of the ancient Benin kingdom, of its kings, its guilds and its place in African art history. However, they engage with the material, the form and the style of Benin artwork, imbuing each dimension with creative meanings that become shared stories presented to customers as adding value to the piece. Gallery owners tirelessly repeat phrases such as, 'Let me tell you the story of this piece . . . If you hear the story, you may need to buy this' in order to attract customers and inspire them to buy one of the artworks on display. And here too, the story, very much like the artwork, is a creative reinterpretation of traditional knowledge, anthropological narratives and historical facts pieced together in a plausible although for the most part invented story.

One very clear example relates, again, to the Mangbetu pot. In the market, this type of jug is almost consistently presented as the *cruche de succession*, a mystical container used to hold and determine the successor to the title of family head. Just as Salifou the potter thinks of these containers as being inhabited, so the dealers at the market imbue them with meaning connected to traditions that never existed, but that make sense, in local terms, of the possible use of such striking anthropomorphic containers. What is at play here, I argue, is not just a ruse at the expense of the unknowing customers. While narratives are certainly created to sell, in reality this quest for sense is as much a quest for local artists, dealers and customers as it is a ploy to provide the foreign customers with what they are looking for. As Ranger (1983) points out, invented traditions are not just something imposed from the outside, but also developed and embraced locally and reified through discourse and practice.

In a similar way, these stylistically exogenous pots, which are increasingly more common than containers made in the Bamum style, are de facto part of local material culture and are being invested with new meanings and symbolic functions. While I have not been able to document a household head succession ritual where such pots are used, many other commercial objects have by now become common in the decor of palaces and prominent households. Thus, Congo-style *minkisi* are found in the treasures and public displays of many palaces in the western and north-western regions of

Cameroon; from Bafoussam to Bafut, Igbo figures stand alongside typical Grassfield-style commemorative figures; while the entrance of the palace of Batoufam, a small kingdom about 80 km west of Foumban, is surmounted by a Punu-style female mask that has been chosen as a framing piece in virtue of its evocative aesthetic. According to the palace carver at Batoufam, a young man trained in Foumban who has an atelier and shop in the palace, this choice was based on the desire to highlight the social and spiritual importance of women in local society. As he explained, 'I know that the style is Punu, but it is clearly a woman. In our tradition, we do not have masks that clearly represent women. This one conveys the message very clearly, it is made by a Batoufam sculptor. It is our mask.'[13]

Blurred boundaries and contaminated taxonomies

In *The System of Objects*, Jean Baudrillard suggests that stripping an object of its complex layering of social functions is an essential prerequisite of the self-reflexive desire to possess that is at the base of collecting. 'The collection', he states, 'offers us a paradigm of perfection . . . within a space where the everyday prose of the object-world modulates into poetry, to institute an unconscious and triumphant discourse' (Baudrillard 1994: 7). The triumphant discourse that for over a century has removed African objects from their context of use and transformed them into the embodiment of Western longing for purity and origin is at the core of the restrictive rules that determine the value of these objects as collectibles. From the vantage point of the Western art market, value, authenticity and ultimately meaning are predicated on a closed system, which cannot be transformed unless it bursts (Steiner 1996). The closure of the system emerges particularly in its formal avoidance of any possible contaminations with traditional-looking artworks created after the international African art market was developed. Yet, paradoxically, it is this closed system that continues to inspire the production of thousands of artists operating in Africa today.

Despite their appearance, the canonically inspired commercial objects produced for the local, tourist and international markets are anything but a closed and fixed repetition of meaningless forms removed from the flux of daily life and simply aimed to satisfy outsiders' tastes. They are pieces shaped by multiple feedbacks, commodification and use. Although they are not conceived for specific rituals or local performances, these objects are reconnected to their spiritual aura through invented market narratives, and inspired by the almost religious quest for authenticity and spiritual meaning

that the Western collectors have identified as the inescapable marker of the art of others. If in the market interaction these artworks are refetishized for Western consumption, their function as mediators is not limited to this setting. Considering decades of creative thinking and skill applied to these stylistically diverse artworks, it would be simplistic to reduce this production to a form of outward communication. When absorbed into local practices, these commercial artworks reflect the ongoing traditions and new inventions that shape the cultural landscape of the contemporary societies of the western and north-western regions of Cameroon. Just as society changes and transforms, so do aesthetic sensibilities and the awareness of a discourse of African identity. This is not just an abstract concept, but also materially expressed through apparently foreign objects that become intertwined with local histories narrated in market stalls and increasingly in compounds and palaces. Thus by choosing a pan-African aesthetic to symbolize and enact contemporary Cameroonian culture, artists, dealers and consumers are continuing with a well-rooted historical tradition of strategic appropriation and visual diplomacy, while at the same time clashing with the almost religious and inflexible tenets of the African art canon worshipped in the West.

Notes

1 The text *Histoire et Coutumes des Bamum* was translated in 1952 by Pastor Henri Martin from an original written under the king's supervision using an indigenous form of writing developed by King Njoya at the beginning of the 1900s. Besides the history compiled by Njoya (1952), I draw my account of Bamum historical events from Geary (1983, 2011), Loumpet-Galitzine (2006) and Tardits (1980, 2004). Warnier (1985), Perrois and Notué (1997) and Fowler (1997) provide a number of historical examples of the importance of exchange networks in creating a region-wide visual and artistic consistency throughout the Grassfields.

2 A detailed account of the royal succession and historical expansion of the kingdom is found in Tardits (1980).

3 According to Geary (1983: 126), *nja* – a spectacular harvest festival described in early colonial sources – was last celebrated in 1918 when the French administration took full administrative control over the kingdom. The *ngwon* celebration was banned in 1924 when the colonial government prohibited tributes to the king. This celebration was reconstructed and reinstated in 1976 as a biennial event and is still observed today.

4 Peabody Museum, Harvard University, (PM) 30–2, Letter to Dr Hooton from George Schwab, 5 January 1930. I am most grateful to Jonathan Fine for sharing this archival source with me.

5 Peabody Museum, Harvard University, (PM) 30–2, Letter from Donald Scott, Assistant Director, Peabody Museum, to George Schwab, 15 March 1930.

6 This theoretical framework has been applied to a broad range of settings by contributors to a special issue of the journal *African Arts* edited by Peter Probst (2012). Particularly thought provoking and relevant to the discussion of the Cameroonian context presented here are the contributions of Strother (2012), Nevadomski (2012) and Cameron (2012).

7 The 'Bangwa queen' sculpture from Cameroon, once part of the Helena Rubinstein collection and photographed by Man Ray, was sold for US\$ 3.4 million in 1990, setting a record price for African art, which was not surpassed for over a decade. However, it is easy to argue that this extraordinary price was influenced by the important modernist pedigree of this specific piece than by an increased market interest in Cameroonian artworks.

8 Interviews with Souleman N. (Foumban, August 2011), Moustapha M. (Foumban, July 2012), Salifou N. (Foumban, July 2012).

9 Interviews with Idrissou K. (Foumban, August 2011 and July 2012), Salifou N. (Foumban, July 2012), Ibrahim N. (Foumban, August 2011).

10 Interview with Nji Tapche (Foumban, July 2013).

11 Interview with Salifou N. (Foumban, July 2012).

12 Interview with Mahomed N. (Foumban, 13 July 2013).

13 Interview with Ibrahim (Batoufam, 12 July 2013).

References

Baudrillard, J. (1994) 'The System of Collecting', in J. Elsner and R. Cardinal (eds), *The Cultures of Collecting*, 7–24, London: Reaction Books.

Ben-Amos, P. (1977) 'Pidgin Languages and Tourist Arts', *Studies in the Anthropology of Visual Communication* 4 (2): 128–39.

Bravmann, R. A. (1973) *Open Frontiers: The Mobility of Art in Black Africa*, Seattle: University of Washington Press.

Cameron, E. L. (2012) 'Coming to Terms with Heritage: Kuba Ndop and the Art School of Nsheng', *African Arts* 45 (3): 28–41.

Clifford, J. (1988) *The Predicament of Culture: Twentieth Century Ethnography, Literature and Art*, Cambridge, MA: Harvard University Press.

Forni, S. (2011) 'Ambiguous Values and Incommensurable Claims: The Canon, the Market and Entangled Histories of Collections and Exhibits, *Critical Interventions* 7: 150–9.

Fowler, I. (1997) 'Tribal and Palatine Arts of the Cameroon Grassfields: Elements for a Traditional Regional Identity', in J. MacClancy (ed.), *Contesting Art: Art, Politics and Identity in the Modern World*, 63–84, Oxford and New York: Berg.

Geary, C. M. (1983) *Things of the Palace*, Wiesbaden: Franz Steiner Verlag.

Geary, C. M. (2011) *Bamum*. Milan: 5 Continents.

Geary, C. M. and S. Xatart (2007) *Material Journeys: Collecting African and Oceanic Art, 1945–2000*, Boston, MA: Museum of Fine Arts.

Gebauer, P. (1979) *Art of Cameroon*, Portland, ME: Portland Museum of Art.

Hobsbawn, E. J. and T. O. Ranger (eds) (1983) *The Invention of Tradition*, Cambridge: Cambridge University Press.

Jules-Rosette, B. (1984) *The Message of Tourist Art: An African Semiotic System in Comparative Perspective*, New York: Plenum Press.

Latour, B. (2002) 'What Is Iconoclash? Or Is There a World beyond the Image Wars?' in B. Latour and P. Weibel (eds), *Iconoclash: Beyond Image Wars in Science, Religion and Art*, 13–28, Karlsruhe: Center for Art and Media.

Loumpet-Galitzine, A. (2006) *Njoya et le royaume bamoun: Les archives de la Société des missions évangéliques de Paris, 1917–1937*, Paris: Karthala.

Mudimbe, V. Y. (1986) 'African Art as a Question Mark', *African Studies Review* 29 (1): 3–4.

Nelson, S. (2007) 'Collection and Context in a Cameroonian Village', *Museum International* 59 (3): 22–30.

Nemeth, E. (2011) 'Art Sales as Cultural Intelligence: Analysis of the Auction Market for African Tribal Art', *African Security* 4 (2): 127–44.

Nevadomsky, J. (2012) 'Iconoclash or Iconoconstrain: Truth and Consequence in Contemporary Benin B®and Brass Castings', *African Arts* 45 (3): 14–27.

Njoya, Sultan (1952) *Histoire et coutumes des Bamum rédigées sous la direction du Sultan Njoya*, trans. Pasteur Henri Martin, Douala: Memoires de l'Institut Francais d'Afrique Noire.

Perrois, L. and J. P. Notué (1997) *Rois et sculpteurs de l'Ouest Cameroun: La panthère et la mygale*, Paris: Karthala.

Probst, P. (2012) 'Iconoclash in the Age of Heritage', *African Arts* 45 (3): 10–13.

Schildkrout, E., J. Hellman and C. Keim (1989) 'Mangbetu Pottery: Tradition and Innovation in Northeast Zaire', *African Arts* 22 (2): 38–47 and 102.

Schildkrout, E. and C. Keim (1990) *African Reflections: Art from Northeastern Zaire*, Seattle: University of Washington Press.

Steiner, C. B. (1994) *African Art in Transit*, Cambridge: Cambridge University Press.

Steiner, C. B. (1996) 'Can the Canon Burst?', *The Art Bulletin* 78 (2): 213.

Steiner, C. B. (2002) 'The Taste of Angels in the Art of Darkness: Fashioning the Canon of African Art', in E. Mansfield (ed.), *Art History and Its Institutions: Foundations of a Discipline*, 132–45, London: Routledge.

Strother, Z. S. (2012) 'Iconoclash: From "Tradition" to "Heritage" in Global Africa', *African Arts* 45 (3): 1–6.

Tardits, C. (1980) *Le royaume bamoum*, Paris: A. Colin.

Tardits, C. (2004) *L'Histoire Singulière de l'Art Bamoun: Cameroun*, Paris: Afredit.

Warnier, J.-P. (1985) *Echanges, développement et hiérarchies dans le Bamenda pré-colonial (Cameroun)*, Stuttgart: Franz Steiner Verlag.

Hybridity in form and function

FIGURE 10.1 *Large gourd with Maya profile carved by Luís Ayuso of Muna, Yucatán, Mexico, 2011. Photograph by Mary Katherine Scott.*

10

Mediating between Mayas and the art market: The traditional-yet-contemporary carved gourd vessel

Mary Katherine Scott

The object before you is a gourd made by Luís Ayuso, an artisan who self-identifies as Maya from the Puuc region of Yucatán, Mexico: a rural, hilly area in the south-western part of the state known for its numerous Maya archaeological sites dating to the ninth and tenth centuries (Figure 10.1). The gourd is round, lightweight and hollow, and approximately 10 inches tall, with a diameter of 12 inches. It has been painted black with several thin layers of varnish on its surface. These layers have been subsequently chiselled away using an electric rotary tool to create a high-contrast, low-relief image producing an effect that is similar to that of the black figure vessels made by the ancient Greeks. The imagery on this gourd vessel depicts a stylized rendering of a male face, carved in profile with flowing hair. To his right is a variant of the *ahau* hieroglyph, meaning 'king' or 'ruler', but in this form it refers to the day of the same name on which the end of a twenty-year cycle, or *k'atun*, would typically fall. According to ancient Maya tradition, on this day the king would participate in rituals to celebrate the passing of this *k'atun* period and to solicit the continuing beneficence of the gods towards his people. The imagery presented on this gourd does not originate from a single source, such

as a ceramic painting or stone carving, but is rather a combination of stylized images from different pre-Columbian sources.

This carved gourd and others like it are sold as handicrafts, or *artesanías* as they are called in Yucatán, which are a kind of tourist art. The category of *artesanías* differs from *arte popular* (popular or folk arts) in that it refers to those handmade objects by artisans that are created with the intention of being sold to the international tourists who visit the region. Both folk arts and *artesanías* are 'Maya' in the sense that they are made using traditional processes, but *artesanías* also tend to replicate or reinterpret pre-Columbian Maya imagery in a variety of materials. In addition to making replicas, artisans specializing in *artesanías* modify traditional object forms, making typically functional items decorative (and vice versa) or deliberately combining unrelated figures and styles from across the Maya region into composite souvenirs. Such hybridization of form and function communicates mixed messages to tourists about the greatness of the Maya past through the altered and synthesized display of some of its highlights.

To find pre-Columbian Maya imagery carved on a gourd, then, is not unexpected. Plain, unembellished gourds have been used as containers among Maya peoples since pre-Columbian times, and so represent an aspect of traditional culture. Once carved, however, they function as commodities for their principal buying audience, composed primarily of North American and European tourists who come for one- or two-week tours of the Puuc region and surrounding areas. Consequently, gourds have undergone some interesting transformations during the process of commoditization, with resulting changes in meaning and value for both producers and consumers. As objects that mediate between these two groups, they communicate a long history of Maya knowledge about the significance of gourds in domestic and ceremonial settings. They also serve to bridge the gap between traditional lifeways and the demands of local commercial art markets patronized by international tourists.

It is important to note that the relatively small handicraft industry concentrated in the Puuc region is very different from other large-scale handicraft and tourism industries that exist at the archaeological zone of Chichén Itzá, for example, or on the opposite side of the peninsula at the beach resort of Cancun. The difference in scale is a direct result of the higher numbers of tourists who visit these locations each year compared to the much lower numbers in the Puuc region. It follows that where Cancun might have hundreds of artisans and thousands of vendors regularly operating in the city centre alone, the Puuc region has a fraction of these numbers. There are very few (around six) in this region who consistently work with gourds for the handicraft market, which in turn are sold by just a handful of local vendors if not the artisans themselves. As such, discussions

here represent a focused case study of the Puuc region and should not be compared with other, larger handicraft industries elsewhere in the peninsula (e.g. Castañeda 1996, 2004a, 2009; Re Cruz 2003, 2008; Heusinkveld 2008; Papanicolaou 2011).

In this chapter I begin by summarizing the history of gourd usage among Maya peoples to situate its transition to a contemporary art object within its cultural and historical contexts. In addition to the gourd discussed above, made by Luís Ayuso, I consider other examples carved by his cousin, Pedro Ayuso, and a fellow wood and gourd carver, Russel Xool (both from the Puuc region), to explore regional trends and contexts. In subsequent sections, I analyse how carved gourds made for tourists can be considered hybrid objects in terms of their form and function, and how this 'inbetween' status communicates diverse meanings to different audiences. The agency of carved gourds and the ways that they mediate between different groups of makers and buyers are also explored. Throughout these discussions, I examine how carved gourds represent their makers' creative responses to globalization, and argue that certain dichotomies need not be fixed or absolute, but rather are fluid and flexible. They are acknowledged or ignored depending on the needs and desires of the different individuals who make, buy or sell carved gourd vessels.

History and usage of gourds

Fragments of gourd vessels have been found in archaeological sites in Mexico dating from 7,000 to 5,000 BCE (Heiser 1979: 81). Whereas the nobility and aristocracy of the ancient Maya world had access to polychrome ceramic vessels for their serving utensils, especially for banquets and rituals, gourds were the domestic serving tools of the masses. Apart from the few pieces of painted and stuccoed gourds that have been found in archaeological contexts (see Moholy-Nagy, Coggins and Ladd 1992: 359–68; Summit and Widess 1997: 57), most of the fragments that have survived are plain and undecorated, and there is little evidence to suggest that gourds were ever carved among the pre-Columbian Maya of Yucatán, or, for that matter, elsewhere in the Maya region. This is due to the fact that carving makes some types of gourds porous and therefore unusable as containers (Moholy-Nagy et al. 1992: 359–68; see also Summit and Widess 1997: 116).

In addition to their utilitarian value, gourds were also spiritually embedded in ancient Maya culture. The tree gourd, which is not a true gourd but the fruit of the calabash tree (*Cresentia cujete*), has a strong mythological role in the Quiché Maya sacred book, the *Popol Vuh*, where it features prominently in the

legend of the Hero Twins and their quest to save their father, the Maize God, from the Lords of Xibalba, the Underworld (Heiser 1993: 26–7; Tedlock 1996).

This long tradition of gourd usage has continued within Maya communities in non-urban areas in both domestic and ceremonial spheres, though it is not as widespread as it once was. Until the use of plastic became commonplace in Yucatán in the 1960s and 1970s, an individual would keep a gourd cup – called a *jícara* – for ten years or more, making it, by today's standards, an environmentally friendly vessel. Indeed, during a visit in 2010, I observed that Pedro Ayuso was quick to describe this ecological aspect as a marketing strategy to a group of Italian tourists visiting his shop. This was in an effort to appeal to 'green living' ideas that are becoming increasingly popular, especially among visitors from developed nations around the world.

Yet, the domestic use of the gourd vessel is on the decline among rural Maya people. This is due in part to the high availability and cheap prices of plastic and other mass-produced materials. The time- and labour-intensive process that is required to prepare a gourd vessel is another large factor, as it involves drying, soaking, scraping and polishing a gourd over a period of weeks to months depending on humidity levels and other climate-related factors. However, in the villages that are still fairly secluded in eastern Yucatán, people continue to use gourd vessels in their homes as primary culinary utensils. For example, during the five weeks in 2006 and again in 2008 that I spent studying the Yucatec Maya language in the monolingual village of Xocen, near the urban centre of Valladolid, I noticed that gourds remained a preferred storage and serving vessel. Commercially manufactured ceramic and plastic plates, cups and bowls are also used, but gourds are always favoured in certain activities over other materials. For instance, the people of Xocen use gourds as portable water containers (*chuuj*) and as small, wide-mouthed cups for mixing maize gruel (*jícara*) while working at their agricultural plots. Perhaps most importantly, large gourds with holes cut in the top (*lek*) are present in every home to keep tortillas warm. Due to the material properties of the gourd, the *lek* allows air to escape in small quantities, which means that the heat of the tortillas will not produce a build-up of condensation that would cause the hot tortillas to become soggy. The plastic tortilla containers that are used in other, more urban areas of Yucatán have this problem, requiring users to place absorbent cloths or paper towels with the tortillas, but this has the adverse effect that the tortillas can become too dry, hard and inedible in a just a few hours. Xocen is not a tourist destination, and the use of the gourd in this case is not an intentional performance of an idealized identity or culture. Rather, the gourd is a locally available resource that continues to serve local needs more effectively than the commercially manufactured equivalent. Additionally, in rural areas throughout the Yucatán peninsula, the Puuc region included, gourds remain important ceremonial objects in the various seasonal

agricultural rituals (e.g. the *Ch'a Chaak*) that are performed prior to planting a field.

The strong historical and mythological roots of gourds in Maya culture explain in part why they have become an attractive source material for artistic elaboration among some Maya artisans in the Puuc region. They know that tourists locate authenticity and cultural value in an object by learning from the artisan-vendor what the piece represents, both in an historical context and within contemporary usage (Steiner 1994: 158). This exchange between individuals, then, is one way that souvenirs are imbued with value for the tourist. As Susan Stewart (1984: 147) notes, souvenirs 'acquire their value only within the context of [a particular] narrative; without such a narrative, they are . . . meaningless'.

Clarification on how I use the terms 'souvenir' and 'authenticity' is necessary, as they are central to the arguments presented in this chapter. I define 'souvenirs' as those meaningful and easily portable objects that tourists purchase or acquire through their travels (Graburn 2000: xii–xiii). In this way, they become part of the tourist's narrative and serve to authenticate for others his or her experiences in a foreign place (Stewart 1984: 134; Hitchcock 2000: 5). Similarly, I use 'authenticity' to refer to what tourists believe to be faithful to a society's traditions, language, material culture or outward appearance. Authenticity, however, as a cultural construction, is negotiable and can be assigned to newer traditions depending on what the individual traveller desires of his or her touristic experience (see Cohen 1988). The souvenir, then, appropriates the distance between a past experience (the source of the authenticity) and the present, in effect becoming the new point of origin for the tourist's narrative as the memories of the experience fade (Stewart 1984: 136, 147; see also Steiner 1994).

The inbetweenness of carved gourds

Pre-Columbian Maya imagery carved on a gourd vessel visually recalls the Maya civilization of the past. The juxtaposition of this imagery with the gourd's materiality and its inherent associations with history and domesticity also allude to the waning traditions of contemporary Maya peoples, preserved in a portable and economical souvenir for tourists. Unlike artisans specializing in woodcarving (see Scott 2009) or even ceramics, who regularly produce both replicas and special commissioned pieces for particular clients, gourd carvers make mostly non-commissioned pieces in a range of price points (from 100 to 5,000 MX pesos, or around £4–£230) to suit diverse audiences. In this way, the carved gourd at the beginning of this chapter exists in an inbetween

space. It is a hybrid object that is both 'art' and 'artefact', a stubborn distinction that persists among scholars despite convincing arguments against it (e.g. Clifford 1988: 224; Gell 1996). It is also an object that represents past and present, and lies within both traditional and contemporary creative practices. Yet it challenges these binary designations by appealing simultaneously to international tourist buyers and, increasingly, to local middle- and upper-class consumers in Yucatán's cities, a situation that indicates a shift in the way that Maya art and culture are perceived among cultural insiders.

Foreign tourists and even local buyers are not the only ones who seek a multilayered souvenir to encapsulate Maya culture. The hybridization found in gourd crafts, as with examples in other media, may also be a way for artisans to negotiate how they want to present themselves to the outside world. If artisans knew that tourists would buy only one souvenir during their travels to Yucatán, how could they ensure that it represented all the subtleties of Maya culture, past and present? More importantly, why would they care? Unlike the pan-Maya movements of Guatemala, the people of Yucatán are still exploring what it means to be Maya in a postcolonial era. With the ubiquity of the Internet and mobile phones, even in the most rural of areas, previously isolated villages are increasingly connected to global trends in fashion, popular culture and ways of thinking, which become part of their own identity as Maya people. Even within the ten years since I began working in the Puuc region, villages in this area have transitioned from having no access to mobile or Internet coverage to being very connected to these and other associated technologies. Now, almost every person has a mobile phone, a Facebook account and other forms of digital communication.

In these ways, I suggest that the carved gourd serves as a cultural metonym for Yucatán's local populations and the inbetween space they occupy as a colonized and postcolonial people who acknowledge a shared identity with the culture of their colonizers (e.g. Taussig 1993). They recognize that preserving their traditions and cultural knowledge is important for local identity formation, but the need to preserve may contradict their desires to better their own situations by modernizing. Whether this takes the form of buying a new piece of technology or learning English, they want to be part of the global community.

Although economic gain is a primary goal among local people working within the tourism industry in the Puuc region, for some, tourism may also be responsible for them establishing connections with and finding new value in Maya culture, whether through the development of local sites for tourism or through the opportunities tourism offers artisans to sell their *artesanías*. Aline Magnoni, Traci Ardren and Scott Hudson (2007: 359–60), for example, have observed that this revaluing of local culture is especially true among a younger generation of intellectuals and activists in Yucatán. From my own fieldwork and

research around the state, I have found that this is also true among *mestizo* middle- and upper-class professionals who have the resources to invest in Maya art and culture to decorate their homes and enrich their lives through theatre and musical performances. These individuals are concentrated mostly in urban areas, particularly in Mérida, the state capital. There are others from rural areas who migrated to cities in order to pursue secondary, vocational and higher education studies, or to find higher paying jobs in the service sector. After living in the city for some time, they become accustomed to speaking Spanish as a daily language and dressing in Western-style clothing, and once assimilated, few return to the Maya-speaking, rural villages of their youth. However, they maintain a nostalgia for the imagery and traditions that shaped their experiences growing up and may return to purchase locally made *artesanías* or wearing *huipiles* and other traditional types of Maya clothing in their old age.

Interestingly, this revaluation also exists among the rural, comparatively poor and largely uneducated (few attend beyond primary school) people who live near the archaeological sites that tourists visit in the Puuc. These individuals, many of whom work in the service or labour sectors associated with the local tourism industry, are in regular contact with not just tourists, but also local and foreign archaeologists and academics. This relationship encourages them to locate value in both the culture and history of the pre-Columbian Maya people who built the nearby pyramids, and in the ceremonies, language, oral histories and other traditions that those living in the Puuc continue to practice today (see also Castañeda 1996: 69–77; Kroshus Medina 2003: 361–2).

This cultural revaluation, identity exploration and inbetweenness presents itself in the handicrafts where artisans combine Maya or other pre-Columbian images into one object or design when in fact these images have origins that are temporally and geographically distinct. These instances evince a 'hybridity of form', such that a single object exhibits a mixture of pre-Columbian cultures, timelines and styles that are possibly combined with contemporary artistic techniques and other designs. Deirdre Evans-Pritchard (1993: 18) has observed such hybridization of form among Costa Rican artisans who produce works primarily for a tourist market, noting that 'they regularly change designs while keeping the piece recognizably Pre-Columbian in style' and mix together different symbols. In this way, she argues that 'the buying public can have a symbolically rich, if not authentic, object', allowing the artisans to exercise their creativity 'while staying within the confines of a Pre-Columbian format' (ibid.; see also Graburn 1976: 3–21). In the Puuc case, such an amalgamation makes these kinds of handicrafts collectively more appealing for tourists who have become familiar with specific iconic images via their own travels in Mexico, or through exposure to this imagery in popular media sources, such as tourism marketing or Hollywood films. The carver Russel Xool, for instance,

FIGURE 10.2 *Gourd with carved imagery from Maya ceramic vessel 'Kerr 5164', made by Rusel Xool of Muna, Yucatán, Mexico, 2014. Photograph by Mary Katherine Scott.*

replicates and stylizes well-known pre-Columbian Maya imagery from ceramic vessels, stone carvings and codex illustrations on the surface of his gourds. These designs transfer well to the new material due to the linear quality of the original paintings or carvings (Figure 10.2).

Puuc artisans, however, do not only carve Maya and pre-Columbian imagery into their gourds. Pedro Ayuso, for example, also experiments with Native American, Egyptian and New Age designs, such as insects, footprints, spirals, and solar and lunar symbols (Figure 10.3). The deliberate combination of a locally significant Maya object – the gourd vessel – with multicultural and unrelated figures and styles, which he finds in issues of the *National Geographic* magazine or pulls from the Internet, further collapses the Maya/ Other binary as well as the past/present chronology. The carved gourd vessel is thus imbued with new meanings that are no longer about Maya, or even Mesoamerican, cultural idiosyncrasies. This hybridization of form seems to be more a marketing ploy to attract and satisfy the diverse tastes and preferences of the tourists who pass through the Puuc region, and may have little to do with artisans' intentions to reinvent the Maya – or their material culture – as transcultural and globally connected.

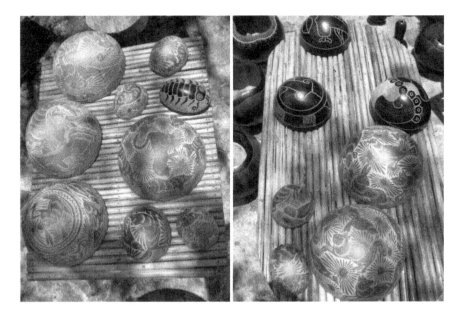

FIGURE 10.3 *Examples of carved gourds with animal and insect imagery sold by Pedro Ayuso of Muna, Yucatán, Mexico, 2011. Photograph by Mary Katherine Scott.*

These juxtapositions may seem to contradict each other in theory, but in practice they demonstrate effective marketing and the popularization of Maya culture to international tourists. Consequently, what could be viewed as a bastardization of Maya culture and history merely for commercial gain might instead be regarded as an artisan's successful navigation of local art markets. One's ability to promote Maya heritage in a way that is attractive to outsiders, even if this representation differs somewhat (or quite a lot) from the reality of many Maya people, still brings attention, esteem and an injection of money to this region that would otherwise not exist. Ultimately, through the handcrafted and hybridized souvenirs they purchase, as well as through their interactions with artisans, tourists gain insight into what it means to be a contemporary Maya person in the Puuc region and they can compare how this reality relates to their own lives in the United States, Europe and elsewhere.

In addition to hybridity of form, the modification of an object's primary function in its local context is another example of hybridization. The hybridization of function occurs when some kind of utilitarian or otherwise useable feature that did not exist in a given object has been introduced for the purpose of commoditization (or the reverse, adding an overtly decorative element to a generally utilitarian item). In reference to his gourd designs, Pedro Ayuso explained to me:

There is no limit in what one can engrave, or draw into these fruits . . . It is a really nice material that, in the future, I'm thinking about making earrings. I want to make necklaces, bags, purses, and belts for women with this material. That is, I still have room to experiment with this fruit.

Of the two main types of gourds used to make vessels in the Puuc region, the tree gourd (*Cresentia cujete*) from the calabash tree and the vine gourd (*Lagenaria siceraria*), only the vine gourd, with its very thick shell, remains watertight after it is carved. As such, the decorative elements added to the vine gourd's surface combined with its primary purpose as a container hybridize its function. While it still could be used as a culinary container by the tourist who purchases it, it is unlikely as they would risk sullying it and cracking or damaging its detailed imagery. Consequently, although it still exists, its utility value is replaced with its value as a decorative object along with other souvenirs collected by the individual.

Unlike vine gourds, tree gourds become porous on being carved, and the petroleum-based paints and stains that Luís and Pedro use to decorate them can also soak through the thin walls. In this case, once carved their function is reassigned rather than hybridized, as the gourd loses its primary function (as a drinking vessel) and gains another (as a decorative object). As commodities for the tourism industry, the tree gourd's function shifts to something that is meant to be displayed and admired in the tourist's home. Also interesting to consider is the way that tree gourds are traditionally prepared: they are cut in half so that each gourd makes two cups (*jícaras*) for drinking maize gruel. When converted to tourist commodities, all of the incised decoration appears on the convex exterior, or the part that would normally be cupped in the hands and hidden from view. Their hybridization of form and function is emphasized in local Yucatecan shops when they are displayed upside down in order to show potential buyers the carved imagery, thus concealing the interior cup that is the foundation for their utility and importance among the Maya.

Karen Stevenson (2008: 159), in her reflections on hybridity in art, has found that 'hybrid' is a catch-all term for the mixing or blending of ideas, imagery or cultures, and has been overused in academic circles and popular culture.[1] For her, it has come to embody a 'variety of meanings, depending on the context', ultimately becoming its own stereotype that can lead to misrepresentation (see also García Canclini 1995: xxiv; Coombes and Brah 2000: 1). However, hybridity can and should be thought of in a positive way for it encourages overlap and the mixing of ideas, cultures and other things that would normally be considered contradictory. By its very nature, hybridity removes the fixation on categorization. For this reason, it can serve as a useful analytical tool for unpacking the different methods of cultural representation among indigenous peoples operating within local tourism industries. Yet the reassigned

and hybridized forms and functions found in carved gourds should not be viewed as derivative kinds of cultural expressions. Instead, they represent a progressive way to think about a material that has strong associations with Maya culture and has been adapted to the changing preferences of both local and international audiences.

Agency, messages and mediation

Maya identity, and specifically its classification and politicization in Yucatán, constitutes an inherently complex issue. Artisans living in historically Maya areas in Yucatán may or may not self-identify as 'Maya', but they are receptive to the ways their culture is perceived by outsiders. Popular media sources, the film industry and even tourist guidebooks and advertisements exaggerate and conflate aspects of Maya culture, past and present, for entertainment purposes (see Lerner 2011). But as Quetzil Castañeda (2004b) and Magnoni et al. (2007) have shown, using 'Maya' as a blanket term to refer to those primarily rural and Yucatec-Maya speaking individuals who live in the state today presents numerous problems. 'Maya' was primarily used by early Spanish colonizers as a way to categorize the indigenous people as racially different from themselves. During the colonial period, it became a derogatory identifier used by the Spanish to impose further separation based on class and socio-economic status. The negative associations with being 'Maya' during the colonial period have persisted, making local people reluctant to identify publicly as 'Maya' or of a 'Maya' heritage, despite some localized efforts to re-embrace this cultural identifier (Castañeda 2004b; Magnoni et al. 2007).

Complicating matters further, locals who work in or otherwise benefit from the tourism industry often identify as 'Maya' in the presence of tourists. They present themselves as living within a traditional culture and engaged in local customs and belief systems and connect themselves to pre-Columbian Maya peoples. These same identifications are not necessarily emphasized within their local communities, which places their outward identifications as 'Maya' to tourists as a kind of 'staged authenticity' (MacCannell 1973). Likewise, for strategic reasons, artisans emphasize this pre-Columbian connection in their work to appeal to tourists' preferences for certain kinds of imagery (i.e. exhibiting a 'Maya' style) over others, which are reflected in the available *artesanías* (Stewart 1984: 150). These strategic marketing tactics and cultural representations aimed at tourists construct misleading understandings of what constitutes Maya culture today, as if its value lies in how closely it

preserves various recognizable and static images or ideas associated with different aspects of the Maya past.

With this in mind, carved gourds and other local Puuc *artesanías* can serve many functions for those who acquire them. For instance, they may be exotic souvenirs that tell of the purchaser's adventures travelling in Mexico. They also demonstrate the consumer's knowledge of Maya culture by his or her ability to describe how the object was made, or to interpret the various elements in its design or iconography that he or she learned from the artisan-vendor. For other collectors these objects might act as talismans that are conduits for mystical forces that New Age Tourists seek to harness through rituals on-site at Chichén Itzá (*Incidents of Travel in Chichén Itzá* 1997). These tourists believe that objects made by Maya people, as well as the ancient structures of their ancestors and surrounding lands, are charged with spiritual energy associated with the rituals performed long ago by the pre-Columbian Maya. Finally, for others, carved gourds might represent high-quality craftsmanship that speaks to the buyer's refined judgement and taste. In this last example, the buyer might imbue the gourd with certain meanings that take on qualities of its original carver. That is, the value the buyer attaches to the gourd is personified so that the carved imagery on the gourd's surface represents, for the buyer, not just the technical mastery and talent of the maker, but also the maker himself.

Pedro Ayuso, for example, always signs his work using his electric router tool and often in the presence of the buyer. Signing *artesanías* is rare among Puuc artisans, with the few exceptions existing among particular artisans working in woodcarving and ceramics. Therefore Ayuso's intentional identification as the maker, represented via the action of signing, increases the value of the piece for tourist buyers in that they were able to acquire a Pedro Ayuso 'original'. The gourd, then, has agency, or action caused by prior intentions (Gell 1998: 17), through its ability to enchant the viewer (Gell 1992). In this sense, the agency of objects also mediates relationships not only between people, but also between observers and the objects with which they interact (Gell 1998). The meanings created from these distinct interactions, however, are also dependent on context – itself constantly shifting – a point well established in the work of Howard Morphy. Morphy (2009: 9) argues that meaning is more complex than simply reading the visual codes or 'signs' of an object (Baudrillard 1996). Instead, he proposes that identifying those characteristics that separate art objects from other kinds of material culture is central to understanding 'how art can be a mode of action – a means of intervening in the world' (Morphy 2009: 6).

Consequently, the action, or agency, of carved gourd vessels does not end when they leave their makers' hands and are sold to international tourists. In their new locations outside the Puuc region, they mediate new

social relations and convey different kinds of meanings to viewers based on their trajectories or 'social lives' as exchanged objects (Appadurai 1986). As commodities, the different kinds of values and meanings that are attributed to carved gourds as they are made, marketed, purchased, collected, displayed or received as gifts are what comprise their 'cultural biographies' – that is, the meanings and other associations that are attributed to them as they move in and out of commodity phases (Kopytoff 1986). These biographies are what are ultimately associated with the qualities, memories or narratives that are both relevant and deeply personal to the observer. Daniel Miller has likewise observed that people who establish strong emotional attachments to material things also are able to maintain meaningful relationships with people through things (e.g. Miller 2008). In this way, objects do not usurp meaning in personal relationships, but actually help mediate them between different individuals.

Tourists buy souvenirs because they remind them of something they already know, or they regard them as a metonym for something they want to remember. When tourists appropriate the Maya imagery in the *artesanías* they buy and relate it to their own lives, they imbue the objects with the power to inspire reflection on past experiences – both within and beyond the host country – in ways meaningful for them. However, there is an alternate interpretation, that is, that this appropriation drains these objects of their original meaning. Their 'social lives' as tourist kitsch are more like an afterlife in which these objects refer to one's personal adventure interacting with exotic cultures in a foreign land. Even as reproductions, their 'aura' or ability to represent Maya culture and traditions, which was given to them by the people who created them, diminishes once they leave the Puuc region in tourists' suitcases and become part of a new context (Benjamin 1973).

From either perspective, whether one argues that the original meaning intended by the maker is retained or reassigned, it is important to accept that the carved gourd vessel remains meaningful (Schneider 2012). We might compare carved gourds to something like a commemorative plate purchased in Britain around the time of events like the 2012 Olympics or a Royal Wedding. Plates are historically and currently functional items, but when they are carefully painted, perhaps with lead-based paints or other materials not suitable for culinary use, their primary function and meaning change to being commemorative, and secondarily decorative. They are meant to remind the viewer of a memory or experience, maybe to be admired, and perhaps contemplated based on aesthetic qualities, like a painting. If compared in this way, the gourd vessel, painted with toxic varnishes and carved with imagery that makes its thin walls permeable, is similarly now a purposefully aesthetic object. However, it is both art and artefact, or neither, depending on one's perspective (Gell 1996).

But how do carved gourds – objects clearly made for the tourist art market – challenge other dichotomies including those of insider/outsider, past/present and contemporary/traditional? First, and as noted above, locals are starting to buy carved gourds, too, which helps to break down the regional stigma that is attached to Maya crafts in general. Many types of *artesanías*, such as woodcarvings or replica Maya ceramics, that are produced in Yucatán are not highly valued among locals because they are viewed as inauthentic exploitations of Maya culture. This is because they are made for and sold primarily to international tourists. This prejudice against the objects exists even though many *artesanías* draw on long-standing local traditions and creative and skilful reinterpretations of pre-Columbian Maya imagery.

However, perhaps due to his charismatic personality as a former tour guide, clever business strategy, stockpiling of work and direct access to tourists through owning his own handicraft shop (a situation that most artisans from this region cannot afford), Pedro Ayuso seems to have found a way to break through this insider/outsider barrier with his carved gourds. Through constant innovation of his designs and techniques, he aims to produce the next highly marketable item. For instance, at the spring 2011 Amigos de Artistas/Artesanos Nuevos de Yucatán[2] art fair in Mérida, Ayuso exhibited a new line of carved gourd insects made by attaching several *jícaras* together to create the appearance of a segmented exoskeleton, an idea he got after carving a number of two-dimensional representations of different insects on gourds, imagery he found in his own books or through Internet searches (P. Ayuso pers. comm.). According to Joan Farrell, a local American expatriate and organizer of this event, these bugs continue to sell extremely well to both international tourists and local buyers in the Mérida area. Pedro continues to exhibit and sell these and other Maya-style carved gourds via his personal Facebook page. Although the function of these gourds is no longer as containers and vessels for the home, the materiality of the gourds still evokes a nostalgia for what they represent in local history. This, coupled with low prices, makes the reinterpretation of traditional gourd vessels appealing to locals who used them domestically as children.

Second, traditional, uncarved gourds continue to meet local needs and it is this association that makes selling carved examples in contemporary art markets profitable. Tourists and other buyers may have trouble making the connection between replica and hybrid crafts in other media, such as polychrome ceramics or stone carving, because these materials – and the Maya imagery represented on them – are either accessible only at archaeological sites or museums (and thus distant and isolated) or the originals have not survived the passage of time. Furthermore, painted ceramics and stone carvings are associated with the 'ancients', having not been used ritually or domestically

among local peoples in living memory. Conversely, gourds are and always have been portable objects that tourists can observe being used by modern people in the villages around the Puuc region and elsewhere in the state. Thus, their hybridization via the inclusion of carved imagery or the alteration of their function enhances their meaning for tourists rather than making them less meaningful.

Finally, gourds, along with other locally made arts and crafts, are spurring the entrepreneurial spirit among some artisans. Creativity leads to the reinterpretation of culturally embedded and locally important symbols, blurring the boundaries between the traditional and the contemporary. Accordingly, for some artisans re-envisioning Maya imagery is a process of cultural preservation, which leads to engendering pride in one's culture and makes the past seem alive, present and contemporary rather something distant and dead. There are many who market this 'past' only for their own financial gain and their interest in cultural history stops there. But for other artisans and tourism workers, the increased global interest in Maya culture – spurred by both advances in archaeological research and developments in tourism infrastructure – has instilled in them a deep-rooted pride in being Maya. As the inheritors of this history, it has inspired some to learn more about their culture and share it with others through a range of outward presentations, including the making and selling of Maya *artesanías*.

Conclusion

In this chapter I have argued that carved gourd vessels, as hybrid objects, challenge dichotomies by mediating between Maya peoples and the outside world, and by satisfying the demands of traditional life and the contemporary art market. For tourists, owning a contemporary handicraft modelled on a reinterpreted or perhaps idealized historical past acts as proof of a traveller's journey to the Maya world. As Stewart (1984: 148) has remarked, 'removed from its context, the exotic souvenir is a sign of survival – not its own survival, but the survival of the possessor outside his or her own context of familiarity'. However, the very existence of the carved gourd-as-souvenir is also a sign of the survival of Maya people and their ability to adopt and adapt to the culture of their colonizers, and ultimately use their inbetweenness as a way to preserve and redefine what 'being Maya' means today.

Accordingly, carved gourds serve as an illuminating example of how some Maya people in Yucatán are creatively responding to the pressures of globalization. By marketing a domestic tool that is made from a locally abundant material and inextricably linked to Maya culture and history,

artisans present gourds as objects that are not only desirable as souvenirs for tourists, but also completely valid and authentic representations of past and present Maya lifeways. As hybrid objects, these carved gourds mix Maya and non-Maya imagery, temporalities, styles and functions, and it is this that makes them attractive souvenirs. Both locals and tourists desire to participate in an exchange mediated by this object owing to its historical, iconographical and cultural complexity. Furthermore, the fact that local people are beginning to buy carved gourds, which I have argued is due to both a local nostalgia for Maya traditions and the innovative manipulation of gourd as a material, is noteworthy in that it signifies a change in the perception among locals of the cultural or artistic value of some contemporary Maya *artesanías* (Bunten 2006).

To conclude, the hybridization and reinterpretation of Maya imagery and material culture, and the conversion of some of these forms into utilitarian and decorative items, are the artisans' way of providing something for everyone. In the end the carved gourd vessel offers tourists a new experience with a local Maya community and serves as an example of the shifting value of objects in relation to tourism, globalization and the pressures of local art markets and their audiences.

Notes

1 See also discussion by Harris (2003: 20, 233–246) on how 'hybridity' is in danger of becoming synonymous with 'tradition' due to the former term being used too loosely in art-historical circles. Harris (2003: 240) believes that this conflation of terms derives, at least in part, from the idea that both 'tradition' and 'hybridity' imply continuity, i.e. that an object or idea, while not the same as its predecessor, continues 'evolving' from an earlier form. For discussions of cultural hybridity in relation to colonialism, race and cultural identity, see, e.g. Bhabha (1984), Brah and Coombes (2000), Taussig (1993) and Young (1995).
2 Friends of New Artists/Artisans of Yucatán.

References

Appadurai, A. (1986) 'Introduction: Commodities and the Politics of Value', in A. Appadurai (ed.), *The Social Life of Things: Commodities in Cultural Perspective*, 3–63, Cambridge: Cambridge University Press.
Baudrillard, J. (1996) *The System of Objects*, trans. J. Benedict, London and New York: Verso.
Benjamin, W. (1973) 'The Work of Art in the Age of Mechanical Reproduction', in H. Arendt (ed.), *Illuminations*, 217–42, London: Fontana.

Bhabha, H. K. (1984) 'Of Mimicry and Man: The Ambivalence of Colonial Discourse', *October* 28: 125–33.

Brah, A. and A. Coombes, (eds) (2000) *Hybridity and Its Discontents: Politics, Science, Culture*, New York and London: Routledge.

Bunten, A. (2006) 'Commodities of Authenticity: When Native People Consume Their Own "Tourist Art"', in E. Venbrux, P. Sheffield Rosi and W. R. Welsch (eds), *Exploring World Art*, 317–36, Long Grove, IL: Waveland Press.

Castañeda, Q. (1996) *In the Museum of Maya Culture: Touring Chichén Itzá*, Minneapolis: University of Minnesota Press.

Castañeda, Q. (2004a) 'Art-Writing in the Maya Art World of Chichén Itzá', *American Ethnologist* 31 (1): 21–42.

Castañeda, Q. (2004b) '"We Are Not Indigenous!": An Introduction to the Maya Identity of Yucatán', *Journal of Latin American Anthropology* 9 (1): 36–63.

Castañeda, Q. (2009) 'Aesthetics and Ambivalence of Maya Modernity: The Ethnography of Maya Art', in J. Kowalski (ed.), *Crafting Maya Identity: Contemporary Wood Sculptures from the Puuc Region of Yucatán, Mexico*, 133–52, DeKalb: Northern Illinois University Press.

Clifford, J. (1988) *The Predicament of Culture: Twentieth-Century Ethnography, Literature and Art*, Cambridge, MA: Harvard University Press.

Coggins, C. and O. C. Shane (eds) (1984) *Cenote of Sacrifice: Maya Treasures from the Sacred Well at Chichen Itza*, Austin: University of Texas Press.

Cohen, E. (1988) 'Authenticity and Commoditization in Tourism', *Annals of Tourism Research* 15 (3): 370–86.

Coombes, A. E. and A. Brah (2000) 'Introduction: The Conundrum of Mixing', in A. Brah and A. Coombes (eds), *Hybridity and Its Discontents: Politics, Science, Culture*, 1–16, New York and London: Routledge.

Evans-Pritchard, D. (1993) 'Ancient Art in Modern Context', *Annals of Tourism Research* 20 (1): 9–31.

García Canclini, N. (1995) *Hybrid Cultures: Strategies for Entering and Leaving Modernity*, trans. C. Chiappari and S. López, Minneapolis: University of Minnesota Press.

Gell, A. (1992) 'The Technology of Enchantment and the Enchantment of Technology', in J. Coote and A. Shelton (eds), *Anthropology, Art and Aesthetics*, 40–66, Oxford: Clarendon.

Gell, A. (1996) 'Vogel's Net: Traps as Artworks and Artworks as Traps', *Journal of Material Culture* 1 (1): 15–38.

Gell, A. (1998) *Art and Agency: An Anthropological Theory*, Oxford: Clarendon Press.

Graburn, N. H. H. (1976) *Ethnic and Tourist Arts: Cultural Expressions from the Fourth World*, Berkeley: University of California Press.

Graburn, N. H. H. (2000) 'Foreword', in M. Hitchcock and K. Teague (eds), *Souvenirs: The Material Culture of Tourism*, xii–xvii, Aldershot: Ashgate.

Harris, J. (2003) 'Hybridity, Hegemony, Historicism', in J. Harris (ed.), *Critical Perspectives on Contemporary Painting: Hybridity, Hegemony, Historicism*, 15–36, Lilverpool: Liverpool University Press.

Heiser, C. (1993) *The Gourd Book*, Norman: University of Oklahoma Press.

Heusinkveld, P. (2008) 'Tinum, Yucatán: A Maya Village in the Lights of Cancún', in E. Baklanoff and E. Moseley (eds), *Yucatán in an Era of Globalization*, 112–33, Tuscaloosa: University of Alabama Press.

Hitchcock, M. (2000) 'Introduction', in M. Hitchcock and K. Teague (eds), *Souvenirs: The Material Culture of Tourism*, 1–17, Aldershot: Ashgate.

Incidents of Travel in Chichén Itzá (1997) [Film] Dir. J. Himple and O. Castañeda, USA: Documentary Educational Resources.

Kopytoff, I. (1986) 'The Cultural Biography of Things', in A. Appadurai (ed.), *The Social Life of Things: Commodities in Cultural Perspective*, 64–91, Cambridge: Cambridge University Press.

Kroshus Medina, L. (2003) 'Commoditizing Culture: Tourism and Maya Identity', *Annals of Tourism Research* 30 (2): 353–68.

Lerner, J. (2011) *The Maya of Modernism: Art, Architecture and Film*, Santa Fe: University of New Mexico Press.

MacCannell, D. (1973) 'Staged Authenticity: Arrangements of Social Space in Tourist Settings', *American Journal of Sociology* 79 (3): 589–603.

Magnoni, A., T. Ardren and S. Hutson. (2007) 'Tourism in the Mundo Maya: Inventions and (Mis)Representations of Maya Identity and Heritage', *Archaeologies* 3 (3): 353–83.

Miller, D. (2008) *The Comfort of Things*, Cambridge: Polity Press.

Moholy-Nagy, H., C. Coggins and J. Ladd (1992) 'Miscellaneous: Palm Nut Artifacts, Decorated Gourds, Leather, and Stucco', in C. Coggins (ed.) *Artifacts from the Cenote of Sacrifice, Chichen Itza, Yucatan*, 359–68, Cambridge, MA: Harvard University, Peabody Museum of Archaeology and Ethnology.

Morphy, H. (2009) 'Art as a Mode of Action', *Journal of Material Culture* 14 (1): 5–27.

Papanicolaou, A. (2011) 'Authenticity and Commodification: The Selling of Mayan Culture in Mexico's Mayan Riviera', in O. Moufakkir and P. M. Burns (eds), *Controversies in Tourism*, 41–53, Wallingford: CABI Press.

Re Cruz, A. (2003) 'Milpa as an Ideological Weapon: Tourism and Maya Migration to Cancún', *Ethnohistory* 50 (3): 489–502.

Re Cruz, A. (2008) 'Chan Kom Tourism and Migration in the Making of the New Maya Milpas', in E. Baklanoff and E. Moseley (eds), *Yucatán in an Era of Globalization*, 134–46, Tuscaloosa: University of Alabama Press.

Schneider, A. (2012) 'Beyond Appropriation: Significant Overlays in Guaraní-Inspired Designs', *Journal of Material Culture* 17 (4): 345–67.

Scott, M. K. (2009) 'Representing the Maya: When Is It Appropriate to Call 'Appropriations' Art?', in J. Kowalski (ed.), *Crafting Maya Identity: Contemporary Wood Sculptures from the Puuc Region of Yucatán, Mexico*, 174–90, DeKalb: Northern Illinois University Press.

Steiner, C. B. (1994) *African Art in Transit*, Cambridge: Cambridge University Press.

Stevenson, K. (2008) 'Urban Polynesians: Fashioning a New Language', in K. Stevenson (ed.), *The Frangipani Is Dead: Contemporary Pacific Art in New Zealand, 1985–2000*, 159–86, Wellington: Hula.

Stewart, S. (1984) *On Longing: Narratives of the Miniature, the Gigantic, the Souvenir, the Collection*, Durham, NC: Duke University Press.

Summit, G. and J. Widess (1997) *The Complete Book of Gourd Craft*, New York: Lark Books.

Taussig, M. (1993) *Mimesis and Alterity: A Particular History of the Senses*, London: Routledge.

Tedlock, D. (1996) *Popol Vuh: The Definitive Edition of The Mayan Book of The Dawn of Life and The Glories of Gods and Kings*, 2nd ed., New York: Simon & Schuster.

Tozzer, A. M. (1957) *Chichen Itza and Its Cenote of Sacrifice*, 2 vols, Cambridge, MA: Harvard University, Peabody Museum of Archaeology and Ethnology.

Young, R. (1995) *Colonial Desire: Hybridity in Theory, Culture, and Race*, London: Routledge.

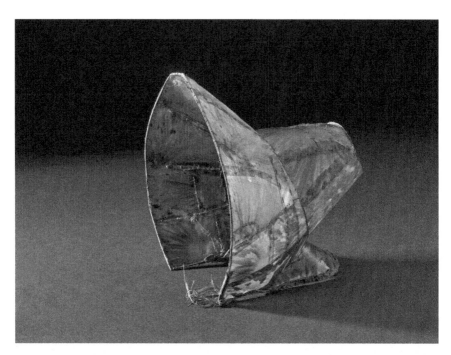

FIGURE 11.1 *Bonnet, hat made of turtleshell, cotton cloth and vegetable-fibre thread. Navigator's Island (Samoa). Height: 33.2 cm, width: 36.7 cm, depth: 30 cm.* © *The Trustees of the British Museum.*

11

Queen Victoria's Samoan bonnet

Catherine Cummings

Introduction

In 1841 Queen Victoria donated a turtleshell bonnet to the British Museum (Figure 11.1). It was collected in Samoa by the Reverend Thomas Heath (d. 1848) of the London Missionary Society (LMS) sometime between his first posting there in 1836 and 1840, which situates it at a relatively early period of European colonization in the Pacific Islands. Heath presented the bonnet to the queen in 1840. It is made from a composite of materials, including turtleshell, vegetable-fibre thread and European printed cotton cloth, and the design mimics a style of bonnet that was popular in England during the 1830s. The style of the bonnet and the combination of the use of turtleshell gives the bonnet both a familiarity and a strangeness: it is English, but not quite, and Samoan, but not quite, which situates it in an interstitial or inbetween space, 'almost the same but not quite' (Bhabha 1994: 86).

Missionaries were an important part of the imperial project in the expansion of the British Empire. The bonnet emerged at a time of intense missionary activity in Samoa and represents an interdictory object in the encounter between two cultures and religions. In this chapter I consider the inbetweenness of the bonnet, which occupies a third space 'in between' cultures, as tangible evidence of a specific time and place, and as part of the imperial project in the expansion of the British Empire. I question why the bonnet was made in a style that mimics European fashion and the possible meanings of copying the colonial other. Furthermore, I consider what the bonnet may have embodied for the Samoans, and, conversely, what it may

have embodied for its collector, Thomas Heath. I argue that we need to understand the bonnet from a reciprocal perspective in that the bonnet does not just represent the European discovery of Samoa, but also represents the Samoan discovery of the European (Tcherkézoff 2008).

I discuss the hybrid, or inbetween, nature of the bonnet and its mimicry through the theory of Michael Taussig (1993), Homi Bhabha (1994) and James Ferguson (2002). The making of the bonnet is explored through the concept of creative transculturation, the idea that marginal groups can select aspects of the dominant culture and decide what to use, what not to use and how to use it (Ortiz [1940] 1995; Pratt 1992). Serge Tcherkézoff's (2008) reinterpretation of first encounters between Samoans and Europeans, and the resultant misunderstandings during early contact, and Peter Burke's (2009) analysis of cultural hybridity provide critical social and cultural frameworks through which to discuss the bonnet.

The bonnet is not, however, just an inbetween object that merely embodies exchange or transformation as the inevitable result of the encounter (Thomas 2000). This implies that the Samoans were unaware of what they were doing. I consider an alternative proposition: by mimicking a European bonnet, I argue that the Samoans were not simply adapting or assimilating European culture and complying with the missionaries, but were defiantly remaking the bonnet on their own terms and according to their own logic. This suggests that the inbetweenness and mimicry of the bonnet can be interpreted in terms of mockery and menace (Bhabha 1994: 84), and as a form of subterfuge that challenged the authority of the missionary intervention in Samoa. I suggest, then, that the bonnet emerged as a result of the conscious agency of the Samoans who translated the material culture of the missionaries into their own material culture and that the mimicry of the English bonnet functioned to camouflage resistance to missionary intervention.

The production of the bonnet must be understood within the context of Samoan ontology and the different world views that emerged from the encounter between Samoans and Europeans in the 1830s. Furthermore, I suggest that the bonnet functioned as a syncretic object analogous to the Samoan's syncretic approach to religion and can be situated in between two cultures, two religions and two ontologies. The mimicry of the bonnet created an unstable, inbetween space for intervention, which in turn created a threat to missionary authority and this highlights some of the complexities that occur when one culture encounters another.

The Samoan bonnet

The bonnet is made from turtleshell, vegetable-fibre thread and European printed cotton cloth in the style of an English Victorian bonnet. The

provenance of the bonnet, accessioned by the British Museum under number Oc1841.0211.12, is recorded as Navigator's Islands, an earlier name given to Samoa. Samoa is in western Polynesia and consists of two large tropical islands, Savai'i and Upolu, and six smaller islands, in the Pacific Ocean, northeast of Fiji. To the east is the island of Tutuila, which is now American Samoa. They were first known to be visited by the Dutch explorer Jacob Roggeveen (1659–1729) in 1722 and later by the French explorer Louis-Antoine de Bougainville (1729–1811) in 1768, who named the islands Navigator's Islands due to the seafaring and navigational skills of the islanders. While there had been centuries of contact between Pacific islanders through trade, exchange and intermarriage before Western colonization in the nineteenth century, it was not until the arrival of the first missionaries in 1830 that Samoa can be said to have had cultural contact and trading with the West on any scale.

The turtleshell bonnet is a particular style of bonnet that was fashionable in England from about 1810 to 1850. It was known as a 'poke bonnet' and was designed in the shape of a hood, featuring a wide projecting rim in the front, which would shade the face of the wearer, and a high crown at the back. It usually had a strap that allowed the hat to be tied under the chin. It was called a poke bonnet because there was room in the back of the hat that allowed the woman's hair to be 'poked' inside it. The style became so exaggerated that it became known as the 'coal scuttle bonnet' and even though it was ridiculed in the popular press it remained the height of fashion. Queen Victoria was sketched wearing a wide-brim poke bonnet on the morning of her accession to the throne in 1837 and again in 1841. The poke bonnet that she wore on her wedding day in 1840 was later photographed and published as a postcard (Figure 11.2).

The turtleshell bonnet was skilfully made by moulding the turtleshell into shape and then drilling holes into the shell to sew and knot it together using organic sennit. The edges were trimmed with European printed cotton cloth that was stitched on to cover the sharp edges around the neck. The bonnet had a practical element to it in that the wide brim kept the sun off the eyes and face and the back of the neck.

Turtleshell

During the mid-nineteenth century in Samoa the use of turtleshell and eating of turtle meat was associated with people of high status. Turtleshell was used in the manufacture of many objects, including combs, bracelets and other small items of adornment, and it was a highly valued material due to its rarity (Kaeppler 2008: 127). The bonnet uses a substantial amount of turtleshell, which may have reflected the high social status of the person who owned it, but unfortunately Heath did not record who owned the bonnet or from whom he collected it. The composite make-up of the bonnet was not unusual in

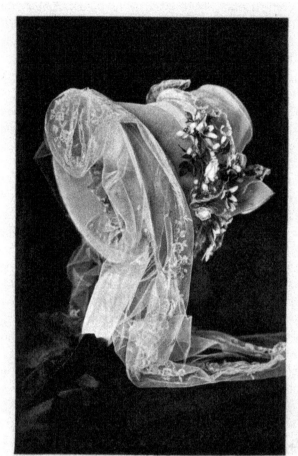

Queen Victoria's Wedding Bonnet, The Nursery, Kensington Palace.

FIGURE 11.2 *Postcard: Queen Victoria's wedding bonnet worn for her marriage on 10 February 1840. Author's collection.*

Samoan objects. The most widespread use of turtleshell was in fish hooks, which were manufactured from a composite of materials, including turtleshell, sennit and shell. The techniques used to make a fish hook were similar to those used to make the bonnet, and both, according to the missionary George Turner, were made by women (Turner 1861).

Missionaries

Thomas Heath and his wife, Eliza, were among the first missionaries to work in Samoa. They were based in Manono Island, approximately three

kilometres to the west of Upolu.[1] Heath must have collected the bonnet sometime between his arrival in Samoa in 1836 and 1840, when he gifted it to Queen Victoria. For the Samoans, the arrival of the missionaries also meant the arrival of European goods. According to Janet Davidson (1969), British missionaries were not the first white people who Samoans had contact with, and the islanders already possessed European goods when the missionaries arrived in 1830. For two hundred years since the seventeenth century blue glass beads were immensely valued and in great demand (Neich 1991), but 'by the mid-1840s, it was European cloth and rolls of material which were most valued, certainly under missionary pressure and the new rules of dress for church services' (Tcherkézoff 2008: 86). This desire for Western goods was also recorded by Charles Barff, who had accompanied the LMS missionary John Williams on his first visit to Samoa, and who recorded that the 'desire for European goods and for new knowledge and the taste for ceremonial and disputation predisposed them to look with favour upon the new religion' (Barff, cited in Davidson 1967: 33). According to Alan Daws (1961), missionaries struggled to convert Samoans on the island of Upolu, and Western dress was not generally adopted. He reports that in 1838 in Pago Pago on the island of Tutuila, eight of the twelve principle villages had adopted Christianity to various degrees, but four villages remained totally heathen (ibid.: 328). This demonstrates that not all the Samoan villages were ready to accept the new religion and when Christianity was adopted it was usually syncretic and practiced alongside their own indigenous beliefs rather than replacing them (Freeman 1959).

Clothing as a weapon of conversion

Missionaries had a profound impact on the culture and life of the Samoans, and not only in the introduction of new materials and objects. While not all missionary activity was negative, missionaries engaged in acts of iconoclasm, in the destruction of Samoan traditions and in the banning of indigenous clothing. Thomas Heath's correspondence and journals record the desire for trade and the acquisition of European goods and that boxes of 'presents' were sent to him from England, including clothes and books, which were used as currency to trade with the Samoans and as barter for food and supplies.[2]

Many missionaries were accompanied by their wives in the colonies and most of these women retained their Victorian English clothing. In order to attend Sunday church service, converted Samoan women were required to cover their heads, and the bonnet, which was worn by missionary wives, was considered the proper costume for Sunday. For the missionaries the adoption of European clothes by the Samoans was an outward visible sign

of their becoming 'civilized' and converting to Christianity. As Susanne Küchler and Graeme Were argue, it might be said that the most visible of the transformations brought about by missionaries was the introduction of European dress to the South Pacific and clothes thus became 'weapons of conversion' (2005: 42). This was not, however, straightforward and there was a variety of responses: some wore European clothing alongside their indigenous dress, some concealed their own clothing underneath their European dress and sometimes local clothing was produced in the style of, or to mimic, European dress. As observed by Sean Mallon:

> For men in the colonial period, the white shirt and the wraparound of calico cloth became very popular and widely used. There are many old photographs from Samoa of chiefs and others wearing various combinations of local and introduced dress including hats, blazers and naval jackets (Mallon 2002: 186).

The bonnet can be included as part of this idiosyncratic response to intercultural encounter.

The West on the head

European visitors responded in a variety of ways to the sight of Samoans dressed in European clothing. Newton Rowe (1930) wrote about the reaction to the bonnet by English naval officers who witnessed the women in church at a Sunday service in Tutuila:

> Wherever their eyes turned, they were sure to rest upon something most astounding in the way of bonnets. Under a huge coal-scuttle of native manufacture, built upon the most exaggerated scale of the fashion prevailing when European missionaries first came to these islands, they saw the happy, contented-looking face of a girl, looking as though she had been got up for a pantomime, who, in her native head-dress of a single flower, would have been much more becomingly arrayed (Rowe 1930: 74).

The officers were critical of the bonnet and remarked that the missionaries were mistaken in encouraging the Samoan women to wear it. The change in Samoan culture and dress was recorded by Admiral Sir Edward Gennys Fanshawe in his watercolour 'Sunday bonnets at the Navigators' Islands, Apia Bay, Septr 14th 1849' – painted eight years after Queen Victoria's donation of

her bonnet to the British Museum (Figure 11.3). This shows a group of women outside a hut dressed in their 'Sunday-best' and the composition is designed to show the front, profile and back of the costume. Fanshawe describes in his biography of 1904 how Samoan woman decorated their hair with flowers and looked graceful and pretty, but,

> unluckily, this habit was closely interwoven with their heathen beliefs and practices so that the missionaries felt it necessary to forbid the wearing of flowers and prescribe bonnets to those who became Christians. So they made their fine native plaits of vegetable fibre, and carefully copied the missionaries' wives in their headgear [woven from the plaits] . . . The women also wear Western cotton fabric (cited in Fanshawe 1904: 222–3).

The bonnets were reserved for Sundays and state occasions, indicating that it was considered an important item of clothing. Fanshawe, like many Europeans, lamented the loss of an authentic Samoan culture and was critical of European intervention. His view demonstrates that Europeans did not have a homogeneous approach to the material culture of colonized peoples.

FIGURE 11.3 *'Sunday Bonnets at the Navigator's Islands' [Samoa], Apia Bay, Septr 14th 1849', watercolour by Edward Gennys Fanshawe. No. 23 in Fanshawe's Pacific Album, 1849–1852.* © *National Maritime Museum, Greenwich, London.*

Similarly, the Samoans did not have a homogeneous approach to missionaries or European colonizers.

The missionary George Turner, who spent nineteen years in Polynesia, published an account of his time there in 1861 and he referred to the turtleshell bonnet and included a line drawing of it. He recorded that a marked change in Samoan society took place soon after the arrival of the missionaries and wrote, 'With few exceptions, the men cut their hair short, abandoned the short and narrow leaf-apron worn while at work and they appeared at public worship, dressed if possible, in a regatta or white shirt, and a piece of calico around the loins' (Turner 1861: 207). In referring to the bonnet he wrote that it was made by women:

> Coats, waistcoats, trousers, neckerchiefs, and straw hats came into use. The women too, commenced wearing loose calico dresses, and were rarely seen without a *tiputa* or upper garment of the same kind. Straw bonnets and shawls were also soon in demand. In the lack of the former some women showed great ingenuity in manufacturing a novel and very durable article from tortoise-shell [sic] (ibid.: 208).[3]

Missionary collections

The banning of indigenous practices and objects by European missionaries within Samoa had different outcomes. Many objects became obsolete and some were made available for European collectors, including missionaries. Many new objects were made, some of which were hybrid in form, exemplifying an inbetweenness resulting from the intervention of one culture on another.

Margaret Jolly, Serge Tcherkézoff and Darrell Tryon observe that material exchanges between Pacific peoples and Europeans 'were crucial from the first moments, when food, water, wood and indigenous artefacts were exchanged for European cloth, beads, nails or iron tools' (2009: 20). These exchanges led to the formation of collections, which were the foundation collections of many European museums in the second half of the nineteenth century and the first decades of the twentieth century. Many missionaries made collections of indigenous objects from the places in which they were stationed. This practice of collecting served different purposes; some missionaries collected objects that they themselves had made obsolete and that did not fit with their ideas of Christianity; some collected them to sell on their return to England to supplement their income; and some collected them for the mission museum in London where the objects were displayed as evidence of the success of the mission in the conversion of indigenous peoples to Christianity (Küchler and Were 2005).

Objects were obtained in different ways: they may have been deliberately sought out to be bartered and collected, others may have been gifted and some were made available to collectors as they had become obsolete due to the prohibition of certain Samoan rituals and practices. Missionaries had supplies of European goods, including calico, printed cotton material and clothing. Such goods had become currency on the island, as payment for employment and to barter for food and domestic supplies (Turner 1861). This exchange and barter of European clothing indicated the mutuality of the colonial encounter, the desire of the Samoans for European goods and the needs of the Europeans for Samoan goods.

Thomas Heath: Collecting the bonnet

There was nothing unusual in Heath's collecting practices in Samoa. The LMS received large collections of objects from those colonies in which it had established missionary stations. In a letter dated 21 October 1839, Heath wrote that he was sending curiosities back to England.[4] In his journals of 1840, Heath recorded that due to the death of John Williams on a visit to the New Hebrides he had been given a new role to travel to other Pacific islands on board The Camden, including Rotuma, Tanna, the New Hebrides and New Caledonia, and that he 'bought many of their manufactures'.[5] In the same year Heath wrote to Sir George Gipps, the governor of New South Wales at Sydney, to say that he had visited the islands of Erromango, Isles of Pines and mainland New Caledonia, and that he had placed native teachers on most of them. Heath requested to meet with him and wrote, 'I wish also to present a few articles of manufactures and other curiosities, both from Samoa and the islands lately visited.' These curiosities were intended to be presented to Queen Victoria.[6]

Heath also wrote a letter to Queen Victoria regarding his presentation in which he referred to his collecting, stating that 'during our voyage I had the opportunity of collecting various curiosities illustrative of the manners of the several people visited'. He outlined his visit to Gipps and wrote, 'I took the liberty of enquiring whether he thought that a selection of the curiosities referred to, would gratify your Majesty and he expressed himself of the opinion that they would.'[7]

On 6 February 1841, the earl of Uxbridge, Lord Chamberlain of the Household, wrote to Sir Henry Ellis, principal librarian at the British Museum, concerning the presentation of objects from the South Sea Islands by Queen Victoria, including 'curiosities from the South Sea Islands, presented to her Majesty by the Reverend Thomas Heath, a missionary of the London Society

in Sydney', which the queen wished to be deposited at the British Museum.[8] The letter includes a list of all the articles to be donated, including a 'tortoise shell [sic] Bonnet from Navigator's Islands'.[9] Already in 1842 the bonnet was on display at the British Museum and was included in a published synopsis of the museum's contents, in which it is described as 'a woman's bonnet, formed of tortoise-shell [sic], from Navigators' Islands . . . composed of thin laminae or plates of the shell, drilled and perforated, and then sewed or tied together. The back of this article has been decorated with portions of printed cotton. It was presented in 1841, by Her Majesty' (Hawkins 1842: 8). A guidebook to the British Museum published in 1850 included a line drawing of the bonnet and reads, 'An object of interest to lady-visitors is a bonnet made of plates of tortoiseshell [sic] sewn together; the shape is that of a common English bonnet, and the article was doubtless intended as a novelty by some Polynesian lady of fashion' (Masson 1850: 42).

The inbetweenness of the bonnet

The Samoan bonnet was produced at the interface between two cultures and this inbetweenness can be interpreted as an intrinsic component of hybridity. The bonnet represented familiarity and strangeness – the turtleshell material was strange and novel to the missionaries who were familiar with the design of the bonnet and the European design was new and strange to the Samoans who were familiar with objects made from turtleshell. For the missionaries and the Samoans, the use of organic material coupled with familiar design situated the bonnet as 'almost the same but not quite' (Bhabha 1994: 86). The bonnet is mixed (in its design and use of material) and split (in that it is partial: neither one nor the other). It is recognizable partly as an English bonnet and partly as Samoan in its use of turtleshell. From a postcolonial perspective, the potential of the hybrid is its ability to traverse both cultures, and as such, it disrupts ideas of 'fixity' and allows for the opening up of spaces other than established categories, and therefore new forms of cultural meaning and production (Bhabha 1994). But how can the inbetweenness of the bonnet be understood in particular?

Mimicry as inbetweenness

In making the bonnet the Samoans 'mimicked' an English design using their own indigenous material to produce a hybrid object in which the identity of the bonnet is ambivalent: the bonnet has the presence of an English design but at

the same time its 'otherness' is represented in the presence of exotic material (turtleshell) for the missionaries and in the English design of the bonnet for the Samoans. It is part English and part Samoan and therefore incomplete for both cultures. This quality of incompleteness and partialness is, according to Bhabha (1994), the basis of mimicry (if it was an exact copy, it would be mere imitation), which disturbs and disrupts 'the narcissistic demand of colonial authority' (ibid.: 88), including the authority of the missionaries. The incompleteness of the bonnet can therefore be interpreted as threatening to the missionary project itself, which is thereby 'transformed into uncertainty' (ibid.: 86). Through this uncertainty the partial condition of the bonnet functions to revalue the normative knowledge of what an English bonnet is or should be, and, in mimicking the English bonnet, which was associated with the missionaries, I suggest 'it deauthorizes them' (ibid.: 91).

Mimicry can have various complex and contradictory interpretations. According to Taussig (1993), mimicry is essential in the construction of knowledge and identity and is an intrinsic part of colonial history. He suggests that mimesis is a form of sympathetic magic in that it is not just copying but can embody the power of the original. There were many different forms of colonialism and missionary intervention in colonized cultures and this, in turn, elicited a variety of responses from colonized peoples, not all of which were negative. Ferguson (2002) acknowledges that some colonized peoples actively wanted to reject their own culture and one way of doing this was through mimicking and imitating the colonizers. He argues that mimicry was not simply imitation and adaptation, but that it was a survival tactic at a time of colonial domination and those who did imitate were psychological victims of colonial repression. Furthermore, he maintains that the political question raised by colonial emulation was not about the adoption and incorporation of Western materials or objects, but about the place that colonized people were to occupy in a 'global sociocultural order' (Ferguson 2002: 555; see Fabian 2002 for critique).

The bonnet emerged due to missionary prohibition of some Samoan religious practices. By making the bonnet in turtleshell using traditional Samoan techniques, I suggest that the Samoans were employing their own local materials and skills of making, which had been prohibited by the missionaries. It was made in between what was permissible and what was prohibited in Samoan culture by the missionaries, 'both against the rules and within them' (Bhabha 1994: 89). The making of the bonnet can therefore be said to be a form of 'denied knowledge' that worked to estrange the basis of missionary authority and 'its rules of recognition' (ibid.: 114).

The Samoans, by appropriating the Western design, mimicked and made a mockery of the missionaries and 'denaturalized and contested their authority . . . within the terms of their own cultural system' (Ferguson 2002: 554). In this

sense, I argue that mimicry, whether tangible or intangible, becomes an act of defiance and autonomy that acknowledges the agency and power of colonized peoples. The bonnet is not an imitation of an English bonnet, but a unique (singular) hybrid object in and of itself. It is a material expression of intercultural encounter and negotiation situated inbetween the agency of the Samoan people and the imposition of the missionaries.

Creative transculturation

Discussing the inbetweenness of the bonnet simply as an inbetween object produced from the encounter between Samoan people and English missionaries can be limiting: the inbetweenness of the bonnet lies beyond its mere hybridity. Rather it results from the agency of the Samoans who creatively translated this European artefact into their own visual language through the use of local materials. Samoan agency and the absorption of European objects into their own material culture can be understood through the concept of creative transculturation. This was first employed by the Cuban anthropologist Fernando Ortiz in the 1940s in an attempt to understand the impact or influence of one culture on another and the creative potential of cultural encounters ([1940] 1995). For Mary Louise Pratt (1992) transculturation is a phenomenon of the contact zone – that place 'where cultures meet, clash, grapple with each other, often in highly asymmetrical relations of domination and subordination' (ibid.: 4) such as in colonialism. In the contact zone, 'subordinated groups select and invent from materials transmitted to them by a dominant or metropolitan culture' to produce transcultural works in which colonized people 'write back' to their colonizers and speak themselves, albeit on the colonizers' terms (ibid.: 7). This is qualified by the admission that the marginal group, although they cannot control what is sometimes forced on them, can exert their own power and agency by determining 'to varying extents what they absorb into their culture and what they use it for' (ibid.: 6). The concept of creative transculturation is reciprocal and allows for both sides of the encounter and avoids the 'fatal impact' theory of colonialism.

 The adoption of the English bonnet by Samoan women, whether made of straw or turtleshell, was an outward signifier of success for the missionaries in their objective to civilize and convert them to Christianity. This *appearance* of conformity – epitomized in the ambivalent appearance of the bonnet – can, however, be interpreted as a form of camouflage on the part of the Samoan women: a form of passive resistance, albeit silent, that probably went largely unnoticed by colonizers at the time. This exemplifies the agency of the Samoan

people in how they shaped their own objects and decided what was and what was not to be incorporated into their culture and how they represented themselves to the West. Furthermore, Samoans did not adopt Christianity – or the bonnet as an outward signifier of that adoption – as a substitute or replacement for their own religion: on the contrary they simply absorbed it as a complement to, and alongside, their existing belief systems. From this perspective, the bonnet can be interpreted as a syncretic object, analogous to the Samoan's syncretic approach to religion: the Samoans enriched their own culture rather than diminish its significance and 'cultural exchange took place, as it often does, by addition rather than substitution' (Burke 2009: 44). The uniqueness of the bonnet lies in its transculturation, 'a combination of foreign techniques with local culture' (ibid.: 18).

Conclusions

The turtleshell bonnet emerged between two cultures, between two religions, and between the LMS's zeal to convert the Samoans to Christianity and the Samoans' desire for European goods. It also emerged in between two *ontologies*. Through the prohibition of Samoan religious practices and clothing, the bonnet emerged as an interdictory object. The emergence of the bonnet has to be understood in the context of a longer history of encounters, in which the Samoan experience of European colonists was only the most recent episode. Their interconnectedness with other Pacific islands made them receptive to new ideas, materials and practices and allowed them to be agents in the transmission of their own culture. They had their own networks of relationships and trade in which material objects, skills, technologies and practices were exchanged. This emphasizes the interconnectedness of the Pacific islands rather than their isolation and demonstrates that 'hybrid forms are often the result of multiple encounters rather than a single one' (Burke 2009: 25). As Nelson Graburn (1976: 11) states, 'All societies that are in contact with each other eventually exchange materials, items and ideas.' We also have to acknowledge that even without these new materials, changes in form and content would, and did, happen due to the creativity of indigenous people themselves. Through their own creative freedom to experiment, change was always (and is) a continuous and ongoing process. In England, the poke bonnet itself was never a 'pure' design, but emerged from other designs and soon became obsolete as new forms of bonnets emerged in the Victorian desire for new fashions. There never was 'cultural purity' of the bonnet. The inbetweenness of the bonnet as a hybrid object is an example that all cultures are hybrid and challenges the notion that cultures and objects can remain 'pure'.

Contemplating the Samoan bonnet raises questions of resistance and reveals that there were many forms and levels of European missionary encounters, which each had diverse impacts on indigenous cultures and simultaneously elicited diverse responses from them. The adoption of Western ideas and practices was not homogeneous in Samoa. Rather, the diversity of responses showed that not all accepted the new religion and Western ideas: some Samoans defended their own material culture and religious traditions. The introduction of European styles of clothing may have been an unwelcome interference into their own material culture for some, while for others the making of the turtleshell bonnet may have represented a form of innovation and creative freedom: 'a fashion for the foreign' (Burke 2009: 81) or a desire 'to become like you' (Ferguson 2002: 552). The response to the missionaries and their European goods was heterogeneous and, as Burke (2009: 87) argues, 'when people are confident in the superiority of their culture, they often take little interest in foreign ideas'. The making of this inbetween bonnet reveals that the Samoans and LMS missionaries were both affected by their encounter. The missionaries absorbed the Samoans into their culture through their conversion to Christianity, but likewise the Samoans absorbed the English into their culture by producing an object such as the bonnet. But this was achieved to various degrees, with a range of responses, and both, just like the bonnet, were incomplete.

The bonnet, however, does not simply sit in between the two cultures. Rather it was important in the convergence of those cultures and practices and therefore its inbetweenness played an essential role in the formation and maintenance of relationships between them. The bonnet can be interpreted as a symbol of the process of convergence of Samoan religion with Christianity. The inbetweenness of the bonnet does not situate it merely as an interstitial object, but testifies to the centrality of material objects in cultural encounters and the role of objects in mediating social relations. The mission stations where Samoans and English gathered were contact zones, inbetween spaces, 'neither completely foreign, nor totally indigenous, but rather something new emerging as a result of cross cultural interaction' (Flexner 2012: 39).

But what did the bonnet embody for the missionaries and, in particular, for Thomas Heath such that he was motivated to collect it and gift it to Queen Victoria? And what did the bonnet embody for the Samoans? For Thomas Heath, the bonnet and the adoption of European clothing embodied the aims of the LMS in the conversion of Samoan 'heathens' to Christianity and the first stage of the civilizing process, but it may also have been an unusual feminine curiosity. This was, however, an outward appearance that camouflaged the inward conviction and continuity of the practice of Samoan religion. The making of the bonnet in turtleshell demonstrates the Samoans' self-empowerment and it therefore might be regarded as a transgressive and subversive act.

However, the success of the missions was in part due to the Samoan demand for Western goods and some islanders converted to Christianity simply in order to obtain them. Although the bonnet can be said to be partial and incomplete, neither Samoan nor English, for the missionaries the 'part-object' represented the whole of Samoan conversion to Christianity – 'the part is *already* the whole' (Bhabha 1994: 111). The bonnet therefore functioned as a metonymic object for the missionaries and the collecting of the bonnet by Heath was 'proof' of the success of the LMS. The presentation of it to Queen Victoria, and her acceptance of it, reinforced the aims of the imperial project in the expansion of the British Empire. But this was based on a Western logic of dualisms and binary oppositions in which Samoans were perceived as Other in relation to Europeans, as *either* civilized *or* savage, *either* Christian *or* heathen – there was no inbetween.

Tcherkézoff (2008) has analysed the different world views between the Samoans and the Europeans they encountered. For Polynesians 'everything was a question of integration and of the relationship between a whole and its different parts . . . a god was an invisible whole and every visible manifestation of this god was a partial form of that whole. A chief was thus a partial form of a god. A new creature could just as easily be a visible form of the divine or meaningless and virtually non-existent' (ibid.: 214). From this perspective the bonnet, for the Samoans, represented neither the Samoan conversion to Christianity nor the rejection of their own system of belief. Rather, I suggest that the bonnet has to be understood in the context in between two world views and in between European and Samoan ontologies. Within Polynesian ontology 'objects can communicate indigenous concepts and values; indeed, they are often celebrated as embodiments of ancestral power and as articulating the voices of the "ancestors" ' (Jolly et al. 2009: 20). For the Samoans, I suggest that the bonnet represented their continuing creativity and skill as makers, their adaptation, dexterity and craftsmanship that had endured for centuries. As Turner (1861) observed, the bonnet was made by Samoan women who decided to copy the bonnet, whose style was alien to them, but in a material that was familiar to their culture, and this combination created a slippage in meaning. They selected and mixed materials, and reinvented the bonnet for themselves through their own agency and in doing so negotiated their own identity. The bonnet was deprived of its full English presence, but embodied native Samoan knowledge in a display of inbetweenness, which functioned to challenge the authority of the missionaries. The habitus of the Samoans, the knowledge embodied in their hands and eyes, was Samoan rather than European (Bourdieu 1984).

The use of the turtleshell in the making of the bonnet can be interpreted as a continuation of the Samoan way of life when their systems of belief and material culture were threatened with extinction due to Western colonization

and missionary control. The missionaries attempted to alter their identity, to position them as *Other* and to master them. Mastery, however, is no longer possible and 'the West, as mirrored in the eyes and handiwork of its *Others*, undermines the stability which mastery needs' (Taussig 1993: 237). The visible presence of the turtleshell meant that the presence of missionary authority was no longer visible; rather it was incomplete and undermined. The making of the bonnet by the Samoans in their own materials did not result in 'a total disappearance of the pre-existing culture' (Bhabha 1994: 114). The irony was that so-called hybrid or inbetween objects, such as the bonnet, were products of the intervention of Europeans and missionaries, yet at the same time they were a menace to their authority. The inbetweenness of the bonnet, located between 'resemblance and menace' (Bhabha 1994: 86) and its incompleteness, mimicry and ambivalence exposes the incompleteness of the missionary project and exposes the complexities and contradictions in intercultural encounters.

Notes

1 Manono consists of four villages: Faleu, Lepuia'l, Apai and Salua. The arrival of Thomas Heath and his fellow missionaries is described in the journals of Aaron Buzacott, May 1836–March 1837 (SOAS Special Collections [henceforth SOAS] CWM/LMS/South Seas/Incoming correspondence/Box 13, Reverend Aaron Buzacott). Heath's wife, Eliza, died in 1838, just two years after their arrival. Thomas Heath died in 1848.

2 SOAS CWM/LMS/South Seas/Incoming correspondence/Box 12, Reverend Thomas Heath.

3 Turner describes the *tiputa*, which had been introduced to Tahiti, as 'simply a couple of yards of cloth with a hole in the middle, through which they put their head, letting the ends hang down before and behind like a Spanish poncho' (1861: 208). This is similar to that worn by the women in Fanshawe's painting.

4 SOAS CWM/LMS/South Seas/Incoming correspondence/Box 12, Reverend Thomas Heath.

5 SOAS CWM/LMS/South Seas/Incoming correspondence/Box 9, Reverend Thomas Heath.

6 SOAS CWM/LMS/South Seas/Incoming correspondence/Box 13, Reverend Thomas Heath.

7 SOAS CWM/LMS/South Seas/Incoming correspondence/Box 13, Reverend Thomas Heath.

8 British Museum, Original letters and papers of 1841.

9 The bonnet was included as part of a 'box of curiosities' donated by Queen Victoria and is recorded as 'tortoise-shell bonnet of the modern type, of thin plates sewed together, edged with cotton. Navigator's Island'. The bonnet

is one of fifty-one curiosities listed (British Museum, Inventory of Southsea Objects presented by Her Majesty Queen Victoria, 11 February 1841). In addition to the bonnet, Heath collected a wooden image or idol, which according to Janet Davidson (1975) was acquired by Heath as 'proof' or indication of the decline of the Samoan religious system at the beginning of the mission period.

References

Bhabha, H. (1994) *The Location of Culture*, London: Routledge.

Bourdieu, P. (1984) *Distinction: A Social Critique of the Judgment of Taste*, Cambridge, MA: Harvard University Press.

Burke, P. (2009) *Cultural Hybridity*, Cambridge: Polity.

Davidson, J. W. (1967) *Samoa mo Samoa: The Emergence of the Independent State of Western Samoa*, Melbourne: Oxford University Press.

Davidson, J. M. (1969) 'Settlement Patterns in Samoa before 1840', *Journal of the Polynesian Society* 78 (1): 44–82.

Davidson, J. M. (1975) 'The Wooden Image from Samoa in the British Museum: A Note on Its Context', *Journal of the Polynesian Society* 84 (3): 352–5.

Daws, A. G. (1961) 'The Great Samoan Awakening of 1839', *Journal of the Polynesian Society* 70 (3): 326–37.

Fabian, J. (2002) 'Comments on "Of Mimicry and Membership"', *Cultural Anthropology* 17 (4): 570–1.

Fanshawe, A. (ed.) (1904) *Admiral Sir Edward Gennys Fanshawe GCB*, London: Spottiswoode.

Ferguson, J. G. (2002) 'Of Mimicry and Membership: Africans and the "New World Society"', *Cultural Anthropology* 17 (4): 551–69.

Flexner, J. (2012) 'Erromango: Cannibals and Missionaries on the Martyr Isles', *Current World Archaeology* 56: 35–9.

Freeman, J. D. (1959) 'The Joe Gimlet or Siovili Cult: An Episode in Religious History of Early Samoa', in J. D. Freeman and W. R. Geddes (eds), *Anthropology in the South Seas*, 185–99, New Plymouth, NZ: Thomas Avery.

Graburn, N. (ed.) (1976) *Ethnic and Tourist Arts: Cultural Expressions from the Fourth World*, Berkeley: University of California Press.

Hawkins, E. (1842) 'Upper Floor, First Room', *Synopsis of the Contents of the British Museum*, 44th ed., 4–9, London: G. Woodfall.

Jolly, M., S. Tcherkézoff and D. Tryon (eds) (2009) *Oceanic Encounters: Exchange, Desire, Violence*, Canberra: Australian National University Press.

Kaeppler, A. L. (2008) *The Pacific Arts of Polynesia and Micronesia*, Oxford: Oxford University Press.

Küchler, S. and G. Were (2005) *Pacific Pattern*, London: Thames & Hudson.

Mallon, S. (2002) *Samoan Art and Artists: O Measina a Samoa*, Hawaii: University of Hawaii Press.

Masson, D. M. (1850) *The British Museum, Historical and Descriptive*, Edinburgh: William and Robert Chambers.

Neich, R. (1991) 'Samoan Figurative Carvings and Taumualua Canoes – A Further Note', *Journal of the Polynesian Society* 100 (3): 317–28.

Ortiz, F. ([1940] 1995) *Cuban Counterpoint: Tobacco and Sugar*, trans. H. de Onís, Durham, NC: Duke University Press.

Pratt, M. L. (1992) *Imperial Eyes: Travel Writing and Transculturation*, London: Routledge.

Rowe, N. A. (1930) *Samoa under the Sailing Gods*, London and New York: Putnam.

Taussig, M. (1993) *Mimesis and Alterity: A Particular History of the Senses*, New York: Routledge.

Tcherkézoff, S. (2008) *First Contacts in Polynesia: The Samoan Case 1722–1848: Western Misunderstandings about Sexuality and Divinity*, Canberra: Australian National University Press.

Thomas, N. (2000) 'Technologies of Conversion: Cloth and Christianity in Polynesia', in A. Brah, and A. E. Coombes (eds), *Hybridity and Its Discontents: Politics, Science, Culture*, 198–215, London: Routledge.

Turner, G. (1861) *Nineteen Years in Polynesia: Missionary Life, Travels and Researches in the Islands of the Pacific*, London: Snow.

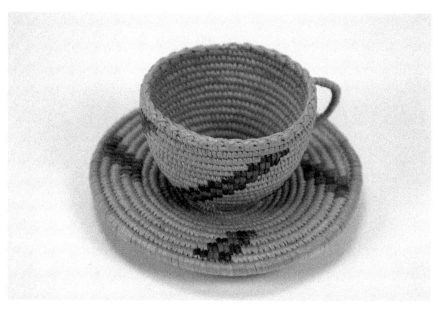

FIGURE 12.1 *Nl'akapamux basketry cup and saucer, c. 1900–1941, Edward and Mary Lipsett Collection, Museum of Vancouver Collection, AD 261. Image reproduced with permission from the Museum of Vancouver.*

12

The indigenization of the transcultural teacup in colonial Canada

Madeline Rose Knickerbocker and Lisa Truong

Tiiturumagama, tiituqatiginiaqpinga?, Aaha! Aaha!
(For I would like to drink some tea, are you going to drink tea with me?)

– Inuit song

There must be thousands of fine teacups and tea sets sitting in museum stores and displays around the world. The ones we discuss in this chapter are not, however, manufactured from smooth porcelain hailing from England or China, but created by Indigenous artists using roots and stone. The Museum of Vancouver, which has a collection of these enigmatic objects, houses a basketry-woven teacup made in the first half of the twentieth century by an unnamed Nlaka'pamux artist from cedar root, decorated with red and black cherry bark imbrication, and paired with a matching saucer (Figure 12.1). In a private collection across the country in Toronto resides another teacup and saucer, carved in the 1960s by the Inuit artist Josephee Kakee from greenish-grey stone (Figure 12.2). Despite being made from different materials using different techniques, the formal

FIGURE 12.2 *Stone teacup by Josephee Kakee, 2013. Photograph by Lisa Truong, collection of Carmen Victor.*

qualities of both cups are similar; they are small, domed cups, with dainty handles. This chapter situates these teacups, and others like them, in the context of colonial Canada; we historicize their creation and explain this as the 'Indigenization' of the already-transcultural teacup form. As the Inuit song quoted above suggests, tea, tea culture and teaware were (and are) significant aspects of Indigenous social life, food histories and cultural heritages, and these cups are no exception.

The teacups are imbued with a sense of inbetweenness that is both physical and theoretical. The intentions and meanings embodied in the objects are not easily accessed, and there are many possible ways of conceptualizing their materiality. No single interpretive framework can encompass the entirety of these objects' significance. Here we propose four, perhaps overlapping, ways of thinking about these things ethnographically. First, the artist wanted to create something they believed would be familiar to the potential buyer – the teacup; second, the artist wanted to satirize the culture of the potential buyer (usually a European settler) by showing how the buyer's settler society appeared to the 'natives' and perhaps mimicking it; third, the artist wanted to demonstrate their virtuosity in creating an object from unconventional materials, through innovative use of local natural resources; and, finally, the artist wanted to represent a form that is already a cherished part of their own

material culture, while recognizing that it holds significance for the potential buyer as well.[1]

In this chapter, we focus on this last idea. Contextualizing these teacups in the long history of Indigenous tea culture, Indigenous-European encounters mediated by tea and other foods, and the settler art market, we argue that by the time these teacups were produced in the early to mid-twentieth century, they were an Indigenous reproduction of a by-then Indigenous form. Though a casual glance might lead us to believe that these objects represent an attempt at British refinement, we argue that they belong to a history of Indigenous tea culture, which includes the Indigenization of the (already-transcultural) teacup form. To make these arguments, we first discuss the findings of a survey of 'Indigenous' teacups in museums and collections, asserting that the extensive production of these cups from a variety of materials and across much of Canada indicates that the Indigenization of the teacup was also not a localized phenomenon, but part of a broader trend. We then go on to discuss the teacups in light of theories of inbetweenness and materiality in colonial contact zones, arguing that 'Indigenization' be understood as a distinct form of 'transculturation'. Next, we chart the uses of tea in Indigenous cultures in the pre- and early-contact periods in Canada, and consider tea culture itself in a transcultural lens. Subsequently, we trace the Indigenization of teacups in the historical record and conclude by pointing to examples of how the Indigenous tea cultures remain highly significant today. Analysing these inbetween teacups in this way affirms Indigenization as a process that is historically rooted and founded on community-based traditions of tea and material culture. Ultimately, this perspective presents an alternative theoretical approach to material culture in the colonial context, which foregrounds Indigenous artistic agency and centres Indigenous cultural heritage.

Encountering Indigenous teacups

There are numerous examples of Indigenous teacups in several museum collections we accessed through online databases. Including the Nlaka'pamux teacup discussed above, we know of thirty-six woven teacups, variously from the Northwest Coast, Northwest Plateau and the Northern territories of Canada (including the Northwest Territories, Nunavut, Nunavik and Nunatsiavut). Nine teacups are Tlingit; eight are Nlaka'pamux; six are Haida; two are Klickitat; two are Quileute; two are undefined Interior Salish, and there is also one each from Inuit, Makah, Nooksack, Okanogan, Stó:lō, Yakama and Yakutat communities. The most common materials are cedar root or spruce root, with imbrication from cherry bark and beargrass. Today, they are housed in

museum collections worldwide: eleven are at the Autry National Centre (Los Angeles); ten are at the Burke Museum (Seattle); five are at the Museum of Anthropology at the University of British Colombia (Vancouver); four are in the Museum of Vancouver; two are in the Chilliwack Museum; and the American Museum of Natural History (New York), the New Westminster Museum, the Pitt Rivers Museum (Oxford) and the Royal British Columbia Museum (Victoria) each have one. This list is not exhaustive, as woven teacups are also held in Indigenous and settler family collections.

While woven teacups appear to be fairly common, the carved teacup is rare in Inuit art. We were able to find only two examples. This is curious, especially considering the ubiquity of tea drinking in Inuit culture and its representation in other forms of Inuit art. Kakee carved the soapstone teacup and saucer described above in Pangnirtung, Nunavut.[2] The second Inuit example is in the Museum of Inuit Art Shop in Toronto, Ontario – a piece carved of serpentine by Ekidlua Teevee of Cape Dorset in 2009. Both were made for sale as fine art pieces, as we discuss further below. Like the woven teacups, these carved teacups are specifically representational: the communication of identity, virtuosity and perhaps cross-cultural connection.

Gender is significant here, in terms of both production and acquisition, and helps us understand the distinctions between woven versus carved teacups. The artists who made the woven teacups were women; in societies in the Pacific Northwest and Northwest Coast, weaving is generally considered to be women's work. Anthropological collecting in this area during the 1800s and well into the 1900s privileged works created by men; whereas totem poles, house posts and feast bowls were prized objects about which significant information was collected, baskets were often acquired en masse, and they were judged to be simple, utilitarian items as opposed to artworks. Indigenous women would often make and sell basketry to tourists to support their household's mixed economy (Phillips 1998; Raibmon 2005). Provenance information records the name of only one of the female artists who crafted the woven teacups, which reinforces the extent to which not only basketry, but also women's artwork in general were relatively undervalued during this period. Further, it appears that settler women were the principal collectors of woven teacups; twelve of the donors are female, while only six are male. The teacup is closely connected with domestic space, which in settler society during the late nineteenth and early twentieth centuries was gendered as the women's sphere. This settler colonial association between the domestic sphere and basketry as being feminine helps account for the greater number of the teacups in women's collections, since acquiring objects that represented a limited ideal of femininity would have fit appropriately with the social logic of the time. While Inuit artists have not historically been constrained to one particular medium on the basis of their gender, and both men and women

engaged in any form of art production that suited their aesthetic sensibilities, it is notable that the two carved teacups we found were both sculpted by male artists and, unlike the woven cups, were marketed as fine art objects. In terms of developing a full awareness of the creation and circulation of these teacups, gender is thus especially significant for the woven teacups and somewhat more enigmatic for the carved ones.

Theorizing the teacups

While theories of hybridity and transculturation have certainly informed our thinking on these teacups, we argue here for an understanding of the Indigenization of the teacup form in colonial Canada. This process, we posit, is a particular kind of transculturation that foregrounds the agency of Indigenous peoples, their perspectives and their histories. In the next section we discuss the revelations and limitations of these other theories vis-à-vis the teacups while explaining the merits of Indigenization as a theory of a process.

Part of our insistence that the teacups are emphatically Indigenous comes from a critical consideration of hybridity theory, which indicates that objects have the qualities of two different origins. The limitation of this approach, as Amiria Henare, Martin Holbraad and Sari Wastell also argue, is that there is no space to consider the object as something new; it is always a pidgin of two separate representational forms (2006: 2). In the case of the teacups, though they may be formally recognizable across cultures, we contend that in the lives of their makers, they are distinctly not hybrid.

Another reason we reject the idea of simple hybridity in the case of these teacups is because doing so falls back on old tropes of authenticity and acculturation. Authenticity assumes that Indigenous objects created for commercial purposes are not valuable because of their post-contact production; in an anthropological paradigm that viewed Indigenous people as an inevitably vanishing group, authenticity was prized because pre-contact era objects would represent the 'true' art forms of a particular nation prior to their degeneracy through exposure to Euro-American culture. As Ruth Phillips points out, 'the authenticity paradigm marginalizes not only the objects but [also] the makers' (1998: x). These teacups point to a way that Indigeneity is simultaneously rooted in tradition and yet influenced by transcultural phenomena, vanquishing tropes of authenticity and opening up space for dialogue about Indigenous modernities. Hybridity often serves as an extension of authenticity discourses – if we declare that the Indigenous teacups are hybrid, the implication is that they are a derivative amalgam, a distorted reflection of a 'true', 'original' form (as though there were such a

thing). Looking at these objects as being purely based on the European form both belies the significance of tea culture in Indigenous peoples' lives and denies Indigenous peoples' participation in modernity.

Theories of transculturation could likewise be applied to these teacups, but for us there are several problems with such an application: it offers only a shallow interpretation of the teacups, it signifies a duality instead of an Indigenous-centric perspective and it implies cultural loss. Transculturation theory offers a surface-level descriptive analysis of the teacups: a visual blending implies a cultural sharing. This straightforward interpretation aligns easily with existing scholarship that has focused on European and North American settler fascination with and utilization of Indigenous culture in colonial art. However, as Nicholas Thomas (1999) has shown, such a phenomenon also dispossesses Indigenous peoples as settlers who deploy a primitivist 'Indigenous' aesthetic to create and affirm settler colonial nationalism. This is acculturation, an idea closely associated with transculturation, the conception common in the late nineteenth and early twentieth centuries that contact with Europeans irrevocably and intrinsically changed Indigenous societies, and that these changes operated only in one direction. Phillips opposes this view, arguing that 'numerous examples of mutual appropriation . . . evidence a lively two-way traffic' (1998: 210). She illustrates this with reference to two moosehair-embroidered boxes created by a settler woman in a style influenced by Indigenous artistry and incorporating 'exotic' materials such as the moosehair itself as well as birchbark (ibid.: 126–8, 143–4). Today, we readily recognize that these are Euro-Canadian settler objects, despite our simultaneous awareness that the boxes' construction relies on Indigenous aesthetics. Our argument with the teacups follows a similar, though inverted, logical pattern. Ultimately, our study is interested in the significance of the teacups for Indigenous peoples, not for settlers, so neither transculturation nor acculturation theories fit.

Another issue with the application of transculturation theory is the implication of cultural loss. In anthropologist Fernando Ortiz's (1995: 102) perspective, transculturation does not merely refer to the 'transition from one culture to another', but 'also necessarily involves the loss or uprooting of a previous culture'. The loss inherent in transculturation is problematic in its alignment with settler colonial ideas of the inevitable extinction of Indigenous peoples and the correlating salvage paradigm. Moreover, with specific reference to the teacups, the idea of cultural loss does not make sense because there is no evidence that the Indigenization of the teacup form into Indigenous lifeways correlated with a decrease in the use of Indigenous vessels for beverages or foods. Saying, then, that the teacups have been Indigenized allows us to emphasize that an already

transcultural object has been integrated into an Indigenous context, while rejecting the notion of loss or uprooting that Ortiz recognizes in the process of transculturation.

We contend that these teacups represent a process of Indigenization, which itself can perhaps be best understood as a particular form of transculturation that centres Indigenous peoples, too often otherwise marginalized. Unlike these other theories, Indigenization focuses on Indigenous peoples' incorporation of colonially imported goods into their lifeways. While there is already a plethora of studies on settler colonial adoptions of Indigenous cultural practices, we think it is time that there is space to focus solely on Indigenous peoples' experiences of material culture in the highly contingent context of European exploration and settler colonialism. Our historicization of these teacups below reveals that regardless of initial origin, Indigenous peoples rapidly incorporated the 'British' teacup into their everyday lives from the nineteenth to the mid-twentieth century. As we show below, the Indigenization of the teacup was possible due to existing Indigenous tea cultures, including a degree of cultural commonality around the social ritual of tea drinking, and was carried out by artists relying on tradition and innovation, with a deep knowledge of community-based aesthetics, local plants and historically adopted forms. Thus, by the time these Indigenous teacups were made, porcelain teacups were already a familiar part of Indigenous life.

The inbetweenness of tea culture

Two elements allowed for the rapid incorporation of teacups into Indigenous peoples' lives in the early contact period: the ubiquity of existing tea culture and tea culture's own inherent inbetweenness. Indigenous peoples had their own tea culture long before contact with Europeans. For example, a 2012 find at Cahokia, an Indigenous archaeological site in Illinois near St. Louis, dates tea drinking in that region back at least 1,000 years (Shultz 2012). Indigenous teas, mainly herbal infusions or tisanes, were central to social and community life. They could also be used for medicinal purposes. Gathering tea was a social occasion, as women worked alongside each other to collect tea plants that would later be dried (Port Simpson Curriculum Committee 1983). Other tea plants were used when freshly picked, as in the case of Slavey men gathering leaves for consumption while on the trap line (Lamont 1977).[3] Further, sharing tea was also (and still is) considered a mark of hospitality and signifies the creation or maintenance of relationships between people. Indigenous tea

cultures were thus well established and integrated into Indigenous societies long before the arrival of Europeans.

These tea cultures relied on a variety of plants from surrounding environments, so there is both some similarity and significant divergence in the types of plants Indigenous peoples historically used for tea. Many Indigenous communities took advantage of two commonly found plants: Labrador tea and wild mint. The two varietals of Labrador tea were (and continue to be) widely found across Canada. Ethnobotanists have shown that the Ojibwa, Potawatomi, Algonquin, Cree, Micmac, Malecite, Montagnais, Fisherman Lake Slavey, Gwich'in, Chipewyan, Stoney Assiniboine and most Indigenous peoples of the Pacific Northwest Coast used the fresh or dried twigs and leaves of *Ledum groenlandicum* to make tea (Kuhnlein and Turner 1991). The other varietal, *Ledum palustre*, sometimes also called 'Eskimo tea', was used by the Slavey, Dene, Chipewyan and Tanaina peoples, and by many Alaskan and Canadian Inuit groups (ibid.). Field mint was a common tea plant for the Ojibwa, Fisherman Lake Slavey, Chipewyan and Woods Cree, Blackfoot, Lillooet, Okanagan-Colville, Shuswap, Kootenay and Chilcotin peoples, as well as Flathead, Kootenay and other Montana groups. Some Indigenous peoples also combined field mint leaves with Labrador tea (ibid.). Beyond mint and Labrador tea, Indigenous peoples across Canada used many other tea plants – early ethnographic sources number at least fifty-two different tea plants (ibid.). Tea plants used by some Indigenous groups were not used by all; while usage of particular plants varied across the continent, some form of tisane was consumed by most Indigenous peoples in the pre-contact period. The widespread use of tea and the staggering diversity of types of tea plants indicate how significant tea was in Indigenous peoples' lives in the pre-contact period.

In the early contact period, tea retained its social and epicurean importance, but Indigenous peoples' encounters with Europeans resulted in changes to their tea culture. Initially, Indigenous peoples introduced Europeans to their teas. Indeed, when a group of Iroquois taught French explorer Jacques Cartier and his men how to make a tea from white cedar in 1535, they were, in effect, also helping prevent the explorers from developing scurvy, which had already caused the deaths of twenty-five of Cartier's men (Turner and Szczawinski 1978). Subsequently, European fur traders began to use Indigenous teas, especially the more common varietals. Men in the Hudson's Bay Company apparently particularly enjoyed Labrador tea. Writing in the 1770s, Samuel Hearne (1911) asserted that Labrador tea was 'much used by the lower class of the [Hudson's Bay] Company's servants as tea; and by some is thought very pleasant'. In the early eighteenth century, the Hudson's Bay Company even experimented with exporting Labrador tea to Britain to supplement the fur trade (Payne 2004). Further, some *coureurs des bois* followed the practice

of Slavey men on the trap line by collecting plant leaves for tea themselves, though in their case, they favoured the water plantain (Rousseau and Raymond 1945). This European adaptation to Indigenous teas and tea culture affirms the mutuality of cultural change in the contact zone.[4]

At the same time, Indigenous peoples began taking up 'European' teas, which were, of course, imported from China, India and elsewhere and had their own complex histories of global trade and imperialism (e.g. Melillo 2015). As with European adoption of Indigenous teas in Canada, Indigenous adoption of European tea culture should be seen as the extension of the familiar act of infusing water with plants. Early Inuit encounters with whalers and, later, the Hudson's Bay Company included trading furs for tea, tobacco and biscuits, items that quickly became staples in their diets (Pauktuutit Inuit Women of Canada 2006). During this period some eastern Inuit continued to gather local plants for tea, but their preference was for tea from the fur traders (Billson and Mancini 2007). Alaskan Inuit peoples were known to mix Labrador tea with imported European tea leaves (Oswalt 1957). Large social and ritual gatherings also involved tea. Fur trade records, captivity narratives and other sources make clear that by the end of the nineteenth century, Indigenous peoples had fully incorporated the consumption of imported European teas into their diets.

The incorporation of European tea into Indigenous diets is also evident linguistically. Many groups have specific words for tea plants. By the late nineteenth century, the English loan word 'tea' came into use to specifically refer to European tea. For example, among the Labrador Inuit, Labrador tea is called *mamaittukutik*; another plant, the prickly saxifrage, is called *kakillanakutik*; while European tea is simply called *tek*. The embeddedness of tea in Labrador Inuit culture is further evidenced by how they speak of a cup. A cup in itself is referred to as *kajottak*. A cup of tea on the other hand has its own word, *tetuk*, literally translated as 'tea vessel' (Virtual Museum of Labrador 2009). Thus, throughout the eighteenth and nineteenth centuries, Indigenous people and Europeans shared tea with each other, and, consequently, aspects of European tea culture became integrated into Indigenous societies.

This Indigenization is also evident by looking to material culture. As Laurier Turgeon (1997: 3) writes with reference to the inbetweenness of Basque and Miqmaq *chaudières* (commonly translated as 'kettles' but also referring to 'cauldrons'), 'the material object became the preferred means of exchange and communication'. As people shared meals with each other, they also came into contact with the materiality of each other's food cultures. The ritual of sharing food and drink was an important arena of socialization between Indigenous peoples and European explorers and settlers, so it is no surprise that food materiality, including teaware, was metonymous with this point of social contact. Discussing the copper *chaudières* and the market

for European goods among Indigenous communities in New France, Turgeon (1997: 2) offers a conventional articulation of technological acculturation, which posits that European objects irreversibly transformed Indigenous ways of living, and made Indigenous peoples reliant on European-manufactured goods. The woven and carved teacups with which we are concerned here complicate and challenge this interpretation. They show that while Indigenous peoples were certainly manufacturing 'European' items, they used local materials, as well as techniques mastered and passed down through generations. Further, the ubiquity of these teacups in European collections demonstrates the extent to which Europeans themselves engaged with the objects were affected by their encounters with Indigenous peoples. Seen in this light, these teacups challenge the technological acculturation thesis. Indeed, the history of museum and anthropological collecting indicates an entirely opposite flow of goods; while Europeans may have been importing and trading their items, at the same time, Indigenous people were creating and selling objects of their own, many of which were highly desired and valued by collectors.

It is also important to note that the tea culture introduced to Indigenous peoples by European explorers was already transcultural. Although tea culture is today regarded as synonymous with 'Britishness', tea and parts of the tea service originated in China (Jolliffe 2007; Kin Han 2007). In the eighteenth century, tea bowls were imported to Europe where by the end of the century they were adapted, with the addition of the handle and saucer. Throughout the nineteenth century, tea and tea culture, formerly so exotic, increasingly became connected to notions of Britishness (Forrest 1973). British collection, preservation and interpretation of a wide variety of tea-themed objects from the colonies represented not only the ubiquitous act of tea drinking, but also a fascination with others' tea cultures (Jolliffe 2007: 40). Although the vessel-for-tea is a combination of Chinese and English design and function, we now consider the teacup to be quintessentially British rather than a representation of a hybrid between the two tea cultures. The same conceptualization could be applied to the Indigenous teacups. While some of the basketry cups were not used for tea drinking, well-made basketry items like these can effectively hold water (Andrea Laforet pers. comm.), and their purpose, we contend, does not alter their origins in a deeply rooted Indigenous tea culture that had already integrated the 'British' teacup form. While it is easy to see their inbetweenness, as stated above, we argue that understanding them through concepts of hybridity or transculturation does not reflect the power dynamics between Indigenous and settler societies in colonial Canada. Rather, by historicizing these teacups in Indigenous contexts, as we go on to do in the next section, we can begin to see them as manifesting an inherently Indigenous art form, regardless of their transcultural roots.

Indigenous integration of 'European' teacups

The ubiquity of herbal and medicinal teas in Indigenous everyday life led to the rapid incorporation of not only 'European' or 'British' tea, but also teacups. Although Indigenous cups were made from different local materials, such as wood or seal skin, the high percentage of ceramic teaware shards that have been found at various Indigenous archaeological sites across Canada indicates the early uptake of ceramic tea vessels into Indigenous material cultures. Shards found at historical trading posts as well as seasonal settlements point to the ubiquitous incorporation of ceramics into Indigenous peoples' everyday lives, most of which was acquired through trade with the Hudson's Bay Company or missionaries (Burley 1989; Maas 1994; Cabak and Loring 2000). In Nain, Labrador, nineteenth-century travellers recorded the prevalence of ceramics in homes and tents, but noted that Inuit chose to use only the types of vessels that served their existing foodways (Cabak and Loring 2000: 27). Despite the fragility of ceramic teacups and saucers, they have also been found at archaeological sites of highly mobile peoples, such as the Plains Métis (Burley 1989). Writing about the scarcity of food among one Métis hunting brigade in 1840, Alexander Ross noted that, despite their fragility 'for such a mode of life', people in the community still used teacups and saucers (quoted in Burley 1989: 100).

Not only were the newly integrated cups used in utilitarian ways, but they also took on spiritual significance and community-contingent meaning. Among the Métis, ceramic teaware and the act of taking tea were assimilated into the existing culture of hospitality and the maintenance of social relations (Burley 1989: 104). In Alaska, teacups and saucers were incorporated into mortuary practices and by the 1880s replaced Indigenous artifacts (Jackson 1991: 208). During the same time period, the Heiltsuk on the West Coast incorporated ceramics, particularly cups and saucers, into their potlatches, demonstrating that tea and teacups had become fully integrated into their social lives (Maas 1994: 84). Another example of the extent to which European tea culture was being integrated into Indigenous lives can be seen in photographs taken in Fort Simpson in *c.* 1890, showing Tsimshian people having a 'tea party' and using porcelain teacups and saucers (Figure 12.3). The degree of their familiarity with the teacups and saucers, as well as the intimacy of the setting, helps us understand the extent to which European tea culture had been adopted by Indigenous peoples by the late nineteenth century.

The Indigenization of the teacup continued in the twentieth century. Photographic evidence from the 1940s and 1950s shows that 'European' teacups were part of Indigenous peoples' everyday lives in this period.[5] The historical record clearly shows the deep integration of the 'British' teacup into

FIGURE 12.3 *'Tsimshian Tea Party,' c. 1890, Fort Simpson. Photograph by Robert Reford. Library and Archives Canada, C-060817.*

Indigenous lives prior to and during the period in which our teacups were created. So, while the teacup form may be identified as British, this history demonstrates that in colonial Canada, it was simultaneously and equally Indigenous.

Settler markets for Indigenous teacups

Alongside the Indigenous appropriation of the 'European' teacup, the nineteenth century also saw the beginning of a rapidly growing Indigenous art market. Not only the teacup, but also 'European' tea materiality itself went through a transformation during this time. In Canada, tea-themed objects, sold as souvenirs or gifted, were often utilitarian, embellished according to their own style of decorative art that indicated 'Nativeness' through materials and motifs (Phillips 1998: 126–9). From the late nineteenth century into the early twentieth century, both professional and amateur Euro-Canadian collectors increasingly sought products like these. The transcultural teacups belong to this tradition of tea material culture.

As briefly touched on above, the form of the teacup as well as the medium of basketry help explain why settler women might have been interested in purchasing these items, as they reflected a femininity appropriate to the domestic sphere. Indigenous basketry was very popular as household

decoration in the late nineteenth and early twentieth centuries. Primary sources from the time indicate that 'every well-appointed house might appropriately arrange an Indian corner' and that, further, 'no home is complete now-a-days without a neat and artistically arranged Indian basket corner' (cited in Raibmon 2005: 144). Phillips (1998: 210) argues further that the popularity of fancy basketwork among Euro-Americans can also be explained in the context of Christian beliefs, where the purchase of objects made by Indigenous artisans demonstrates the charity of the buyer while also representing the 'worth and "civilizability" of their makers'. Collectors could thus emphasize their position as civilizing Christians, while basketry was also a particularly appropriate art form for settler women to acquire.

Although the beauty and tightness of the weaving, as well as the patterns and finish of this basketry, was admired, skill was not necessarily the main factor that attracted Euro-American buyers to them. Rather, the prevalence of basketwork in the region meant that a basket would probably be available for whatever price the collector was willing to pay. For Tlingit women in particular, while basketry was an established skill, its importance increased with the development of the tourist industry. Paige Raibmon (2005: 146–7) notes that 'Tlingit women wove baskets for an array of indigenous uses from berry gathering to baby carrying and produced astonishingly water-tight drinking and cooking vessels. Different shapes and designs appeared in items designed for the "curio corners" featured in travel literature. Baskets shaped like teapots, stew pots, bottles and canes sat for sale beside older utilitarian designs'. Fancy basketwork, as it was called, was ubiquitous, and late-nineteenth-century Canadian catalogues list a wide variety of available forms of baskets and basketry, including work baskets, flower baskets, kettles, knitting baskets, satchels and fans. One advertisement lists 'Basket Pincushions, Napkin Rings, Ladies' and Dolls' Hats, Cradles, Cornucopias, Card Receivers, Tea Sets, Paper Holders, &c. Collar, Baby, Scrap, Match, Comb, Hairpin, clothes, and Band Baskets' (cited by Phillips 1998: 233). However, the vast quantity of forms of basketry, and their use as utilitarian objects, including in their communities of origin, meant that the artists who made them were not always recognized as such.

Given this undervaluing of certain forms of Indigenous artwork, it is important to understand the extent to which Indigenous artists were participants in capitalist markets from the nineteenth century onwards. They engaged with contemporary thinking regarding material objects and the success of the souvenir industry is a reflection of their knowledge of consumers' tastes. For example, Phillips (1998: 89) discusses the production and sale of miniature birch bark *mokoks* that were produced for the souvenir market as a signifier of the important commodity trade of maple sugar. We would extend this line of argumentation to say that the sale of the woven and carved teacups likewise

reflects the active participation of Indigenous peoples in the tea trade and their familiarity with tea culture. As early as the mid-nineteenth century, there are records of Indigenous women making and selling baskets as a method of self-sufficiency, especially at times when the men were away hunting (Phillips 1998: 254). Indigenous artists, including a high number of women, complemented their living and met their material needs through the sale of art to settlers. However, due to the trope of authenticity, discussed above, and attendant ideologies of the salvage paradigm and cultural evolutionism, scholars have not yet fully grappled with the ways in which Indigenous peoples negotiated the commoditization of their 'traditional' art and aesthetics. As Phillips (1998: 261) argues, scholarship on nineteenth-century consumer culture has not adequately recognized 'the active participation of colonized indigenous peoples', and indeed 'much of what is now regarded as "traditional" [Indigenous art] has origins in later nineteenth-century Victorian innovation'. Indigenous peoples were active players in the modern capitalist art market, and their participation, which balanced 'traditional' approaches with newer formal innovations, steadily increased in the twentieth century.

The fact that Indigenous artists sold carved or woven teacups in the settler art market does not diminish our argument about the Indigenization of the teacup. Rather, in the context of decreasing options through settler land and resource appropriation and the entrenched limitations on Indigenous peoples' rights, for the sake of their own livelihoods in the new colonialist system, Indigenous artists frequently had to sell much more sacred objects. For example, throughout the 1950s and 1960s, studio managers, galleries and art buyers encouraged Inuit artists to produce images and sculptures that represented 'traditional' Inuit culture (i.e. without European influence). The fact that the two stone teacups discussed above remained unsold in their respective galleries reveals settler Canadians' preference for Inuit objects that are unfamiliar to them. Although tea and teacups are as much a part of Inuit culture as the ulu (a woman's knife) or a polar bear, the material culture that is familiar to the settler buyer is less desirable as a subject for the Inuit fine art market, despite the fact that such representations have meaning for Inuit artists. Thus, the teacups discussed here are material evidence of an Indigenous modernity that sometimes included the capitalist market and sometimes repudiated it.

Conclusion: Indigenous teacups today

Insisting on the historical context outlined above enables us to understand that by the early twentieth century, the time during which most of the teacups discussed in this chapter were made, two things had happened.

First, Indigenous peoples had completely adopted 'European' teacups into their everyday lives. While the teacup may have initially represented a formal 'other', its familiarity within Indigenous communities, and centrality in Indigenous sociality, affirms that they can be considered to be inherently Indigenous despite their transcultural roots. Second, this development allowed for Indigenous peoples, through their interactions with Euro-Canadian collectors, to create a new tea material culture (epitomized in the basketry and stone cups), which, while reflecting an 'inbetweenness' was also wholly Indigenous.

A further rationale for our emphasis on the Indigeneity of the teacups comes from an awareness of Indigenous peoples' ongoing artistic deployment of tea culture. In his ink and coloured pencil drawing, *Kananginak and Shooyoo at Home*, for example, the Inuit artist Kananginak Pootoogook depicts his subjects in their domestic environment with house plants to one side, and their colourful collection of teacups and teapots in a shelf above their heads.[6] In her multimedia installation, *Rising to the Occasion*, Anishinabekwe artist Rebecca Belmore used china teacup saucers as the breast plates of a dress that incorporates both Indigenous beadwork and settler elements.[7] Reflecting on her use of the saucers, Belmore (2009) recalls the china dinnerware of her childhood home: 'It had roses on it, it was probably from England. I grew up with those plates, and I never thought of "well, where does this come from?" until I was making this dress. It was a natural thing: I grew up with those dishes and I grew up looking at that beadwork.' Such works speak powerfully to the commonplace presence of such teaware in everyday Indigenous life, its inextricability from what might be assumed to be more typical Indigenous objects.

Indigenous artists have also innovated with the teapot form. Silversmith and sculptor Michael Massie is inspired by teapot imagery because of its connection to his memories of sharing tea with family. His silver-bodied teapots, inlaid with wood and stone, pay homage to his grandmother's ritual of serving a warming pot of tea to welcome guests in from the cold.[8] Further, Indigenous artists still weave teacups today. Nlaka'pamux people continue to weave teacups from local materials, often as part of an extended family activity (T. Grenier pers. comm.). Similarly, Yup'ik artist Gladys Abraham and Inuk artist Naomi Williams continue to make and sell woven sea grass tea services, with cups, saucers, teapots and serving plates and utensils, and Inuit artists also continue to carve and sell cups made from stone.[9] The ongoing reproduction of the teacup in Indigenous artwork destined both for family and community use, and for the art market, reinforces the idea that while these teacups may be 'inbetween', they are simultaneously wholly Indigenous.

In relation to the Indigenization of material culture in the context of colonial Canada, we have argued that it is important to recognize that the woven and carved teacups we discuss here may not necessarily allude to a 'European' form at all. These teacups were made by Indigenous people, from Indigenous materials, according to Indigenous techniques and they reproduced a type of object that had been fully Indigenized. The teacup form is thus not not-European, but at the time the teacups were created, it was no longer *only* European – it had also become Indigenized. Moreover, the teacups' paradoxical nature – at once familiar and foreign to the collector, but fully Indigenous to the artist – requires us to complicate our understandings of Indigenous material culture in the context of the art market. Ultimately, as Phillips (1998: ix) writes in reference to souvenir art more generally, these objects 'disrupt our stereotypical expectations of Indianness'. They challenge our notions of Indigeneity, daring us to accept Indigenous modernity and Indigenous self-representation on their own terms.

Acknowledgements

The authors wish to thank Paul Basu, Mary-Ellen Kelm, Andrea Laforet and Ruth Phillips for guidance on initial versions of this chapter, and to our colleagues at the Inbetweenness of Things symposium for their feedback; any faults that remain are our own. We also wish to acknowledge the assistance of Igah Muckpaloo for sharing and Janet Tamalik McGrath for translating the Inuit song in the epigraph. Thanks also to Museum of Vancouver curator Joan Seidl, collections manager Wendy Nichols and collections assistant Camille Owens, as well as Alysa Procida from the Museum of Inuit Art and Carmen Victor for their assistance engaging with objects from their collections. This research was supported by the Social Sciences and Humanities Research Council of Canada, the Ontario Ministry of Training – Colleges and Universities, Simon Fraser University and Carleton University.

Notes

1 Although the stone teacup was carved by Josephee Kakee, who was recognized as an Inuit artist, the Nlaka'pamux woman who wove the basketry teacup would not have necessarily been recognized as an artist at the time. However, Ruth Phillips (2012: 349) notes how the criteria of fine and applied arts based on European hierarchies have been placed on Native North American art, often classifying 'beautiful and meaningful Aboriginal-made objects' as 'craft', thus ignoring Aboriginal ways of seeing and their criteria of

value. Pieces made for the souvenir trade are thus 'art commodities', which were instrumental for preserving traditional technical skills and were sites for artistic innovation (ibid.: 357). As a result, we identify the makers of these art commodities as 'artists'.

2 Bibliographical records from the Inuit Art Index list two artists named Josephee Kakee, both from Pangnirtung, both equally likely to be the artist.

3 We represent the names of Indigenous communities as found in the source material we are referencing, although the colonial naming of those communities is often at odds with the demonyms those communities use to self-identify. Our decision shows our reliance on the colonial production of knowledge about Indigenous peoples, and although we acknowledge the problematic aspect of using these names, we do so in order to ensure that other scholars looking for this information will be able to find it in the literature we cite.

4 Indigenous teas still have a place in contemporary settler Canadian society. Northern Delights is a Nunavik Inuit company that produces herbal teas while simultaneously perpetuating traditional knowledge of the medicinal properties of various plants. During her tenure as governor general, Adrienne Clarkson served Northern Delights at functions at Rideau Hall, and the teas are still available for purchase in the Rideau Hall gift shop (*Nunatsiat News* 2001).

5 e.g. Richard Harrington fonds, 'George Lush and an Inuit man share a cup of tea', 1949–1950, near Tha-Anne River, photograph by Richard Harrington, Library and Archives Canada, accession number 7–45, item 6, PA-140611; National Film Board fonds, 'Governor General's Northern Tour. Inuit women preparing tea for Governor General's reception at Frobisher Bay, N.W.T.', Iqaluit, 1956, photograph by Gar Lunney, National Film Board of Canada, Library and Archives Canada, accession number 76038, e002265644.

6 *Kananginak and Shooyoo at Home*, ink and coloured pencil on paper, Kananginak Pootoogook, 2010. Marion Scott Gallery, Vancouver.

7 *Rising to the Occasion*, mixed media artwork, Rebecca Belmore, 1987. Art Gallery of Ontario.

8 *Subtle-tea*, sterling silver and bird's eye maple artwork, Michael Massie, 1997. Museum of Inuit Art.

9 *Tea for Two in Alaska!* seagrass artwork, Gladys Abraham. Spirit Wrestler Gallery, Vancouver (www.spiritwrestler.com/catalog/index.php?cPath=2_64&products_id=4725); *Cup of Tea in Labrador!* salt water grass artwork, Naomi Williams. Spirit Wrestler Gallery, Vancouver (www.spiritwrestler.com/catalog/index.php?cPath=2_64&products_id=4657); Inuit Art Auction Catalogue, 19 April 2010, Waddington McLean & Company, Toronto.

References

Belmore, R. (2009) 'Rebecca Belmore on "Rising to the Occasion"', Art Gallery of Ontario, available online: www.youtube.be/ANQTQcS8pgo (accessed 20 March 2014).

Billson, J. and K. Mancini (2007) *Inuit Women: Their Powerful Spirit in a Century of Change*, Lanham, MD: Rowman & Littlefield.

Burley, D. (1989) 'Function, Meaning and Context: Ambiguities in Ceramic Use by the *Hivernant* Metis of the Northwestern Plains', *Historical Archaeology* 23 (1): 97–106.

Cabak, M. and S. Loring (2000) '"A Set of Very Fair Cups and Saucers": Stamped Ceramics as an Example of Inuit Incorporation', *International Journal of Historical Archaeology* 4 (1): 1–34.

Forrest, D. (1973) *Tea for the British: The Social and Economic History of a Famous Trade*, London: Chatto & Windus.

Hearne, S. (1911) *A Journey from Prince of Wales's Fort in Hudson's Bay to the Northern Ocean in the Years 1769, 1770, 1771, and 1772*, Toronto: Champlain Society.

Henare, A., M. Holbraad and S. Wastell (2006) 'Introduction: Thinking through Things', in A. Henare, M. Holbraad, and S. Wastell (eds), *Thinking through Things: Theorizing Artefacts Ethnographically*, 1–31, New York: Routledge.

Jackson, L. (1991) 'Nineteenth-Century British Ceramics: A Key to Cultural Dynamics in Southwestern Alaska', PhD dissertation, University of California, Los Angeles.

Jolliffe, L. (2007) 'Tea and Travel: Transforming the Material Culture of Tea', in L. Jolliffe (ed.) *Tea and Tourism: Tourists, Traditions and Transformations*, 38–52, Toronto: Channel View.

Kin Han, P. L. (2007) 'Tracing the History of Tea Culture', in L. Jolliffe (ed.) *Tea and Tourism: Tourists, Traditions and Transformations*, 23–37, Toronto: Channel View.

Kuhnlein, H. and N. Turner (1991) *Traditional Plant Foods of Canadian Indigenous Peoples: Nutrition, Botany, and Use*, 2nd ed., Amsterdam: Gordon and Breach.

Lamont, S. M. (1977) 'The Fisherman Lake Slave and Their Environment', MSc dissertation, University of Saskatchewan, Saskatoon.

Maas, A. (1994) 'The Adoption and Use of 19th Century Ceramics at Old Bella Bella, British Columbia', MA dissertation, Simon Fraser University, Burnaby.

Melillo, E. D. (2015) 'Empire in a Cup: Imagining Colonial Geographies through British Tea Consumption', in J. Beattie, E. Melillo and E. O'Gorman (eds) *Eco-Cultural Networks and the British Empire*, 68–91, London: Bloomsbury.

Nunatsiat News (2001) 'His Excellency and Inuit Tea', available online: www.nunatsiaqonline.ca/archives/nunavut011221/news/nunavik/11221_4.html (accessed 1 April 2013).

Ortiz, F. (1995) *Cuban Counterpoint: Tobacco and Sugar*, new ed., Durham, NC: Duke University Press.

Oswalt, W. H. (1957) 'A Western Eskimo Ethnobotany', *Anthropological Papers of the University of Alaska* 6 (1): 17–36.

Payne, M. (2004) *The Fur Trade in Canada: An Illustrated History*, Toronto: James Lorimer.

Pauktuutit Inuit Women of Canada (2006) *The Inuit Way: A Guide to Inuit Culture*, revised ed., Ottawa: Department of Canadian Heritage.

Phillips, R. (1998) *Trading Identities: The Souvenir in Native North American Art from the Northeast, 1700–1900*, Seattle: University of Washington Press.

Phillips, R. (2012) 'Aboriginal Modernities: First Nations Art, c. 1880–1970', in A. Whitelaw, B. Foss and S. Paikowsky (eds) *The Visual Arts in Canada: The Twentieth Century*, 349–69, Toronto: Oxford University Press.

Port Simpson Curriculum Committee (1983) *Port Simpson Foods: A Curriculum Development Project*, Prince Rupert, BC: People of Port Simpson and School District No. 52.

Raibmon, P. (2005) *Authentic Indians: Episodes of Encounter from the Late Nineteenth-Century Northwest Coast*, Durham, NC: Duke University Press.

Rousseau, J. and M. Raymond (1945) *Études Ethnobotaniques Québécoises*, Montréal: Université de Montréal.

Shultz, C. (2012) 'Archaeologists Discover 1000-Year Old Hyper-Caffeinated Tea in Illinois', *Smithsonian Magazine*, available online: www.smithsonianmag.com/smart-news/archaeologists-discover-1000-year-old-hyper-caffeinated-tea-in-illinois-16192278/?no-ist (accessed 20 March 2014).

Thomas, N. (1999) *Possessions: Indigenous Art/Colonial Culture*, London: Thames & Hudson.

Turgeon, L. (1997) 'The Tale of the Kettle: Odyssey of an Intercultural Object', *Ethnohistory* 44 (1): 1–29.

Turner, N. J. and A. F. Szczawinski (1978) *Wild Coffee and Tea Substitutes of Canada*, Ottawa: National Museum of Natural Sciences, National Museums of Canada.

Virtual Museum of Labrador (2009) 'English-Inuttut Dictionary', available online: http://www.labradorvirtualmuseum.ca/english-inuttut.htm (accessed 20 March 2014).

Between image, text and object

FIGURE 13.1 *Woodcut illustration from Francesco Marcolini,* Le Ingeniose Sorti: Giardino di Pensieri *(Venice, 1550 [first edition 1540]), Syn.3.55.1. Cambridge University Library.*

13

'Curious statues so cunningly contrived': Plato's Silenus, inwardness and inbetweenness

Lucy Razzall

Plato's Silenus

At the centre of this chapter's consideration of 'inbetweenness' is an object from ancient Greece, brought to our attention by Plato towards the end of the *Symposium*, one of his most famous philosophical dialogues. Socrates has just delivered his climactic speech about love, but the intense atmosphere that follows is disrupted by the unexpected arrival of the politician Alcibiades, in a state of considerable drunkenness. Breaking the traditional social conventions of the symposium, he bursts in with a group of revellers, and immediately takes over the proceedings by persuading everyone to drink more wine. In response to Socrates's disapproval, Alcibiades announces to the assembled company that in fact he intends to eulogize his great teacher, explaining 'the way I shall take, gentlemen, in my praise of Socrates, is by similitudes. Probably he will think I do this for derision; but I choose my similitude for the sake of truth, not of ridicule'.

In what becomes one of the most famous images of his tribute, Alcibiades surprises his audience by comparing Socrates to 'the Silenus-figures that sit in the statuaries' shops; those, I mean, which our craftsmen make with pipes or flutes in their hands: when their two halves are pulled open, they are found to contain images of gods'. The contrast between the rustic external appearance

of these statues and the glory of the divine images they contain mirrors the person of Socrates, whose manner gives the impression of one who is 'utterly stupid and ignorant'. However, Alcibiades explains, this behaviour is 'an outward casing he wears, similarly to the sculptured Silenus': if 'you opened his inside, you cannot imagine how full he is, good companions, of sobriety' (215a-b, 216e).

Socrates is someone who spends his whole life 'in chaffing and making game of his fellow-men', and Alcibiades speaks at length about the frustrated attraction he feels towards this elusive character, turning the Silenus simile into a full-blown metaphor: 'Whether anyone else has caught him in a serious moment and opened him, and seen the images inside, I know not; but I saw them one day, and thought them so divine and golden, so perfectly fair and wondrous, that I simply had to do as Socrates bade me' (216d, 217a). Alcibiades's rapturous description of what he 'one day' saw inside the 'opened' Socrates articulates his desire to understand him in sensual terms that convey the rare privilege of this experience. The effectiveness of the Silenus depends on the visual contrast between outside and inside to provoke surprise and delight, but at the same time this contrast also emphasizes the value of what is within, which seems all the more wondrous because of the disparity with what is without.

It is not just Socrates himself who must be 'opened up' in order to be fully understood. Alcibiades returns to the 'Silenus-figures' at the end of his speech, saying of Socrates:

> His talk most of all resembles the Silenuses that are made to open. If you chose to listen to Socrates' discourses you would feel them at first to be quite ridiculous; on the outside they are clothed with such absurd words and phrases – all, of course, the hide of a mocking satyr. His talk is of pack-asses, smiths, cobblers, and tanners, and he seems always to be using the same terms for the same things; so that anyone inexpert and thoughtless might laugh his speeches to scorn. But when these are opened, and you obtain a fresh view of them by getting inside, first of all you will discover that they are the only speeches which have any sense in them; and secondly, that none are so divine, so rich in images of virtue, so largely – nay, so completely – intent on all things proper for the study of such as would attain both grace and worth (221d-222a).

This famous passage establishes the Sileni 'that are made to open' as models for the interpretation of 'discourses', and 'speeches', as well as the appearance and behaviour of individuals. While Socrates's choice of 'absurd

words and phrases' and subjects of 'talk' might seem 'quite ridiculous', worthy of 'scorn', they too represent the deceptive exterior of something that must be 'opened'. The person who listens to Socrates should be active in his or her intellectual curiosity, seeking to discover the 'fresh view' that is 'inside' what is being said. Socrates exemplifies the crucial slippage between the interpretation of personhood and the interpretation of language: while his ugly exterior and exasperating behaviour conceal a beautiful soul, his teachings also hide their 'sense' and 'images of virtue' inside a base, comic exterior, portrayed in the material, bodily terms of clothing and skin, 'the hide of a mocking satyr'. Throughout this speech, the tactile surfaces of bodies and their coverings become tangible starting points for thinking about the discovery of truth behind people's appearance and behaviour, and in their 'words and phrases' – hidden in language itself.

What exactly were the entertaining 'Silenus-figures' that Alcibiades says can be found in 'statuaries' shops'? The answer to this question is less straightforward than one might think, and its implications are central to this chapter. According to Greek myth, Silenus was a god of drunkenness, said to be the mentor of Dionysus. He is usually depicted as a jovial, bearded old man with the ears and tail of an ass or a goat, and his satyr followers are referred to as the Silenes or the Sileni. There are plenty of visual representations of the god Silenus, in all kinds of media, surviving from Greek antiquity onwards, and Clare Rowan's discussion of coinage iconography in early Roman Macedonia in this book demonstrates just one context for the reach of Silenus imagery beyond ancient Greece. Depictions of Socrates, similarly bearded, are even more ubiquitous in visual and material culture. However, despite the vivid description expounded by Alcibiades in the *Symposium*, today there are no known surviving examples of the 'Silenus-figures' to which he compares the great philosopher. Classicists have speculated that these objects may never actually have existed in ancient Greece – in other words, that Plato invented them for the rhetorical purposes of his dialogue (Lissarrague 1990: 55).

In her discussion of the prevalence of statues in ancient Greece, Deborah Tarn Steiner (2001) reveals the extent to which they were integral to political, economic and religious life – and thus the considerable number of ways in which such objects appear to have been good to think with. Plato would most likely have been aware of statues with intricate internal mechanisms used for drinking games, which may well have been found at a symposium (Lissarrague 1990: 55), and that are perhaps the closest thing to the 'Silenus-figures' Alcibiades describes. Examples of these survive in museum collections today, and not unlike seventeenth-century European 'puzzle jugs', such objects are

associated with entertainment and particular forms of social interaction. Plato's Silenus, like these related objects, offers not just temporary amusement but also a model for thinking about the potentially problematic nature of the relationship between the superficial and the intrinsic (Steiner 2001: 79–120; see also Lissarrague 1990: 53–9).

As a figure of frivolity and disarray, Silenus offers an obvious comparison with Socrates in the context of Alcibiades's symposium speech. Multiple playful doublings are at work in this scene: while Silenus was the mentor of Dionysus, the god of drinking, Socrates was the mentor of Plato and the intoxicated Alcibiades, whose unexpected speech exploits the very dynamic between superficially off-putting exteriors and hidden depths that it is attempting to clarify. In this speech, Plato embodies a fundamental problem of interpretation in an apparently common material object: how do we get past external surfaces to discover what more substantial things are hidden? As a powerful metaphor for understanding Socrates, and for thinking about interpretation more generally, the Silenus depends on the vivid conception of the physical appearance, properties and affordances of this material object. However, this material object is one that must be imagined: the reader must think through something tangible and material in order to understand the intangible, but this object is in the end something that exists only in the imaginary realm. Plato's Silenus is a strange, slippery kind of object, occupying an ungraspable position, somewhere in between the material and metaphorical spheres.

This chapter is about the Silenus statue as an embodiment of inbetweenness. Beyond its initial appearance in the *Symposium*, the Silenus is resurrected in Renaissance Europe (Figure 13.1), as a commonplace for thinking about the problem of discerning truth from deceptive exteriors, whether of people, things or texts. Plato's image is explicitly associated with Socrates, but in its subsequent reincarnations in sixteenth- and seventeenth-century European literary cultures, the Silenus proves adaptable to many different imaginary uses. While the Silenus of the *Symposium* has specific physical characteristics, and a particular origin in 'statuaries' shops', in Renaissance Europe nobody is quite sure what this mysterious object looks like, what it is made from or what exactly it contains. The essential form of the object as a hollow receptacle with a distinctive interior and exterior is always retained, but the material properties of the early modern Silenus are reimagined with many variations.

The relationship between the interior and exterior of the Silenus is one of opposition or inversion: what can be seen from the outside always turns out to be the reverse of what is inside. It might seem, then, that it models the very opposite of 'inbetweenness': that it denies the possibility of anything in between its emphatically contrasting interior and exterior. The playful

privileging of its own inwardness, however, allows the Silenus-figure to become a very useful metaphor, and something inherently inbetween: a form that can help to negotiate between different spheres. My sources will mainly be literary ones, and in this close reading of the Silenus, I will show that the relationship between materiality and metaphor can often be best understood as one of useful flexibility, embodied in the Silenus as something that has both material and metaphorical identities. Much of the agency of the Silenus, I argue, has to do with the mystery of its elusive identity, which constantly slips between the material and the metaphorical.

Between metaphor and the material

Across material culture studies, the relationship between metaphor and the material continues to stimulate much critical discussion. What does this mean for the Silenus-figure? In their classic study of metaphor, George Lakoff and Mark Johnson point out that 'most of our fundamental concepts are organized in terms of one or more spatialization metaphors' (1980: 17). There is an 'internal systemacity' to each spatialization metaphor – while 'up' is associated with positive experiences or feelings, for example, 'in' or 'hidden' is associated with profundity, depth and sophistication. They remind us that 'we are physical beings, bounded and set off from the rest of the world by the surface of our skins, and we experience the rest of the world as outside us. Each of us is a container, with a bounding surface and an in-out orientation. We project our own in-out orientation onto other physical objects that are bounded by surfaces' (ibid.: 29). Putting it more ardently, Julian Thomas argues that 'the body is not a container we *live in*, it is an aspect of the self we live *through*' (1996: 19).

The Silenus-figure is both a container and an anthropomorphic form. Another way of stating this might be to say that the Silenus-figure, like many anthropomorphic forms, is a container, because many containers are closely associated with or even explicitly modelled on the human body. The category of the 'container' is one of the most fundamental technologies, characterizing much of our engagement with the material world, and 'the idea of containment, like many metaphors through which humans understand the world around us, stems from the body and from the basic experience of being' (Knappett, Malafouris and Tomkins 2010: 593). Indeed, the evolution of containers as crucial forms in material culture is closely interwoven with the evolution of human experience. 'Instruments and containers have great antiquity and have always been referenced to the body', Clive Gamble reminds us: and so 'material metaphors that understand the world in terms of experience have

always been a consequence of hominin bodies inhabiting space and time'
(2007: 110).

The critical consequences of thinking more broadly about containers and
containment in material culture and the culture of the body have sometimes
been overlooked, however. Knappett and colleagues have recently pointed
out that although clay pots very often form one of the most abundant
categories of archaeological discovery, such artefacts are usually analysed
as 'ceramics', not 'containers'. They suggest that a more fruitful approach
might be based instead on categories of practice – how these objects were
used, in comparison with other containers, such as baskets – which would
allow 'a more dynamic perspective on human practices of containing, one
that acknowledges the constitutive role of material culture itself in changing
notions of what it means to contain, literally and metaphorically' (2010: 589–
90). There is a need for greater recognition, they argue, that containers
'are not simply vessels but action possibilities that bring forth new forms
of mediated action, agency, and material engagement' (ibid.: 591). While
they may partly be read as an invitation to think about the Silenus-figure and
its operations in relation to the several other containers discussed in this
book, the words of Knappett et al. are also a reminder that the categories of
container and containment do not simply classify material objects, but also
signal the possible fluidities between material things and metaphorical ways
of thinking.

The Silenus-figure illustrates the way in which, through lived experience,
we often expect a certain relationship between containers and their content.
Because we think of ourselves as being internally focused and 'profound',
we generally attribute profundity to other things that are hidden or unseen,
rather than to what is most immediately visible. In his contribution to
critical discussions of the relationship between metaphor and material
culture, Christopher Tilley offers a detailed and convincing account of how
metaphors provide the basis for an interpretative understanding of the
world. His reminder that 'metaphor provides a way of mediating between
concrete and abstract thoughts' emphasizes the essential inbetweenness
of all metaphor, which has at its etymological root the sense of 'carrying
across' (1999: 8). Despite his rather dismissive comments about 'literary'
metaphors and the work of literary critics and philosophers (ibid.: 33),
I argue that as a human-like form, a container that must be opened, and
yet, simultaneously, an object that in all likelihood never actually existed, the
Silenus-figure serves as a crucial metaphor in the truest sense of the word,
filling the gap between the material world and comprehension. While Tilley's
aim is to take 'metaphor out of language and into artefacts' (ibid.: 35), the
Silenus-figure suggests that 'language' and 'artefacts' might not be so easily
separated.

Significant insides: Some Silenic models

In several ways the Silenus statue is an especially appropriate object for the 'cabinet of curiosities' evoked by this book as a whole. It shares many of the properties of other artefacts typically found in such cabinets, which emerged in seventeenth-century Europe as ancestors of the museum: it is a relic from the classical past, an example of the virtuosic potential of art, and a stimulus for intrigue and wonder. In his beautifully photographic history of cabinets of curiosities, Patrick Mauriès reminds us that each was essentially 'a sequence of containers holding within them yet more containers in diminishing order of size, in the ceaseless quest for the allusive essence of a particular realm of knowledge' (2002: 35). In the distinctive playfulness between exterior and interior that it embodies, the Silenus is also virtually a miniature cabinet itself, provoking in the spectator an enjoyment in its mystery, but moreover a desire to move inwards and to discover its elusive contents.

In their celebration of the wonders of art and nature, as well as the potential dialectics between life and death, and the natural and the supernatural, cabinets of curiosities explicitly exploit their own form, incorporating their various surfaces, insides and outsides into their overall exploration of the phenomena of marvels. The spaces and surfaces they create have an almost sacred feel. The sacred possibilities of other objects with distinct insides and outsides has been discussed by the anthropologist Alfred Gell. The 'possession of significant interiors', he reminds us, is 'a very common feature of sculptural works specifically intended for cult use' (1998: 141). The potential of statues with 'significant interiors', to say something quite profound about the phenomenon of hiddenness, makes them particularly important in the context of religion. Gell refers to Plato's Sileni in his discussion of the animation of idols, juxtaposing them with a Polynesian idol in the form of a statue that has an exterior covered in little gods, and a hollow interior filled with further images of gods. This object, as Gell explains, represents divinity as an assemblage, obviating the contrast between 'one and many, and also between inner and outer' (ibid.: 137–43). The interior of this object replicates in manifold its exterior, collapsing the distinction between the two: the container *is* its content, and it demonstrates one way in which three-dimensional idols might powerfully articulate beliefs about the location of the divine.

Alongside the ancient pagan Silenus figure and contemporary Polynesian idols, Gell invites us to consider medieval 'vierges ouvrantes' (Figure 13.2): carved and polychromed wooden statues of the Virgin Mary that open to reveal the image of Christ, or the whole Church gathered under the protection of the Mother of God (1998: 141; see also Camille 1989: 230–3). Sometimes used as sacred tabernacles for storing the body of Christ in the form of bread

FIGURE 13.2 *A medieval 'vierge ouvrante', open and closed, made in the Rhine valley* c. *1300. The Metropolitan Museum of Art (17.190.185a,b), Gift of J. Pierpont Morgan, 1917.* www.metmuseum.org.

consecrated during the celebration of the Mass, these representations of Mary as 'a box, a physical container that opened and closed like a winged altarpiece' (Walker Bynum 2011: 88) emphasize the woman who bore God incarnate in the receptacle of her womb as the ultimate sacred vessel. As a human container for the divine, the body of the Virgin Mary is enriched by the body of the child within, but at the same time Mary's humanity is essential to the identity of Christ as the Word made Flesh.

While the Silenus statue is distinguished by an ugly exterior that contrasts with the beautiful images of gods inside, these medieval 'vierges ouvrantes' are beautiful inside and out. When opened, they may also reveal narrative scenes depicting the events of Mary's life. We might think of them as contiguous with certain other storytelling structures in Christian sacred spaces, such as folding altarpieces and other diptych or triptych paintings. The potential of these artefacts and furnishings to open and reveal scriptural or doctrinal truths literally underpins the pedagogical or devotional revelations they perform.

In medieval Europe these objects were not uncontroversial. As Gell says, this was partly because they were 'all too animate' (1998: 142; see

also Camille 1989; Freedberg 1989), which made them susceptible to accusations of idolatry. It is, however, this animation – the opening of their doors and the revelation of what they contain – that in large part makes these three-dimensional objects visually and metaphorically effective. In Plato's articulation of the 'Silenus-figures' as a metaphor for Socrates, Alcibiades emphasizes the moment of opening and 'getting inside' as crucial. Therefore it is animation that underwrites the metaphorical potential of the Silenus: it is not simply what it looks like, but also what happens when it is physically manipulated, which enables it to fulfil its physical and metaphysical potential. Objects with 'significant interiors', Gell writes, challenge our tendency to think of boxes as 'less significant than their contents' (1998: 137). The Silenus does not privilege container over content, or vice versa, but something inbetween: what is privileged above all in the Silenus is the moment of epiphany when the crucial contrast between the two is revealed.

Writing the Silenus-figure

The failure of the Silenus to inspire many visual representations, even though there have been plenty of iconic images of Socrates and of the original Silenus and his drunken followers, may be attributed to the fact that the artefact Plato describes is not an inert object. It derives its force from the act of being opened to reveal its inner glories, and so the flat, static nature of the painting or drawing does not allow the Silenus figure to 'work' to its full potential. Instead, it is the textual arena that provides the temporal dimension necessary for the Silenus figure to operate. The focal point in the sixteenth century for the literary resurrection of the Silenus is the work of the humanist writer Desiderius Erasmus, who engaged with Plato's metaphor at great length. Most notably, he included the Silenus as a substantial entry in his *Adages*, a monumental handbook of commentaries on thousands of Greek and Latin quotations. Plato's Silenus figure has an obvious place in this compendium of rhetorical exercises, each of which is concerned with revealing the wisdom hidden in ancient literature. In what follows, I consider some of the complexities of this Erasmian Silenus as an object whose rhetorical force depends on a material and metaphorical slipperiness, even as it insists on the recollection of a particular object. In this reincarnation, which is an emphatically literary, textual reincarnation, the Silenus enables negotiation between different spheres, especially between the profane and the sacred.

Beginning with the claim that the Silenus 'seems to have passed into a proverb among educated people', Erasmus asserts their place in the common memory. He summarizes several of their key material properties:

> [They are] said to have been a kind of small figure of carved wood, so made that they could be divided and opened. Thus, though when closed they looked like a caricature of a hideous flute-player, when opened they suddenly displayed a deity, so that this humorous surprise made the carver's skill all the more admirable (CWE 34: 262).

These objects exist as a kind of rumour – we know only what they are 'said to have been', and so they are mysterious things of the distant past. Erasmus claims that they were made of 'carved wood', a detail that is not given by Plato, who specifies only that they are found in 'statuaries' shops', which might well suggest other materials such as clay or stone. Finally, this passage draws attention to these objects as things of 'humorous surprise', which show off the 'skill' of their maker when they 'suddenly' reveal an inside that contrasts dramatically with their 'hideous' external appearance. Again, Plato's description does not explicitly mention the suddenness of the Silenus's revelation, and so this is another elaboration from Erasmus, who emphasizes the Silenus as something surprising and entertaining, like a sort of magic trick, as well as instructive. While Alcibiades explains in the *Symposium* that Socrates had a laughable exterior but a serious interior, for Erasmus it is, crucially, the act of revealing what is inside that prompts enjoyment.

The Sileni are more than skillfully crafted toys, however; they ultimately exemplify 'the nature of things really worth having':

> Their excellence they bury in their inmost parts, and hide; they wear what is most contemptible at first glance on the surface, concealing their treasure with a kind of worthless outward shell and not showing it to uninitiated eyes. Vulgar, unsubstantial things have a far different design; their attractions are all on the surface and their beauties are at once displayed to all and sundry, but look inside and you will find that nothing could be less like what was promised by the label and the outward view (CWE 34: 264).

This passage establishes the Silenus as the epitome of the essential hermeneutic problem of the dichotomy between inside and outside. In things that are substantial and worthy of praise, 'excellence' is always 'inmost', while the 'surface' is 'contemptible'. The exact opposite is true of 'vulgar, unsubstantial things'. Thus the Silenus exemplifies the dilemma of how to discern hidden truths from what is visible: those with 'uninitiated eyes' cannot get beyond the outside.

The Silenus figure originally offered a model for explaining the person and discourses of Socrates, but in *Sileni Alcibiades*, having explained the basic principles of the object, Erasmus argues for its universality. He explains how the Silenus simile is applicable to not only numerous individuals from the classical past, but also key biblical figures such as John the Baptist, a humble man of the desert 'clothed in camelhair with a leather girdle round his loins', who in his actions 'far surpassed kings with their purple and their precious stones'. Many saints are notable for their asceticism, but the figure of John the Baptist in his loincloth is particularly iconic. Usually depicted with long hair, a beard and ragged clothing, his appearance is not entirely dissimilar to illustrations of the wild followers of Silenus, or even of Socrates himself. The iconography of John the Baptist would have been familiar in sixteenth-century Europe from visual representations including devotional statues, and thus while Erasmus says that the Silenus figure provides one way of thinking about this saint, we might wonder whether traditional representations of John the Baptist (see Baxandall 1980: plates 4, 79) influenced how Erasmus imagines the Silenus in his own contemporary context, as a comparable 'small figure of carved wood'.

While John the Baptist is an exemplary Silenus in several ways, those who bedeck themselves with external tokens of wisdom or courage and do not substantiate these outward material claims in their behaviour 'reproduce Silenus inside-out'. 'Anyone who looked thoroughly into the driving force of things and their true nature', Erasmus explains, 'would find none so far removed from real wisdom as those whose honorific titles, learned bonnets, resplendent belts, and bejewelled rings advertise wisdom in perfection' (CWE 34: 265–6). 'Honorific titles' join an array of material tokens to form a catalogue of outward things that are literally superficial: the 'true nature' of all things is that 'real wisdom' is never immediately visible. To this end, the Silenus serves as an illustration for how we should approach the whole of creation. 'So true it is in things of every sort that what is excellent is least conspicuous', Erasmus emphasizes:

> In things of every kind the matter, which is less valuable, is most fully open to perception, while the principle, the moving force active for good, is perceived through the value of that activity, and yet is itself far removed from perception (CWE 34: 266–7).

The Silenus is a three-dimensional model not just of the dissonance between what is perceived and what is 'far removed from perception' in earthly terms, but also of the relationship between the earthly and the divine. The sacraments offer one manifestation of this relationship between earthly 'matter' and divine 'principle': 'You see the water, you see the salt and the oil, you hear the words of consecration, and this is like seeing a Silenus from the outside; the power from heaven you neither hear nor see, in the absence of which all the rest would be mere mockery' (ibid.). Water, salt and oil are

(like wood, the material from which Erasmus claims the original Sileni were made) very ordinary, basic substances, but when they are put to sacramental use they are transformed into the outward signs of the 'power from heaven', which itself cannot be perceived by human ear or eye.

As an exercise that aims to reveal hidden meaning in a text, it is the exposition or exegesis, of all literary forms, that may most readily be compared with the opening of a Silenus. Erasmus explains that although some of the stories in the Old Testament seem completely repugnant, 'yet under these wrappings, in heaven's name, how splendid is the wisdom that lies hidden!' (CWE 34: 267). The 'wrappings' of scriptural Sileni may be as off-putting as the rough clothing and skin of Socrates, but like the outer casings of the great philosopher, they actually conceal glorious 'wisdom'. To recognize the value of the Silenus image is to participate in the universal unfolding of the Christian narrative, and even to imitate Christ himself, the greatest of all Sileni. The temporal structure of revelation encoded in the Silenus is central to Christian understanding, both in its intermittent epiphanies or revelations of divine will, and in the apocalyptic shape of history as something that is continually being opened.

For Erasmus, a pagan statue becomes a crucial tool for explaining some of the fundamentals of the Christian faith. The Silenus appears again and again throughout his writings, illustrating how we might better understand people, things and texts. The strengths of the Silenus as a metaphor are those involving its capacity to inspire wonder, marvel and curiosity; in other words, the irrational desires that underpin religious faith. Although he was explicitly suspicious of some of the material artefacts associated with traditional Catholic devotion, Erasmus recognized the potential of the material to draw the faithful closer to the spiritual. His extensive engagement with the Silenus figure represents one way of negotiating between these difficulties, because it involves a statue that is pagan, not Christian, and moreover, an object that probably never actually existed. With his recovery of the Silenus, Erasmus does not simply materialize intangible concepts, but also elaborates on them through a complex interaction between the material and the metaphorical.

The ever-shifting identity of the Silenus in Erasmus's writing means that it remains unclear what exactly we are supposed to imagine when we are told to think of this object. One of the lengthiest of the *Adages*, the *Sileni Alcibiades* was also printed separately in Latin in 1517, and was quickly followed by translations into other languages. In one of these early English versions, published in 1543, the first page announces 'a scorneful image or monstrus shape of a maruelous stra[n]ge fygure called, Sileni alcibiadis' and features a woodcut depicting a headless man, with a smiling face on his torso. It seems that the printer selected this illustration because it shows a suitably 'scorneful image or monstrus shape', but it does not look like the classical god Silenus,

or Socrates or the metaphors Erasmus constructs in the text. This page thus encapsulates the early modern response to the Silenus: nobody is quite sure what this object is, but all are aware that it is something 'maruelous' and 'stra[n]ge'.

These qualities of the marvellous, the strange and the protean dominate the Silenus's identity in the later sixteenth and early seventeenth centuries. While it endures as a recognizable commonplace – something neat, concrete and quotable – it remains the case that no one is quite sure exactly what the material artefact underpinning this commonplace looked like, or what it contained. The early modern imagination gave material form to an object that did not exist, and that had probably never existed, in order to create a useful metaphor, something essentially immaterial.

Erasmus is the only Renaissance writer to meditate on the Silenus at any length. Its subsequent appearances in sixteenth- and seventeenth-century texts are usually more fleeting as, for example, in the 1612 *The young divines apologie for his continuance in the Vniuersitie with certaine meditations*, a posthumously published defence of the study of theology by a young man called Nathaniel Pownall. The Sileni appear after a discussion of the famous competition held between the ancient painters Zeuxis and Parrhasius, as reported by Pliny, to see 'which had the masterie in his art' (1612: 22). Parrhasius, who deceived his fellow painter with 'his figured artificiall vaile' and was deemed to have won the contest, produced 'the true emblem of Judicious silence'. Picking up on this imagery of concealment, Pownall criticizes those students of theology who have too much to say for themselves: like 'superficiall Artizans', such men believe that there is 'nothing at all covered under the vaile of judicious silence'. 'Whereas indeede', he argues:

> as in the auncie[n]t *Sileni* (curious statues so cunningly contriued, that while they were closed, they seemed rough hewne and deformed, but vnioyned appeared most curious) there is much beautie within, though at first little shewe without. So that in the end all will with the Orator, prefer the discreete silence of the one, before the others fond babling.

Pownall is momentarily fascinated by the idea of the 'auncie[n]t *Sileni*', but seems at a loss as to how to depict them, describing them as 'curious statues' when 'closed' but also 'most curious' when 'vnioyned'. Though we are told that they were 'cunningly contriued', Pownall does not give a specific description of what they looked like. Apart from saying that they 'seemed rough hewne and deformed', he leaves the ideas of the 'cunning' and the 'curious' to suffice in their useful imprecision. Inside these Sileni there is 'much beautie', but Pownall is again vague, not elaborating on this abstract

noun. While his rhetorical point turns on the contrast between 'within' and 'without', his picture is devoid of any concrete details, and thus this is an image that is paradoxically almost without any substance.

Sometimes, however, early modern writers have a more specific conception of the material form of the Silenus, and what was contained inside it. In his mythological poem *The Third Part of the Countesse of Pembrokes Yvychurch*, Abraham Fraunce (1592) brings the Sileni into a passage of commentary on the similarities between poets and painters, a standard concern for Renaissance writers. Each Ovidian episode in the poem is followed by a lengthy reflection in prose, by an old shepherd called Elpinus. In his first reflection, Elpinus explains the commonplace idea that in poetry profound mysteries are hidden beneath 'an amyable figure and delightsome veyle'. He elaborates: 'As the learned Indians, Æthiopians, and Ægyptians kept their doctrine religiously secret for fear of prophanation, so the Grecians by their example, haue wrapped vp in tales such sweete inuentions, as of the learned vnfolder may well be deemed wonderfull, though to a vulgar conceit, they seeme but friuolous imaginations' (sig. B1v). This physical imagery of wrapping and unfolding emphasizes the processual aspects of both writing and interpreting in tactile terms, and makes the text into a sacred object that hides its riches in the profane exterior of language. It is then an easy step from pagan texts to the Judaeo-Christian scriptures: 'Yea that song of the most wise Salomon, called for the excellencie thereof the song of songs, is altogether mysticall and allegoricall . . . which may well bee compared to sweete grapes couered with leaues and bra[n]ches, or to the old Sileni, which being but ridiculous in shew, did yet inwardly conteine the sacred image of some God' (sig. B1v). The 'sacred image' contained in such a Silenus is something appropriately religious, but 'some God' is also deliberately generalized.

While Fraunce's depiction allows the Silenus a certain specificity – it contains a representation of divinity within an exterior 'ridiculous in shew' – it also retains a vagueness, which establishes it as something from the ancient past. This vagueness allows it to fit in with the hermeneutic agenda of a text that according to its title page is explicitly concerned with the framing and unfolding of 'the most conceited tales of the Pagan Gods . . . together with their auncient descriptions and Philosophicall explications', but that also invites the reader to think about the Christian scriptures. For those who turn to the Silenus after Erasmus, the vagueness of the original Silenus as something that contained the image of a god becomes essential to their use of the metaphor. By skipping over the precise contents of this object, or leaving them sufficiently indistinct, writers in the seventeenth century deliberately ignore the potentially troubling resonances of the Silenus as something that takes the form of an ancient god (like a pagan idol) on the outside, and contains further images of divinity (akin to Catholic icons) within it.

As texts like these reveal, the Silenus statue becomes a powerful mediatory object, offering a way to think in material terms about some fundamental intellectual problems of discernment and interpretation. In its very origins the Silenus is a playful object, and this playfulness endows it with a remarkable mobility, or flexibility, allowing it to move between the antique past and the early modern present; to appear at some times in great detail, and at others only in the vaguest of outlines; to vary in its exact form, as long as the crucial element of opposition between inside and outside is maintained.

Beyond fixed dichotomies

What eventually happens to the Silenus? It is related to many other proverbial images of hidden virtue, and also to universally used similes that invert the Silenus-figure's ugly exterior and attractive interior – an apple with a rotten core, or a poisonous snake hiding beneath beautiful flowers, for example. While the Silenus-figure fades from popular usage after the seventeenth century, the essential phenomenological concerns embodied in it remain lively across many human societies, and it is not so culturally specific as one might assume. In her discussion of the social and political implications of secrecy in relation to the materiality of gestures and objects in twentieth-century Sierra Leone, for example, Mariane Ferme writes that 'the skill to see beyond the visible phenomenon and to interpret deeper meanings is . . . a culturally valued and highly contested activity . . . It is a skill that bridges the gap between history and the present, between old and new technologies of communication and interpretation' (2001: 4). For societies in the region she is concerned with, masks play important roles, and the examples she talks about, including a Silenus-like ugly mask, often reinforce 'the greater appeal of the contained source over the visible manifestations of power' (ibid.: 163).

However, in Western thought, at least, there has been a recent critical turn against this dichotomous vision of container and content, or of surface and depth. Daniel Miller terms this the problematic *depth ontology*, whereby we 'presume a certain relationship between the interior and the exterior'. Through this cultural construction, we tend to think that what is on the surface is superficial, and that the truth is always hidden. Our attitude towards clothes exemplifies this, Miller suggests – we think of clothing as a superficial exterior, and our true identity as hidden 'deep' within us. Consequently those who pay attention to the matters of the surface, whether they are keen clothes shoppers or academics or both, are often seen as 'shallow': there is 'a larger denigration of material culture in our own society, where materialism itself is viewed as superficial' (2010: 16, 22). As superficiality increasingly becomes a

critical and moral problem, the Silenus-figure no longer seems to offer such an obvious simile to reach for.

In thinking about what 'inbetweenness' means, it is tempting to use dichotomous 'and/or' constructions, finding a fixed point or identity between two poles. Although the Silenus is dichotomous in its very form – it operates on an 'open' or 'closed' basis – its appearances in early modern writing demand that we think beyond binary constructions that can often be limiting, as Miller hopes we will. In its resurrection in the early modern imagination, this object becomes something malleable, and often hard to pin down. Inbetweenness, when we are looking at the Silenus, is not about being one thing or the other, but about the complex interplay between material and imaginary spheres, which allows this imagined object to work across various intellectual contexts. Plato's Silenus figure shows us, ultimately, that metaphor and the material can be powerfully co-constitutive of each other.

References

Baxandall, M. (1980) *The Limewood Sculptors of Renaissance Germany*, New Haven, CT: Yale University Press.
Camille, M. (1989) *The Gothic Idol: Ideology and Image-Making in Medieval Art*, Cambridge: Cambridge University Press.
Erasmus, D. (1543) *Here Folowith a Scorneful Image or Monstrus Shape of a Maruelous Stra[n]ge Fygure Called, Sileni Alcibiadis Presentyng ye State [and] Condicio[n] of This Present World*, London: John Goughe.
Erasmus, D. (1974–2011) *Collected Works*, 78 vols, Toronto: University of Toronto Press.
Ferme, M. C. (2001) *The Underneath of Things: Violence, History, and the Everyday in Sierra Leone*, Berkeley: University of California Press.
Fraunce, A. (1592) *The Third Part of the Countesse of Pembrokes Yvychurch Entituled Amintas Dale*, London: Thomas Orwyn for Thomas Woodcocke.
Freedberg, D. (1989) *The Power of Images: Studies in the History and Theory of Response*, Chicago, IL: University of Chicago Press.
Gamble, C. (2007) *Origins and Revolutions: Human Identity in Earliest Prehistory*, Cambridge: Cambridge University Press.
Gell, A. (1998) *Art and Agency: An Anthropological Theory*, Oxford: Clarendon Press.
Knappett, C., L. Malafouris and P. Tomkins (2010) 'Ceramics (As Containers)', in D. Hicks and M. C. Beaudry (eds), *The Oxford Handbook of Material Culture Studies*, 588–612, Oxford: Oxford University Press.
Lakoff, G. and M. Johnson (1980) *Metaphors We Live By*, Chicago, IL: University of Chicago Press.
Lissarrague, F. (1990) *The Aesthetics of the Greek Banquet: Images of Wine and Ritual*, trans. A. Szegedy-Maszak, Princeton, NJ: Princeton University Press.

Mauriès, P. (2002) *Cabinets of Curiosities*, London: Thames & Hudson.

Miller, D. (2010) *Stuff*, Cambridge: Polity Press.

Plato (1967) *Symposium*, trans. W. R. M. Lamb, London: William Heineman.

Pownall, N. (1612) *The Young Divines Apologie for His Continuance in the Vniuersitie with Certaine Meditations*, London: Cantrell Legge.

Steiner, D. T. (2001) *Images in Mind: Statues in Archaic and Classical Greek Literature and Thought*, Princeton, NJ: Princeton University Press.

Thomas, J. (1996) *Time, Culture, and Identity*, London: Routledge.

Tilley, C. (1999) *Metaphor and Material Culture*, Oxford: Blackwell.

Walker Bynum, C. (2011) *Christian Materiality: An Essay on Religion in Late Medieval Europe*, Cambridge, MA: MIT Press.

FIGURE 14.1 *Bronze coin of Macedonia, 168–166 BC, Classical Numismatic Group, Mail Bid Sale 76, lot 321 (www.cngcoins.com).*

14

Coinage between cultures: Mediating power in Roman Macedonia

Clare Rowan

Consider this bronze coin struck in ancient Macedonia soon after the Romans took control of the region in 168 BC (Figure 14.1; MacKay 1968: no. 1). As a piece of currency, the role of this object *is* one of inbetweenness, since monetary instruments mediate between different value systems and goods. Whether in the form of coinage or another object, money is one of the key media through which different cultures and social actors connect and interact with each other. Conquest, colonialism and empire-building depend on these media of commensuration, on objects that can render 'epistemically equivalent and transitive once incomparable objects and ideas, signs and meanings' (Comaroff and Comaroff 2005: 109). Money is also designed to travel between individuals, with each monetary transaction actively building social relations and an imagined community. In this way the materiality of money, its physical presence, participates in the construction and/or reinforcement of a particular type of community, whether this takes the form of a modern nation state or larger entities like the European Union (Backhaus 1999; Helleiner 2003). Keith Hart (2005) points out that money also has a memory function, in that it is a medium that keeps track of our 'proliferating connections with others', and in this sense, money also sits in between past, present and future social transactions or exchanges of value.

In exploring the use of currency by the Romans in Macedonia, this chapter identifies some of the characteristics of money that facilitate its inbetweenness. Issues of ambiguity, mobility, appropriation, unfamiliarity and acceptability form its focal themes. Notably, these characteristics can apply to both the object itself (the physical coin) and the imagery on it (the coin type), demonstrating the interconnectedness of numismatic iconography and the monetary instruments that carry it.

Ambiguity

The imagery carried on the coin in Figure 14.1 is a mix of Macedonian and Roman motifs. On the obverse ('heads') side is an image of Roma. Similar iconography appears on Roman silver coinage struck at Rome in this period (Figure 14.2a; Crawford 1974: no. 157/1); in this sense the image can be placed within a Roman iconographic tradition. But the image of Roma here could be mistaken for the hero Perseus, who was portrayed on Macedonian coinage before the Roman conquest. On several issues the hero is strikingly similar to Roma (Figure 14.2b, with Perseus on the obverse). On Roman currency Roma was also portrayed in differing ways; while sometimes a rather feminine figure (e.g. Figure 14.2a), this is not always the case, and she is often represented in a manner more akin to that in Figure 14.1. The complex set of possible associations surrounding the iconography on the Roman-Macedonian coin (Figure 14.1) increases when we observe that the Hellenistic king of Macedonia, Philip V, had presented himself as Perseus on coinage by adopting the griffin-head helmet (Figure 14.2c, with Philip portrayed as Perseus on the obverse and a Macedonian shield forming a border). His son, the last king of Macedonia, was named Perseus. So the helmet worn by Roma in Figure 14.1 may also have possessed an association with the defeated Macedonian monarchy. The imagery is thus ambiguous – to a Roman eye the image could be read as Roma, but to a Macedonian glancing at the coin, the immediate association may have been Perseus, a hero associated with the kings who had previously ruled the region. As the coin travelled from person to person and context to context, individual meaning(s) would be attached to the image.

The ambiguity of the imagery may have been intentional. Coinage has the power to combine image and text, and the Romans often used text on their coinage to explain unusual iconography, or to add subtle layers of meaning (Rowan 2009). The absence of an identifying inscription here would have increased the ability of the image to be subject to multiple, 'mutually incompatible interpretations' (each held to be correct) in a way not possible had the image been accompanied by text (Landau 2002: 18). Roma is not

FIGURE 14.2 *(a) Roman silver denarius, 179–170 BC, Classical Numismatic Group, Auction 90, lot 1301 (www.cngcoins.com); (b) bronze coin of Philip V of Macedon, 211–179 BC, Classical Numismatic Group, Electronic Auction 239, lot 64 (www.cngcoins.com); (c) silver coin of Philip V of Macedon, 221–179 BC, Nomos AG, Auction 6, lot 56; (d) silver coin of Macedonia, 187–168 BC, Classical Numismatic Group, Electronic Auction 261, lot 50 (www.cngcoins.com); (e) Roman denarius, 127 BC, Yale University Art Gallery, 2001.87.697; (f) Roman denarius, 82–80 BC, Classical Numismatic Group, Electronic Auction 196, lot 227 (www.cngcoins.com); (g) Roman denarius, 126 BC, Roma Numismatics, Auction 2, lot 409 (www.romanumismatics.com).*

portrayed with prominent earrings or other features that unmistakably identify her as a female goddess, as in Figure 14.2a. An ambiguous image would have facilitated the movement of the object between cultures, value systems and users, while simultaneously forming a focal point through which Roman and Macedonian cultures could intersect. Shared usage of an image or object does not necessitate a single interpretation. On the contrary, common use of an object/image minimizes the need to insist on shared meaning (Seligman and Weller 2012: 160–1). The iconography of Perseus on earlier Macedonian coinage may have evoked the image of Roma in the minds of the Romans, inspiring them to adopt 'Roma' or 'Roma-Perseus' as a coin type in the region. In this period the iconography of Roma was rare outside the city of Rome, and its appearance here might be explained as a reaction to local currency. In reality, however, we cannot discern whether the official or die engraver responsible for this coin intended to create a deliberately ambiguous image, or whether ambiguity arose as the coin travelled between users and cultures, as well as over space and time.

The reverse ('tails') side of the coin (Figure 14.1) also simultaneously has Roman and Macedonian associations. The oak wreath that frames the reverse is taken directly from Macedonian coinage (Figure 14.2c), and the use of Greek rather than Latin is also more appropriate to this region than to Rome. But while the coinage of the Macedonian kings displayed the club of Hercules and gave the name of the reigning monarch on the reverse (Figure 14.2c), the issue struck by Roman authorities has no club, and the coin gives the name of the region as well as the name and position of the Roman magistrate responsible for the coin, Gaius Publilius. As an object inbetween cultures, the coin is named as a product of *both* the Macedonians and the Roman government.

Hart (2005) argues that money, along with language, is one of the most important vehicles for collective sharing or common meaning (culture), and it is striking that both language and monetary iconography make use of ambiguity. Although ambiguity is less valued in the modern-day English-speaking world, it is an important (and often overlooked) communication strategy within and between cultures (Levine 1985). The vagueness of ambiguous images, objects and language can, as Donald Levine (ibid.: 35, 218) notes, have a socially binding function. A more modern example is the Parthenon marbles, transported to Britain by Lord Elgin in the early nineteenth century. Here ambiguity was not the intention of the creator, but arose as audiences attempted to interpret the reliefs after their rediscovery. The elusiveness of meaning meant that they could offer numerous messages for British viewers, who were then able to use the marbles to construct differing views of British identity (Rose-Greenland 2013). Initially satirized as a mass of 'broken arms, legs, and shoulders' (*Examiner* 1816, cited by George 1949: 685), the marbles were eventually categorized as works of art and put on display in the British Museum. What these reliefs 'meant' differed according to the viewer, reflecting differing ideas of what it was to be 'British'. Some compared the physiques of the horse riders favourably with British athletes, others saw a representation of (British) masculinity or of military prowess that might be equated to Britain's own power. Although originally polychrome none of the colour on the reliefs survived, meaning the marbles could also be used to make claims about white superiority (Rose-Greenland 2013: 663–7). The Elgin marbles became a focal point for the discussion of British identity, and although the imagery of the reliefs was 'shared', their meaning differed from person to person.

In the same way our Roman-Macedonian coin and its imagery may have attracted differing interpretations by different users, a shared object/image forming the basis for multiple ideas about what Macedonia 'was' after the fall of the Macedonian monarchy. Interpretations may also have changed over time as Roman power in the region developed. Images can move between

various societal domains (imaginary, linguistic, intellectual, material) to form a concrete focal point for a community (Zubrzycki 2011: 24). As with the Roman-Macedonian coin, images, and the material objects that bear them, make abstract ideas of community and nationhood concrete (Olsen 2010: 3–5; Zubrzycki 2011).

Mobility

The iconography of this coin and others struck from the same dies may have been subject to multiple interpretations dependent on context and user. Unlike larger monuments or other types of visual material, money is constantly in motion, travelling between one user and the next, being stored or spent, pulled out or put away (Mwangi 2002: 31–4). Spatially, money moves inbetween. While other monuments may be placed in a manner that guides the way they are experienced and interpreted (e.g. through context, juxtaposition, approach routes), coins have no such reference point. Meaning is thus generated by a changing series of contexts and social actors. Mobility has been identified elsewhere as an important feature of images that pass between cultures, in particular images that move beyond the boundaries of the signifiers that gave the objects their 'original' meaning (Landau 2002: 16). The physical characteristics of coinage (e.g. its small size) give it (and its imagery) a mobility that is key in allowing it to travel inbetween.

This mobility affects our understanding of money as a communication media. The implications of modern technology for the interpretation, associations and dissemination of imagery have concerned scholarship since Walter Benjamin's essay on the work of art in the age of mechanical reproduction (1999). Benjamin observed that modernity's ability to easily reproduce images or paintings fundamentally altered the way in which they are viewed, since these objects are no longer placed within a specific context (consider, e.g. the multiple contexts and associations of the image of the Mona Lisa: on keychains, billboards, mobile phone covers, posters and elsewhere). But the mobility of money, and the fact that it was a mass-produced medium in antiquity, means that many of the factors Benjamin highlights were also present before the modern era. The ability of the Internet to bring images into the households of a geographically vast section of the population has also led to a reconsideration of different contexts of 'viewing', but here too money formed an important forerunner (Hörisch 2004; Mitchell 2005: 309–35). We should not lose sight of money's qualities as a *media* (of exchange). The mobility of ancient money meant that its imagery could travel and permeate different contexts; by transiting

inbetween, the images carried on coinage reached a relatively large number of viewers and contexts.

Finds of the Roman-Macedonian coin (Figure 14.1) are rare, but the few find spots that do exist demonstrate the mobility of the object. No examples of this particular coin have yet been found in coin hoards within Macedonia, although two specimens of another type of Publilius were found in a hoard just outside the ancient city of Pella (Inventory of Greek Coin Hoards 2015, no. 483). One find spot is the city of Corinth, where an example of our coin was found in a manhole alongside other debris in a fill context, roughly dating from the second to first centuries BC (Romano 1994: 61). How a local Macedonian bronze coin arrived in Corinth is unknown, although other Macedonian coins were also present in the fill (Romano 1994: nos. 134–8). These issues may have been brought by the Roman army (the Romans famously razed Corinth in 146 BC), or else arrived with merchants or other individuals. Whatever the particular actor(s) responsible, once these objects arrived in another city, in another region, in another context, the particular associations of the coin and its imagery would have changed. One might imagine that the play between 'Roman' and 'Macedonian' on the coin may have been lost, and instead the object might have been seen more as one issued by the Roman government, or it may have been valued purely in terms of its materiality (a bronze coin-like object that would serve as small change, regardless of its imagery).

Appropriation

Our Roman-Macedonian coin and its imagery probably had multiple associations as it travelled between Roman and Macedonian, soldier and merchant, maker and receiver. But it was not only the physical object that travelled between cultures – the imagery of coinage also did. From the Roman perspective, the use of Macedonian imagery may have signified that, as conquerors of the region, they had also 'conquered' the iconography of the area. Both Romans and Macedonians may have seen the iconography of Figure 14.1 as rightfully 'theirs', just as both parties may have possessed mutually incompatible interpretations of the image. This phenomenon has been identified elsewhere, albeit in a more recent context. During the German occupation of the Channel Islands in the Second World War, the imagery carried on local coinage (Guernsey and Jersey crests, the king's portrait) was used as a symbol of resistance by local inhabitants. The king's portrait in particular was converted into small pieces of concealable jewellery that could be worn as a form of hidden rebellion. But having conquered the Channel Islands, the Germans also saw themselves

as the 'rightful' owners of the islands' crests. Local coins were sent back to Germany as souvenirs, or converted into pieces of 'trench art'. The king's portrait was increasingly utilized by the Germans in this context. As Gillian Carr (2012) details, while locals used coin imagery to make statements of local identity, the Germans appropriated the same iconography. The imagery was consequently positioned inbetween, with sometimes common, sometimes distinct associations and meanings for both sides.

The Romans too may have considered the iconography of Macedonia rightfully 'theirs' after the conquest. The subjugation of the region resulted in various monuments celebrating Roman military prowess and the victories of individual generals. A common motif in many of these monuments was the Macedonian shield, a symbol that had graced local silver currency before the Roman conquest (Figure 14.2d, with a Macedonian shield on the obverse). These shields are, for example, carried by defeated Macedonians on the frieze of a monument in Delphi erected for Lucius Aemilius Paullus, the general who led the Romans to victory in Macedonia in 168 BC (Kähler 1965). Paullus converted a monument originally intended for the Macedonian king Perseus; a Latin inscription states that Paullus 'took it from King Perseus and the Macedonians', a clear statement of appropriation (Russell 2012: 159). Macedonian armour, including shields, were brought back to Rome to be paraded in Paullus's triumph (Plutarch, *Aemilius* 32.5–8; Livy 45.35.3). The Macedonian shield and its symbolism, then, had been 'captured' and appropriated by the Romans.

This is also suggested by the iconography of particular coins struck at Rome. In the Roman Republic, the *tresviri monetales* (a board of three men elected annually) were responsible for the Roman coinage issued each year. Moneyers normally came from elite families and the position was often the first step of their political career. While Roman coinage initially carried rather standard imagery (head of Roma on one side, the Dioscuri on the other), from the 130s BC the decoration of Roman silver coinage became more diverse, with types reflecting the historical achievements of the moneyer's family (Meadows and Williams 2001: 37–8). In this manner Roman coinage became characterized by an ever-changing array of images, a distinctive approach to currency design. This cultural peculiarity might be connected to the fact that *moneta*, the origins of our word 'money', came from the Latin *monere*, which has among its meanings 'to remember or to recall' (Meadows and Williams 2001; Hart 2005). In the Roman Republic, coinage was a medium of not only exchange, but also memory, which communicated and commemorated the achievements of one's ancestors. Money was truly 'media' or a 'monument in miniature' (Chueng 1998).

Among the changing iconography celebrating Rome's past, three issues are of particular relevance here. Each carries the image of a Macedonian

shield. The first was released by the moneyer M. Caecilius Metellus in 127 BC, and displays Roma on the obverse and a Macedonian shield on the reverse (Figure 14.2e; Crawford 1974: no. 263/1a–b). Metellus's father, Q. Caecilius Metellus Macedonicus, had quashed an uprising in Macedonia in 148 BC (Morgan 1969). The use of the Macedonian shield here by the younger Metellus alludes to the achievements of his father: the shield has been appropriated as the spoils of victory. The image thus travelled culturally and spatially from Macedonia to Rome, becoming a symbol that referenced, and sat in between, both regions. It should be noted that the Macedonian shield is presented in a slightly modified form on Metellus's coinage: an elephant's head has been added to the centre. The elephant was the symbol of the Metelli family (Linderski 1996: 173), and its addition to the Macedonian shield here can be read as a further act of appropriation.

The son of a cousin of Caecilius Metellus became a moneyer in 82–80 BC, and again struck coinage with a Macedonian shield decorated with the Metellian elephant (Figure 14.2f; Crawford 1974: no. 369/1). The shield also appears on coinage struck by the moneyer T. Quinctius Flamininus in 126 BC (Figure 14.2g, with a Macedonian shield below the horse-riding Dioscuri on the reverse; Crawford 1974: no. 267/1), referring to a Macedonian victory of one of his ancestors (in this case the victory of T. Quinctius Flamininus over Philip V). These examples demonstrate that individual families in Rome appropriated the Macedonian shield as a sign of military success; as conquerors of the region, they had 'rightfully' gained the use of its local symbols. Coins may have physically moved different iconography to different contexts, but imagery could also move independently: alongside a social life of things, there is a social life of images (Mitchell 2005: 90–3).

In ethnographic studies of consumption, appropriation has been used to describe the process by which a 'global' object becomes 'local'. Hans Hahn (2004), for example, identifies four stages to the appropriation of objects: material appropriation (when the commodity becomes the personal possession of someone), objectification (in which objects are categorized or classified in relation to other objects), incorporation (the creation of a local way of 'correctly' using something) and transformation (when the object becomes fully integrated into the local context). Importantly, these stages are never completed; rather appropriation is an ongoing process as objects are continually assigned new contexts, meanings and functions. In the archaeological record the stages of material appropriation and incorporation are easier to identify than objectification or transformation (Stockhammer 2012: 49). Although Hahn focuses on material objects, the concept can equally be applied to images: in this instance we can spot the 'material appropriation' of the Macedonian shield as it is removed from its 'global' (Hellenistic) context and transformed into a 'local' (Roman) possession, 'owned' by particular elite families. Hahn

(2004: 220) notes that material appropriation can include changes to the form of an item, and we can see this too in our example through the addition of the elephant's head. Other aspects of appropriation remain more difficult to identify given the incomplete nature of the record from the ancient world, but it is important to note that Hahn emphasizes the ambiguity of the appropriation process, in which original and new meanings can exist simultaneously.

It was not just the Macedonian shield that was appropriated by the Romans: the portrait of the Macedonian king was also used. In 113 or 112 BC, a moneyer in Rome released a coin issue showing the portrait of the deceased Macedonian king Philip V on the obverse, accompanied by a monogram of the word ROMA (Figure 14.3a; Crawford 1974: no. 293/1). The image is made 'readable' to its audience by the presentation of the king in a helmet with goat's horns (in Roman literature this is the traditional headdress of a Macedonian monarch; Livy 27.33.2-3; Plutarch *Pyrrhus* 11.5), and by the presence of the Greek letter phi (φ) before the bust, the first letter of Philip's name. The image has at least two levels of association, both of which submit the Hellenistic monarch to a very Roman context. The first is that the coin type uses the monarch's portrait as a pun: the moneyer responsible for the coin

FIGURE 14.3 *(a) Roman denarius, 113 or 112 BC, Yale University Art Gallery, 2001.87.779; (b) bronze coin of Macedonia, 168–166 BC, Yale University Art Gallery, 2004.6.1438; (c) bronze coin of Macedonia, 187–168 BC, Yale University Art Gallery, 2004.6.1374; (d) bronze coin of Macedonia, 166–165 BC, Yale University Art Gallery, 2001.87.10903; (e) silver tetradrachm of Macedonia, c. 90–70/65 BC, Yale University Art Gallery, 2007.182.360; (f) tetradrachm of Athens, 86–82 BC, Yale University Art Gallery, 2004.6.1978.*

issue was named L. Philippus. The use of visual 'puns' (called 'canting' types in numismatics) was a well-established tradition in antiquity. The image of the king may also refer to the activities of one of the moneyer's ancestors – a Q. Marcius Philippus led an embassy to King Perseus of Macedon in 172 BC, where he famously tricked the monarch into believing peace was possible, thus giving Rome time to improve her military position (Livy 42.37–47; Briscoe 1984: 151). From either perspective, the image of Philip V was appropriated by the Romans – either as a reference to a trick allowing Rome to conquer the region or as a pun, or both.

'Macedonian' imagery thus did not remain 'Macedonian'; it moved from 'global' to 'local', becoming an iconography that sat between both (see Yarrow 2013 for other examples). Returning to Figure 14.1, Gaius Publilius (the Roman official responsible) struck several other coin types in addition to this design (MacKay 1968: nos. 3–6). The iconography of these coins is largely identical to the imagery of pre-conquest Macedonian currency, the only difference being the addition of Publilius's name and official position in ancient Greek (compare Figures 14.3b, a coin of Publilius, and 14.3c, a Macedonian coin struck before the Roman conquest). But the addition of Publilius's name communicates the fact that this Macedonian coin type is struck by a Roman, making the resultant object a product that sits in between two cultures. The use of Macedonian imagery by Publilius again may be interpreted as the appropriation of iconography by the conqueror (transforming the image into one that sat between cultures), or its intention may have been to ensure that these pieces integrated easily into the existing economic system and were accepted by the Macedonian population (facilitating the coin as an object to move between users).

Unfamiliarity?

After the release of the 'Roma-Perseus' coins by Gaius Publilius, and similar issues struck by his successor, Lucius Fulcinnius (MacKay 1968: no. 7), a new coin type was released carrying iconography that was neither traditionally 'Roman' nor 'Macedonian' (Figure 14.3d; MacKay 1968: nos. 8–9). The obverse of this coin series carries a frontal image of the god Silenus, the companion and tutor of the wine-god Dionysius. In classical mythology Silenus exists in an almost constant state of inebriation. The reverse of the coin type has an ivy wreath (a reference to Dionysius) rather than the traditional oak variety, and the name of the Roman official is absent. Instead there is a reference to Macedonia in Greek, with the Latin letter 'D' above. The mix of alphabets again marks the object as neither wholly Macedonian nor Roman. The choice of Silenus is odd since the god had never before appeared on Roman or

Hellenistic-Macedonian coinage (though he would later make an appearance on Roman silver coinage in 91 BC; Crawford 1974 no. 337/1).

Silenus had appeared on coinage of the Thraco-Macedonian region several hundred years earlier, in the sixth and fifth centuries BC. On these issues he is shown drinking, pursuing a nymph, squatting or in the company of a donkey (e.g. Gaebler 1935: 115, nos. 8–9). The god may also have been portrayed frontally on a silver issue from an unknown mint in the region in this early period (ibid.: 138, no. 26). Were the Romans referencing this archaic money when selecting Silenus as a coin type? At first glance it seems doubtful, but the Romans seem to have had an interest in older coin types. For example, during the first century BC in Roman Athens a coin type was released showing a gorgoneion, a possible reference to the coinage of Athens struck in the sixth century BC, knowledge of which was probably preserved in literary texts (Kroll 1972: 98). If a similar phenomenon is occurring here, the Silenus imagery is local to the region, but its selection and presentation are performed within Roman memorial and archaizing monetary culture. The image sat between the heritage of archaic Macedonia and the monetary culture of Republican Rome, as the object it graced moved between different users and contexts.

If the Roman authorities chose to make a reference to the archaic coinage of the region through the Silenus type, it is likely that the reference was lost on most of the coin users, who probably would have considered the iconography unusual for this medium. Obscure and unfamiliar imagery can play an important role in cultural mediation; like the ambiguous image, an unfamiliar or unusual one is also malleable in its interpretations, attracting multiple understandings or associations depending on the viewer and context (Landau 2002: 18). Rather than hybrid or creole imagery, inbetweenness here may have been facilitated by an obfuscation of imagery, which mediates by being non-symbolic or unusual to all concerned.

Unlike the Silenus simile discussed by Lucy Razzall in this book, this Silenus image exists on a particular object. Whereas the unusualness of Silenus here attracts multiple meanings, in Razall's study it is the ambiguity associated with a material metaphor that seems to have no corporeal existence that makes it attractive for authors of the early modern period. Again we find similarities between language and images. Whether it is physical, verbal or something that exists only in the mind, 'an image is not a text to be read but a ventriloquist's dummy into which we project our own voice' (Mitchell 2005: 140). Images are something that must be interpreted; a picture is worth a thousand words since 'the exact words that can decode or summarize an image are so indeterminate and ambiguous' (ibid.). It is perhaps this inherently ambiguous nature of images, be they mental, verbal or physical, which aid their inbetweenness.

The varying discussions of the Socrates-Silenus discussed by Razzall are paralleled by the multiple interpretations our Silenus has received in modern scholarship. The god was initially believed to be a pun on the name of a Roman official called D. Junius Silanus Manlianus. This proposal has since been disproved as the coin issue is now dated to an earlier period (MacKay 1968: 8–9). Hugo Gaebler (1935: 9) observed that one specimen was overstruck on an earlier Roma-Perseus type and concluded that the Latin D stood for *decreto*, a Roman senatorial decree that allowed the recall and conversion of the earlier 'Roma-Perseus' series. Some specimens of the Silenus coins appear to be overstruck on other coin types and both Gaebler and MacKay believed the 'Roma-Perseus' coin series was the target, since the presence of Roma wearing the helmet of Perseus might have proven offensive to the local population. A more detailed study of this series is needed before any firm conclusions about this hypothesis can be reached.

The observed instances of overstriking suggest that, for whatever reason, the earlier Roma-Perseus coin was deemed unsatisfactory. Perhaps the type of Roma was thought too bold by the Romans, whose conquest of Macedonia had been presented as 'liberation' from the tyranny of kingship. It would only be in 148 BC that the region would be converted into a 'province' proper (Kallet-Marx 1995: 11–56). It is worth noting here that the Roman Republican concept of empire was quite different to our own territorial model. For the Romans of the Republic, to be *sub imperio* was to be 'under Roman sway' or obedient to Rome (ibid.: 25). 'Empire' or *imperium* was the power held by an individual magistrate, while *provincia* or 'province' referred to the area or sphere in which that power was to be exercised (Richardson 2011). The Roman Republican Empire was thus not a territorial one, but an empire of power, influence and control. It is thus difficult to pinpoint the 'moments' when a particular Roman province was created. The contemporary Greek writer Polybius, for example, certainly believed that the Romans had power or *archē* in Macedonia from 168 BC, and the Romans probably also believed Macedonia to be under their influence or *imperium* from this time (Kallet-Marx 1995: 30).

Nonetheless, the use of Roma and the titles of a Roman magistrate may have been considered unsuitable. The names of Roman officials appear neither on the Silenus issue nor on other bronze coins struck in Macedonia in the succeeding decades. There thus may have been a period of negotiation in the selection of appropriate coin types.

Acceptability

As an object that travels inbetween, coinage continued to reflect the changing relationship between Rome and Macedonia. This contribution has thus far

focused on bronze coinage or small change. These coins generally had a localized circulation, meaning these denominations were often used to make statements about local identity (Howgego, Heuchert and Burnett 2005). The lower face value of bronze coins meant that if someone did not accept the coin because they did not recognize the design the economic loss was not significant (although, admittedly, we have very little concrete evidence of this in antiquity). There was a lower inherent risk in changing the iconography of this type of coinage. But the Romans also continued the production of Macedonian silver coinage after the conquest, and the high value of these pieces meant that their acceptability to a variety of parties had to be ensured. This, in turn, led to a different strategy in order to ensure the ability of these objects to move inbetween.

The Romans struck silver coin issues that displayed the bust of the goddess Artemis within a Macedonian shield on the obverse, and a club within an oak wreath on the reverse, accompanied by a reference to Macedonia and the region in which the coin was struck. Although the precise dating of these coins is difficult, the most recent suggestion is that this particular coinage began to be struck before the Roman conquest, and the Romans continued its production (Prokopov 2012: 23–31). As a currency used for transcultural, large-scale payments, the Romans may have been reluctant to change the imagery of silver coinage. In many of the regions Rome conquered, local precious metal currency continued to be produced unaltered, although it was now being produced for, and used by, Rome (de Callataÿ 2011).

It was only in the first century BC that the iconography of Macedonian silver coinage was altered. The obverse now carried the image of Alexander the Great accompanied by a legend referring to Macedonia, while the reverse displayed a club within a laurel wreath, accompanied by the name of a Roman official in Latin (AESILLAS), a reference to his position as quaestor (Q), as well as the insignia of his office: the *sella quaestoria* (magistrate's chair) and *cista* (money chest) (Figure 14.3e; Bauslaugh 2000). This is the first time since the issues of Publilius and Fulcinnius that a Roman magistrate is named on coinage in this region, and the first time direct reference is made to Roman hegemony since the use of Roma. The new iconography was struck over a number of years, with some issues being struck under the authority of other officials (Bauslaugh 1997: 118–20).

Again we see a mixture of Roman and Macedonian motifs. Like Figure 14.1 the coinage was issued in the name of the Macedonians, under the authority of a Roman official. Alexander the Great was one of the most famous Macedonians (particularly in Roman eyes) and the use of the club and the wreath recall earlier Macedonian coinage. But at the same time, the reference to Aesillas and his position allude to Roman control; the quaestor would have served under a governor or Roman consul. Analyses of currencies issued within

more modern 'contact' situations have demonstrated that money often carries elite visions of the conquering empire, as well as an elite understanding of the region conquered (Mwangi 2002; Rowan 2014). From this perspective, the Aesillas coin type communicates an elite Roman understanding of Macedonia. Alexander the Great had great appeal and interest to the Romans, and it is very likely that the dominant elite continued to associate their province with its legendary hero. The find spots of these coins, however, suggests another level of interpretation.

Hoards containing these coins are mostly found in the region of the river valleys that lead from northern Macedonia into Thrace. The lack of wear of the specimens in these hoards suggests that the coins did not circulate for long – instead they must have been hoarded and buried rather quickly (Bauslaugh 1997: 129). These coins were probably struck in the period from c. 90 to 65 BC, which, in conjunction with their limited area of circulation, provides a clue to their purpose. It was at this point in time that Rome fought a series of wars against Mithridates VI of Pontus; the Aesillas coins may have been struck to pacify the Thracian tribes that lived in the region of the Via Egnatia (an important strategic road), or for some other military purpose connected with these campaigns (Bauslaugh 1997: 129). These 'Macedonian' coins, therefore, were not intended for circulation within Macedonia. Rather they are objects that carry the image of Alexander the Great and the name of Macedonians, struck by or for the Romans, in order to function as payment for a third group, the Thracians.

That these coins were used as bribes for barbarian tribes may explain the high number of known specimens that were converted into jewellery (Dahmen 2010: 61). The use-context of these coins also explains the iconography. The portrait used by the Romans, showing Alexander adorned with the horns of Ammon, was the same portrait used by the Hellenistic king Lysimachus on his coinage in Thrace in the late fourth and early third centuries BC. This particular image of Alexander the Great was thus an established one in the region, though the Romans chose to omit the diadem (referring to Alexander's position as king) on their representation (Dahmen 2010: 61). The image thus falls at the intersection of several cultures: it references Macedonia's past glories and the traditional numismatic iconography of Thrace, but in a manner that conformed to Roman aesthetics and ideology. The Romans needed a coinage that would be acceptable as payment within the region of Thrace, one that could physically go between cultural, value and governmental systems with relative ease, and this probably influenced the selection of this particular iconography.

The entanglement of cultures and imagery witnessed in the Aesillas coinage can be demonstrated with another silver issue. Hoard finds demonstrate that in the second half of the second century BC Athenian silver coinage circulated

in Macedonia (de Callataÿ 1991–2). These 'Athenian' coins may have been shipped to Macedonia to pay the Roman troops stationed in the region, but equally they may have been produced in Athens for use by Rome (de Callataÿ 2011: 70, 77). While occupying Athens in 87 BC, the Roman general Sulla also struck coins of this type, though the reference to Athens was removed in favour of monograms referring to different magistrates (Figure 14.3f). The complexity of imagery (Athenian), coining authority (Athenian and/or Roman) and coin use (Macedonian) in this particular example is suggestive of an entangled network involving multiple traditions and cultures.

Conclusions

As the myriad approaches within this book demonstrate, images and things continue to resist a single interpretative philosophy, leading some to adopt a 'bricolage' approach, an eclectic mix of methodologies that may be better suited to the complexity that objects present (Olsen 2010: 13–14). Indeed, the complexity with which objects interact with each other and with people has led to the label 'entanglement'. Rome, and the Roman Empire, was constituted by an entanglement of objects, cultures and social actors; a community formed by 'objects in motion' (Versluys 2014). Money, as both an object and a medium carrying a particular design, formed a key part in this process. The complexity of the coin imagery studied here suggests that by 'going between', money and the imagery it carried connected and transformed the cultures it came into contact with, switching between 'global' and 'local' (and then back again).

Money is a medium designed to be in a state of inbetweenness – to travel between different social actors and cultures, to act as a form of stored or realized value, to be in between past, present and future interactions. Money is the method by which contrasting cultural systems of value are made commensurate, and the medium is thus at the forefront of mediation between different cultures and political powers, a phenomenon that influences the iconography placed on money. This chapter has highlighted some of the strategies that assisted coinage in going inbetween in Roman Macedonia. The meanings attributed to the images discussed here are only some of the possible associations the iconography may have had. The fact that coins exist in quantity and move between people and contexts means that the imagery a coin bears can change meaning; as an object, a medium and an image, it remains in a state of inbetweenness.

But in addition to facilitating inbetweenness, the mobility of money also produces a unifying effect. As money circulates, it generates a sense of belonging and shared identity: the circulation sphere of a particular type of

currency often coincides with the area under the control of the money's issuing authority. The exchange of money between two social strangers affirms that they both belong to the same political economy; it is, as Wambui Mwangi states, 'a momentary recognition of a common "imagined community"' (2002: 35). The Romans understood this concept, and used coinage as a tool to generate identity and belonging, as well as to disseminate ideology. Coinage and its imagery, in this sense, went inbetween in order to not only cross cultural boundaries, but also remove them.

References

Backhaus, J. G. (1999) 'Money and Its Economic and Social Functions: Simmel and European Monetary Integration', *American Journal of Economics and Sociology* 58 (4): 1075–90.

Bauslaugh, R. A. (1997) 'Reconstructing the Circulation of Roman Coinage in First Century B.C. Macedonia', in K. Sheedy and C. Papageorgiadou-Banis (eds), *Numismatic Archaeology, Archaeological Numismatics*, 118–29, Oxford: Oxbow.

Bauslaugh, R. A. (2000) *Silver Coinage with the Types of Aesillas the Quaestor*, New York: American Numismatic Society.

Benjamin, W. (1999) 'The Work of Art in the Age of Mechanical Reproduction', in H. Arendt (ed.), *Walter Benjamin: Illuminations*, 211–44, London: Pimlico.

Briscoe, J. (1984) 'The Cognomen *Philippus*', *Gerión* 2: 151–3.

Carr, G. (2012) 'Coins, Crests and Kings: Symbols of Identity and Resistance in the Occupied Channel Islands', *Journal of Material Culture* 17 (4): 327–44.

Chueng, A. (1998) 'The Political Significance of Roman Imperial Coin Types', *Schweizer Münzblätter* 191: 53–61.

Comaroff, J. and J. Comaroff (2005) 'Beasts, Banknotes and the Colour of Money in Colonial South Africa', *Archaeological Dialogues* 12 (2): 107–32.

Crawford, M. H. (1974) *Roman Republican Coinage*, 2 vols, Cambridge: Cambridge University Press.

Dahmen, K. (2010) 'The Numismatic Evidence', in J. Roisman and I. Worthington (eds), *A Companion to Ancient Macedonia*, 41–62, Chichester: Wiley-Blackwell.

de Callataÿ, F. (1991–2) 'Athenian New Style Tetradrachms in Macedonian Hoards', *American Journal of Numismatics* 3–4: 11–20.

de Callataÿ, F. (2011) 'More Than It Would Seem: The Use of Coinage by the Romans in Late Hellenistic Asia Minor (133–63 BC)', *American Journal of Numismatics* 23: 55–86.

Gaebler, H. (1935) *Die antiken Münzen Nord-Griechenlands III.2: Die antiken Münzen von Makedonia und Paionia*, Berlin: Walter de Gruyter.

George, M. D. (1949) *Catalogue of Political and Personal Satires Preserved in the Department of Prints and Drawings in the British Museum*, vol. 9, London: The British Museum.

Hahn, H. P. (2004) 'Global Goods and the Process of Appropriation', in P. Probst and G. Spittler (eds), *Between Resistance and Expansion: Explorations of Local Vitality in Africa*, 211–29, Münster: LIT Verlag.

Hart, K. (2005) 'Notes towards an Anthropology of Money', *Kritikos* 2, available online: http://intertheory.org/hart.htm (accessed 16 December 2015).

Helleiner, E. (2003) *The Making of National Money: Territorial Currencies in Historical Perspective*, Ithaca, NY: Cornell University Press.

Hörisch, J. (2004) *Gott, Geld und Medien: Studen zur Medialität der Welt*, Frankfurt am Main: Suhrkamp Verlag.

Howgego, C., V. Heuchert and A. Burnett (eds) (2005) *Coinage and Identity in the Roman Provinces*, Oxford: Oxford University Press.

Inventory of Greek Coin Hoards (2015) IGCH 0483, available online: http://coinhoards.org/id/igch0483 (accessed 16 December 2015).

Kähler, H. (1965) *Der Fries vom Reiterdenkmal des Aemilius Paullus in Delphi*, Berlin: Verlag Gebr. Mann.

Kallet-Marx, R. M. (1995) *Hegemony to Empire: The Development of the Roman Imperium in the East from 148 to 62 BC*, Berkeley: University of California Press.

Kroll, J. (1972) 'Two Hoards of First-Century B.C. Athenian Bronze Coins', *ΑΡΧΑΙΟΛΟΓΙΚΟΝ ΔΕΛΤΙΟΝ* 27: 86–120.

Landau, P. S. (2002) 'An Amazing Distance: Pictures and People in Africa', in P. S. Landau and D. D. Kaspin (eds), *Images and Empires: Visuality in Colonial and Postcolonial Africa*, 1–40, Berkeley: University of California Press.

Levine, D. N. (1985) *The Flight from Ambiguity*, Chicago, IL: University of Chicago Press.

Linderski, J. (1996) 'Q. Scipio Imperator', in J. Linderski (ed.), *Imperium sine fine: T. Robert S. Broughton and the Roman Republic*, 145–85, Stuttgart: Franz Steiner Verlag.

MacKay, P. A. (1968) 'Bronze Coinage in Macedonia 168–166 B.C.', *American Numismatic Society Museum Notes* 14: 5–13.

Meadows, A. and J. Williams (2001) 'Moneta and the Monuments: Coinage and Politics in Republican Rome', *Journal of Roman Studies* 91: 27–49.

Mitchell, W. J. T. (2005) *What Do Pictures Want?* Chicago, IL: University of Chicago Press.

Morgan, M. G. (1969) 'Metellus Macedonicus and the Province Macedonia', *Historia* 18: 422–46.

Mwangi, W. (2002) 'The Lion, the Native and the Coffee Plant: Political Imagery and the Ambiguous Art of Currency Design in Colonial Kenya', *Geopolitics* 7 (1): 31–62.

Olsen, B. (2010) *In Defense of Things: Archaeology and the Ontology of Objects*, Lanham, MD: Altamira Press.

Prokopov, I. S. (2012) *The Silver Coinage of the Macedonian Regions 2nd–1st Century BC*, Wetteren: Moneta.

Richardson, J. (2011) *The Language of Empire: Rome and the Idea of Empire from the Third Century BC to the Second Century AD*, Cambridge: Cambridge University Press.

Romano, I. B. (1994) 'A Hellenistic Deposit from Corinth: Evidence for Interim Period Activity (146–44 BC)', *Hesperia* 63: 57–104.

Rose-Greenland, F. (2013). 'The Parthenon Marbles as Icons of Nationalism in Nineteenth-Century Britain', *Nations and Nationalism* 19 (4): 654–73.

Rowan, C. (2009) 'Becoming Jupiter: Severus Alexander, the Temple of Jupiter Ultor and Jovian Iconography on Roman Imperial Coinage', *American Journal of Numismatics* 21: 123–50.

Rowan, C. (2014) 'Iconography in Colonial Contexts: The Provincial Coinage of the Late Republic in Corinth and Dyme', in N. Elkins and S. Krimnicek (eds), *'Art in the Round': New Approaches to Coin Iconography*, 147–58, Tübingen: Verlag Leidorf.

Russell, A. (2012) 'Aemilius Paullus Sees Greece: Travel, Vision and Power in Polybius', in L. Yarrow and C. Smith (eds), *Imperialism, Cultural Politics, and Polybius*, 152–6, Oxford: Oxford University Press.

Seligman, A. B. and R. P. Weller (2012) *Rethinking Pluralism: Ritual, Experience, and Ambiguity*, Oxford: Oxford University Press.

Stockhammer, P. W. (2012) 'Conceptualizing Cultural Hybridization in Archaeology', in P. W. Stockhammer (ed.), *Conceptualizing Cultural Hybridization*, 43–58, Berlin: Springer.

Versluys, M. J. (2014) 'Understanding Objects in Motion: An Archaeological Dialogue on Romanization', *Archaeological Dialogues* 21 (1): 1–20.

Yarrow, L. (2013) 'Heracles, Coinage and the West: Three Hellenistic Case-Studies', in J. R. W. Prag and J. Quinn (eds), *The Hellenistic West: Rethinking the Ancient Mediterranean*, 348–66, Cambridge: Cambridge University Press.

Zubrzycki, G. (2011) 'History and the National Sensorium: Making Sense of Polish Mythology', *Qualitative Sociology* 34 (1): 21–57.

Index